Irish art
and architecture

from prehistory to the present

Irish art
and architecture

from prehistory to the present

PETER HARBISON

HOMAN POTTERTON

JEANNE SHEEHY

with 316 illustrations, 40 in color

THAMES AND HUDSON

Library of Congress Catalog card number 78–55034

Filmset in Great Britain by Keyspools Ltd, Golborne, Lancs.
Printed in The Netherlands by Drukkerij de Lange/van Leer, Deventer and London
Bound in Great Britain

CONTENTS

Part Three: *The nineteenth and twentieth centuries by Jeanne Sheehy*

PREFACE AND ACKNOWLEDGMENTS

Irish art and architecture have a history which goes back almost five thousand years, and includes not only works by Irish artists at home and abroad, but also those by foreign artists who made a significant contribution to the country's heritage. It has not been easy to compress a subject of such scope and complexity, and much simplification and many omissions have been inevitable. What follows is offered in the hope that it may provide the reader with a useful summary of the main trends and monuments. (A guide to further reading is provided by the Bibliography.) The book has been planned not as a catalogue of facts, but as a discourse on selected works of art and architecture, chiefly those that are *accessible*. In writing about them we have tried to place them in the context of their time and to relate them to contemporary styles of art and architecture outside Ireland. By doing so we hope that our text will lead to a more ready appreciation of those artists, buildings, paintings and sculptures which have had to be omitted.

The book could not have been written had it not been for the researches of past and present generations of art historians, to all of whom a debt of gratitude must be expressed. In particular, the chapter on the Early Christian period has benefited greatly from Françoise Henry's *Irish Art* trilogy, and that on the later medieval period owes much to the work of Harold Leask and John Hunt. For the chapters on later centuries we owe thanks to colleagues who shared the fruits of their researches, helped with information, illustration and in numerous other ways, and, in some cases, devoted time to a critical reading of the text: to Anne Crookshank and Edward McParland in particular, and also to Cyril Barrett, Mary Boydell, C. E. B. Brett, Hilary Carey, Maurice Craig, Hugh Dixon, the Knight of Glin, Catriona McLeod, Maighread Ó Murchadha, Donal O'Donovan, Malcolm Rogers, Patrick Shaffrey, Janet Sheehy, Oliver Snoddy, Ann Stewart, Clare Tilbury, Dorothy Walker, James White and Michael Wynne. Our thanks go also to the officials of the following institutions, too numerous to mention individually, for their unfailing kindness and patience, and for their help, which was always so readily given: Bord Fáilte – Irish Tourist Board, the National Gallery of Ireland and its library, the National Library of Ireland, the National Museum of Ireland, the Office of Public Works (National Parks and Monuments Branch), the Royal Irish Academy and its library, the library of Trinity College, Dublin, the Ulster Museum, Belfast, and the Victoria and Albert Museum, London, and its library.

In addition, we and the publishers would like to thank the collectors and institutions who have allowed works in their possession to be reproduced, and to express our indebtedness to the following for illustrations:
Aerofilms 145; An Chomhairle Ealaíon 265; Historic Monuments Branch, Department of the Environment, Belfast 112, 113, 185; Copyright Ulster Museum, Belfast 14, 16, 60, 117, 118, 165, 232, 255, 257, 260, 273, 275; Bord Fáilte – the Irish Tourist Board 11, 13, 18, 26–28, 30, 36, 59, 64, 68, 71, 72, 77, 78, 84, 88, 90, 92, 97, 102, 103, 142, 143, 178, 182, 188, 189, 191, 218, 244, 250, 269,

Note
References in **bold** type denote colour plates. In the captions to paintings, the medium is oil on canvas unless otherwise stated.

PART ONE

From prehistory to 1600

by Peter Harbison

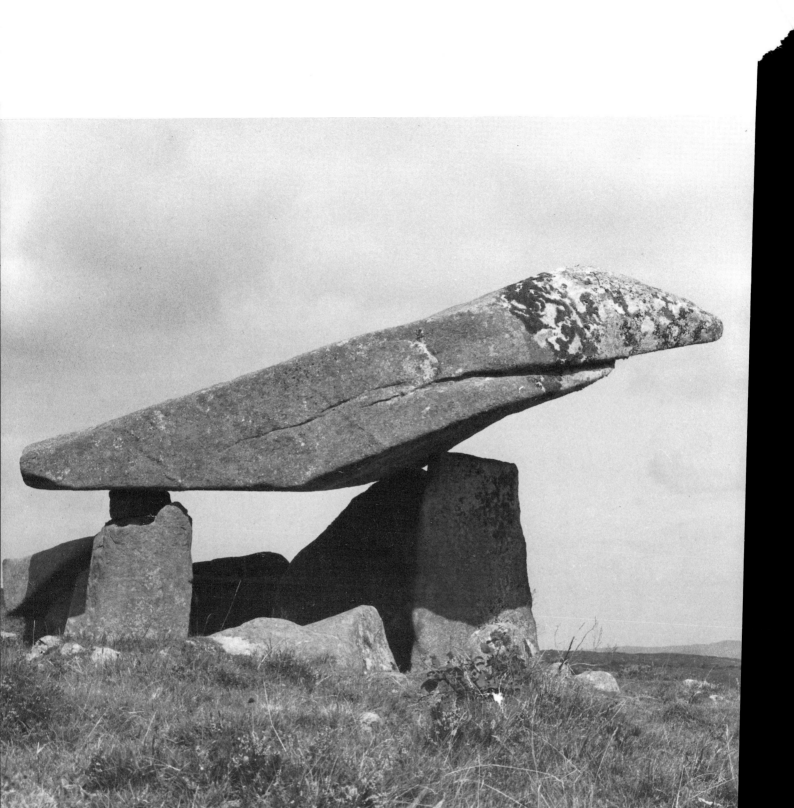

The earliest traces of man's presence in Ireland that can be reliably dated go back to the Mesolithic or Middle Stone Age period, around 7000 BC. They are found particularly in north-eastern Ireland, but also in the midlands. The island's first inhabitants were simple hunting and fishing folk who had come via Scotland from the North European Plain. To archaeologists they are largely known only through the implements which they made from flint and which they used for hunting, fishing and preparing leather.

By around 3700 BC these hunters and fishermen were gradually displaced by newcomers. The new arrivals came from the Continent, almost all probably in small groups via Scotland and England, and fanned out over wide areas of the country from their first bridgeheads, which were probably in the north-east. Unlike the Mesolithic hunters and fishers, they were tillers of the soil and, aided by the seeds and livestock which they brought with them, they practised agriculture and dairying. Using polished stone axes, they began to remove parts of those forests which had grown up in Ireland after the Ice Age glaciers had retreated, and in the glades which they cleared they created permanent but small settlements consisting of round or rectangular houses.

We cannot say to what race this new stock of Neolithic or New Stone Age farmers belonged, nor what language they spoke. We know comparatively little of their way of life. Much of our knowledge about them is derived from their stone graves, known as megalithic tombs (from the large size of the stones used in their construction), in which a number of their dead were buried collectively. They were also the first people to make pottery in Ireland. These Neolithic farmers and tomb-builders, along with the older hunter-fisher folk of the Mesolithic, formed the basic stock from which the population of modern Ireland is descended.

The Mesolithic period (*c.*7000–3700 BC)

The earliest people who arrived in Ireland around 7000 BC do not appear to have brought with them any of the traditions of the great animal paintings which had been executed many thousands of years earlier in the caves of France and Spain. For them, the gathering of food and the hunting of wild animals was a constant and full-time struggle for survival, and this necessitated a roving way of life little conducive to long-term settlement. However, one winter during the Middle Stone Age around 6800–6600 BC, some of these people settled long enough at Mount Sandel, Co. Derry, to have made it worth their while to construct several round huts measuring about 6 m. (20 ft) in diameter and with walls supported by a framework of upright posts. These huts are the earliest known traces of human building activity in Ireland.

Houses and tombs of the Neolithic period (*c.* 3700–2000 BC)

1 Dolmen at Kilclooney, Co. Donegal, 3rd millenium BC. The capstone is about 6 m. (20 ft.) long.

What seem to be the remains of a more permanent settlement were found at Ballynagilly near Cookstown in Co. Tyrone. There, around 3200 BC – not long

after the dawn of the Neolithic period in Ireland – a rectangular house measur[...]
6.5 × 6 m. (21⅓ × 20 ft) was built, its walls made of radially-split planks of woo[d]
and strengthened by posts at the corners. The small proportions of such Stone
Age dwellings and the ephemeral nature of the building materials used seem like
a symbol of the passing nature of this life; they form a contrast to Stone Age
man's belief in the greater permanence and importance of life after death, as
embodied in the great stone tombs of the time which have survived so
effortlessly down to our own day. Indeed, the creative energy of the whole
community seems to have been directed towards the building of grandiose and
imposing resting places for the tribal dead rather than comfortable earthly
abodes for the living. These graves, the megalithic tombs, are built usually of
large stones, and they vary considerably in size and shape. The simplest form is
the dolmen with between three and seven legs supporting one or two capstones.
In some instances, dolmens may have been partially covered by a stone or
earthern mound, the main purpose of which may have been as a ramp for
hauling up the capstone, but in almost all cases they stand revealed to us now as
intentional or unintentional pieces of stone sculpture rising gracefully from the
ground. The imaginative eye could see in the example at Kilclooney, Co. 1
Donegal, the form of a bird about to take flight – a shape as poetic as the folk belief
which identifies these tombs as nocturnal resting places for the fugitive lovers
Diarmuid and Gráinne.

A more complicated form of megalithic tomb is represented by what is
known as a court-cairn or court-tomb. This has the form of a rectangular burial
chamber, often divided up by jambs and sills, and entered from a court or
forecourt which is roughly semi-circular in shape and in which some form of
funerary ritual probably took place. But this basic form can be altered in a variety
of ways – by being placed back to back as at Cohaw, Co. Cavan, or front to
front, thus forming a large open central court off which the burial chambers
opened, as is the case at Creevykeel, Co. Sligo. The burial chambers were usually 2
covered by a long mound.

It was around 2500 BC, or possibly somewhat earlier, that art was first applied
to architecture in Ireland, when the two combine on what are known as passage
graves or passage tombs. These passage graves are also megalithic tombs, but
they differ considerably in shape from dolmens and court-cairns. They consist of
one or two tomb-chambers roughly in the centre of a large round mound of
earth or stone, which as the name implies are reached by means of a passage from
the edge of the mound. The most famous of all Irish passage graves is
Newgrange, which, with its close companions Knowth and Dowth, forms a 3–7
cemetery group in a bend of the river Boyne some kilometres upstream from
Drogheda. The great mound at Newgrange is about 11 m. (36 ft) high and about
85 m. (280 ft) in diameter, a size so impressive that it presupposes a well-organized
society capable of building it. The passage, lined and roofed with large stones,
slopes gently upwards over a distance of 18.9 m. (62 ft) before it opens into the
burial chamber, off which there are three tomb-niches with stone basins. The
roof of the chamber is of corbel construction and rises to a lofty height of about
6 m. (20 ft). The corbel technique required layers of flattish stones to be laid
roughly in a circle, each layer jutting inwards beyond the one below it until the
circle was sufficiently small to be closed by a single stone at the top. The stones
used in this way at Newgrange tilt downwards away from the tomb – a measure
designed to ensure that any water which percolated through from the top of the
mound would not penetrate into the chamber. Another ingenious method
employed apparently for the same purpose was the sinking of small continuous
grooves in the upper surfaces of the roof-stones of both chamber and passage

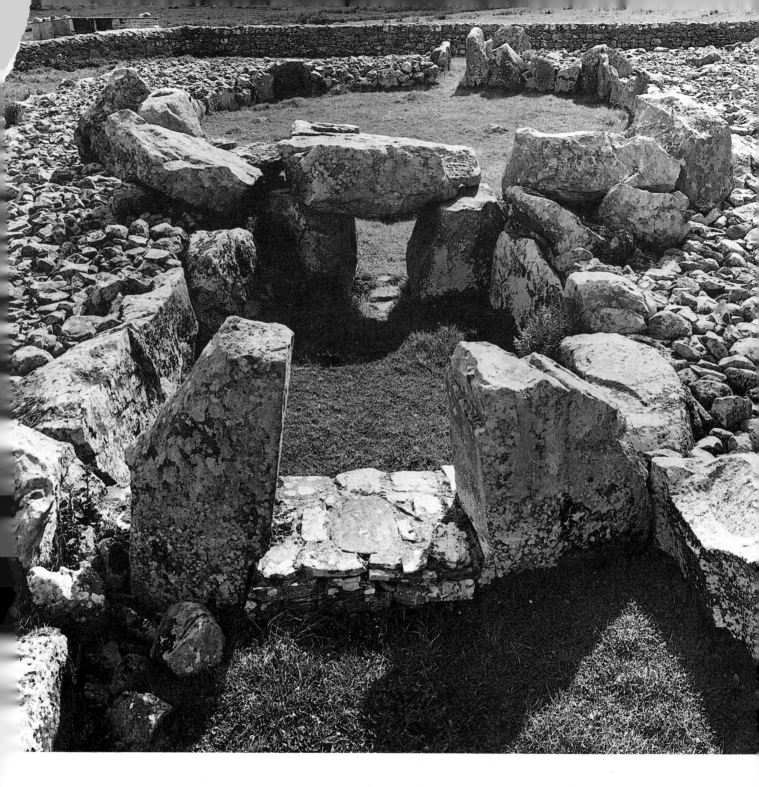

2 Court-cairn at Creevykeel, Co. Sligo,
c. 3000–2500 BC. The burial chamber
(12 m., or 30 ft., long) is in the foreground,
the entrance court beyond.

to serve as channels to drain off surplus rainwater. The dryness of the tomb to this
day is indeed a great compliment to the ingenuity of its builders.

The burial mound at Newgrange stands off-centre in a circle of large standing
stones of which 12 still survive out of the 35–38 which must originally have made
up the full circle. This circle may have been in existence before the tomb was
built, and could have served for the recording of astronomical observations
used in the planning of the tomb. It is certainly remarkable that if the line from

the centre of the tomb-chamber to the centre of the entrance of the passage is extended to the horizon, it marks the point where anyone standing at the tomb could see the sun rising on 21 December, the shortest day of the year. That this is not just coincidence is demonstrated by the fact that above the entrance to the passage there is a small cavity known as the 'roof-box', the sole purpose of which appears to have been to allow the sun to shine through a gap in the roof-stones of the sloping passage at a sufficiently high level for its rays to reach the central point of the tomb on and around the shortest day of the year. The civilization of the builders and designers of this tomb must have been sufficiently far advanced for them to have possessed an annual calendar, on which the orientation of the tomb and its passage must have been based. This need not surprise us greatly, if we remember that at the time when Newgrange was built the civilization which constructed the pyramids in Egypt had already long possessed such a calendar.

But what distinguishes the passage graves above all from the other kinds of megalithic tombs in Ireland is the fact that some of them, particularly those in the eastern half of the country, bear ornamentation on some of their stones. This consists in the main of purely geometric motifs, such as circles, spirals, arcs, zigzags, lozenges or diamonds, dots in circles and wavy, parallel or radial lines. What these motifs symbolized we cannot say, though they were certainly not just 'art for art's sake'. They must have had considerable significance for their creators, much as the Book of the Dead had an obvious relevance for the ancient Egyptians who depicted scenes from it on the walls of their tombs. The sense of well-planned and intentional design on the major stones which were visible at Newgrange when the tomb was completed is best seen on the great stone in front 3 of the entrance to the passage, which was carved after it had been placed in position. The composition is divided into two unequal portions by a groove running down from near the centre of the top of the stone. This groove was apparently intended to indicate where the entrance to the tomb lay. On one side of the line is a triple spiral – repeated only once in the whole of passage-grave art,

3 Decorated stone at the entrance to the passage grave at Newgrange, Co. Meath, *c.* 2500 BC. L. 3.2 m. (10 ft. 6 in.).

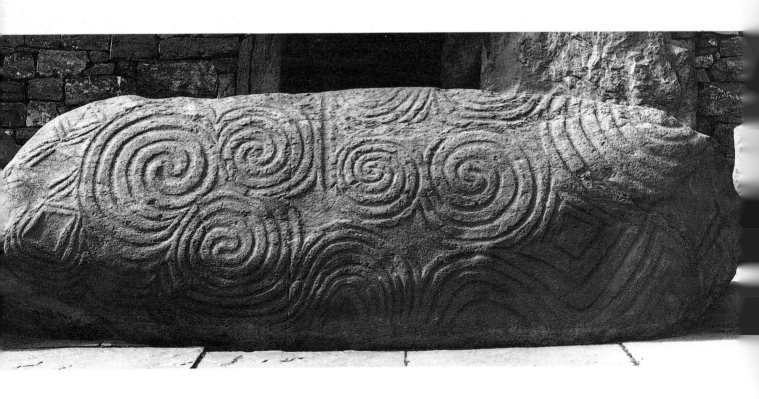

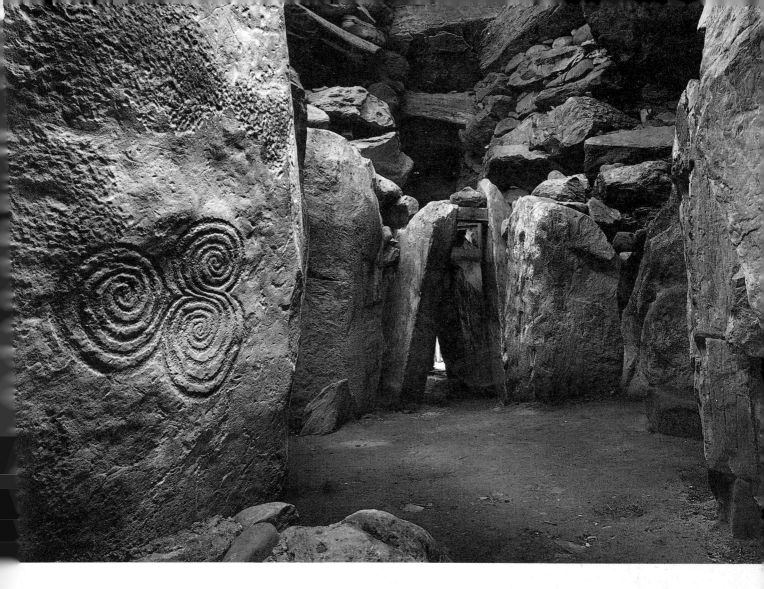

4 View from the hindmost burial niche at Newgrange, with its triple spiral ornament, looking back along the passage towards the entrance.

in the hindmost recess of the Newgrange tomb-chamber. Flanking the triple 4 spiral are three lozenges. In the other and larger portion of the stone are double spirals, and a lower pair of arched wavy lines which form an overflow from the triple spiral and remind one of a pair of bushy eyebrows. Near the end of the stone, the spirals enclose a further lozenge. This stone was carefully dressed smooth after the broad shallow grooves forming the patterns had been carved by means of pocking with stone chisels. A number of the stones which line the passage are also decorated. One in particular has a combination of zigzags, spirals and a lozenge. The chamber, too, is richly ornamented, individual stones bearing triangles or diamonds which are pocked out and accentuated by leaving similarly formed areas smooth and undecorated, and further zigzags and spirals can also be found. The capstone of the right-hand burial niche is also highly decorated, bearing zigzags, arcs placed garland-wise surrounding a central lozenge, concentric circles and other devices. This stone was carved before it was placed in position, as the decoration continues behind the wall.

Irish passage graves belong to a type found in southern Spain and along the Atlantic seaboard of Europe from Portugal northwards to Scandinavia. The combination of corbel-vaulted passage grave and spiral decoration is found in a more refined form in the Mycenaean civilization, but that is almost a thousand

years later than Newgrange. Malta also provides parallels for the decoration, but it is in the Gulf of Morbihan in Brittany and on the west coast of Wales that the closest correspondence is found with the decoration of the Irish tombs. Gavrinis, in Brittany, is the only non-Irish example which can compare with Newgrange in the fineness and complexity of its decoration. It is difficult to say whether the decorated Breton passage graves are older than Newgrange, as are a number of undecorated Breton tombs of this type. Equally, it is not easy to ascertain whether the builders of Newgrange came from Brittany, and whether the decorations found in Brittany and at Newgrange are parental one to the other or whether they may both go back to some other common source such as woven cloth which has not survived.

Newgrange is not the only decorated tomb of its type in Co. Meath. The neighbouring tumuli of Knowth and Dowth also bear somewhat similar decoration. Tombs at Loughcrew in the north-eastern part of the same county have decoration applied in a less systematic way, and include a motif of a circle with lines radiating out from it, giving support to the theory that the builders of these tombs may have been sun worshippers. Other decorated tombs are found in counties Wicklow, Tyrone and Sligo.

Of all the Irish passage graves, perhaps the most unusual is that at Knowth, which recent excavations have shown to have not one but two burial chambers placed practically back to back. One of these was constructed like the burial chamber at Newgrange, but the other had a flat roof and in plan was little more than a widening of the passage. The decorative motifs at Knowth diverge considerably in type from those at Newgrange, its nearest neighbour, though they are applied in the same pocking technique. The kerbstones surrounding the foot of the mound bear, among other things, a nest of boxed rectangles and strange horn-like motifs somewhat like the later 'horns of consecration' in Crete. One of the most curious stones is that at the entrance to one of the tombs, which 5 is characterized by a motif of radiating lines in a semi-circle, looking like a sun-dial. The recently discovered burial chambers at Knowth have also turned out to be rich in ornamentation. A basin stone which was found in a niche of the tomb 6 discovered in 1968 is interesting, as the decoration is applied to rounded surfaces without the object being actually sculpture in the round. On the concave upper

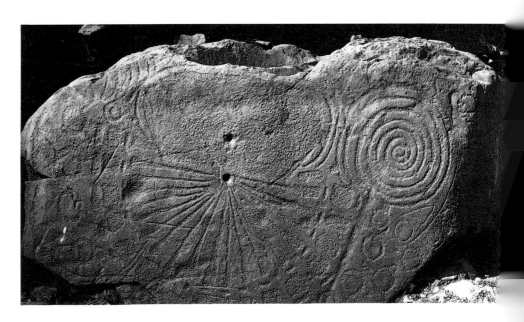

5 Decorated stone near the entrance to the second tomb at Knowth, Co. Meath, c. 2500 BC.

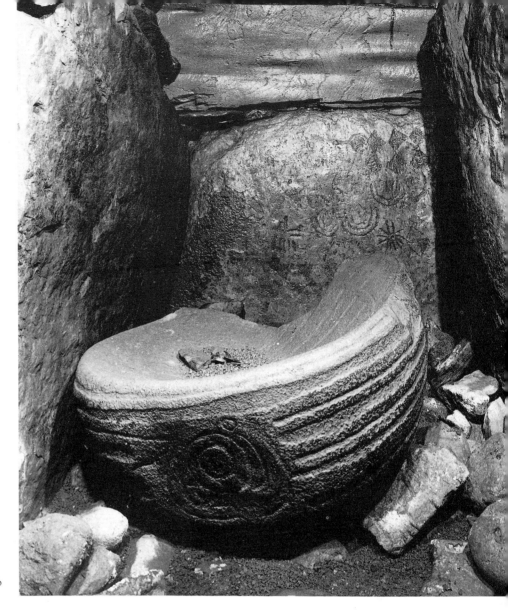

6 Basin stone in a niche of the second tomb at Knowth.

surface of the basin a set of grooved concentric arcs form the basis from which lines radiate as on a shell, while on the rounded exterior horizontal lines emanate from a set of non-concentric circles, giving a faint resemblance to the old Egyptian motif of the winged sun.

One stone in the passage of one of the chambers at Knowth is almost certainly 7 a stylization of the human face. Passage-grave art is normally considered to be non-representational and geometrical, but this stone shows that occasional pieces of representational art can be found, albeit in a very stylized form. One stone in the chamber at Newgrange would seem to represent a fern. Much the most obvious representation of a human figure in a passage grave is found on a small stone which forms part of the chamber at Fourknocks, in Co. Meath. Here one 8 eye is shown as two horizontal boxed lozenges (the other eye is damaged), and the single vertical lozenge in the centre can be interpreted as a mouth, while the crescent below it probably represents a neck ornament. The use of the lozenge in portraying clearly some elements of the human face at Fourknocks prompts the as yet unanswerable question as to the significance of the same motif on the entrance stone at Newgrange. The stele from Fourknocks is among the earliest

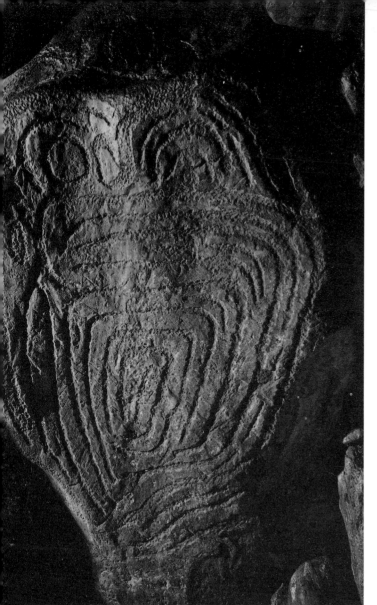

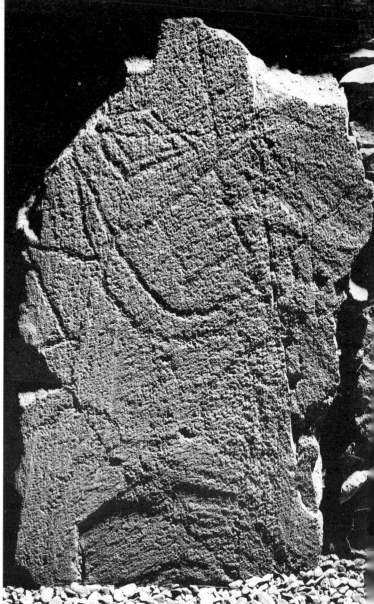

7 Stone in the passage of the first tomb at Knowth, *c.* 2500 BC, probably representing a human face.

8 Stylized representation of a human figure in the tomb chamber at Fourknocks, Co. Meath, *c.* 2500–2000 BC.

known attempts at reproducing the human figure in Ireland, and it can probably be interpreted as the representation of a deity worshipped by the people who buried their dead in the tomb.

The dwellings of the passage-grave builders have so far managed to elude us, and the material remains of these people stand poor comparison with the art and architecture of their tombs. Stone balls and small beads in the shape of miniature hammers have been found in the graves. Much of the pottery is of poor fabric, its surface pierced by a series of jabs, though some Late Stone Age pottery has beautiful grooved decoration. The only other artistically ornamented items are bone pins which have chevron decoration analogous to that seen in the tombs.

THE BRONZE AGE, *c.* 2000–500 BC

The emergence of the Bronze Age around 2000 BC was marked by the introduction of metal weapons, implements and ornaments, and perhaps also by the arrival of new population groups. In contrast to the communal burial rite of the Neolithic period, the Bronze Age people inhumed their dead individually in simple stone-lined cists or else cremated them. Very few Bronze Age settlements are known so far from Ireland. Most of the remains which have come down to us from this period are gold and bronze objects which show Ireland to have been in contact with wide areas of Northern and Atlantic Europe.

Towards the end of the Bronze Age, some time between 1000 and 500 BC, new ritual enclosures known as hill-forts emerge. They suggest a new religious impetus, though of uncertain origin, and possibly also the rise of a class of warrior-priests who may have been gaining the upper hand in society. At the same time the comparative cultural unity of the country which had been a feature of the earlier part of the Bronze Age began to crumble and towards the end of the period a division between northern and southern Ireland began to make itself felt.

Megalithic tombs were re-used during the Early Bronze Age, and it is possible that it was only then that some others were first constructed. These are rather smaller, with a rectangular burial chamber placed in a U-shaped setting of stones and surmounted by a wedge-shaped mound, whence the name by which they are known – wedge-shaped gallery graves or wedge-tombs. Most of the Bronze Age tombs are simple box-like cists and many hundreds of examples are known. Domestic structures, insofar as we know anything about them, continued to be made of wood and daub, and were rarely larger than the houses of the Stone Age. Stone circles of smaller diameter than that at Newgrange were set up, and in them the cycles of some celestial bodies were probably observed and recorded. A number of stone circles were found close together at Beaghmore in Co. Tyrone, but most are found singly, such as that at Lissyvigeen in Co. Kerry, one of the country's smallest examples. Single stones or menhirs were also erected at this period, some possibly to mark burials. One of the comparatively rare instances in Ireland of an alignment of standing stones is to be seen at Eightercua in Co. Kerry.

Art on stone is also found in the Bronze Age, but scarcely ever on tombs. Instead we find it on large erratic boulders, particularly in counties Cork, Kerry and Donegal. The decoration is largely in the form of dots in concentric circles, which have parallels in Scotland and in the Iberian Peninsula. One stone, at Clonfinlough, Co. Offaly, was for long thought to bear a representation of a prehistoric battle-scene, until it was shown recently that the upright lines on the stone – once taken to be human bodies – were natural striations, and that vertically-placed semi-circles adjoining the lines and making them look like the Greek letter Φ were the only man-made signs on it. The significance of these signs is not known.

What makes Ireland's Bronze Age famous is not its stone art but the smaller and more portable pieces of applied art, in the form of pottery, implements and

9

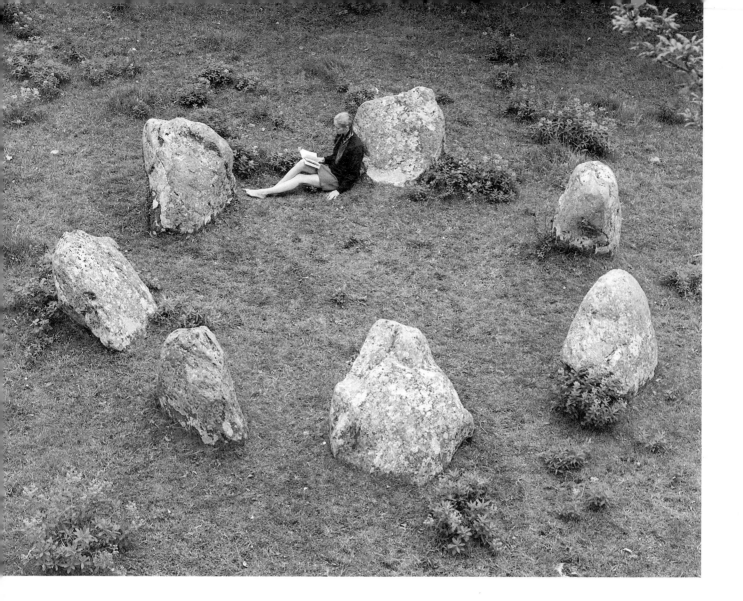

9 Stone circle at Lissyvigeen, Co. Kerry, *c.* 2000–1500 BC. The circle is over 4 m. (14 ft.) in diameter.

1 *Opposite* Gold gorget from Gleninsheen, Co. Clare, Bronze Age, *c.* 700 BC. D. 31 cm. (12⅛ in.). This is perhaps the finest gold ornament to survive from Bronze Age Ireland. National Museum of Ireland. *See p. 29.*

above all, jewellery. It was in this period that the great majority of the gold ornaments now on display in the National Museum of Ireland were made. The country could almost be described as an El Dorado of the West: it was probably Western Europe's greatest producer of gold in prehistoric times. Gold jewellery began on a small scale with the production of discs made of thin gold sheet, which often bear a cross as their main ornament. The decoration was carried out in repoussé technique, hammered out from behind. Before 1500 BC a new technique was introduced whereby the lines were punched in on the front of the gold surface. This is best exemplified on the *lunulae* (literally, 'little moons'), crescent-shaped ornaments probably worn around the neck. Their patterning is purely geometrical, consisting of parallel lines, hatched triangles, zigzags and lozenges, as well as hatched or cross-hatched bands, and it is usually symmetrically placed on both horns. The shape and decoration of lunulae may have been suggested by jewellery originally made of different material, such as jet or leather. The repoussé technique is found at an earlier period in Central and Eastern Europe and may have derived from there, whereas the punched-in or incised type of decoration, which we shall see again on bronze axe-heads, may have been modelled on the pottery of the period from about 2000 BC onwards.

3

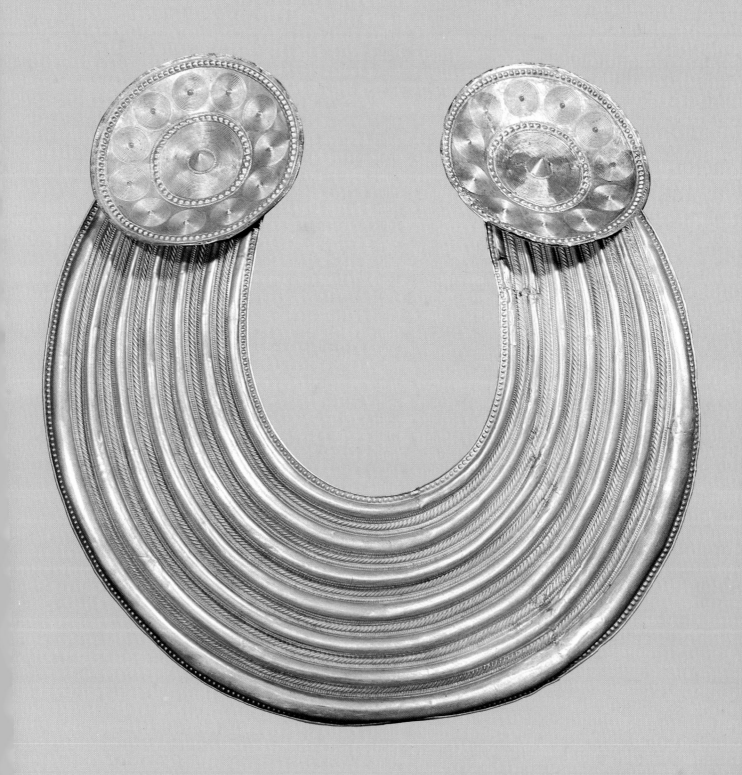

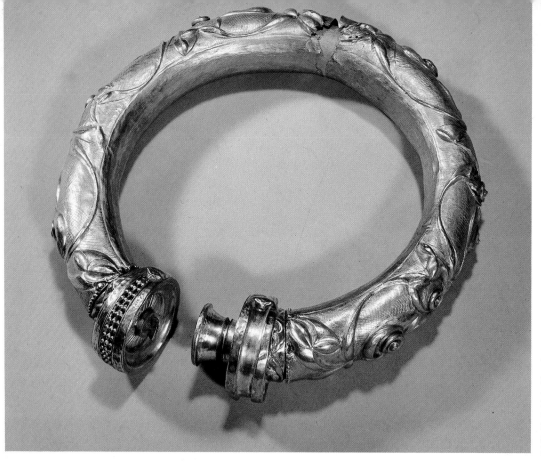

2 Gold torc or neck ornament from Broighter, Co. Derry, probably 3rd C. BC. D. 18.2 cm. (7⅛ in.). The relief decoration is in the La Tène style of the Iron Age, and the sophisticated method of closing the torc demonstrates the advanced techniques practised by Celtic craftsmen. National Museum of Ireland. *See p. 35.*

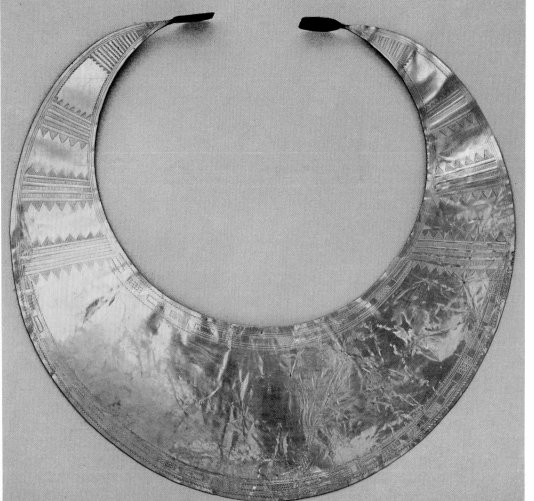

3 Gold lunula from Mangerton, Co. Kerry, Bronze Age, *c.* 17th C. BC. W. of band at the widest point 7.5 cm. (3 in.). It bears incised decoration and was presumably worn around the neck. British Museum, London. *See p. 20.*

4 Gold-plated lead pendant from the Bog of Allen, Co. Kildare, Bronze Age, *c.* 700 BC. H. 6.5 cm (2⅝ in.). The design seems to be a stylized human face, but the object's purpose is not known. National Museum of Ireland. *See p. 29.*

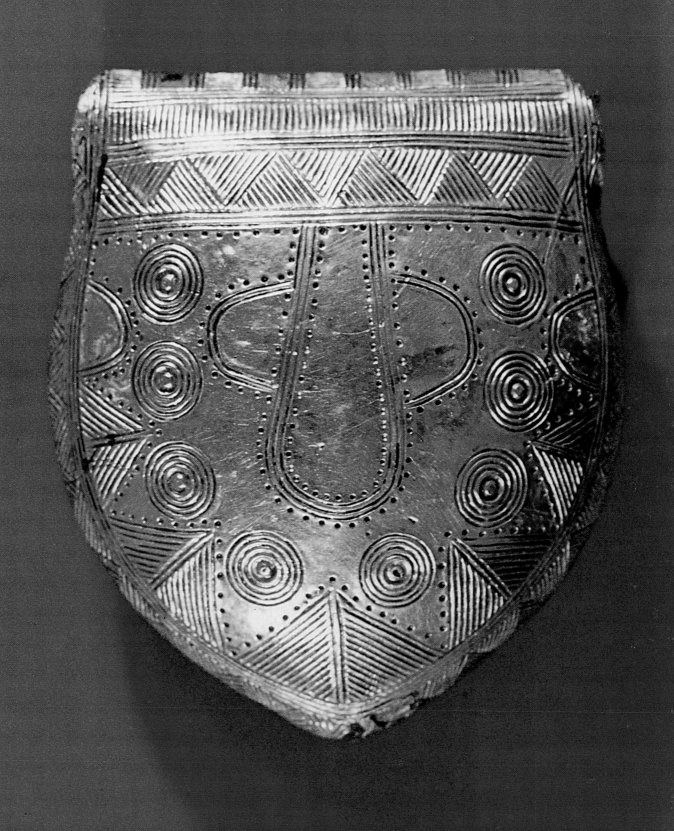

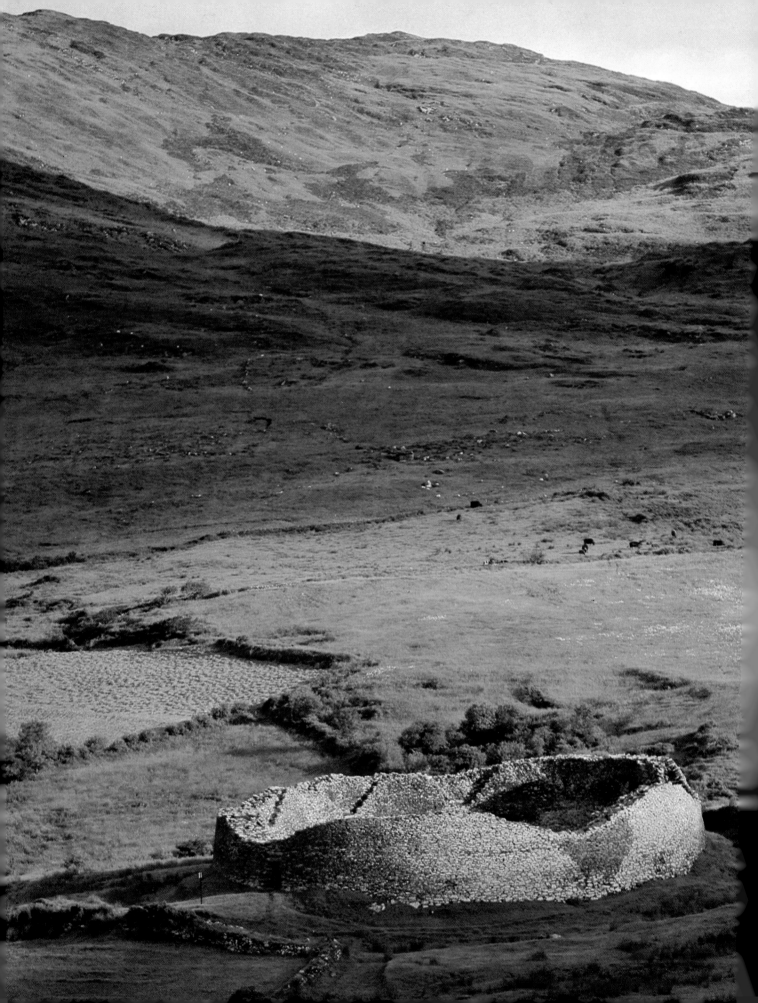

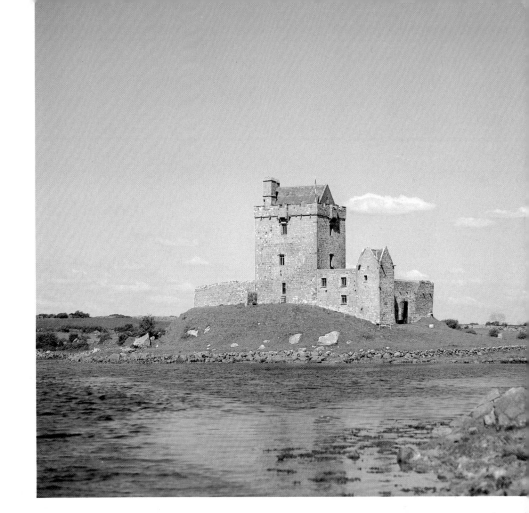

5 Circular stone fort at Staigue, Co. Kerry, probably built during the Iron Age. Its walls stand up to 5.5 m. (18 ft) high. *See p. 31.*

6 Tower-house at Dunguaire, Co. Galway, 16th C. – a very well preserved example of an Irish chieftain's fortified dwelling. *See p. 103.*

7 The keep (right background) and part of the curtain wall of Trim Castle, Co. Meath, Ireland's largest castle, built in the early and mid-13th C. *See p. 101.*

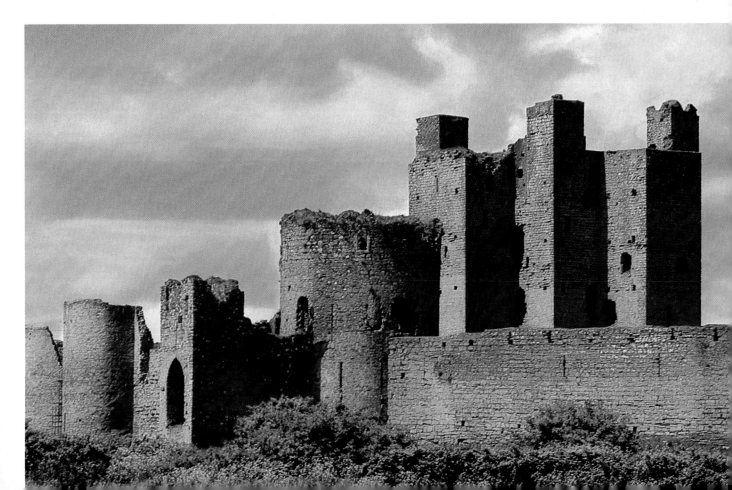

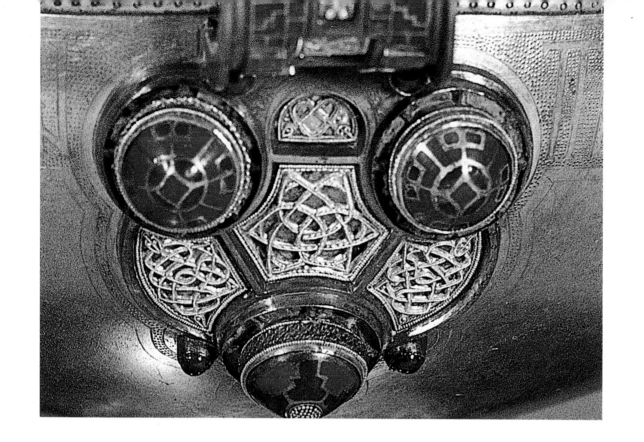

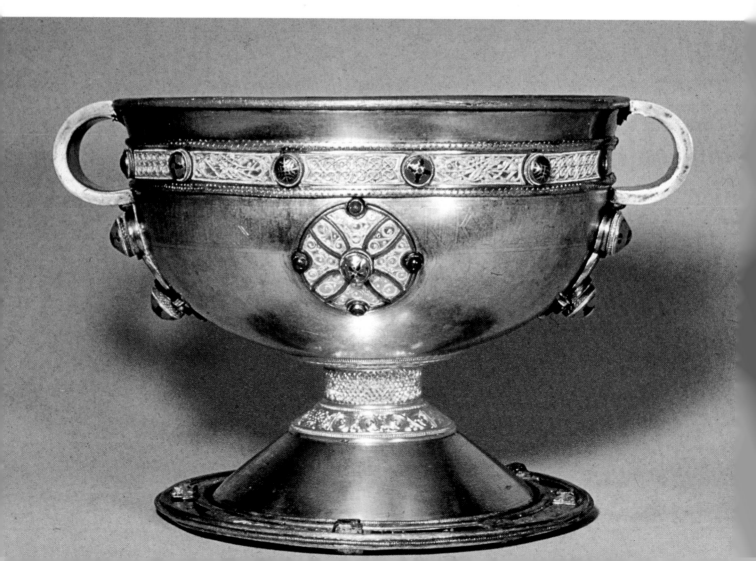

8, 9 The Ardagh Chalice, *c.* 700, found with a hoard of slightly later metalwork (pl. **10**) near Ardagh, Co. Limerick, in 1868. Silver, with decoration in gold and in red and blue enamel, D. 19 cm. (7½ in.). The detail shows the gold filigree and cloisonné enamel studs under one of the handles. National Museum of Ireland. *See pp. 46–47.*

10 Penannular brooches found with the Ardagh Chalice, 9th C. Silver, decorated with stylized animals in gold and with amber and glass (*left*) and enamel (*right*), L. about 26 cm. (10¼ in.). National Museum of Ireland

11 Detail of the front of the Tara Brooch, early 8th C. Bronze, covered with gold and set with amber and glass. National Museum of Ireland. *See pp. 48–49.*

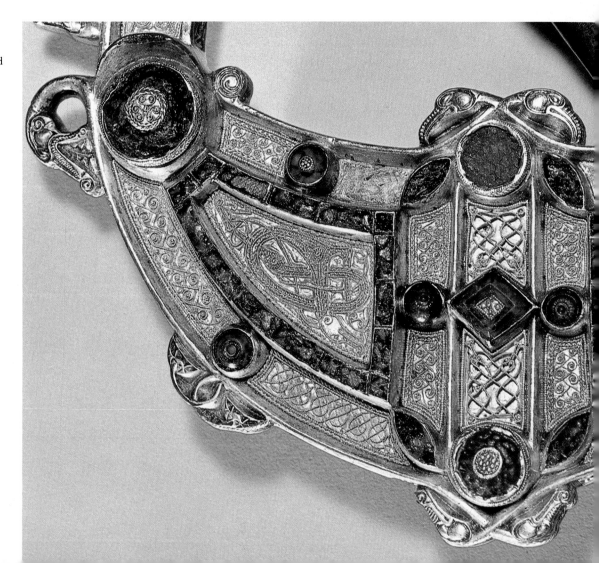

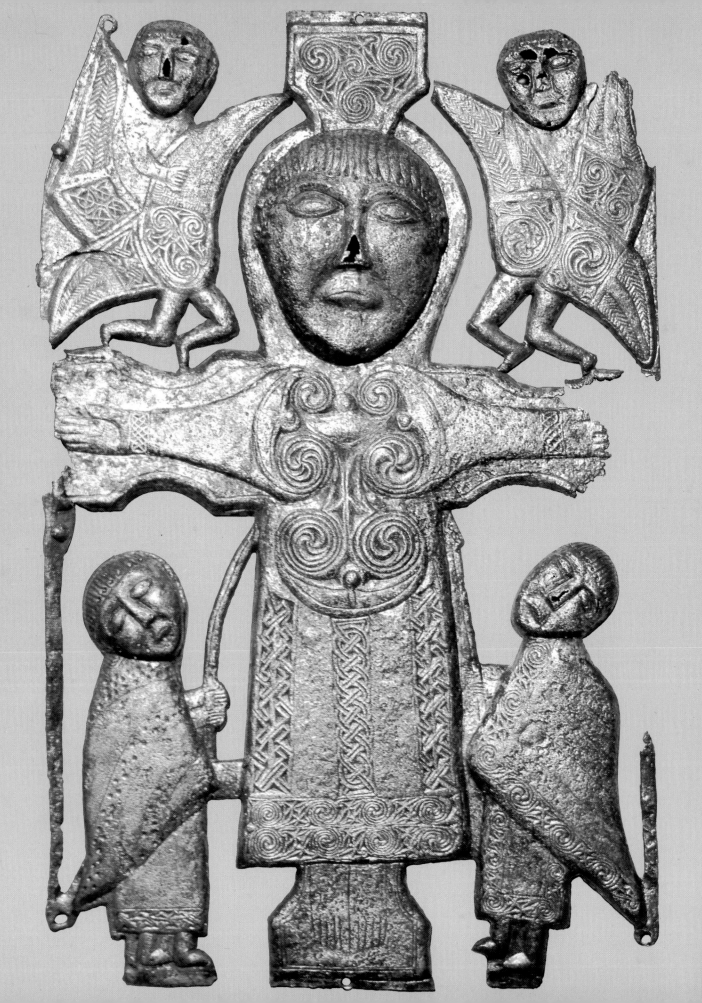

12 *Opposite* Crucifixion plaque from Rinnagan, Co. Roscommon, perhaps originally a book cover, 8th C. Bronze, formerly gilded, H. 21 cm. (8¼ in.). National Museum of Ireland. *See p. 47.*

The manufacture of magnificent gold finery continued throughout the Bronze Age. During the first half of the last millennium B C, in particular, we find a great variety of objects, sometimes of massive gold, decorated with an abundance of circles beautifully woven into concentric designs. These concentric circles often surrounding a central conical boss would appear to be of Scandinavian inspiration, suggesting considerable contact between Ireland and Northern Europe at the time. Goldsmiths used complicated techniques to twist the body of large gold bar torcs such as those found on the Hill of Tara. In the period around the eighth/seventh century B C, the counties bordering the lower Shannon were the centre of an important gold-working industry, culminating in such delicate pieces as the gorget or neck ornament from Gleninsheen, Co. Clare. **I** This piece has round terminals decorated with concentric designs, while the main part of the gorget is composed of a number of ribs in relief, every second one ornamented with cord decoration. The design of the round terminals on such gorgets may owe something to the flower decoration on Phoenician or Iberian goldwork, suggesting a contact with areas in the southern half of the Iberian Peninsula as well with Northern Europe. We have to go as far as the Mediterranean to find parallels for the advanced techniques used in the manufacture of Late Bronze Age gold 'lock-rings' in Ireland. As in most of the rest of Europe, Irish Bronze Age decoration is geometrical and abstract. One exception might be the gold-plated lead pendant or bulla from the Bog of Allen, **4** which seems to attempt to depict the human face. It also bears a curious resemblance to Greek Corinthian helmets of the seventh century B C, with which it must be roughly contemporary.

Some of the early bronze implements also display a fine sense of decoration. There are some few daggers ornamented with designs composed of triangles or dotted lines, but the great majority of decorated bronze objects are axe-heads. In **10** the three thousand or more years since their manufacture, these have acquired a beautiful mellow patina which acts as a fine background for the variegated motifs found on their faces and sometimes also on their narrow sides. The motifs used on the faces are all geometrical: zigzags, herringbone triangles and 'rain-drops', but it is difficult to say whether there is any artistic connection between them and the similar motifs used on the walls of passage graves. The designs were chiselled in or hammered up after the axe-heads were cast. Ireland seems to have been the main centre in Europe for decorating axe-heads. It even exported some

10 Decorated bronze axe-head from Scrabo, Co. Down, one of a hoard dating from around the 17th C. BC. L. 13.5 cm. (5¼ in.). National Museum of Ireland.

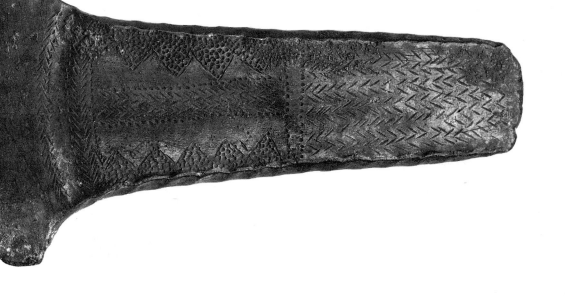

examples to Britain and the Continent, where similar though undecorated axe-heads were common. In the Later Bronze Age Ireland produced some superb decorated bronzework, such as round shields ornamented with raised bosses and concentric circles and also cauldrons and horns bearing conical and incised decoration.

The early centuries of the Bronze Age saw the production of highly decorative pottery, of which the finest examples are the food vessels which were 11 placed in graves to hold sustenance for the dead on their journey to the other world. Similar vessels are also found in Britain. On the Irish bowl- or vase-shaped vessels the whole outer surface is usually covered with ornament, much of which is made by a toothed comb or wheel which produced dotted lines often running parallel with one another. The motifs found include herringbone, chevrons and lozenges, while the bases of the pots are sometimes decorated with a cross pattern. The pots usually have raised bands in high relief, and a light and shadow effect is created by the use of chip-carving. Large urns in which the cremated bones of the dead were placed are often decorated on their outer walls and inside the lip. These urns also have decoration in high relief, with raised bands with notched indentations forming straight and zigzag lines and triangles. Many of the flat surfaces are hatched and cross-hatched, and are frequently interspersed with bosses. This decorative ware disappears around the fourteenth century BC, when a change in burial custom seems to have dictated that the dead should be buried without grave-goods, as people are today. The pottery which appears towards the end of the Bronze Age and which continues under various guises into the Early Christian period is very much inferior to the Earlier Bronze Age wares, and shows little more ornament than some hand-pinching at the rims.

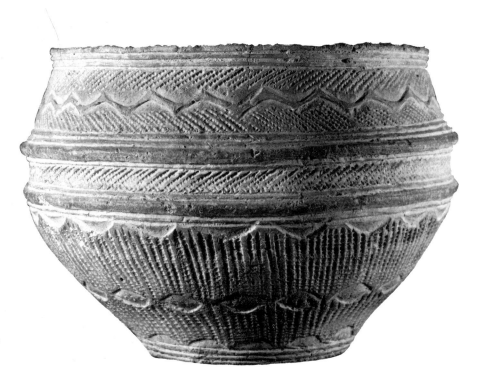

11 Pottery food vessel found at Dunamase, Co. Laois, c. 1600 BC. H. about 10 cm. (4 in.). National Museum of Ireland.

THE IRON AGE, *c.* 500 BC–AD 432

Bronze seems to have remained the main metal in use until the last half of the first millennium BC, when it began to be replaced gradually by iron. The Iron Age is normally considered to have ended with the coming of St Patrick in the fifth century AD, but its culture and way of life continued uninterruptedly for centuries after his arrival. The erection of large fortifications probably began during the Iron Age. Their presence suggests unrest in the community, possibly due to the arrival of new though probably small bands of people from Britain. These people were presumably led by chieftains accompanied by smiths who zealously guarded the secrets of iron-working, with the aid of which they made effective and conquering iron weapons for their masters. These putative chieftains can be identified with virtual certainty as Celts, those people whom we first learn of from Greek authors like Herodotus as living north of the Alps in the latter half of the first millennium BC. But these Iron Age newcomers were not necessarily the first Celts in Ireland. On their arrival they may possibly have found a considerable proportion of the population already speaking some kind of Celtic dialect which could have formed the basis of the Irish language still spoken today.

During the Iron Age, Ireland can thus be seen to have experienced, albeit at some remove, the tremors caused by the expansion of the Celtic peoples from Central Europe around 300 BC. Irish society of the period is reflected in the oldest Irish sagas, such as the *Táin Bó Cualnge*, where we find a warrior élite who rode around the countryside in chariots, constantly warring against one another and intent upon robbing each other's cattle. Their dwellings were the isolated homestead typified later by the circular ring-fort. The equivalent of the druids, as encountered in Caesar's account of the Gallic wars, doubtless played an important role.

Possibly the most famous piece of Iron Age architecture, and certainly the most impressive in its siting, is the great fortress of Dún Aengus on the Aran Island of Inishmore in Galway Bay. There, four great walls enclose an almost semi-circular area abutting on to a steep cliff which falls sheer to the raging Atlantic waves some 90 m. (266 ft) below. The third wall is defended by *chevaux-de-frise*, vertical stones stuck into the ground to hinder advancing invaders – a type of defence practised in wood in Central Europe as early as the seventh century BC, though its use at Dún Aengus is scarcely likely to be much earlier than about the first century BC. Stout defending walls with a number of interior stairways leading to a parapet as found in the innermost fortification at Dún Aengus are also encountered on some other splendid stone forts, such as Staigue in Co. Kerry, the Grianán of Aileach and Lough Doon in Co. Donegal and other sites in counties Sligo and Cavan, though it is difficult to work out even an approximate date for these structures. Other large circular walls on tops of hills, known as hill-forts, began to be constructed as early as the Later Bronze Age, as is the case at Rathgall in Co. Wicklow and Navan Fort near Armagh. Their main period of use, however, is likely to have been during the Iron Age. These hill-forts need not necessarily be seen as having a defensive purpose, since in some cases the wall

13

5

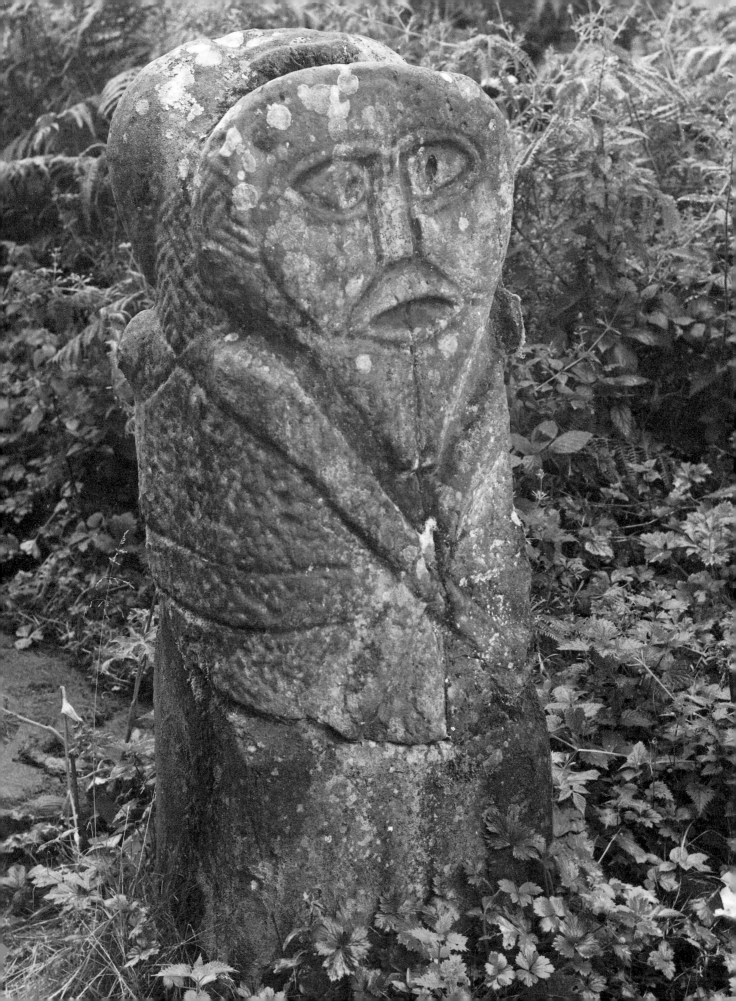

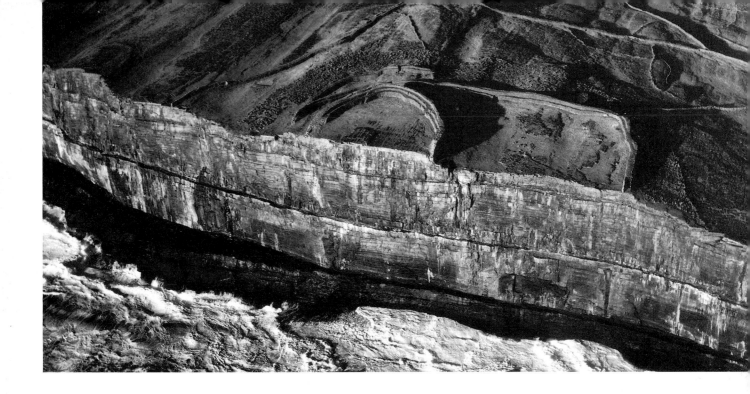

13 Dún Aengus fort, on the Aran Island of Inishmore, Co. Galway, probably 1st C. BC. The *chevaux-de-frise* appear as a rough, darker area in a wide band around the third wall. Only the innermost wall is still complete.

has a ditch on the inner side rather than the outside, contrary to what one would expect in a true fort. As some of these hill-forts such as Navan Fort and Dún Aillinne in Co. Kildare were used at the emergence of the historic period by what may have been priest-kings, we may be justified in seeing at least some of them as ritual rather than defensive sites.

Much smaller in size and also much more common are the circular 'forts' which were built of earth or stone, depending upon the availability of building material in each area. Their circular walls were once much higher than they are now and were sometimes crowned by a wooden palisade. These forts could scarcely have withstood a siege for any length of time, and are best understood as fortified homesteads which would have had a house inside the wall. The walls were doubtless used as much to keep cattle in at night as to keep out human and animal predators. Most of the surviving 'ring-forts' probably date from the Early Christian period. The isolated distribution of the forts is the forerunner of the settlement pattern of houses in rural Ireland to this day, and they continued to be used (though not necessarily to be built) as late as the seventeenth century AD. The same can also be said of the crannógs, which were artificial islands of stone and wood, situated in the middle of or at the edge of lakes, and constructed as early as the Late Stone Age. They are the Irish counterparts of the lake-dwellings of Stone and Bronze Age date known from the Alpine lakes. An idea of the original form of a ring-fort and a crannóg can be gained by a visit to the recently built examples at Craggaunowen in Co. Clare.

During the Iron Age, stone once more became the object of artistic endeavour in Ireland, though there would not appear to be any connection with the carving on the passage graves. The earliest surviving attempts at sculpture in the round are found on stones which are most likely to have been carved during this period. Among the most remarkable of these is the stone double idol at Boa Island in Co. Fermanagh, which presumably represents Celtic deities. The upper parts of the two figures stand back to back, their strands of hair criss-crossing one another. The figures are belted together, and their stiff arms are crossed on their bodies. The faces are bearded, and the lentoid eyes have an earnest mien and piercing

12 Stone double deity at Boa Island, Co. Fermanagh, early Iron Age. H. of surviving fragment 76 cm. (30 in.).

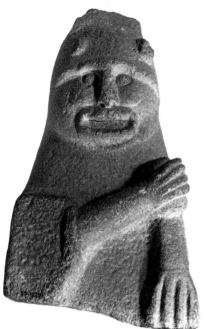

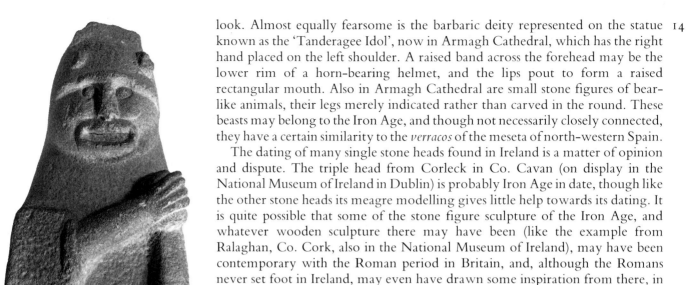

look. Almost equally fearsome is the barbaric deity represented on the statue 14 known as the 'Tanderagee Idol', now in Armagh Cathedral, which has the right hand placed on the left shoulder. A raised band across the forehead may be the lower rim of a horn-bearing helmet, and the lips pout to form a raised rectangular mouth. Also in Armagh Cathedral are small stone figures of bear-like animals, their legs merely indicated rather than carved in the round. These beasts may belong to the Iron Age, and though not necessarily closely connected, they have a certain similarity to the *verracos* of the meseta of north-western Spain.

The dating of many single stone heads found in Ireland is a matter of opinion and dispute. The triple head from Corleck in Co. Cavan (on display in the National Museum of Ireland in Dublin) is probably Iron Age in date, though like the other stone heads its meagre modelling gives little help towards its dating. It is quite possible that some of the stone figure sculpture of the Iron Age, and whatever wooden sculpture there may have been (like the example from Ralaghan, Co. Cork, also in the National Museum of Ireland), may have been contemporary with the Roman period in Britain, and, although the Romans never set foot in Ireland, may even have drawn some inspiration from there, in the same way that Celtic sculpture on the Continent was obviously influenced by Classical Greek and Roman prototypes.

Of considerable importance for the art of this period are a small number of other stones bearing abstract patterns of a rather different nature to those encountered in earlier periods. This new style is called La Tène, after a site in Switzerland where objects decorated in this manner were discovered in the last century. The La Tène style was developed by the Celts living north of the Alps. In its earliest phase, starting around 450 BC, it adapted and stylized Classical Greek motifs such as the honeysuckle, and was infiltrated by animal ornament of Eastern and even Persian origin. Shortly before 300 BC a variant known as the Waldalgesheim style emerged in Central Europe, characterized by flowing tendril ornament. It is an offshoot of this Waldalgesheim style that we meet on a granite boulder at Turoe in Co. Galway. The domed upper part of this stone is 15 covered by a continuous ebb and flow of swelling tendrils in low relief, possibly modelled on a wooden or bronze original, and searching like rivulets of a great tidal stream for an outlet. We see already developing here the triskeles and trumpet-end patterns which we will meet again later. Below this undulating 23 whirl of ornament is a much more staid frieze similar to the Greek step pattern which may owe a debt to the rectangular geometrical art practised in Central Europe by Celtic craftsmen during the Hallstatt period in the sixth century BC. The Turoe stone is thought to have affinities with other decorated stones in Brittany, but recent research argues for a closer link with Britain. The same may also prove to be true of the stone at Castlestrange, Co. Roscommon, that from Killycluggin, Co. Cavan, which is now in the National Museum of Ireland, and the example recently discovered at Derrykeighan, Co. Antrim.

Although iron was becoming increasingly popular, it was on the more traditional materials – not just on stone but on bronze and gold as well – that La Tène art was largely practised in Ireland, in so far as we can judge from the surviving remains. Many of the bronze objects decorated in the La Tène style have a north-eastern bias in their Irish distribution which suggests that northern England and Scotland, and possibly also Wales as well, must have played a considerable role in their development. This is particularly true of the short sword-scabbards which came from Lisnacroghera in Co. Antrim as well as from 16 Toome and from the Bann near Coleraine. In their ornamentation we find trumpet-ends and spiral motifs. The decoration is chiselled in on a flat surface, and shaky lines are made by a rocked tracer.

14 The 'Tanderagee Idol', claimed to have been found 'in a bog near Newry', Co. Down, but possibly from Cathedral Hill, Armagh, Iron Age. Armagh Cathedral.

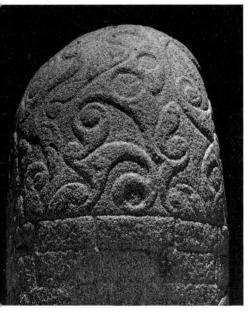

15 Decorated stone at Turoe, Co. Galway, probably of a ritual nature and dating from the 3rd C. BC. or slightly later. It shows the finest Le Tène style decoration on stone to survive in Ireland.

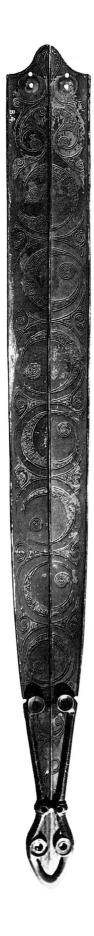

16 Bronze sword-scabbard from Lisnacroghera, Co. Antrim, 3rd–1st C. BC, found with other finely decorated scabbards on the site of a crannóg. Ulster Museum, Belfast.

17 The Petrie Crown, fragments of a bronze crown or possibly a 'candelabra', named after the antiquary George Petrie, in whose collection it first appeared. Early Iron Age. Bronze, the surface designs formed by cutting away metal, H. 15 cm. (6 in.). National Museum of Ireland.

The plasticity of the ornament achieved on the Turoe stone is seen in a more developed form on the masterful gold torc or neck-band from Broighter in Co. Derry. On it, snail-like whirligigs form patterns in high relief with stylized lentoid and other forms emanating from them, and these are further contrasted by being moulded in various planes. The relief is accentuated by the separation of its individual elements by background areas which are roughened with incised cross-hatchings. The same tendency is also apparent on a disc from the river Bann where the background has been etched away into a roughened surface which brings out all the more the remaining ornament in relief. Animal heads form an almost naturalistic oasis where they appear in the otherwise geometrical La Tène patterns on the Petrie Crown, and they are also found on the handle of the Keshcarrigan bowl (National Museum of Ireland), which doubtless owes something to Roman bronze vessels. Other bronze discs have flowing ornament in remarkably high relief. The dominant wave-like spirals can be seen as the eyes of a human face in which a concave basin acts as a mouth – one of the more obvious yet occasionally uncomprehended cases of the stylization of the human face in Celtic art.

The patterns on much of the metalwork of the La Tène period in Ireland, and also those on bone plaques from Loughcrew in Co. Meath, can be seen to have been constructed by the ingenious use of a compass which, when placed in different centres and using differently spaced radii, can produce a mathematically-based asymmetrical design which is full of life and variety. Its

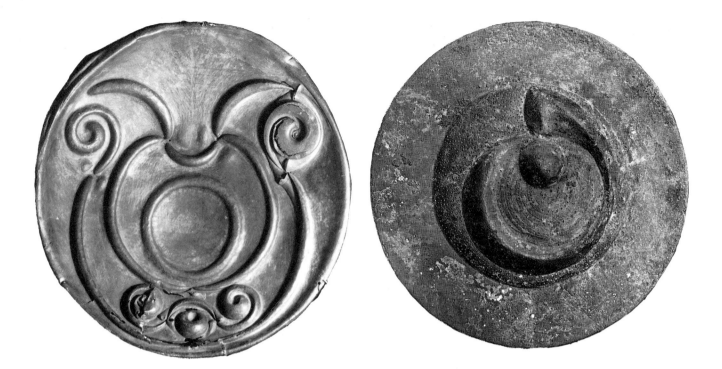

18 Disc of bronze, cast and decorated by hammering with a pattern that resembles a human face. Late Iron Age, probably 2nd C. AD. D. about 30 cm. (12 in.). National Museum of Ireland.

19 Bronze box-lid from Somerset, Co. Galway, part of a hoard of Iron Age objects that also included a gold torc and fibulae. D. 8.1 cm. (3 3/16 in.). National Museum of Ireland.

finest use is on the box-lid from Somerset in Co. Galway, where contrasting arcs 19 of relief form an eye-deceiving but fascinating pattern on various planes. One of the features of the design is a lentoid joint at the meeting point of swelling arcs which we will find again in the Early Christian period, for while Ireland may 23 well have been the last Celtic area to have adopted the flowing art of the La Tène style developed by the Continental Celtic artists, it was also one of the few Celtic realms to have continued to use it when Celtic art was supplanted elsewhere by the naturalistic art of Classical inspiration which spread over wide areas of Europe with the expansion of the Roman Empire.

THE EARLY CHRISTIAN PERIOD,
432–1170

The Christianization of Ireland in the fifth century AD was to be one of the important factors in helping the Church to stay on its feet in Europe north of the Alps after it had been overrun by barbaric hordes from the East just as it was becoming established there. Although St Patrick was not the first man to have brought Christianity to Ireland – he had predecessors in the south of the country – he is undoubtedly responsible for having converted much of Ireland within his own lifetime. Amazingly enough in comparison to the record of other European countries, he was able to do so without the spilling of a drop of martyr's blood. His zeal and determination enabled the pagan druids to be phased out and their sanctuaries to be abandoned gradually or to be converted to the worship of the Christian God. In those territories which St Patrick had already won for the new religion, he left behind him a network of bishoprics. The good work which he had begun was able to flourish without interruption, for Ireland was not troubled by the invasion of the Germanic tribes which caused such political upheaval in England in the fifth century; though as we shall see this invasion was to contribute indirectly to the richness of Irish art during the early centuries of Christianity in the country. As it turned out, however, St Patrick's ecclesiastical organization based on a series of bishoprics gradually diminished in its effectiveness. The development of this episcopal system had taken place in a Roman world where the town was the natural centre for diocesan organization, but towns had yet to make their appearance in Ireland. Within three generations of St Patrick's death, it became apparent that the system of scattered monasteries was more attractive to the early Christians in Ireland and better suited to a society living in isolated farmsteads.

The idea of the life of asceticism and deprivation which had led St Anthony to become the first hermit in the Egyptian desert and which shortly afterwards inspired a number of monks to come together in small communities was one which must have appealed to the European mind during the unsettling years of the fifth century. The island monastery of Lérins near Nice assimilated the monastic principles which had already been developed in the early Coptic world and sent out its roots, at first to France, and later to Scotland and Wales. An Irishman, St Enda, imbibed these ideas in Candida Casa in Galloway and returned to Ireland to practise them in a monastery which he founded at Killeany on the Aran island of Inishmore. One of his pupils there was St Ciarán, who was destined to found the great monastery at Clonmacnoise on the banks of the Shannon in Co. Offaly. St Ciarán had also studied in Wales under St Cadoc. Another who was trained in Wales was St Finnian of Clonard, who was to become one of the great patriarchs of Irish monasticism in the sixth century. St Finnian's pupils founded monasteries which mushroomed in rapid succession over the face of Ireland.

Within a short time these foundations had become such a potent force that the ecclesiastical organization of St Patrick was gradually weakened: the importance of bishops diminished greatly and the abbots of the individual monasteries became in fact the ecclesiastical leaders of the country. These monasteries soon

became important fosterers of culture, and were to have a profound effect not only upon the development of the Church but also upon the art of Ireland and the civilization of Europe. Before the sixth century had run little more than half its course, St Columba – one of St Finnian's greatest disciples – had made his momentous foundation at Iona, on the west coast of Scotland: from there the Picts were christianized, and Columba's monks pressed southwards towards England to evangelize the pagan Anglo-Saxon kingdoms which had established themselves in the wake of the barbaric invasion. Missionaries from Iona included St Aidan, who was sent out to found the great Northumbrian monastery at Lindisfarne on the north-east coast of England, and St Fursa, who was given the old Roman fort at Burgh Castle in Norfolk as a site for his monastery by King Sigebert of East Anglia, among the candidates for the honour of having had the Sutton Hoo ship burial set up as a cenotaph to his memory.

Irish missionary activity did not, however, stop with Britain. St Columbanus, a monk of Bangor, Co. Down, was to make the first and most important breakthrough on the Continent: he founded a monastery at Luxeuil in France, left his pupil St Gall at a spot in Switzerland where later a famous monastery was to grow up bearing that pupil's name, and finally crossed the Alps to found in 613 yet another monastery, at Bobbio in northern Italy, where he died in 615. It was possibly in Italy that Irish monks from Bobbio may have seen Oriental manuscripts, some ornamental details of which found their way into some of the earliest Irish illuminated manuscripts.

Meanwhile, at home, the Irish monasteries flourished and fostered art, learning and literature. The monastic reform movement of the Culdees, towards the end of the eighth century, suggests that the religious practices within the monasteries may already have become lax by that period, but cultivation of learning continued unabated, and it is interesting to note that Irishmen were amongst the finest teachers at the court of Charlemagne around 800, their influence doubtless helping to mould the great cultural flowering of the Carolingian Empire which was of such vital importance in the artistic development of the Middle Ages.

The rapid spread of Christianity in the time of St Patrick in the fifth century caused little change at first in the artistic and archaeological record in Ireland. The culture of the Iron Age, and doubtless the society which nurtured it, continued apparently uninterrupted. The major kingdoms had been crystallizing themselves into the form which they would retain with variations for some hundreds of years, and within them were a number of smaller chieftains whose residences were those ring-forts or raths and crannógs which we saw developing earlier and who kept up the petty warring traditions of their Iron Age antecedents. Some of the petty-kings and large farmers were sufficiently well-to-do to afford wine or olive oil, which was imported from the Mediterranean or from western France in jars, fragments of which have been found in the triple-ramparted forts of Ballycatteen and Garranes in Co. Cork, dating approximately from the sixth or seventh centuries A D.

The masters of such raths were, generation after generation, one of the mainstays of artistic patronage in Ireland. The discovery of crucibles, moulds, iron knives, bronze ornaments and sticks of millefiori glass inside the forts show how metalworking and glassmaking were practised on a small scale in many separate establishments throughout the country by travelling craftsmen whose talent was so highly regarded that it merited for them a position of distinction in Gaelic society. The introduction of such techniques as millefiori glass, and the use of Roman-inspired filigree on the thumbnail-size gold bird from Garryduff in Co. Cork, dating from the sixth or seventh century (now in Cork Museum),

suggests that Ireland may possibly have been a craftsman's haven, profiting from the services of metalsmiths and glassmakers fleeing from England in the wake of the Anglo-Saxon invasion in the middle of the fifth century.

But this lay society in Early Christian Ireland, which was – in Binchy's famous phrase – 'tribal, rural, hierarchical and familiar' (i.e. based on the family), was to receive a succession of jolts from the Viking invasions, which first struck the country in 795 and which brought it out of its centuries-old political isolation. These early invasions were just quick get-away raids, but by 841 the Vikings had created their first long-lasting settlement at Dublin. Others, such as Waterford, Wexford and Limerick, were to follow. These were the first towns in Ireland. At first their inhbitants were more closely connected in both trade and arms with Viking colonies in Britain (as well as with their Scandanavian homeland), but gradually they became more involved in Irish affairs, fighting either against or with one or other of the Irish kings in constantly changing alliances. By the end of the tenth century intermarriage between Vikings and Irish was already an established custom. The Vikings not only introduced the first Irish coinage, around 997, but also taught the Irish the elements of naval architecture and the usefulness of trade and markets.

Just before the turn of the millennium, the Uí Néill dynasty, which had provided Ireland with its High Kings for more than five hundred years, was overpowered by the O'Briens of Munster, whose best-known scion, Brian Boru, defeated Vikings from Dublin and across the seas at the Battle of Clontarf in 1014. While this event ruled out the Norse as a political power in Ireland from then on, it heralded a period in which, paradoxically, Scandinavia provided vital influences in Irish art. The century and a half after Clontarf saw the O'Briens fighting for power among themselves, until they were finally ousted as High Kings by one of the Connacht dynasts, Rory O'Conor. He was destined to be the last of the High Kings, for in 1169 he experienced the invasion of Ireland by the Normans, who quickly set about the conquest of the country for themselves.

Only a quarter of a century before this happened, a new attempt was being made to rekindle the flagging spirit of Irish monasticism. The prime mover was the saintly Malachy of Armagh, who was among the leaders of the reform of the Irish church in the twelfth century. In 1142 he encouraged the establishment of the first foundation of the Cistercian order in Ireland, at Mellifont in Co. Louth. Although this was not actually the first foundation of one of the new Continental religious orders in Ireland, it was certainly the one of most consequence, for it heralded a great new impetus of monastic fervour. The spread of these new Continental orders, which included Dominicans, Augustinians, Benedictines and later Franciscans, brought about the rapid decline of most of the old Irish monasteries whose histories went back over six centuries.

APPLIED ARTS

The continuation of Celtic traditions

There is unfortunately not a great quantity of surviving material with which to fill out the long period between the introduction of La Tène art around 300 BC and the time when the Church began to become a serious fosterer of Irish art about nine hundred years later. So little has survived that it was long thought that there must have been an hiatus, a considerable break between the La Tène art style as practised in the last few centuries before Christ and its revival in the first few centuries after the introduction of Christianity into Ireland. The metalwork of the two periods has so much in common in certain respects that it is often

difficult to date some of the objects discussed above under the Iron Age even to within a few hundred years with any degree of accuracy. The tradition of metalworking established by the La Tène culture in the last few centuries BC may have been strong and resilient enough and have had sufficiently few distractions from outside for it to have continued until it received a new injection of life by being adapted for ecclesiastical purposes some time around AD 600. Such a proposed continuity of La Tène art in Ireland could have found encouragement in a propitiatory policy of the new Christian religion, which permitted the old pagan crafts to flourish under its hegemony, and also in the fact that Ireland was not inundated by Roman soldiers and their mass-produced wares which were elsewhere accepted as the civilized norm. As the Gallo-Roman figures found at the source of the Seine in France suggest, Celtic craftsmen could have worked in wood, while bone and leather are other possible media for an art style which proved more permanent than the materials upon which it was practised. Indeed it is probably objects in these materials with which one should supplement the meagre surviving bronze finds to fill out the artistic picture in Ireland, particularly in the centuries of the Roman domination of Britain.

It must be remembered, however, that in Northern Britain, and in Scotland in particular, traditions of Celtic art could survive during the Roman period. With Romanized territory to the south, it is not surprising that the products of Romano-British workshops began in time to be adapted in Northern Britain. The old La Tène style of spirals and triskeles flowing in never-ending variations (which was to become one of the major elements in Irish art in the seventh century) seems to have been practised vigorously on British metalwork during the sixth century, if not indeed as early as the fifth, accompanied by an infiltration of Roman forms. A strong case can therefore be made for seeing Britain as the prime mover in the revival of this ancient style, at least in the metalwork of the Early Christian period. Ireland could then subsequently have been stimulated (probably again from Northern Britain) to develop the style further to suit its own requirements.

The Roman contribution

Some important developments in Irish metalwork of the Early Christian period cannot be explained without recourse to a consideration of the forms produced in Romano-British workshops and the techniques practised there. The provincial Roman penannular brooch, an almost full ring of bronze with a pin attached to enable it to be fastened to a garment, must have been the ultimate ancestor of the Tara Brooch and a host of lesser ornaments of similar type, which 29, were to prove so popular in Ireland at least as late as the ninth century. The Irish 10 gradually expanded the ends of these brooches, adding to them stylized animal ornament and adapting their own designs. These consisted of the old Celtic repertoire of spirals and triskeles, often enlivened by small pieces of red enamel inserted to form a background – a technique which Celtic craftsmen had practised in pre-Roman times. This enamel was soon joined by a further element, millefiori glass, an art-form practised at Garranes. A number of rods of different-coloured glass were fused together and cut, so that the patterns made by the fused rods can be seen together in cross-section when inserted in the metal terminal of a brooch. This technique can be seen on a brooch from Ballinderry II, Co. Offaly, 20 which may date from the sixth or seventh century AD. Millefiori glass was certainly made in Roman Belgium in the third century AD, and may have been used even earlier in Britain. It was probably from Britain that the technique was introduced into Ireland around the fifth or sixth century.

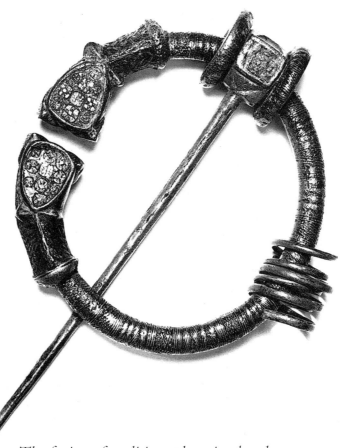

20 Penannular brooch from Ballinderry II, Co. Offaly, 6th-7th C. The bronze ring is incised and the terminals are decorated with inlaid millefiori glass. L. of pin 18.7 cm. (7¼ in.). National Museum of Ireland.

The fusion of traditions: hanging bowls

The influence of late Roman metalwork on that of the Early Christian period in Britain and Ireland may be traced on the so-called 'hanging bowls'. The use of these bowls has long been a matter of debate, but they may have had a variety of purposes, such as acting as lamps and wash-basins. They are bronze bowls, usually round though very occasionally triangular in shape, having on their rims hooks by which they were suspended. The very idea of a bronze vessel of this nature was probably derived from the Late Roman Empire, and there are also Late Roman prototypes for some of the designs on the escutcheons of the hanging hooks. But the decoration of many of these escutcheons is of considerable interest because it comprises a number of adaptations of the old La Tène type of ornament, including trumpet-patterns combined in a three-part design and decorated with enamel and millefiori. Such escutcheons have been found in Saxon graves in England, but a few isolated examples are known from Irish sites such as Ferns and Clonmacnoise. Because some of them may have been produced in monastic workshops, we may be justified in seeing these escutcheons as some of the earliest signs in Ireland of the adoption by ecclesiastical metalwork of the La Tène type of ornament which was to form one of the three staple components of the designs used in decorating works of art in Early Christian Ireland.

While these escutcheons were long considered to have been made almost exclusively in Ireland, there is now reason to think that many, if not all, were manufactured in Britain, whence the idea may well have spread to Ireland, though it is often very difficult to decide on which side of the Irish Sea any one individual piece of metalwork was manufactured.

The earliest illuminated manuscripts: the Cathach and the Book of Durrow

It is in illuminated manuscripts that we may see the earliest fosterage of Irish art by the Christian Church. The inspiration for decorating manuscripts may have come from Italy by way of Bobbio, where St Columbanus's Irish monks (who had remained in constant contact with their homeland) may have seen manuscripts from the Coptic world decorated with features such as dots and interlacing, which we see emerging in some Irish manuscripts written probably in the seventh century. The *Codex Usserianus Primus* (Trinity College Library, Dublin) may even have been brought from Bobbio to Ireland at the time, and have given new ideas for the illumination of manuscripts in the Irish monastic *scriptoria*.

The earliest Irish manuscript of importance to survive is the *Cathach* of St Columba (Royal Irish Academy, Dublin). It is a copy of the Psalms written in the early Irish version of the majuscule script, and its decoration is confined to the first letters of paragraphs. It shows the adaptation of the old Celtic scrolls and pelta motifs from metalwork – a neat and early instance of the cross-fertilization between media which was to have happy results for many years to come. The manuscript is ascribed by tradition to the hand of St Columba, who died in 597, and palaeographically such an early date would be quite possible. But if the dots which surround some of the initials are derived from Coptic models and were 21 transmitted to Ireland through Bobbio, the *Cathach* would have to have been written some time after the foundation of Bobbio in 613, and therefore not in the lifetime of St Columba.

Another feature of importance which we see emerging in the *Cathach* is a new type of stylized animal ornament which – under various guises – was to play a very significant role in Irish decoration throughout the Early Christian period. The tail of the letter Q on f. 45r runs into a spiral out of which grows the head of 22 an animal with open mouth. This animal is not of the same character as the stylized bird head found on the Iron Age Petrie Crown or the handle of the 17 Keshcarrigan bowl. Although no legs can be seen, it belongs to that class of dismembered open-mouthed animals whose bodies are more like those of a quadruped and which are better known from English Anglo-Saxon metalwork. This beast has its origin in the great variety of animal ornament which developed essentially from Late Roman patterns in the Germanic and Nordic provinces. Its arrival in Ireland from England introduced the second great component element in Early Christian Irish art. In time, the beast becomes more ravenous, and what its body develops into can best be seen in the *Book of Durrow* (Trinity College Library, Dublin) – a manuscript which is undoubtedly one of the most important documents in Europe to survive from the second half of the seventh century.

The *Book of Durrow* is a comparatively small manuscript of the gospels which had long associations with the Columban monastery at Durrow in Co. Offaly before it was given to Trinity College in the seventeenth century. In it we see an early stage in the development of a feature which was to become common in the later manuscripts of Britain and Ireland and which may have been influenced by Coptic or Italian prototypes, namely the use of a 'carpet' page, a whole left-hand **13,** page given over to ornament. At the beginning of the manuscript there is a page 23 bearing a double cross, and another with the four Evangelists' symbols as well as the canon tables. Before each gospel there is the symbol of the Evangelist who 24 wrote it, followed by an ornamental 'carpet' page, and the first page of each gospel is also richly decorated. Whereas only black ink was used in the *Cathach*,

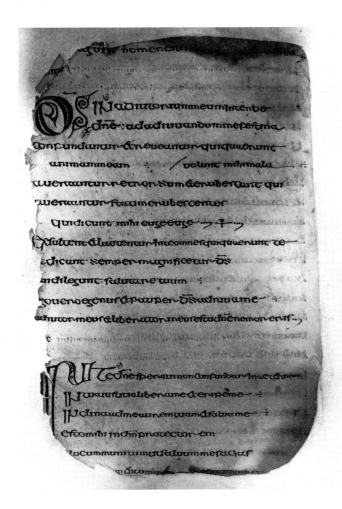

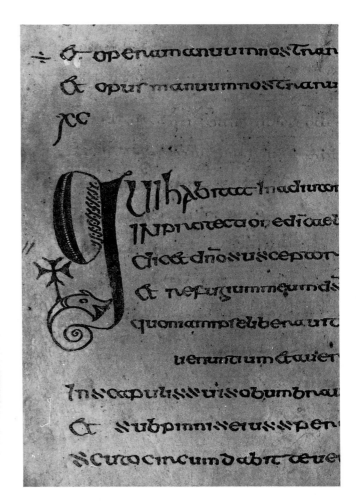

21, 22 Two illustrations from the *Cathach*, probably early 7th C. The initials on f.30v (*left*) are surrounded by dots; that on f.45r (*right*, a detail) terminates in an animal head. The manuscript derived its name, which means 'The Battler', from the fact that it was taken into battle as a talisman by the O'Donnell family who owned it. Royal Irish Academy, Dublin.

the *Book of Durrow* is multi-coloured – using dark green, bright yellow, red and what has now become a dark brown.

As well as the old familiar Celtic spiral ornament and the animal decoration which we have met raising its head hesitatingly in the *Cathach*, the *Book of Durrow* also introduces us to the third great component of Irish art of the Early Christian period, interlaced bands. They seem to be of Coptic or eastern Mediterranean origin, as do the dots which accompany them. Many of the pages are framed by a loose interlace of broad bands of varying colours accentuated by double lines on the edges. The space between the bands is darkened, thus allowing them room to 'breathe'. Characteristics of the *Book of Durrow* include the amount of space left free between the individual elements of the decoration, and the use of large-scale motifs and designs. Two of the main decorative elements can occur on the same page, but never all three together, and they are always kept neatly separated. Either the artist felt that motifs which he knew to have different origins or which for him had different symbolic meanings ought to be kept apart, or else he had not really digested all the components sufficiently to feel confident to mix them together. This characteristic can be seen clearly on one page (f. 3v) which had a cleverly designed large central panel framed by bands of interlacing and bearing a design of Celtic spirals and trumpet ornament which make use of the lentoid joint already encountered on Iron Age metalwork. 23 23 19

One great page (f. 192v) is a masterpiece of controlled animal ornament. The **13**
animals, painted in yellows, reds and greens, have the same long jaws and open
mouths as the *Cathach* animal, but here they have either long snake-like bodies
which interlace with other similar beasts and curl around so that each beast bites its
own hind-leg, or else they are more stocky with ultra-long front legs, and hind
legs which are so extended that they curl around the animal's body. Anglo-
Saxon parents of the Durrow animals are often more dismembered and far less
naturalistic.

The animals in the *Book of Durrow* are more rhythmical and free in their
design, and the overall concept of their composition is much clearer than in what
is known from contemporary England. Yet the script used is considered to be
more English than Irish. On present evidence it is difficult to decide whether the
Book of Durrow was painted in Ireland, in Iona or in Northumbria. But even if it
were more likely to have been written in Northumbria, and brought to Ireland
some time after the judgment in the Easter controversy had gone against the
Irish faction at the Synod of Whitby in 664, there would be ample justification
for discussing it in the context of Irish art: it is almost certainly a product of a
Columban monastery, which the monastery at Durrow was, or of one of its off-
shoots. The very difficulty of deciding where the manuscript was painted shows
how close the artistic connections between Ireland, Scotland and Northumbria
must have been at the time.

But whatever its origins, the *Book of Durrow* was illuminated in a place where
metalwork was practised, for there are indications of borrowing from the
metalsmith's craft. The use of the Celtic spiral ornament is the most obvious 23
example. Another is the millefiori pattern reproduced on the cloak of the 24
symbol of Matthew (f. 21v). The three circles locked in position by interlace in
the roundel of the great animal page (possibly representing the Trinity) have the **13**
same stepped ornamentation as the boss grilles which we shall meet shortly on 26
the metalwork executed little more than a generation later. But the borrowing
process went both ways: a panel on the shrine of the Domhnach Airgid has 25
obviously derived its broad bands of interlace from some manuscript source like
the *Book of Durrow*.

Metalwork of the Golden Age around 700

The amalgamation of a number of patterns of totally differing origins into a
beautifully balanced whole, which we have seen in the *Book of Durrow*, was
developed to maximum effect in a number of pieces of metalwork which must
date from around 700 or shortly after, of which the Moylough Belt Shrine, the
Ardagh Chalice and the Tara Brooch are the finest examples. They represent a
virtuosity of design and technique of a quality which was never to be
surpassed in Ireland, and which finds few if any equals in the European
metalwork of its day. These pieces are justifiedly seen as among Ireland's finest
artistic achievements.

The Moylough Belt Shrine

The Moylough Belt Shrine (found in a bog in Co. Sligo in 1945) houses the belt 26,
of an unknown Connacht saint, and was constructed to look like a belt though 27
never used as one. Its four segments are decorated on their outer surface with
rectangles or cross-like roundels with millefiori- or enamel-decorated frames. It
also bears millefiori and stepped ornamentation on the grilles of its enamel bosses
of the kind imitated in the *Book of Durrow*. The main decorative motifs are in

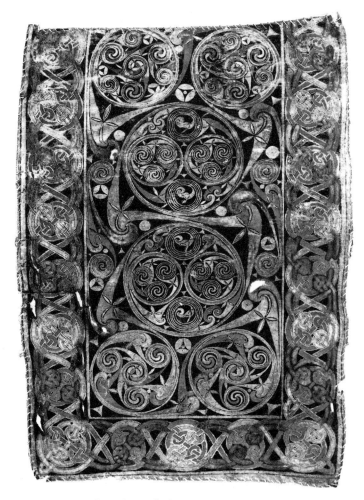

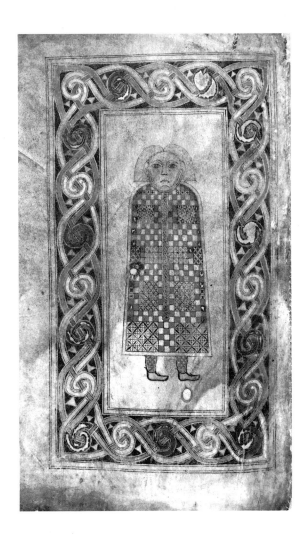

23, 24 Two pages from the *Book of Durrow, c.* 670–80: f. 3v, a carpet page (which has lost its outer parchment border and one end-panel of interlace), and f. 21v, showing the symbol of the Evangelist Matthew. The roundels in the inner corners of the carpet page contain triskeles, motifs with three radiating 'legs'; together with the trumpet shapes throughout the central field, they recall the ornament on the Iron Age Turoe stone (ill. 15). H. of intact page 26 cm. (10¼ in.). Trinity College Library, Dublin.

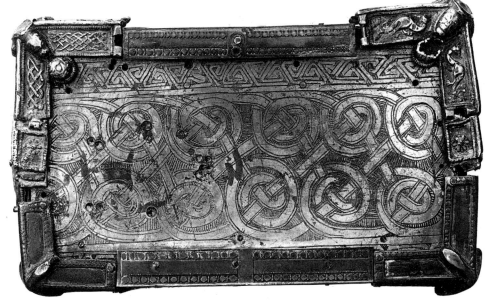

25 Interlace ornament on one end of the Domhnach Airgid ('Silver Church') book shrine, probably 7th C., recalling that in the *Book of Durrow*. Tinned bronze, L. 20 cm. (8 in.). National Museum of Ireland.

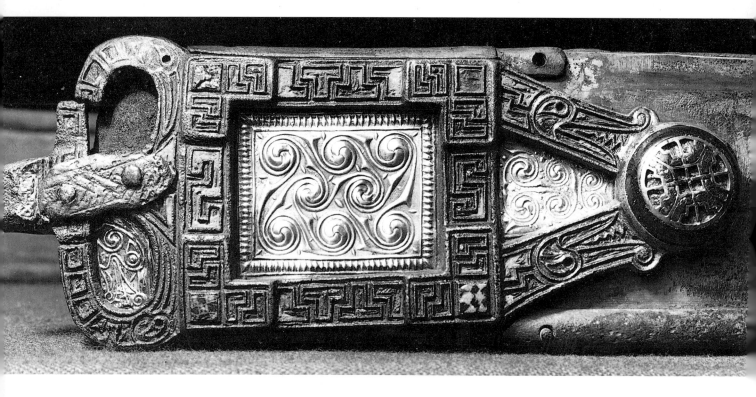

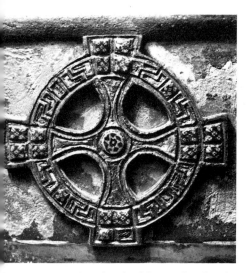

26, 27 Two details of the Moylough Belt Shrine, *c.* 700. Bronze, decorated with millefiori glass and, on the 'buckle', silver plates and an enamel boss, H. about 5 cm. (2 in.). The circled cross prefigures the design of high crosses (see p. 57). National Museum of Ireland.

essence those which we have already encountered in the *Book of Durrow* – the Celtic spirals, the interlacing and the animal head with one or both jaws curling up at the end. Unusual features are the silver panels die-stamped with Celtic 26 triskeles and whorls, some in relatively high relief. The Belt Shrine deserves more acclaim than it has received up till now, for it is worthy to take its place alongside those much better known masterpieces of the great age of Early Christian metalwork in Ireland, the Ardagh Chalice and the Tara Brooch.

The Ardagh Chalice

The Ardagh Chalice, which was found in 1868, is very much a product of the same artistic tradition which produced the Belt Shrine. Its shape, for which there are rare parallels on the Continent, is dominated by the two contrasting forms of the rounded cup and the conical base, neatly set off against one another by the 9 constricted stem which connects them. Further contrast is provided by the large areas of undecorated silver surface and the bright panels of decorated gold below the rim and handles and on the stem. The underside of the conical base is 28 decorated in gold with three balanced friezes of animal ornament, spiral decoration and interlacing placed one outside the other – a neat example of the combination of the three main types of decoration in use at this period. The friezes revolve around a central boss of rock crystal, one of the few cases in Irish art of the time where the Germanic idea of inlaid stones has been imitated. The broad handles which are attached to the brass rim of the chalice are decorated with flat panels of various shapes in red and blue enamel, and also with slightly uninspiring filigree interlace which is also found below the handles. There it is 8 accompanied by studs using the same coloured enamels as on the handles, with the addition of small granules of gold in the centre of the lowest stud. These studs were manufactured by placing a bronze grille of stepped or other pattern upside down in a mould, and then pouring in the red followed by the blue enamel.

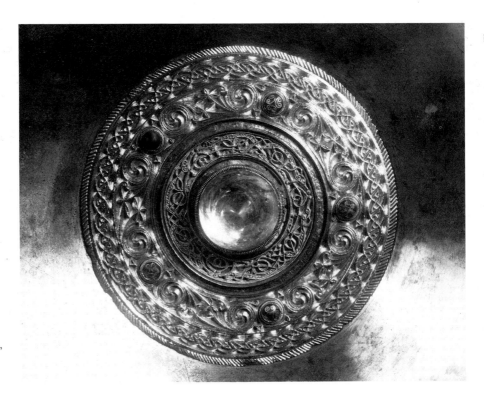

28 Decoration under the base of the Ardagh Chalice, *c.* 700 (see pls. **8, 9**). Gold, set with small enamel and glass studs and a central rock crystal. National Museum of Ireland.

Similar studs punctuate the band of gold filigree below the rim, underneath which is an inscription with the names of the Apostles against a stippled background. The execution of the ornament on the Ardagh Chalice is infinitely finer than anything known from contemporary Anglo-Saxon metalwork. Its technical mastery combined with its grandiose yet restrained and highly colourful design has rightly given it a place among the greatest pieces of Early Christian metalwork.

The Rinnagan Crucifixion plaque

Craftsmen of the period could also turn their hands to the production of smaller pieces of bronze, as shown by the eighth-century Crucifixion plaque from Rinnagan near Athlone, which may once have acted as a book cover. All **12** attention turns to the large strong rounded face of Christ, the Godhead. It stands out both in its proportions and in its smoothness against the profuse decoration of almost all the other surfaces, which are visualized as ornamental rather than organic. Christ's breast is a mass of Celtic spirals in high relief, their position suggesting that they may by this time have had a symbolic meaning for Christians. The bottom of Christ's long garment is decorated with horizontal strips of similar ornamentation set off by vertical interlace and fret-work designs in chip-carving technique, and His truncated arms are outlined against the cross which narrows near its extremities. Stephaton and Longinus stand awkwardly beside the Saviour, their heads turned tortuously in a manner seen in manuscript paintings, and the angels which flank Christ's head – each bearing a short sword – have awkward wings which are more decorative than practical. In this Crucifixion scene we see the Celtic artist deftly avoiding reproduction of the true proportions of the human body in favour of a series of contrasting ornamental surfaces gathered together in a composition which doubtless owes much to the decorative designs of manuscripts.

The Tara Brooch

The metalwork of the Early Christian period was not, however, entirely devoted to the greater glory of God, nor was it the sole monopoly of the Church. That it was also put to use in the embellishment of worldly patrons is well demonstrated in the great variety of surviving penannular brooches, which were used to hold the ends of a cloak together (compare a figure on Muiredach's Cross at Monasterboice). What had started in an unassuming fashion in the fifth century with brooches having simple animal terminals reached its climax in the production of the Tara Brooch in the eighth century, by which time the gap left in the ring of the old penannular brooch had been completely closed.

The Tara Brooch is truly fit for a king, though, having been found apparently on the beach at Bettystown, Co. Meath, it has nothing to do with the famous royal site after which it was named by a dealer who owned it in the last century. It may have been one of a pair, attached to its twin by a chain of trichinopoly work which has unfortunately been severed. The chain attachment bears two glass studs minutely modelled in the shape of the human face. The brooch uses many of the techniques and motifs of the Ardagh Chalice, and with equal virtuosity and effect. Just as the chalice was splendidly decorated under the foot where it was only seen by the celebrant when it was raised at the consecration, so too the Tara Brooch bears a feast of ornament on the back, where it can only have been seen by the wearer when he or she was putting it on or taking it off.

29, 30 The back, and a closer view of the front of the Tara Brooch, c. 700. Bronze, covered on the back with silvered copper and glass studs, and on the front with gold, amber and glass (see pl. II), L. 22.5 cm. (8⅞ in.). The detail, on the right, is reproduced actual size. National Museum of Ireland.

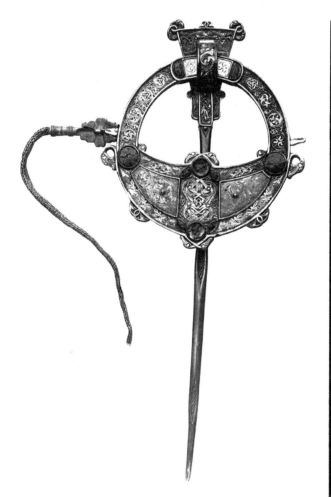

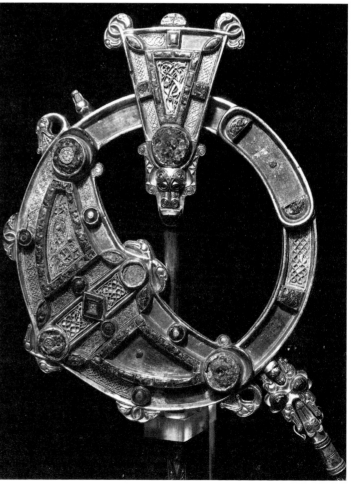

The decoration is profuse, but always clear. What greeted the beholder's gaze on the front was particularly the well-articulated crescent with its panels of 30 interlace and splendid Germanic animal ornament in filigree of microscopic **11** granules, and liberally sprinkled with coloured studs. The stylized animal ornament on the apex of the triangular pin-head looks forward to the animals which were to enliven Romanesque art four centuries later. The back has two finely matching silvered panels with Celtic designs finely engraved on them – flat islands in the midst of an undulating sea of writing animals and birds whose restless battle and pursuit of one another is further stressed by the false relief used to portray them. They are held in check by enamel bosses of the kind already seen on the Ardagh Chalice. Where the front of the brooch has interlace of soothing gold filigree, the back breathes vitality through its lavish use of Germanic-inspired animal contortions. The design and animal ornament of the Tara Brooch are clearly superior to those of a Scottish example with similar decoration from Hunterston in Ayrshire (National Museum of Antiquities of Scotland, Edinburgh), which may have acted as an inspiration. The Hunterston brooch may indicate that the combination on metalwork of Celtic designs and Saxon animal ornament took place in Britain first and was then passed on to Irish craftsmen, whose strength always lay in the successful mixture – and in the case of the Tara Brooch one might almost say the perfect amalgamation – of a number of designs whose separate origins lay outside the country.

Right into the ninth century, if not slightly later, artists continued to produce highly decorative brooches, some concentrating on the animal ornament, others **10** using bosses and thistle-heads to appeal to Viking tastes, but none of them ever succeeding in attaining the finesse of the Tara Brooch.

Whereas the eighth-century manuscripts of Britain and Ireland helped to enrich manuscript illumination of the Carolingian period, the influence of Irish metalwork in its greatest period, as represented by the masterpieces just discussed, would appear not to have reached the Continent.

Illuminated manuscripts of the late seventh to tenth centuries

In the century and a half which followed the writing of the *Book of Durrow*, monastic scriptoria in Britain and Ireland were producing manuscripts which shared a decoration of ever increasing intricacy and greater subtlety of tonal colours. The few which survive did a considerable amount of travelling between the days when they were written and the time when they were deposited in their present resting-places, in libraries scattered widely over large areas of Britain, Ireland and the Continent. The fact that manuscripts did change hands frequently, coupled with the unfortunate lack of internal evidence as to where they were written, has made identification of the origin of many of them so difficult that it is often impossible even to say whether they were 'insular' (that is from Britain or Ireland) or Continental in origin.

Some of these manuscripts are small 'pocket books' which an individual would have carried around with him wherever he went. Such are the *Book of Moling* and the *Book of Dimma*, both dating from the eighth century (and in Trinity College, Dublin), and the *Book of MacRegol of Birr* (Bodleian Library, Oxford), dating from a few decades on either side of 800. They have decorated pages showing either portraits or symbols of the Evangelists, often painted in a few but very bright colours. The supporting ornamental motifs are comparatively simple and consist of geometrical and animal motifs.

In contrast to these small and very personal gospel-books, there are the sumptuous codices which doubtless were only seen when they embellished the

altar on festive occasions. The most famous are the *Book of Lichfield* (Lichfield Cathedral) and the *Book of Lindisfarne* (British Library, London) and the so-called *St Gall Gospels* (library of St Gall, Switzerland). We can presume from a statement added later to the *Book of Lindisfarne* that it was written in the northern English monastery of that name, but it is difficult to place the other two even approximately. In contrast to the *Book of Durrow*, each gospel when complete would originally have been prefaced by a full page bearing a portrait (rather than the symbol) of the Evangelist who wrote it, and many of the figures reflect the Mediterranean influences which were permeating English monasteries in the eighth century. But these books also have large 'carpet' pages and initials beautifully decorated in a fine combination of the old Celtic spiral and trumpet motifs and graceful Saxon animals painted in a great variety of subtly blended colours. The artistic development seen in these luxury volumes culminates in the *Book of Kells*, the supreme achievement of insular illumination and justly one of the world's most celebrated codices.

The Book of Kells

At least as early as 1006 the *Book of Kells* was in the Columban monastery at Kells in Co. Meath, but it was probably largely if not entirely written before 806, when the monastery at Kells was founded or re-founded, and it may have been brought there by Columban monks who had fled from Iona in the wake of the Viking raids early in the ninth century. We will probably never know for certain which monastery saw its masterful decoration come into being: was it a Columban monastery – Iona or Lindisfarne – or could it have been one in Pictish territory north of the Scottish border? Suffice it to say here that it is the most sublime product of any of the monastic scriptoria which had been illuminating manuscripts in Ireland and Britain for almost two centuries before it was written near the end of the eighth century or around 800.

The *Book* consists now of 340 folios (680 pages), but it must have had about thirty more, some of them no doubt richly decorated introductory pages. The second of the existing illuminated pages is the start of the canon tables; there is a page with the Evangelists' symbols, Evangelist figures before two of the gospels, and the lovely Chi-Rho page, and in addition the *Book of Kells* has some unusual figural scenes which we have not yet encountered, such as the Virgin and Child, the Arrest and the Temptation of Christ. Françoise Henry has succeeded in detecting the hands of at least four master illustrators in the *Book*. One, whom she calls the Goldsmith, painted a fine page with eight circles, the introductory pages

31 The *Book of Kells*, *c.* 800: detail of f. 34r, the Chi-Rho page, showing cats and mice (?) and an otter catching a fish, scenes that offer a calm contrast to the agitated decoration surrounding them (see pl. **15**). About twice actual size. Trinity College Library, Dublin.

15

33

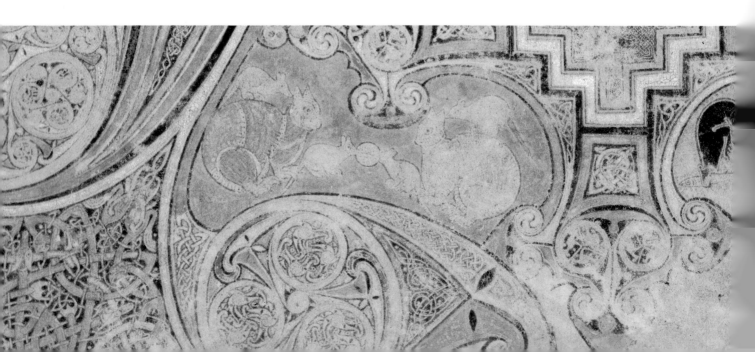

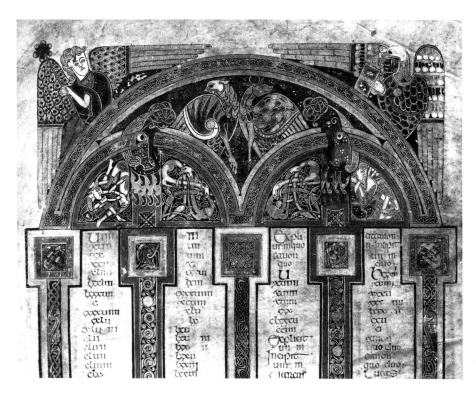

32 Upper part of the eighth page of the canon tables in the *Book of Kells*, f. 5v. Above the tables, which offer a concordance between the four gospels, are the winged symbols of the Evangelists – the angel of St Matthew, the lion of St Mark, the ox of St Luke and the eagle of St John. Trinity College Library, Dublin.

of three of the gospels and the Chi-Rho page, this last perhaps the finest page of **15** the whole manuscript. It has a magnificent sweeping design into which even the most minute detail is meticulously fitted while retaining in full the overall concept. Small figures of cats and mice (?) were added near the bottom of the page **31** by the second master, who was also responsible for producing many of those delightful interlinear and marginal vignettes which present us with so many charming details of everyday life in a stylized but digestible form. They did not make the manuscript look as if it were painted by an angel – as Giraldus Cambrensis said of another probably similar but now lost manuscript from Kildare – but by men who had the gift of commenting in caricature on the farmyard frolics of hen and horse, a feeling for nature mirrored in the early Irish lyric poetry which the monks occasionally wrote on the margins of their manuscripts. The beautifully clear and balanced eighth page of the canon tables **32** may also be the work of the Goldsmith. The composed dignity of the Virgin and Child page and the scenes from the life of Christ are by a third, bold artist, the Illustrator, who was sufficiently sure of himself to have introduced something which at the time must have seemed an adventurous step – a representation of the devil. He had a more subdued imagination than the Goldsmith, but had a greater **33** love than any of his scriptorial confrères for vegetal ornament of a type which we have not yet encountered on any of the previous manuscripts discussed here. The Evangelist figures, the teaching Christ, and perhaps also the *Quoniam* at the beginning of St Luke's gospel and the page with the symbols of the four Evangelists at the beginning of St Matthew's gospel were contributed by another artist, the Portrait Painter, who had a somewhat matter-of-fact approach to his subjects.

The *Book of Kells* uses many of the motifs which had already been used in earlier manuscripts such as the *Book of Lindisfarne*. These include the old familiar spirals, interlacings and key-patterns, but unlike the *Book of Durrow*, the Kells codex does not keep them in separate compartments, but shows that the various

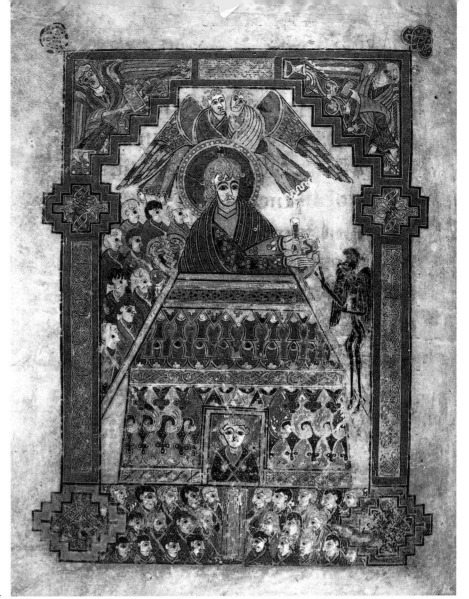

33 The Temptation of Christ, f. 202v of the *Book of Kells*. Christ is shown 'on the pinnacle of the temple' (a building with steep shingled roof and dragon-head finials: see p. 78), tempted by the devil, an emaciated black figure with wings. Above are four angels – two in the centre and two squeezed into the corners with plant scrolls. The reason for the presence of other figures is not clear. Trinity College Library, Dublin.

painters now had such complete familiarity with the various elements – no matter what their origin – that they were able to manipulate and combine them to suit their needs and tastes. The *Book of Kells* is an eclectic manuscript, using elements from a number of sources. The spirals, interlacing and animal ornament had already been in use in manuscripts and metalwork for at least a century and a half. The vegetal motifs are probably of Mediterranean origin. Some of the figure compositions, such as Christ and the Virgin and Child, may go back to Coptic or Byzantine models, and the art of northern France as well as that of Visigothic Spain may also have contributed in one detail or another to the designs. In turn, insular illumination, as represented by the *Book of Kells* and other earlier manuscripts, had its influence upon the development of Charlemagne's scriptoria and of Central European book illumination in the ninth century.

The Book of Armagh and manuscripts of the Viking period
The *Book of Armagh* (also in Trinity College) was at least partially completed in 807 and is therefore only a very little later than the *Book of Kells*. Its decoration is

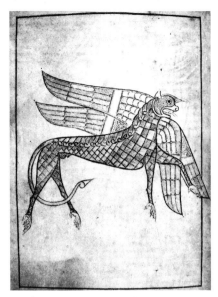

34 The *Book of Armagh*, *c.* 807: f. 53v, bearing the lion, symbol of St Mark. H. of page 19 cm. (7½ in.). Trinity College Library, Dublin.

like a sobering quaff of invigorating cold water after the heady fare offered by the earlier manuscript. Instead of the fantastic coloured intricacies of Kells, the *Book of Armagh* has simple but firm and assured black and white drawings of the Evangelistic symbols. These masterly pen pictures are a splendid example of the totally different manuscript style practised in Armagh in the first half of the ninth century.

The colour style of the *Book of Kells* did linger on elsewhere for more than two centuries, but the few examples of ninth- and tenth-century manuscripts which have survived the Viking raids and other vicissitudes show that they were, understandably, unable to keep up the standard set by the *Book of Kells* and could only continue by simplifying the decoration. Spiral ornament retreats in favour of an increasing amount of animal decoration, and the figural representations become stylized almost to the point of caricature, as for instance in the early eleventh-century *Southampton Psalter* (St John's College, Cambridge).

Metalwork of the Viking period

The Viking raids which were doubtless responsible for the destruction of some manuscripts and for the death or flight to the Continent of some of the great Irish book illuminators would also appear to have had their effect upon metalwork. It is a curious paradox that while the raids reduced the amount of Irish metalwork produced in the ninth and tenth centuries, they led to the preservation of some pieces which might not otherwise have survived. For the Vikings carried off some Irish material with them to Norway and later consigned it to graves where it lay until its rediscovery in our own day. But the metal objects surviving from this period in Ireland and Norway give the impression that while the Vikings contributed greatly to Ireland through the foundation of towns and later to Irish art itself, their raids did not help to improve the quality of Irish metalwork. The filigree ornament becomes coarser and the interlacing duller, though ninth- and tenth-century silver brooches, particularly of the penannular and thistle brooch varieties, do show a certain quality where Irish and Norse elements combine. The tenth-century parts of the Kells Crozier (now in the British Museum, London) show lively animals of the period which demonstrate that the spirit of the eighth century had not entirely succumbed to the unstable circumstances of the time. But we may be underestimating the quality of ninth- and tenth-century Irish metalwork because the best pieces may not have survived.

Metalwork of the eleventh and twelfth centuries

The strongest argument in favour of the survival of a metalworking tradition during the Viking period is the existence of a number of first-class pieces of metalwork dating from the later eleventh century and the first half of the twelfth century which rekindle some of the glory of earlier times and which continue to use some of the old techniques such as enamel studs. By this time, the country was settling down to an era of slightly uneasy peace after the Battle of Clontarf, and instead of being disrupted by incursions from outside, as during the Viking period, it was troubled more by the usual internecine strife among the Irish themselves. As the recent excavations in old Dublin are showing, the Viking city was becoming more integrated into Irish life, and in the workshops there Scandinavian and Irish craftsmen would appear to have worked side by side producing objects sometimes for ecclesiastical use in other parts of the country. The bone 'trial pieces' of very good quality found in the excavations show the gradual penetration of new styles in animal art which had already developed in

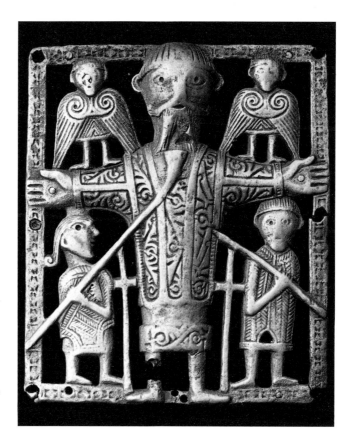

35 Crucifixion plaque from Clonmacnoise, Co. Offaly, probably mid-11th C. Bronze, H. 8.4 cm. (3⅜ in.). National Museum of Ireland.

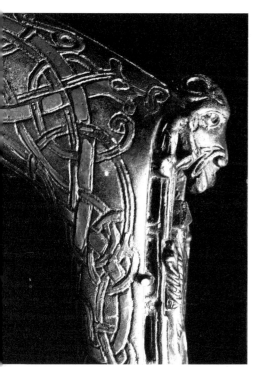

36 Detail of the shrine of the crozier of the abbots of Clonmacnoise, *c.* 1100. Bronze, inlaid with silver bands bordered by niello. National Museum of Ireland.

Scandinavia. Indeed, such workshops were probably responsible for the introduction of these Scandinavian animal patterns that were to dominate Irish decoration in the century before the Norman invasion. It is the use of this animal ornament alongside the older Irish decorative elements and certain features of Romanesque art (which had by now become widespread elsewhere in Europe) that gives Irish art of the eleventh and twelfth centuries its own highly individual flavour, so different from the pure Romanesque art of the rest of Europe.

A charming example of the new Classically-inspired Romanesque ornament combined with an older Irish style is seen in the Crucifixion plaque from 35 Clonmacnoise. The composition, with the two angels on Christ's arms, harks back to the earlier Crucifixion plaque from Rinnagan. The spiral where the 12 angels' wings meet is none other than the old Celtic pelta, but the body of Christ is no longer decorated by Celtic spirals. He wears a chasuble bearing the Classical acanthus pattern of a type used around the middle of the eleventh century, to which period this plaque may belong. The cross itself, though not the cross-form, has disappeared, and we now have before us a Christ more triumphant than suffering. The artist has the old Irish disregard for comparative proportions, but more so than ever before he is preoccupied here with the contrast of lines – the horizontals and verticals of Christ's body and the thieves' crosses nestling at His side, as well as the contrasting diagonals of the angels' wings and the lance and the pole with the vinegar-laden cup.

It is really in the best period of Irish Romanesque metalwork, in the half century from 1090 to 1140, that we feel most the impact of the new Scandinavian animal art styles. The shrine of the crozier of the abbots of Clonmacnoise, which 36 dates from the earlier part of this period, bears on the crook a beast's head and animals in the Scandinavian Ringerike style, which is characterized by limbs and

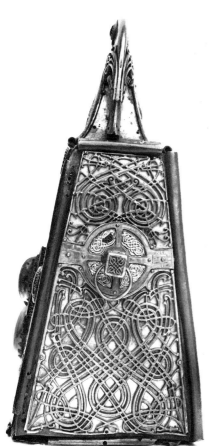

37 Side of the Shrine of St Patrick's Bell, made between 1094 and 1105 (see pls. **16, 17**). Bronze with attached silver-gilt plates, H. 26 cm. (10¼ in.). National Museum of Ireland.

tendrils which curl up at the ends. The animals are formed of inlaid bands of silver bordered by niello – a technique borrowed from the Scandinavians. They are intertwined by narrower bands which also curl up at the ends. With the exception of some of the manuscript illumination, the Irish Ringerike patterns have lost one of the most essential elements of the style as it was practised in the Scandinavian homeland, namely the great lion-like beast fighting against others of more snake-like appearance; but this loss may be understandable when we realize that the style apparently only began in Ireland when it had already given way in Scandinavia to the so-called Urnes style.

In Ireland too the Ringerike style was succeeded by the Urnes style, which is characterized by an intertwining of broader and slenderer animals. This style reached its zenith shortly after 1050 in Norway and Sweden, but – if we rely on the normally accepted dates for the Irish metalwork decorated in this way – it did not become popular in Ireland until almost fifty years later, when it had passed its prime in Scandinavia. One of the first dateable instances of the use of the Urnes style in Ireland is the Shrine of St Patrick's Bell, which dates from somewhere **16,** between 1094 and 1105. The front face of the shrine is divided into rectangular **17** panels bearing a very symmetrical interlacing of elongated animals, some of which form a figure of eight. In Scandinavia the animal ornament becomes dull when it approaches symmetry, but the Irish metalworkers have in many cases avoided falling into this trap. We can see this on the side of the shrine, where **37** subtly intertwined slender animals form a most delicate tracery built up around a cross motif, showing the smoothness which Irish Urnes ornament could achieve.

The Cross of Cong and St Manchan's Shrine

The two great masterpieces of twelfth-century Irish metalwork are the Cross of Cong and the Shrine of St Manchan, which like most of the surviving metalwork of the period are religious in character, and created in the atmosphere of church reform which was pervading Ireland at the time. The Cross of Cong **18** was certainly started if not actually completed in 1123, and may have been executed in Clonmacnoise or some other important centre in the west midlands. The front of the cross is decorated with a setting of rock crystal reminiscent of that used on the underside of the Ardagh Chalice. On the back there are enamel **28** bosses – elements which had also appeared on the Ardagh Chalice and which **8** suggest the essential continuity from the great metalwork of the eighth century. The bosses are now flatter, however, and the colours – red on a yellow background – are the opposite to those found in the earlier period. The front of the cross is divided into small panels which show the typical Urnes element of a large standing four-legged beast, interlaced with a narrower snake-like beast, though surrounding the central boss are panels of filigree spirals which also hark back to eighth-century motifs. The back of the cross shows larger beasts forming symmetrical figures-of-eight and not formally divided into panels as on the front. The bottom of each face of the cross is gripped by a scaly dragon-head of a type which we shall meet again on the stonework of the period, and on the sides between the two heads is a small survival of Ringerike ornament.

The same fine design of interlaced animals is also encountered on the bosses of St Manchan's Shrine (now preserved in the Catholic church at Boher in Co. Offaly), which may be a product of the same workshop as the Cross of Cong. The arms of the cross on the shrine bear geometrically-designed panels with yellow enamel reminiscent of their forebears four hundred years earlier, but the most unusual feature of the shrine is the row of small elongated figures wearing loin-cloths decorated with an interesting variety of geometrical and foliate designs of more typical Romanesque type, as well as Urnes ornament.

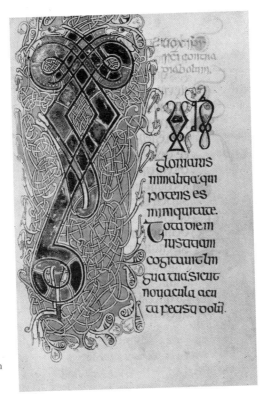

Manuscripts of the eleventh and twelfth centuries

The manuscripts of the eleventh and twelfth centuries have been somewhat unjustly neglected, but they do not attain quite the same standard as the contemporary metalwork. They lack the ornamental pages of the earlier manuscripts; some of the animals which inhabit their decorated initials do bear a resemblance to those of the *Book of Kells*, but with an interesting injection of the Scandinavian styles. Some of those of the eleventh century, such as the *Liber Hymnorum* (Trinity College Library, Dublin), show Ringerike influence, but the final flowering of the illumination, best represented by *Cormac's Missal*, which dates from around the period of the Norman invasion, shows the greater dominance of a fatter single or double animal against a background of more slender legless beasts intermingled with an occasional appearance of Classical acanthus ornamentation.

STONE SCULPTURE

Cross-decorated pillarstones

The stone pillars which may greet us when we visit an old Irish monastic site are not likely to be earlier than the seventh century, and may be even later. The earliest dateable example is that at Kilnasaggart in Co. Armagh, carved shortly after 700. Crosses in circles are cut into the surface of this stone, which may have been a prehistoric standing stone converted here to Christian use. The majority of these stone slabs are found in the west of Ireland, where some of them may have been set up originally as grave-markers. They are sometimes decorated with a Maltese cross in a circle, or with a cross with expanding ends framed by an upright rectangle. A fine example can be seen at Reask in Co. Kerry, where a

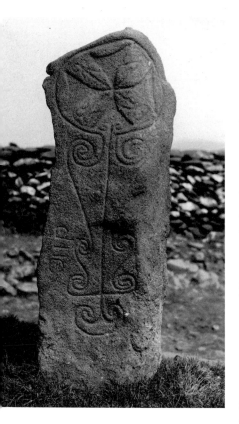

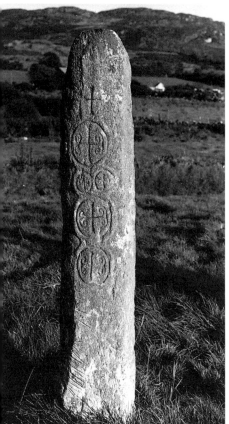

Maltese cross in a circle is supported by spirals of Celtic decoration. Other pillars bearing Christ's Chi-Rho monogram within a circle and dating possibly from the seventh century at the earliest appear to have connections with Galloway in Scotland. One cross-decorated pillar which introduces a certain amount of modelling into the otherwise normally engraved decoration, and which may therefore be slightly more developed, is found at Kilfountain, Co. Kerry, not far away from the Reask stone. On rare occasions these upright slabs bear single figures or a Crucifixion scene.

High crosses

Probably the best known symbol of early Christianity in Ireland is the high cross, a large stone cross with a circle normally surrounding the intersection of shaft and arms, and often decorated with scenes from the Old and New Testaments. These crosses are not uniquely Irish. Others are known, for instance, from Britain, but the Irish ones are among the best preserved and they certainly present the greatest variety. The earliest crosses of the series do not appear to have had either the circle or the biblical scenes. The Rinnagan bronze Crucifixion **12** plaque, of about 700, shows a cross form with concave indents on the limbs which also have long rectangular extremities. The same form can be seen in the *Durham Gospels* (Durham Cathedral Library) and on the Ruthwell Cross in Dumfriesshire, and it was this form which served as a basis for the great series of Irish crosses. That it may already have been executed in the form of a free-standing stone monument in Ireland around or shortly after 700 is suggested by fragments at Toureen Peakaun, Co. Tipperary, where one face of the shaft is decorated with an incised cross motif while the other side bears an inscription with the same kind of lettering as that used on the Ardagh Chalice and the **9** Northumbrian *Book of Lindisfarne*, both belonging to around this time. John Hunt pointed out to me that certain peculiarities in the details of the fragmentary Toureen Peakaun Cross suggested that it was copied from an earlier cross of wood, and there must have been a number of wooden crosses on other sites as well. Possibly some if not all of the crosses which are shown on an eighth-century manuscript plan of the monastery at St Mullins in Carlow may have been such crosses of wood.

The Toureen Cross does not appear to have had a circle. However, the circled cross seems to have been developing at around the same date on metalwork, and this experimental stage we can see on the Moylough Belt Shrine. Here the cross **27** begins to break out of the circular framework which had encased the more purely decorative Maltese crosses on the pillars in the west of Ireland, and the concave indent on the limbs of the crosses moves to a position nearer the junction of arms and shaft. On the Moylough Belt Shrine, cross and circle have almost equal validity, but with the exception of the unique Cross of the Scriptures at **49** Clonmacnoise the cross later becomes the dominant element, and the circle merely plays a supporting role. There has been much argument but little agreement on what significance is to be attached to the circle of the cross.

The Ahenny group of crosses

The emerging form of ringed or circled cross was probably also used for free-standing altar and processional crosses made of wood but with their surfaces decorated with nailed-on bronze panels bearing Celtic spirals, interlacing and fret-work patterns. None of these has survived in Ireland, but we can imagine what they must have looked like by studying the high crosses at Ahenny in Co. Tipperary, which reproduce them in a magnified form in stone. A processional

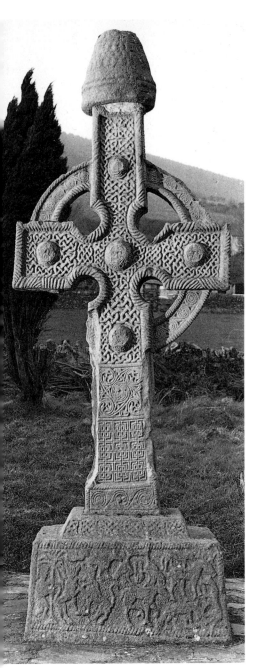

41 North Cross at Ahenny, Co. Tipperary, late 8th C. H. about 3.60 m. (12 ft.).

cross is actually portrayed on one side of the base of one of the Ahenny crosses not reproduced here. On the North Cross at Ahenny we see the shaft and arms of the cross decorated with intricate ornament which would seem more at home on metalwork. Large studs in the centre and on the arms of the cross may reproduce ornamental bosses covering the nails which fastened the bronze panels to the wooden core, while the rope-moulding seen on the corners of the cross probably copies a metal device used to cover the awkward joints where the flat metal panels met at right angles. Just such details can be seen on the processional cross of late eighth-century English origin from Bischofshofen in Austria (now in the Dommuseum, Salzburg).

The base of the North Cross at Ahenny introduces us to a totally different kind of ornament – figure sculpture representing a running man under a palm tree apparently chasing wild and fantastic animals, all of which are markedly more naturalistic in shape than their manuscript counterparts. This composition – and the various hunting scenes shown on the bases of a number of other Irish high crosses – do not belong to the Celtic-based metalworking tradition as represented by the ornament on the cross shaft itself. They seem to be influenced by Late Roman models such as sarcophagi in southern Gaul, and appear in a slightly different form not only on Pictish slabs but also on the Northumbrian ivory box known as the Franks Casket, dating from around 700 (now divided between the British Museum and the Bargello in Florence). Although probably carved in a Christian milieu, the Franks Casket combines both pagan and Christian symbolism: it would not be surprising, therefore, if some of the hunting scenes on the bases of Irish high crosses had a secular rather than a Christian meaning, and one for which we need not necessarily seek an explanation in a purely Irish context.

It is difficult to say whether the original wooden and metal crosses on which the North Cross is likely to have been modelled had a base in the form of a truncated pyramid, its sides decorated with hunting and animal scenes. But whether they had or not, the idea was probably introduced into Ireland from Britain some time in the eighth century, and the more immediate inspiration for the scenes on the bases of the high crosses may possibly be best sought in such British items as ivory work carved before the time of Charlemagne, of which the Franks Casket is one of the few pieces to have survived.

The idea of erecting stone crosses was probably also introduced into Ireland from Britain, where such great crosses as those from Ruthwell and Bewcastle, decorated with figures of Mediterranean and therefore ultimately Roman inspiration, were being erected possibly as early as the late seventh century. The crosses at Ahenny do not stand alone in being apparent imitations of wooden and metal prototypes. Others at Kilkieran and Kilree, both in Co. Kilkenny, share this feature, as does the South Cross at Clonmacnoise, while one cross at Castlekeeran in Co. Meath resembles the Ahenny crosses in shape while lacking their overall decoration.

The Clonmacnoise group of decorated pillars

Clonmacnoise appears to have been the centre of production of another kind of cross or pillar which also uses the hunting motifs seen on the Ahenny cross-bases. On a pillar from Banagher, Co. Offaly, we have the individual elements – a 42 human interlace, a deer caught in a trap, a cleric on horseback and a lion – placed one on top of the other. An interesting parallel is provided by a slab with Lombardic affinities from Aversa in central Italy which shows a horseman thrusting his sword into a lion placed directly above him. An inscription on a cross now at Bealin, Co. Westmeath, which is somewhat similar and possibly

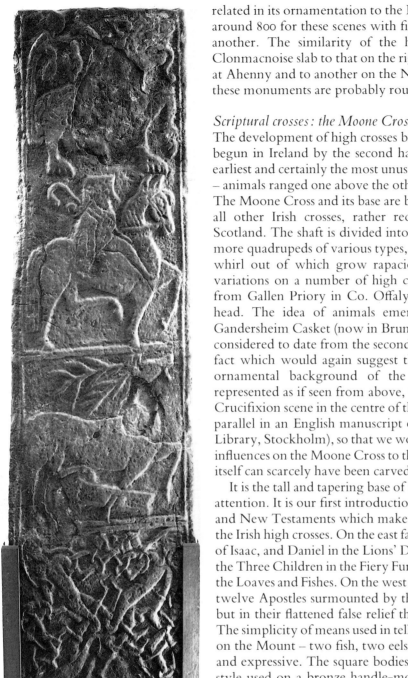

42 Pillar from Banagher, Co. Offaly, probably *c.* 800. H. 1.50 m. (5 ft.). National Museum of Ireland.

related in its ornamentation to the Banagher slab, helps to give a possible date of around 800 for these scenes with figures of men and animals stacked up on one another. The similarity of the head of the topmost animal on a related Clonmacnoise slab to that on the right of the tree on the base of the North Cross at Ahenny and to another on the North Cross at Clonmacnoise suggests that all these monuments are probably roughly contemporary.

Scriptural crosses: the Moone Cross and the iconographical background

The development of high crosses bearing scriptural scenes had probably already begun in Ireland by the second half of the eighth century, and on one of the earliest and certainly the most unusual of these – the cross at Moone, Co. Kildare, – animals ranged one above the other play a considerable role in the decoration. The Moone Cross and its base are both extraordinarily slender in comparison to all other Irish crosses, rather recalling those from Northern England and Scotland. The shaft is divided into a number of small panels containing one or more quadrupeds of various types, while the centre of one side of the cross has a whirl out of which grow rapacious-looking animals – a motif found with variations on a number of high crosses and also, for instance, on a cross-slab from Gallen Priory in Co. Offaly where each of the beasts devours a human head. The idea of animals emerging from a whirl is also found on the Gandersheim Casket (now in Brunswick), an English ivory box which has been considered to date from the second half of the eighth century or around 800 – a fact which would again suggest that ivory carvings may have influenced the ornamental background of the Irish high crosses. The strange animal, represented as if seen from above, which looks down over Christ's head on the Crucifixion scene in the centre of the other face of the Moone Cross finds a close parallel in an English manuscript of the same period, the *Codex Aureus* (Royal Library, Stockholm), so that we would probably be justified in dating the British influences on the Moone Cross to the second half of the eighth century. The cross itself can scarcely have been carved very much later.

It is the tall and tapering base of the Moone Cross which above all attracts our attention. It is our first introduction here to the selection of scenes from the Old and New Testaments which make up the most conspicuous element on most of the Irish high crosses. On the east face of the base are Adam and Eve, the Sacrifice of Isaac, and Daniel in the Lions' Den. The south side shows in descending order the Three Children in the Fiery Furnace, the Flight into Egypt and the Miracle of the Loaves and Fishes. On the west face of the base we see a panel representing the twelve Apostles surmounted by the Crucifixion. The figures are very stylized, but in their flattened false relief they exude a naive charm which is irresistible. The simplicity of means used in telling the tale of the feeding of the five thousand on the Mount – two fish, two eels and five loaves – is extraordinarily appealing and expressive. The square bodies of the Apostles are rather reminiscent of the style used on a bronze handle-mount from a seventh- or eighth-century Irish bucket found in Scandinavia, while the inverted pear shape of their heads recalls Merovingian forms on the Continent. In the sculptor of the Moone Cross we recognize an important master who not only carved a truly wonderful cross but also was one of the first to introduce scenes from the Bible on an Irish stone high cross.

The biblical scenes on the Moone Cross, as well as on others to be mentioned below, revolve around two central ideas: the help which God has given to mankind, and those themes that are common to the Old and New Testaments. The Fall of Man is shown as the first link in the chain of events, the bite of the forbidden fruit which made it necessary for Christ to redeem us. In later crosses,

43, 44

44

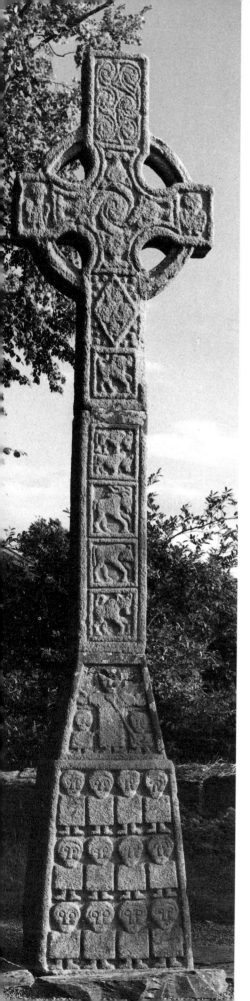

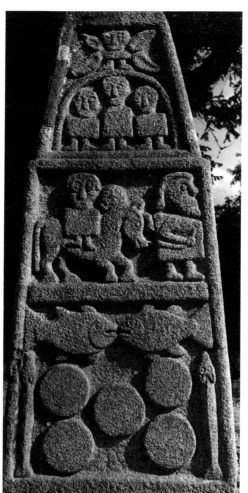

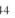

43, 44 West face and south side of the base of the Moone Cross, Co. Kildare, *c*. 800. H. 5.35 m. (17 ft. 6 in.). This is among the earliest of the high crosses to introduce Scriptural scenes.

45 Cross of SS. Patrick and Columba at Kells, Co. Meath, early 9th C. Its name comes from an inscription on the base, *'Patricii et Columbae crux'*.

46 Gravestone at Clonmacnoise, Co. Offaly, 9th–10th C., asking a prayer for Thuathal the Wright. H. about 1 m. (3 ft.).

this scene is almost invariably coupled with one showing Cain killing Abel – the first innocent victim to be slain, and thus Christ's first precursor. Daniel in the Lions' Den, the intervention of the angel as Abraham was about to sacrifice his son Isaac, and the Three Children being protected in the Fiery Furnace are shining examples of how God chose to save the good from destruction, in the same way that the Holy Family was able to escape to Egypt from the Slaughter of the Innocents, and that the five thousand who came to hear the Word on the Mount were fed by a divine miracle. The biblical stories which we find on the high crosses were being popularized in the Irish religious literature of the reformist Culdee movement in the last decade of the eighth century, and the iconography of some of the scenes on the crosses, such as Adam and Eve, Daniel in the Lions' Den and the Sacrifice of Isaac, may have filtered through to Ireland via England from the kingdoms of the Lombards, Burgundians and Visigoths, where they are found on a variety of artistic products dating from the Merovingian period. One scene unconnected with the Bible appears several times, for instance on the north side of the base of the Moone Cross – the meeting of St Paul and St Anthony in the desert. Ireland is one of the few areas outside Egypt and Italy where these figures are known to have been portrayed at this period, but as they are the patrons of monastic life their relevance in an Irish context is obvious.

44

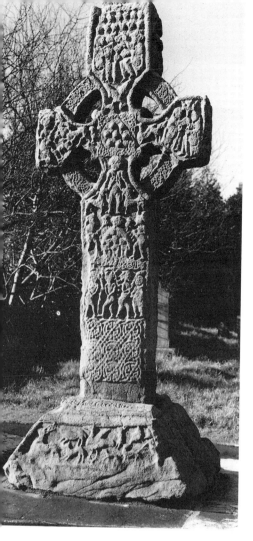

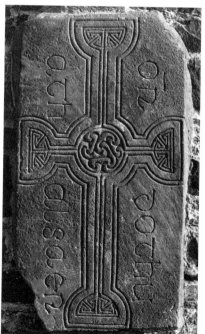

As with the animals on the base of the North Cross at Ahenny, the scriptural scenes on Irish high crosses may have been modelled on ivory reliefs which may have been mounted on smaller wooden crosses, of which the high crosses may have been enlarged versions. It is also possible that the high crosses of stone had carved forerunners in wood. The use of such smaller models might account for the presence of biblical and hagiographical scenes on some crosses (for instance Moone), and their absence on others (for instance Ahenny).

As far as we know, the high crosses were not funerary monuments: surviving inscriptions on them simply request a prayer for the men who erected them. The scriptural scenes probably served as a kind of picture Bible to help explain sacred scripture in public to those who were not able to read the texts in Latin. Early Irish gravestones took a different form. They are flat rectangular slabs of varying sizes bearing different kinds of crosses and almost invariably using the simple formula 'Or[oit] do' (a prayer for) followed by the name of the person whom the stone commemorated. One of the best preserved examples is from Clonmacnoise, where the most extensive collection of such gravestones, stretching over a number of centuries, is found.

The Cross of SS. Patrick and Columba, Kells

The flight of monks from Iona in the wake of the Viking invasions in 806 may not only have helped to bring the great manuscript to Kells: it may also have stimulated the creation of at least some of the fine scripture crosses in stone which still survive from this venerable monastery. On one of these, the one known from an inscription on the base as the Cross of SS. Patrick and Columba, which may well date from some time around the early ninth century, we see the same flight of running animals which we encountered on the base of the North Cross at Ahenny, and many of the scriptural scenes which decorate the Moone Cross are also present here. At Kells these scenes are not confined to the base, but are found also on more exalted and important positions on the main faces of the shaft and arms, where, without any clear demarcation of the individual panels, they intermingle with decorated bosses and interlacing. On the east face we see Adam and Eve with Cain slaying Abel sharing the lowest figured scene; above them come the Three Children in the Fiery Furnace and Daniel in the Lions' Den. The arms of the cross show the Sacrifice of Isaac and SS. Paul and Anthony in the desert. David, the Psalmist, is shown with his harp on the uppermost part of the shaft, and beside him is Christ holding the miraculous loaf in his hand and with two fish crossed beneath His feet – all scenes, with the exception of David, already displayed on the Moone Cross. On the west face, the Crucifixion scene occupies the space of two panels on the shaft just below the circle (as it does also on the roughly contemporary South Cross at Clonmacnoise) and not, as one might have expected, the centre of the cross, where it is found at Moone and on a number of other high crosses.

Drumcliff, Co. Sligo – probably a Columban foundation, like Kells, Durrow and, it seems, Moone – is the site of a cross which is so similar to the Kells cross in its iconographical division, its interlacing and some of its animal ornament that they must be of roughly the same date. The crosses present at all these sites may indicate an important role played by the Columban monasteries in the development of the Irish scriptural crosses.

The other crosses surviving at Kells may have occupied a pivotal position in the further elaboration of the high crosses, for they combine elements of iconography which are found separately on other groups of high crosses – those in the east and midlands (Monasterboice, Durrow, etc.) on the one hand, and those in northern Ireland (e.g. Donaghmore and Arboe) on the other. These

crosses represent the apogee of high cross development in Ireland. They are fairly homogeneous, so that a few samples may be studied in detail as representatives of the groups as a whole.

The great crosses of the east and midlands : Monasterboice and Clonmacnoise
Because of the quality of the sandstone from which they are carved, these crosses have survived weathering better than those in the north.

Possibly the finest of all is the Cross of Muiredach at Monasterboice in Co. Louth. The original crisp quality of the carving can still be judged by looking at the underside of the arms and the circle which have escaped the ravages of time better than most of the exposed faces, but these too have survived remarkably well despite standing in the open for over a thousand years. High crosses may once have been coloured, and even more striking than they are today. 47, 48

The broadness of the shaft on Muiredach's Cross allows for a more expansive composition in the figured scenes. The east face demonstrates the remarkable ability of the carver to accommodate a great number of clearly recognizable figures with considerable depth and plasticity while avoiding any sense of overcrowding. The base has a badly worn scene with men and animals. The lowest panel of the shaft begins the scriptural exegesis, with Eve handing the forbidden fruit to Adam under the gracefully arched branches of an apple tree, while beside them Cain slays the innocent Abel. Above them Goliath, kneeling defeated at the feet of David on the right, shares a panel with Saul and Jonathan. The third panel shows Moses smiting the rock, and above that is a scene of the Adoration of the Magi, the fourth standing figure being most likely a wingless angel rather than Joseph or an additional king from the East. The centre of the cross is dominated by a scene representing Christ in Judgment, holding a cross and a sceptre like that borne by the Egyptian god Osiris. On Christ's right, the good souls are turned towards Him, accompanied by the harpist David who has a bird sitting atop his instrument, possibly symbolic of the sung Psalms. On Christ's left is a man playing the pipes of Pan, beyond whom a devil with a trident herds the damned whose eyes are averted from the Lord. Below the feet of Christ is an amusing representation connected with the final Judgment – the weighing of souls by Michael the Archangel. In front of him is a scales with two pans, in one of which St Michael has placed a soul. Beneath it is a devil lying on his back, who, although St Michael's staff is rammed down his throat, is trying to alter the balance of the scales in his own favour by means of a long pole. The whole of the centre of the cross is a splendid composition, and the most expansive rendering of the Judgment scene on any of the Irish high crosses. Above it we meet SS. Paul and Anthony in the desert once more. The cross is capped by a 'shingle' roof, doubtless an imitation of the kind used on the normal Irish church of the period. On the other face of the cross the crucified Christ occupies the central position, among other scenes from the Passion, including one on the bottom panel of the shaft showing the Arrest of Christ, who wears a garment fastened by a brooch of roughly the same penannular type as the Tara Brooch. 48 · 47 · 29

The inscription on the base of the shaft of the cross informs us that it was erected by one Muiredach. The old Irish Annals tell us of two abbots of Monasterboice named Muiredach, one who died in 844 and the other who died around 921/22. Purely on stylistic grounds, the ninth-century Muiredach might appear to be the more likely candidate. The cord decoration surrounding the panel showing the Arrest of Christ and the animals standing out in high relief around the base of the cross-shaft are so similar in style to the Gandersheim Casket, which, as mentioned previously, has been considered to date from the second half of the eighth century or some time around 800, that they can scarcely 47

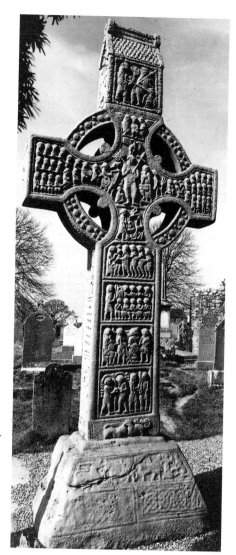

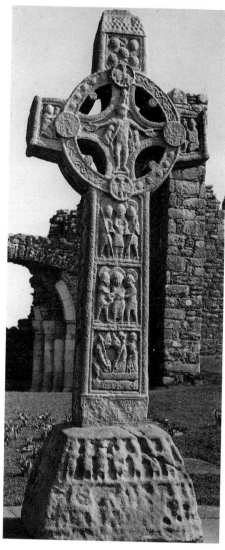

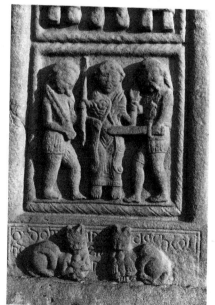

47, 48 *Right and below* East face and detail of the west face of Muiredach's Cross at Monasterboice, Co. Louth, probably mid-9th C. H. 5.40 m. (17 ft. 8 in.).

49 *Far right* West face of the Cross of the Scriptures, or Flann's Cross, at Clonmacnoise, Co. Offaly, probably mid-9th C. H. about 3 m. (10 ft.).

be much later in date. The two animals emerging from the background of that part of the cross on which the inscription is carved are similar in feeling to the cats and mice(?) near the bottom of the Chi-Rho page of the *Book of Kells*, a comparison which would also lead us to a date not very much later than 800 for this type of animal ornament. 31

The Cross of the Scriptures at Clonmacnoise, sometimes known as Flann's Cross, shows such a close workshop connection with Muiredach's Cross that the two must be roughly contemporary. The similarity is seen particularly in the decoration of the underside of the ring, though the shaft at Clonmacnoise is more slender and has far fewer figures in each panel. 49

Petrie's nineteenth-century readings of the fragmentary inscriptions on this cross reconstructed the names of Colman and Flann, which he interpreted as being respectively those of an abbot of Clonmacnoise and a High King of Ireland, who built a cathedral at Clonmacnoise early in the tenth century. Most authorities have accepted Petrie's readings as providing a likely date for this cross in the first quarter of the tenth century, and as supporting the ascription of the Monasterboice cross to the later Muiredach who died around 921.

63

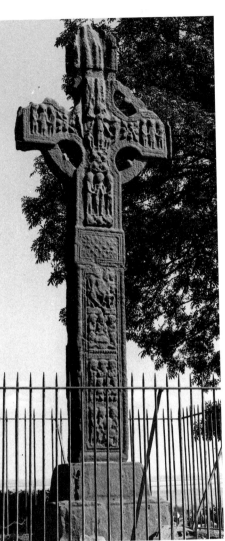

50 High cross at Arboe, Co. Tyrone, probably 9th C. H. about 6 m. (20 ft.).

But Petrie's reconstruction of the name Colman is questionable, as only the last two letters of the name survive intact in the inscription. The third last letter could also be seen as an 'n', so that where Petrie read Colman it would be equally possible to reconstruct a name like Ronan. There was an abbot of Clonmacnoise called Ronan who died between 841 and 844, and who was thus contemporary with the earlier Muiredach at Monasterboice. During Ronan's reign there was also, as it happens, another Flann at Clonmacnoise: he was a prior, who was killed by being drowned in the Shannon around 837. Even though it cannot be proved, it is possible that the Cross of the Scriptures at Clonmacnoise was erected not by Abbot Colman and the High King Flann in the early tenth century, as Petrie suggested, but rather by Abbot Ronan in commemoration of his murdered prior Flann shortly after 837 – a date which would dovetail in neatly with the erection of the Monasterboice cross by the earlier Muiredach, who died in 844. This dating, if correct, would reduce to a mere few decades the otherwise awkward century-long gap implied by Petrie's readings between these crosses and early ninth-century examples such as that of SS. Patrick and Columba at 45 Kells. It could also mean that the Viking raids on Irish monasteries, which began in earnest in the 830s, could be seen as a possible reason for the termination of the carving of this great series of crosses.

Flann's Cross is remarkable in that the cross-shape retreats in favour of the dominant circle surrounding the focal point, from which the arms protrude upwards at a most unusual angle, offsetting the horizontal and vertical elements in the design. The ring provides a worthy surround for the Crucifixion scene, in which the figure of Christ dominates the whole cross. Other scenes are taken from the Passion. The lowest panel shows the soldiers at the tomb, asleep, leaning on their spears; behind them appear Martha and Mary. Below the slab on which the soldiers rest is the body of Christ, wrapped in a shroud decorated by three crosses in relief, and into His mouth a bird breathes life, suggesting that the moment of Resurrection is at hand. Under the circle is a scene apparently representing the Arrest of Christ, and below it is possibly the Flagellation. In its iconography, the cross at Clonmacnoise is very close to the cross at Durrow.

The northern group of crosses

Yet another important group of crosses is located in northern Ireland. Their use of a slightly softer sandstone has led to an unfortunate deterioration in the condition of some of the carvings, and only the crosses at Donaghmore and Arboe in Co. Tyrone have survived the elements sufficiently well to give us at 50 least some idea of their original quality and iconographical scheme. These crosses make a clearer division between the Old and the New Testament, allotting the scenes from each to a different face. Adam and Eve, the Sacrifice of Isaac and Daniel in the Lions' Den appear on each of the two crosses, while Cain and Abel and the Three Children in the Fiery Furnace appear on one or the other. The New Testament scenes repeat some which we have already seen, such as the Adoration of the Magi, but others – such as the Wedding Feast of Cana, the Entry into Jerusalem and the Baptism of Christ – make their appearance here and show the close link between these crosses and the Broken and Market Crosses at Kells which also bear them. In Clones, Co. Monaghan, the lower part of a cross standing in the Diamond is another important remnant of this group.

The Barrow group of crosses

Of the various crosses surviving individually or in groups other than those already discussed, the group in the Barrow valley – mainly in counties Kildare and Kilkenny – lies between the two groups that we have just discussed. The

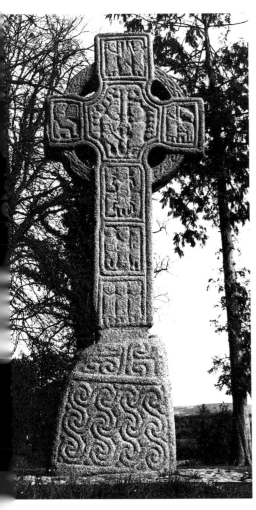

crosses are carved in the somewhat intractable local granite, which forces a certain stiffness on the design and the figures. The scenes are placed in a rigid rhythm of rectangular panels broken only by the one in the centre, which has to fit the space between the arms and the shaft. That panel is filled out in one example from Castledermot, Co. Kildare, by Adam and Eve, the branches of the apple tree accommodating themselves to the shape of the frame, while in other crosses at Castledermot and elsewhere Christ occupies the central panel.

North-western crosses and slabs

A disparate 'group' of carved crosses and slabs in the north-west of Ireland seems to be divorced from the main developments already discussed and may go back to some independent impetus from Scotland. It ranges from small pillars carved with human figures (as at Killadeas, Co. Fermanagh, and Carndonagh, Co. Donegal) through tall upright rectangular slabs decorated with human figures combined with crosses formed of bands of interlacing (as at Fahan and Carndonagh, both on the Inishowen Peninsula) to full free-standing crosses, either complete (as at Carndonagh and Carrowmore) or fragmentary (as at Clonca, Co. Donegal). An inscription on the Fahan slab reproducing the *Pater Noster* in a form approved by the Council of Toledo in 633 gives us a date *post quem* for it, and the bands of interlacing on it and on the Carndonagh cross are of a broad variety which has been compared to those in the seventh-century *Book of Durrow*. It remains a matter of dispute as to whether these two monuments really are as early as the seventh century, and it is not clear whether they belong to the same 'school' as the other monuments in the area. Animal ornament on the Clonca cross-shaft is scarcely much earlier than the late eighth century, and interlacing on the same cross is paralleled on the Carndonagh slab decorated with a marigold-headed *flabellum*, which may be roughly contemporary. The cross at Carrowmore bears what is probably a Crucifixion scene, showing echoes of that from Rinnagan but possibly stemming from around 800 – a date which may not be improbable for most if not all the monuments of this 'group'. One cross-shaft, from Kilnaruane in West Cork, seems curiously reminiscent of the Clonca cross-shaft, but it is strange that full-scale decorated crosses are otherwise entirely absent from the south-west of Ireland.

51 North Cross at Castledermot, Co. Kildare, probably 9th C. H. 3.12 m. (10 ft. 3 in.).

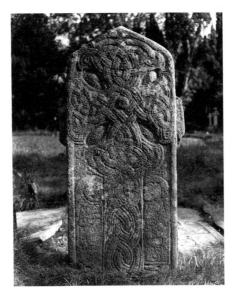

52 Slab at Fahan, Co. Donegal, decorated with a cross flanked by human figures, 7th–9th C. H. 2.13 m. (7 ft.).

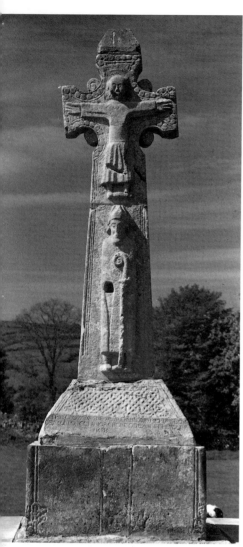

53 Front of the high cross at Dysert O'Dea, Co. Clare, 12th C. H. 3.85 m. (12 ft. 8 in.).

High crosses of the twelfth century

High crosses with biblical scenes stopped being produced early in the tenth century if not before. After an interval of some two centuries crosses of a different form emerged in Munster and Connacht, where practically no crosses (as opposed to cross-slabs) of earlier date survive. There is no obvious reason for the gap: perhaps we should again look to the possibility of long-vanished wooden crosses for a solution to this conundrum.

The twelfth-century crosses have certain features in common, the most obvious of which is the almost complete lack of biblical scenes and their replacement on the shaft by one or two large figures which stand out in high relief. These figures, representing Christ and a crozier-bearing abbot or bishop, stand either one above the other, as at Dysert O'Dea in Co. Clare, or one on each face, as at Cashel in Co. Tipperary. The ring is no longer present on these two crosses, and the Cashel cross has the interesting feature of a stone support for the arms which may echo earlier wooden prototypes. Other twelfth-century crosses in the west of Ireland, such as Tuam in Co. Galway, have shallow interlacing and geometrical designs similar to what we shall meet on Romanesque churches. One fragment on the Aran Islands appears to have a pattern in the Ringerike style, which we encountered on metalwork of the period. One of two surviving crosses from the eastern part of the country dateable to this period, that now in St Kevin's Church in Glendalough, bears Urnes ornament. Urnes ornament also appears in a slightly debased form along with geometrical and floral motifs on the Dysert O'Dea cross.

ARCHITECTURE

Early wooden churches

When we visit the sites of early monasteries in Ireland today, we see practically nothing of what existed there in the days of the founding saints in the sixth century, the stone churches standing there being very considerably later. The often circular bank of earth or occasionally of stone which encloses some of the monasteries is the only surviving feature likely to date from the period of foundation or shortly afterwards. The earliest buildings, both churches and dwellings, were presumably made of wood or wattle and daub, and have not survived. A commentary on the old Irish Brehon Laws, which Professor Binchy assigns to a date after AD 1000, suggests a ground-plan of 4.6 × 3 m. (15 × 10 ft) as the normal size of wooden churches at the time, though the buildings could have been longer. The commentary tells us also that the roof of such churches could be made of either rushes or shingles. Unfortunately, not even the most careful excavations have been able to give us any clear idea of what these wooden churches actually looked like. However, as we shall see below, early stone churches would appear to preserve some of the features of earlier wooden buildings, thus giving us at least some idea of their appearance.

We do have one valuable description of a vanished early Irish church which shows that Ireland was capable of building a structure much more grandiose than the proportions suggested in the commentary on the Brehon Laws. This was the church of the double monastery of St Brigid in Kildare, which is described by the Saint's seventh-century biographer, Cogitosus. At the time Cogitosus wrote, the church he describes had only just been built, having replaced an earlier building – no doubt a common occurrence in Early Christian Ireland. The church was of dizzy height, covered a large area, had many windows and was decorated with frescoes. A wooden partition, also fresco-laden and covered with linen hangings,

divided the eastern part from the rest of the church, and the nave was divided down the middle by another partition which kept the nuns and monks of this double monastery apart. Bishop Conled and St Brigid lay buried on either side of the altar in sarcophagi richly adorned with gold, silver and precious stones and bearing scenes in beaten gold and coloured, and over these hung crowns of gold and silver. The later house-shaped stone sarcophagi at Clones and at Banagher in Co. Derry may preserve for us the form of the tomb-shrines used at Kildare, while the Petrie Crown may have been a precursor of the crowns which hung over them. This rather sumptuous church, somewhat reminiscent of an Orthodox church of today, was presumably built of wood, despite its 'dizzy height'. What a wonderful insight into early Irish art and architecture we would have if it and its contents had survived: the description of the decoration of the sarcophagi certainly shows that the metalwork which has been preserved from this period gives us a very inadequate picture of the quality and nature of all that must once have existed.

The buildings on Skellig Michael and Gallarus Oratory

One of the very few early Irish monasteries whose surviving stone-built structures give us any idea of the appearance of some of the Early Christian monasteries is Skellig Michael. There, perched on small terraces about 180 m. (600 ft) above the sea on the island of Great Skellig, which rises out of the Atlantic to a great peak off the west coast of Kerry, is a small monastery dedicated to St Michael, the patron saint of high places. The well-preserved beehive huts of the monks show the use of the corbel principle in building, which we met at Newgrange three thousand years earlier, and which is still in use on the mainland nearby. These huts, in which the handful of monks passed their lonely existence, are some of the few surviving traces of the domestic buildings of Early Christian monasteries in Ireland. There are two small stone oratories built in the same style, one just below the row of huts, the other (for single meditation) a little farther

54, 55 Beehive huts and one of the oratories on Skellig Michael, Co. Kerry, built at the latest in the 12th C. The oratory measures 4.25 × 3 m. (14 × 10 ft.).

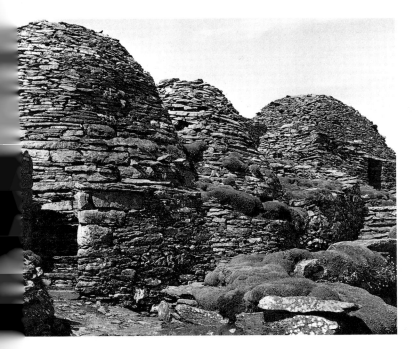
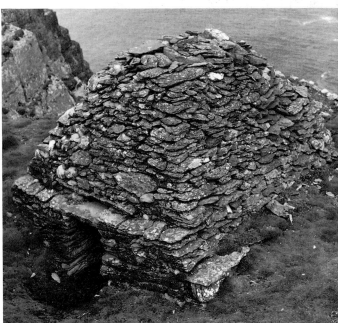

13 *Opposite* The *Book of Durrow*, c. 670–80: f. 192v, a carpet page. H. 26 cm. (10¼ in.). The Maltese cross in the centre of the page is also in the centre of a triangle formed by three circles with decoration like that on enamel bosses (compare pl. **8**), which have been thought to represent the Trinity. Trinity College Library, Dublin. *See p. 44.*

14, 15 *Overleaf* The *Book of Kells*, c. 800: a detail of f. 124r, *Tunc crucifixerant* (the Crucifixion account from Matthew 27:39ff.), showing interlaced bands and animals and the ornamental use of red dots, and f. 34r, the Chi-Rho page bearing the monogram of Christ. H. of page (trimmed) 33 cm. (13 in.). The detail is about twice actual size. Trinity College Library, Dublin. *See pp. 50–52.*

56, 57 Gallarus Oratory, Co. Kerry, 12th C. or earlier. The door-jambs slope inwards, echoing the angle of the walls. H. 5.20 m. (17 ft.).

off. They are rectangular in ground plan and show how the western Irish monastery adapted the principle of the rounded corbel vault to a rectangular building. The oratories had only a very small window and a low doorway, one having a small horizontal slit above it.

Skellig Michael is known to have been inhabited in 823 and 1044, but as the beehive cells have a timeless form they could be earlier or as late as the twelfth century. The oratories do not necessarily date from the earliest use of the site, as excavations of other similar oratories in Co. Kerry have shown, and some of the cross-bearing slabs mentioned earlier could conceivably have been centres of prayer in the open before such oratories were built.

The west coast also preserves other structures which show a refinement of the oratories on the Skelligs. The best example is Gallarus Oratory, also in Co. Kerry, which with its walls sloping inwards looks like an upturned boat. Its stones are all so carefully chosen that it is the only specimen of its kind – other than those on Skellig Michael – which has not succumbed to the danger inherent in using the corbel principle in a rectangular building, namely the collapse of the roof of the longer sides. The date of the building of Gallarus Oratory is a matter of dispute, but it could be as late as the eleventh or twelfth century. 56, 57

The monasteries which used the corbel principle in their buildings seem to form a separate group concentrated in the west and south-west of Ireland, their geographical distribution corresponding interestingly with that of the cross-decorated slabs or pillars. It is also in the same areas that the Irish language has survived most strongly down to the present day, showing that these areas are very pertinacious in retaining their traditions – something which makes the dating of the structures and the pillars all the more difficult. Belonging thus to a possibly archaic building province all its own, this group does not appear to have contributed to the development of the normal stone churches with upright walls found largely in the other parts of the country.

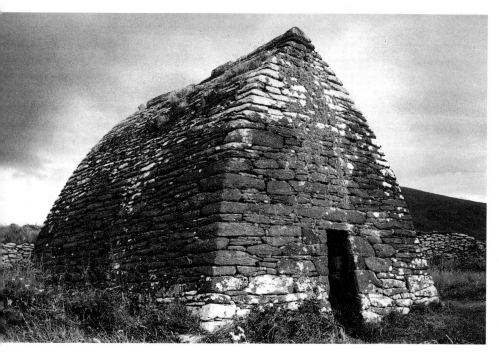
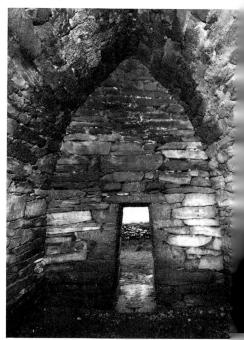

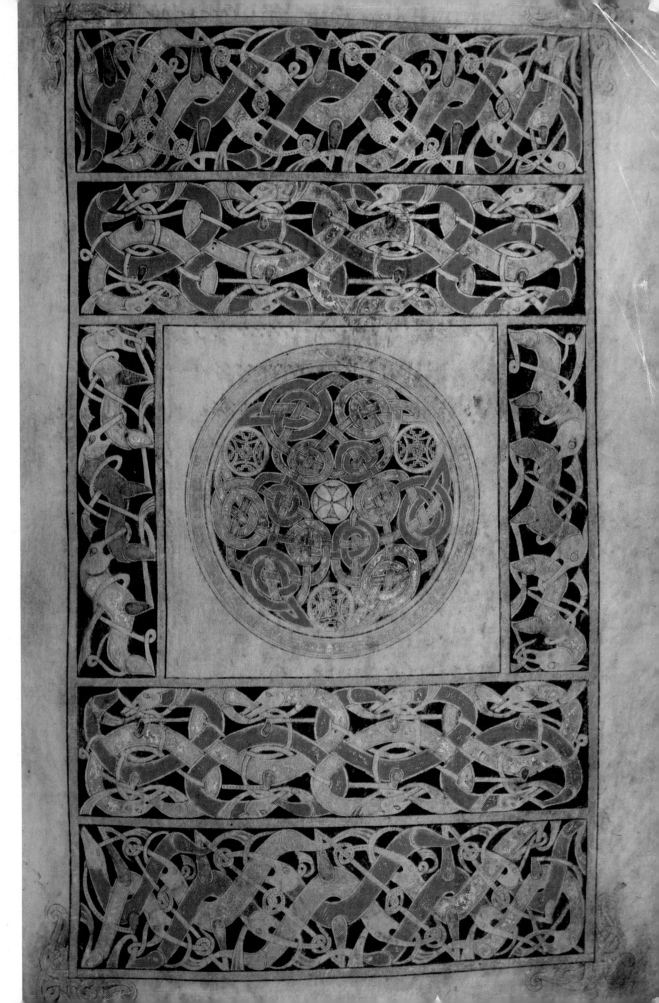

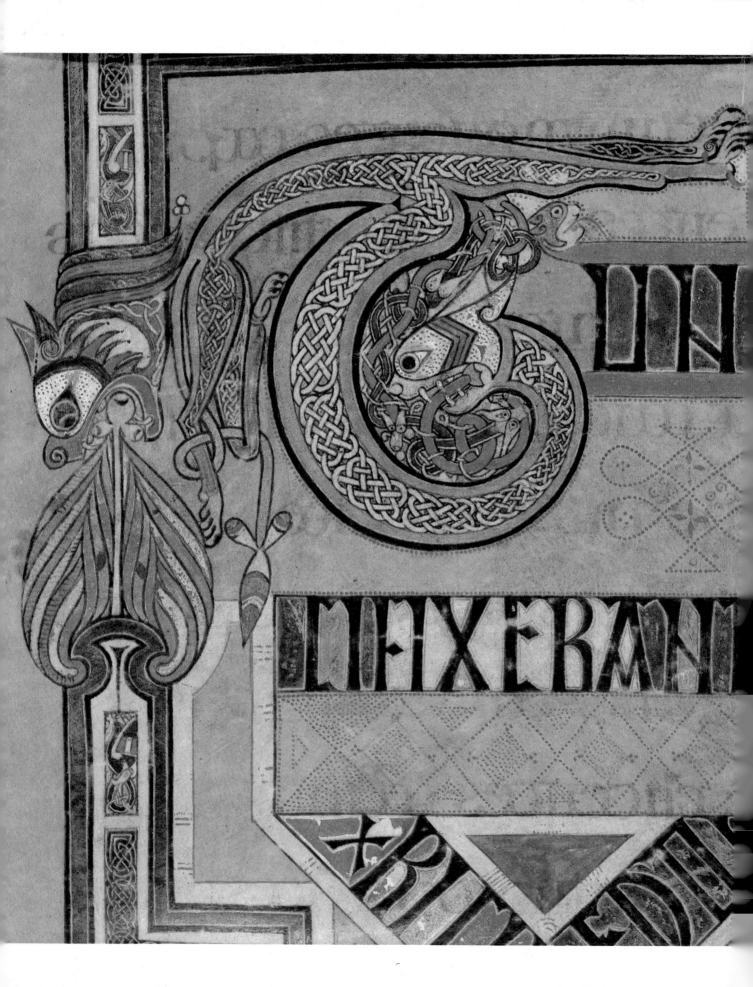

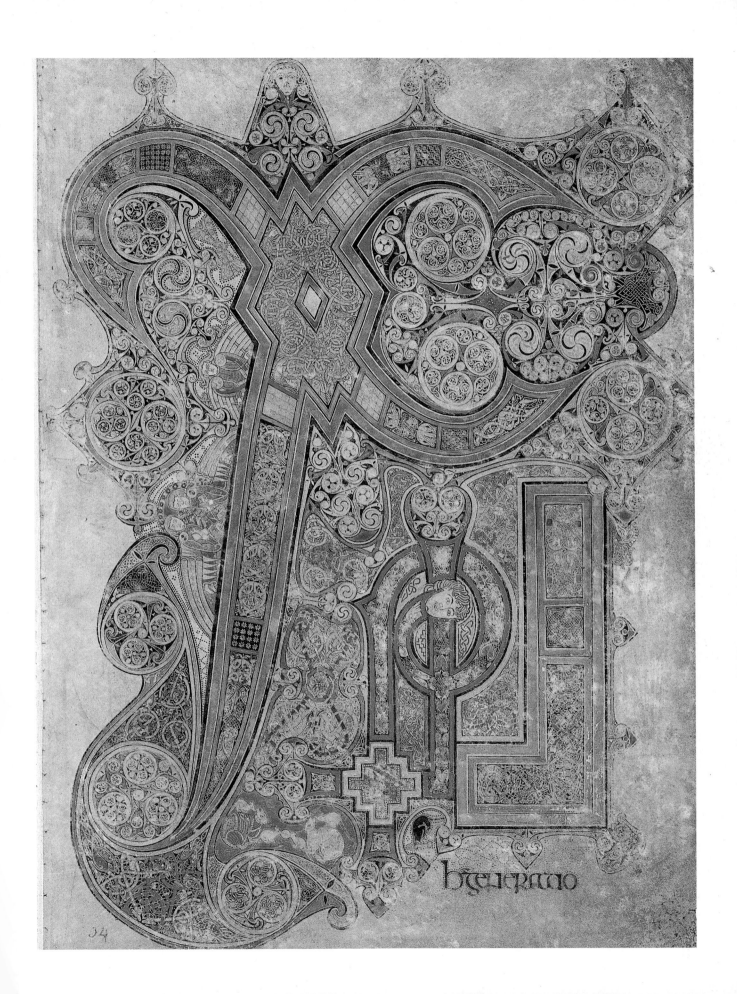

Χ_ι autem generatio

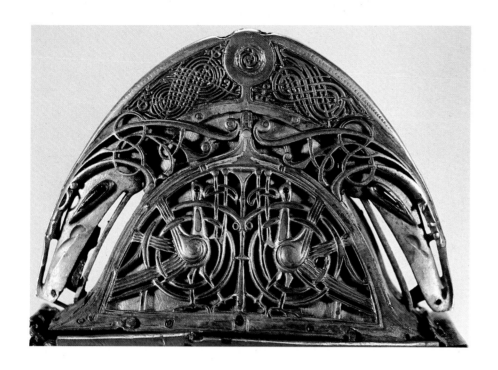

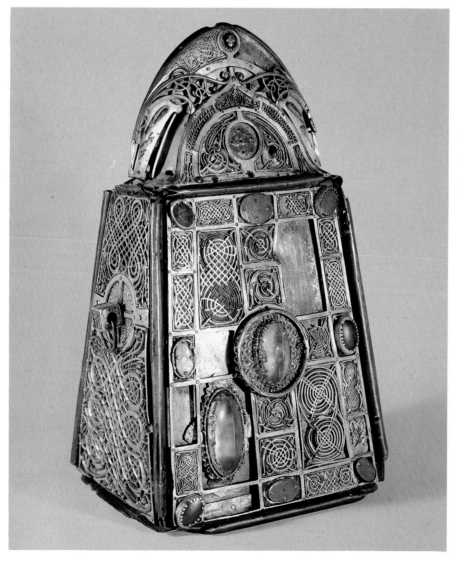

16, 17 Shrine enclosing St Patrick's Bell, made between 1094 and 1105; the detail shows the back of the crest. Bronze decorated with gold and enamel, H. 26 cm. (10¼ in.). The jewels were added later in the Middle Ages. National Museum of Ireland. *See p. 55.*

18 The Cross of Cong, *c.* 1123. Bronze panels with animal interlace are edged by bands of silver, punctuated by studs of glass and niello; at the centre is a rock crystal, at the base an animal with blue glass eyes; H. 76.5 cm. (30⅛ in.). National Museum of Ireland. *See p. 55.*

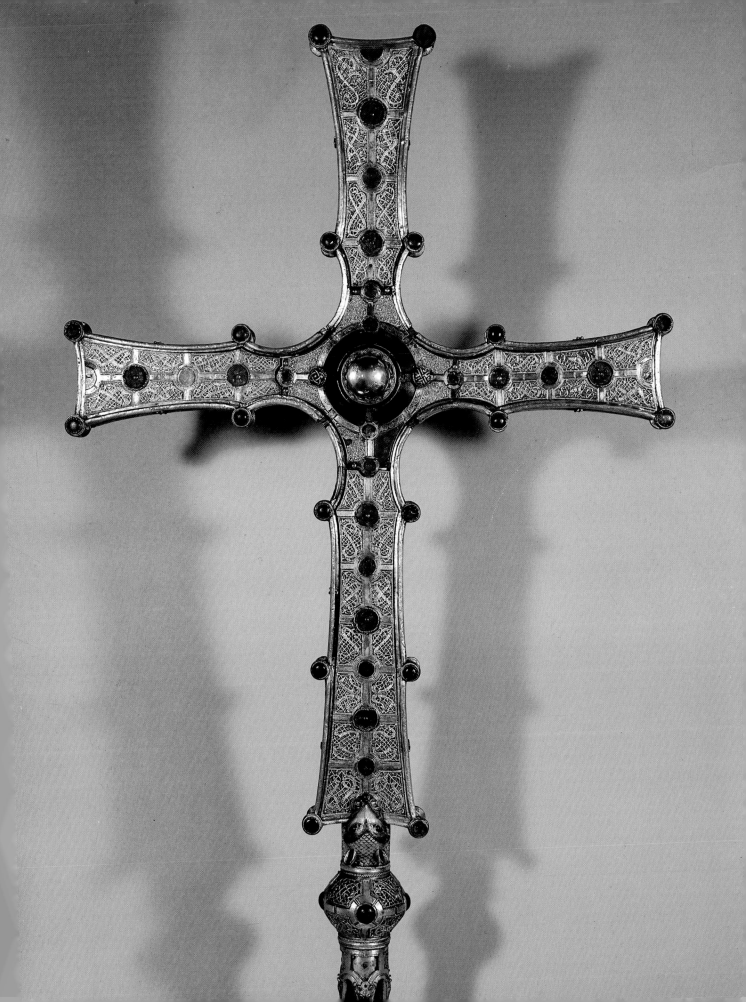

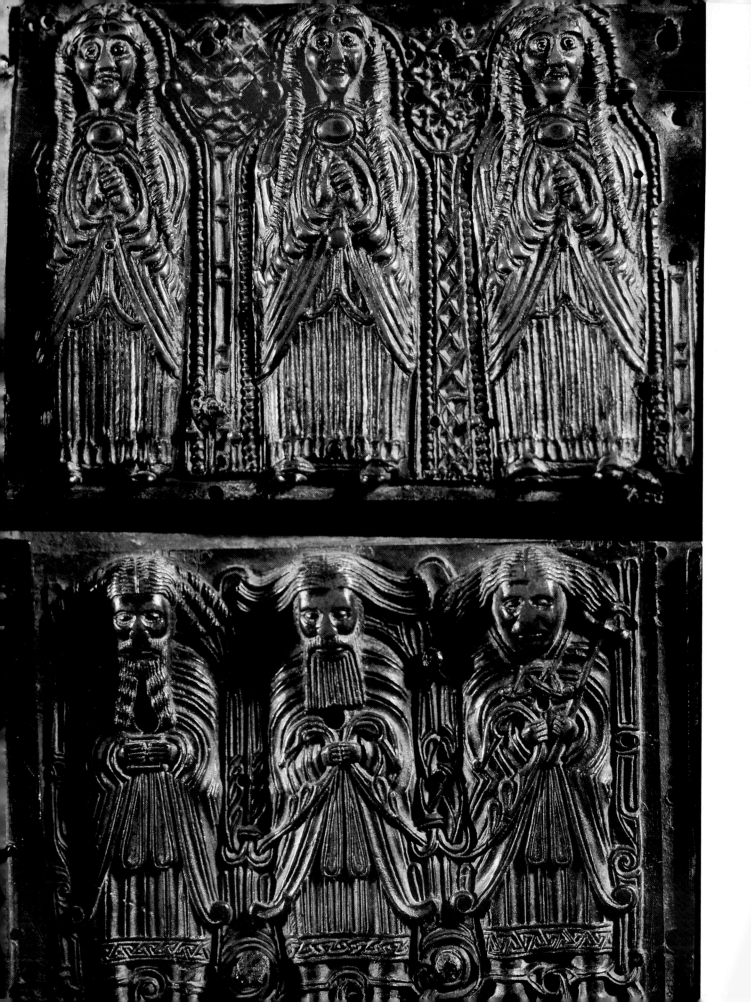

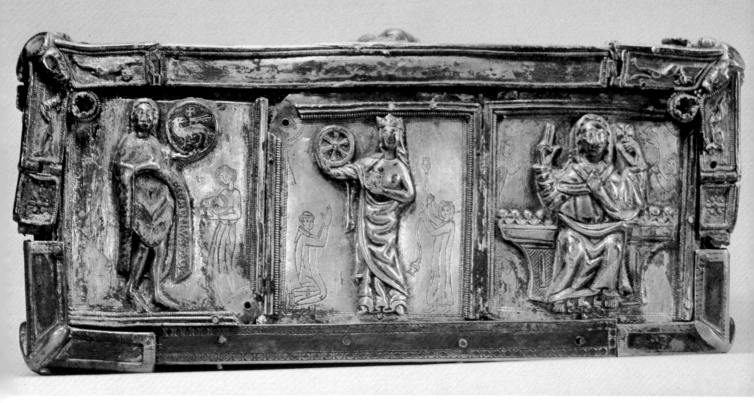

19, 20 Saints, from the bronze casing of the Breac Maodhóg shrine. Normally thought to be Romanesque, they may be as late as the 15th C., when Romanesque features such as the Classical acanthus were revived. H. 5 cm. (2 in.). National Museum of Ireland.

21 Bottom of the Domhnach Airgid book shrine, made *c.* 1350 by John O Barrdan. Left to right are St John the Baptist, St Catherine and an unidentified figure. Silver gilt, L. 23 cm. (9 in.). National Museum of Ireland. *See also ill. 101.*

22 Book shrine of the *Cathach* (see ills. 21, 22). The plaques on the sides date from 1062–98; the top set with rock crystals and other gems, which shows a bishop, Christ blessing and the Crucifixion, dates from *c.* 1400. National Museum of Ireland.

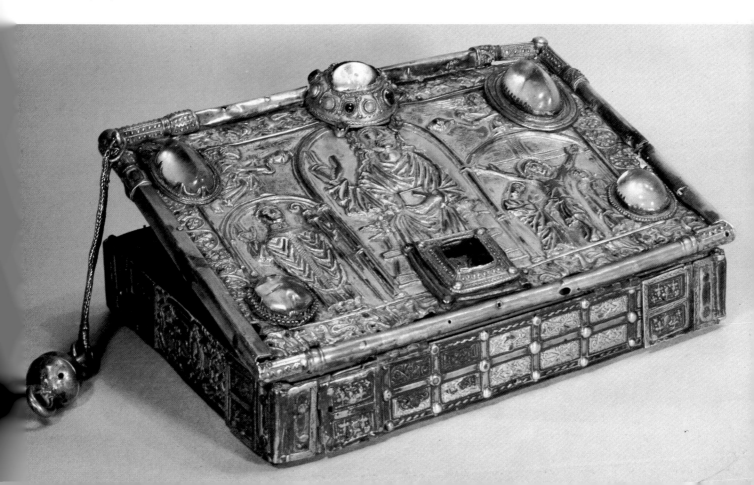

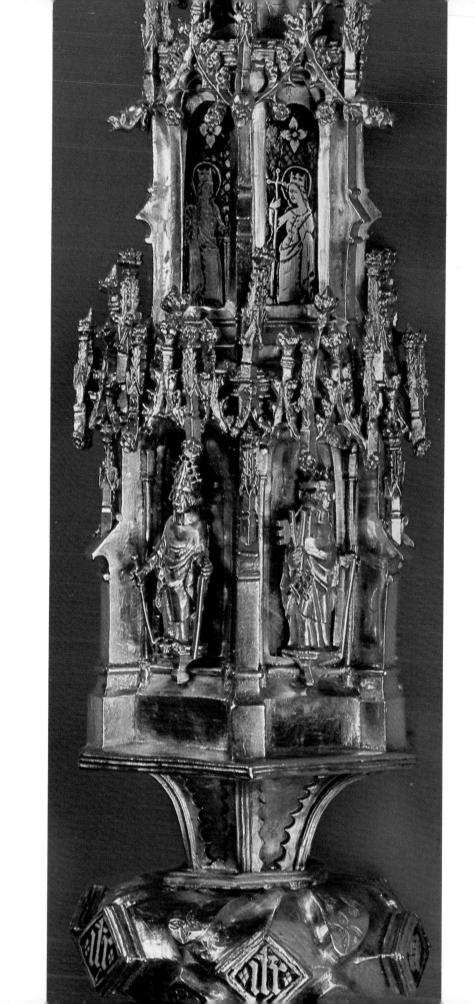

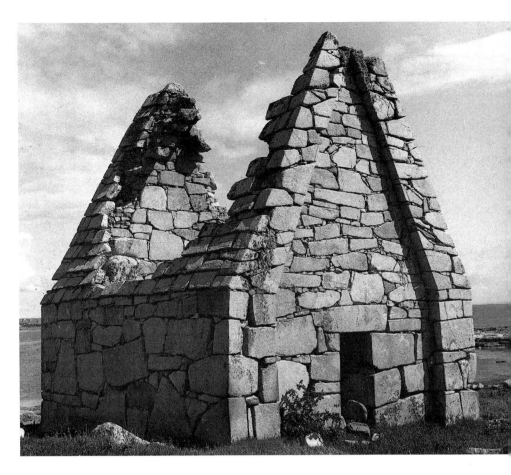

58 Church on St Macdara's Island, Co. Galway, possibly as late as the 12th C., as it appeared before its recent restoration. L. 6.55 m. (21½ ft.).

23 *Opposite* Detail of the crozier made for Cornelius O'Dea, Bishop of Limerick, in 1418 (see ill. 102). Silver gilt decorated with enamel. The two saints standing under canopies are St Patrick and St Peter, holding his two keys. Above them are engraved figures of St Catherine (with her wheel) and St Margaret of Antioch, set against bright enamel grounds. St John's Cathedral, Limerick.

The earliest stone churches

The earliest reliable historical reference to a stone church in Ireland is in the year 788, and there are sporadic references to stone churches at large ecclesiastical sites such as Armagh and Kells in the ninth century. It is only in the tenth century that we begin to hear more frequently in old Irish annalistic sources of churches on the less important sites, and this may hint that very few if any of the surviving stone churches are earlier than the ninth century or around 900.

The earliest existing church which we can identify with any degree of probability is the church at Tuamgraney, Co. Clare, which was begun about 964. The western part of the church there presents us with many of the characteristics of the earliest stone churches which we find also, for instance, in the church on St Macdara's Island off the Connemara coast of Co. Galway. These 58 rectangular churches were small in size, often not more than 6 × 4 m. (19½ × 13 ft), showing a ratio of length to breadth of about 1.5:1, which corresponds reasonably closely to the measurements given in the commentary on the Brehon Laws referred to above. The doorways were flat-headed; their sides sloped inwards as they rose, and were often built of a few large and carefully dressed stones. The north and south walls normally had large irregular but carefully hewn blocks of stone in their lower courses and smaller ones higher up. One remarkable feature of these early churches is the existence of *antae* – projections of the north and south walls out beyond the east and west end-walls, their tops having presumably supported the massive wooden barge-boards which formed the end of the roof. On St Macdara's Church even the barge-boards are imitated in stone.

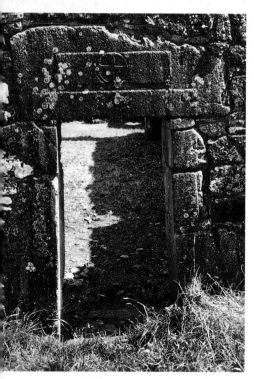

59 Doorway of St Feichín's Church at Fore, Co. Westmeath, 10th–12th C.

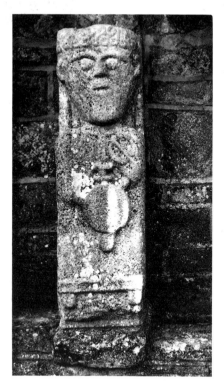

60 Stone figure of a warrior from White Island, Co. Fermanagh, possibly 9th C. H. without base 75.5 cm. (29 in.). Ulster Museum, Belfast.

This remarkable little church seems to be a copy of an earlier wooden church, and the remaining parts of the stone roof seem to imitate a roof of rectangular wooden slates or shingles of somewhat the same kind as those seen on the top of Muiredach's Cross at Monasterboice and, in a more stylized form, on the roof of the temple in the *Book of Kells*. The imitation goes so far that where individual roof-stones were too large to correspond in size to the original wooden shingles, the bottom line of the overhanging slate was carved into the surface of the stone, as can be seen particularly well at the north-western corner. If the small and probably Romanesque stone finial which once belonged to the church was placed in position on top of the gable at the time of construction, the building is likely to be as late as the twelfth century. If, as it seems, the church is a skeumorph of an earlier wooden church, then it gives us some idea of the appearance of earlier wooden churches, and suggests also that pre-Romanesque building techniques lasted into the twelfth century – if not indeed into the early thirteenth – in parts of the west of Ireland. 48 33

On the Continent, this form of simple rectangular building was used for some of the Merovingian churches and probably represents a form of wooden church common in pre-Carolingian times in certain areas of central and north-western Europe. Some of the Continental churches of the period, the foundations of which have come to light through excavation, also had a narrower chancel attached to the nave, and it may be that where some of the early Irish stone churches have a nave and chancel the whole is a copy of an older wooden church consisting of nave and chancel.

The pre-Romanesque churches were largely devoid of any ornamentation, unless their interiors were adorned with frescoes which have not survived, like St Brigid's Church in Kildare. Some may have been painted or whitewashed inside and out. Only in very rare cases is there any sculptural decoration. In a few cases a cross is sculpted in low relief over the doorway, as at Fore in Co. Westmeath, or inserted on the underside of the lintel, as at St Mary's Church at Glendalough in Co. Wicklow. No architectural figure sculpture appears to have survived from this period, with one possible and rather curious exception from White Island in Co. Fermanagh, where seven strange figures discovered in the wall of a church dating from around 1200 may possibly have come from an earlier church on the same site. The figures are squat and have large faces. One holds a crozier and bell, another a shield and sword, and a third holds two small animals by the neck recalling a scene on a Pictish slab at Rossie Priory in Scotland. The warrior has on his breast a penannular brooch of a kind which seems to have gone out of production shortly after 900 and which appears on Muiredach's Cross at Monasterboice, thus suggesting a date not later than the second half of the ninth century for these figures. It is hard to know where they may have been placed in a church as small as that on St Macdara's Island. Of course, they may not have belonged to a church at all, or they may have formed part of an altar or pulpit. One way or the other, they could suggest the existence of some kind of monumental architectural sculpture associated with stone buildings in pre-Romanesque Ireland. 59 60 47

Round towers

One of the most typical products which we associate with Early Christian monasteries in Ireland, along with the high crosses, is the remarkable round towers, of which more than a hundred are known, although only a dozen or so survive reasonably intact. They are tall slender tapering towers, sometimes more than 30 m. (100 ft) high, and are topped by a conical roof. They are divided into a 61 76

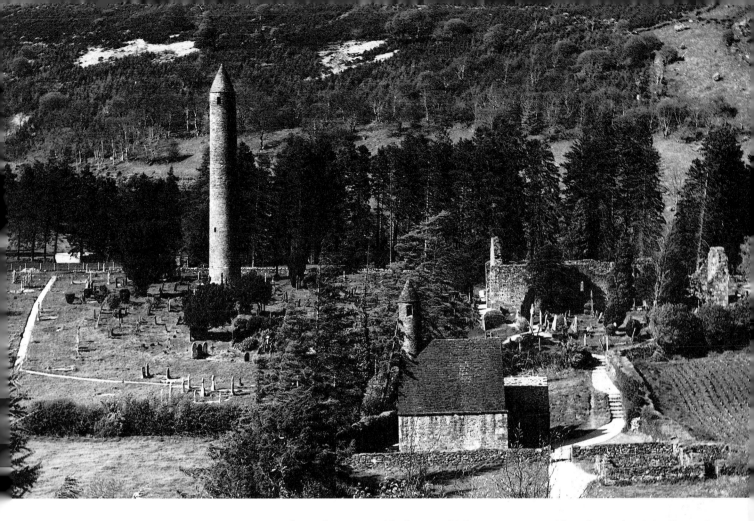

61 Glendalough, Co. Wicklow: on the left is the free-standing round tower, probably of the 11th C., in the foreground the church known as 'St Kevin's Kitchen' (see p. 83), built about a century later. To the right is the cathedral. The round tower is 31.40 m. (103 ft.) high.

number of storeys with floors which were presumably of wood originally and which were connected by a series of ladders. The top storey normally has four windows, and the storeys below it had one window apiece each facing in a different direction. The doors of all the round towers, with the exception of that on Scattery Island in Co. Clare, are 2 or 3 m. (6–10 ft) above the ground, a fact which has prompted the suggestion that the towers were used as fortresses in times of danger and that the height of the entrance was intended to make access difficult for unwanted marauders, be they Irish or Viking. But the old Irish name for these round towers literally means 'bell house', showing that their prime purpose in the eyes of their builders was to serve as a bell tower. The earliest tradition associated with the erection of the round towers dates from the tenth century, but the Romanesque decoration of those at Kildare, Timahoe, Co. Laois, and Devenish Island, Co. Fermanagh, shows that they continued to be built into the twelfth century. They certainly show the capabilities of early Irish builders, and whatever the reason why these men built churches so small in comparison to the height of the towers, it was scarcely because they were incapable of erecting taller structures. Such towers are one of Ireland's most unusual contributions to architecture, though they are not quite unique to Ireland. A few examples are known in Scotland, where they are likely to be imitations of Irish specimens. However, somewhat similar towers were built in northern Italy in the ninth century, and it is possibly from there that the Irish towers are ultimately to be derived, one of the stations en route having perhaps been St Gall, which may have had two such towers erected close to the church in the early ninth century.

Romanesque architecture

As intimated above, the simple box-design of the Irish stone churches built as late as the twelfth century is likely to be a fossilization or petrification of a ground plan which was possibly common in Europe north of the Alps during the Merovingian period before 800. But whereas Ireland, right up to the twelfth century, stuck conservatively to the building tradition of the great monastic founders of the sixth century, the Carolingian Empire graduated to more imposing structures in the basilica style from the end of the eighth century onwards, a development which did not break through in Ireland until the second quarter of the twelfth century. These basilicas, ultimately of Roman origin, were characterized by a nave with lower side-aisles, a round apse at the eastern end, and occasionally transepts which gave the church a cruciform plan. By the early eleventh century, portals, capitals and other parts of such churches on the Continent began to be decorated with carving of a weird and wonderful yet often enigmatic nature which is described as Romanesque because it was associated with churches whose round arches imitated those of Roman buildings. The vogue for Romanesque architecture and decoration developed rapidly over wide areas of the Continent, and was brought by the Normans to England where it very quickly took root, the chevron or zigzag often forming a prominent part of the decoration. Already by the end of the eleventh century England was building large-scale Romanesque cathedrals, of which that at Durham can be cited as a splendid example.

The conservatively-minded Irish had to wait until around 1140 before the great church reformer St Malachy of Armagh introduced what was probably the first basilica-style church to Ireland at Bangor, Co. Down. Unfortunately not a trace of this church survives to give us an idea of its nature or size. As we shall see below, the same building tradition was continued by the Cistercians, whose first Irish foundation at Mellifont in 1142, also inspired by St Malachy, was the first of many Irish Cistercian churches to use the basilica plan. But while Cistercian architecture brought Ireland more into line with the building practices of the rest of Europe at the time, almost all the churches which were built on the old Irish monastic sites throughout the twelfth century remained faithful to the simple nave-and-chancel plan of the earlier stone churches.

The twelfth-century churches on the old Irish monastic sites differed from the earlier Irish stone churches not only in the fact that they were usually slightly longer, but also in that they bore Romanesque decoration. One of the most common motifs used in this ornamentation was the chevron, which was adopted in Ireland long before the Normans invaded the country, and which shows that Irish masons and architects were prepared to borrow architectural decoration from England at the time, without adopting the larger size of Norman churches in England. Because the Irish churches lacked the arcades dividing nave and aisles found in Romanesque churches elsewhere, Irish stonemasons did not have the opportunity of executing full capitals in the Romanesque style, such as were common in most parts of Europe at the time. Instead, the decoration was largely limited to the doorways and chancel arches, and only very occasionally spread to the windows. Nevertheless, the Irish craftsmen did utilize what few opportunities were open to them to exercise their fancy, and they filled the portals in particular with a profusion of ornament which culminates in the doorway of Clonfert Cathedral in Co. Galway, where scarcely any of the surface 67 is left undecorated.

When we realize that the normal Irish Romanesque church of the twelfth century was just a small box-like structure with decoration almost entirely

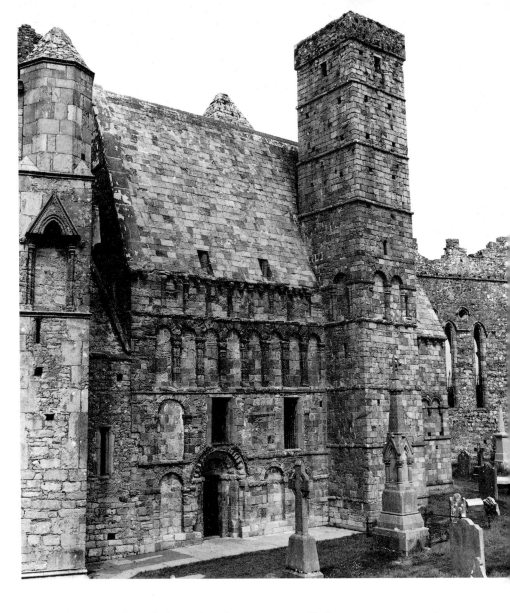

62 South façade of Cormac's
Chapel, Cashel, Co. Tipperary, probably
1127–34. Beyond the right-hand tower is
the chapel's chancel; beyond that, the
chancel of the later cathedral (see p. 92).

confined to portals and chancel arches, it comes all the more as a surprise to
realize too that, judging by existing remains, it is likely that this whole series of
churches was ushered in by a building which differed greatly from the others in
ground plan, in roofing and in the areas bearing ornamentation. This church is
Cormac's Chapel in Cashel, Co. Tipperary, which may be identifiable with the 62–
church built there between 1127 and 1134 by Cormac MacCarthy just after he had 64
been reinstated as king of Desmond, or south Munster. A few years previously,
Cormac had become a friend of St Malachy of Armagh when both spent some
time together at Lismore in Co. Waterford visiting Malchus after he had retired
from the see of Cashel. Malchus was one of the leaders of the reform movement
which swept through the Irish church in the twelfth century. Before becoming
archbishop of Cashel he had been a monk at Winchester and had been
consecrated bishop of Waterford by Anselm at Canterbury in 1096. It may be
that Malchus built a church at Lismore some time after 1110 which reflected the
architectural developments which he would have seen during his stay in England
at the end of the eleventh century. We have no actual evidence of such a church,
but the present cathedral at Lismore still preserves some fragments of a
Romanesque church which could have been erected there before Malchus died in

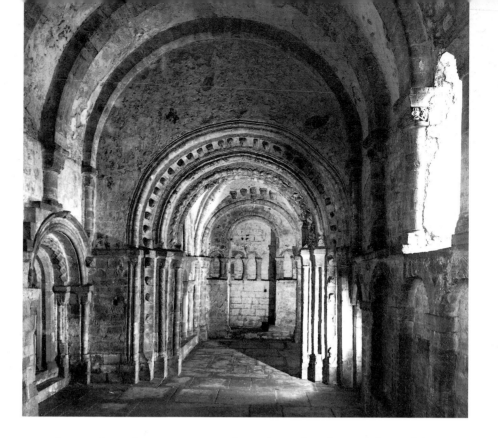

63 Interior of Cormac's Chapel, looking from the nave towards the chancel.

1135. It may have been contacts such as these that formed the architectural background to Cormac's Chapel; for it incorporates a number of features found on English Romanesque churches of the period, such as the chevron decoration and the corbels decorated with heads placed under the eaves, which are of a kind found for instance on the south transept of Winchester Cathedral, built shortly after 1107.

Cormac's Chapel has three doorways, none of them in the west wall, which is where the only doorway in most Irish churches was placed. The door beside the north tower is now blocked up; the other two are unusual in having tympana, that above the north door bearing a fine carving of a centaur shooting an arrow at a lion. Also above the north door is a triangular hood with rosette and chevron decoration in a framework which looks as if it had been imitated from wood. In place of transepts, the church has two tall square towers, one bigger than the other, and divided into eight storeys by string-courses in the external walls. The external south wall is similarly divided into four courses, the three lower ones with a blind arcade, the fourth divided into square panels by pilasters with scalloped capitals. The roof of the chapel is of stone and is supported by a stone croft with a pointed arch which rests upon a barrel vault. 62

Inside, the barrel vault which roofs the nave rests on short columns less than half the height of the wall, and these are in turn supported by a blind arcade. The internal walls of the chancel are also broken by a series of blind arcades. The chancel is covered with pointed rib vaults, the earliest instance in Ireland of a technique which was to characterize Gothic churches for centuries and which had already been developed in the cathedral at Durham by 1093. That the first seeds of the Gothic style, in the shape of ogival vaults, should make their appearance in what is probably Ireland's earliest surviving Romanesque church is an interesting reflection both on the late arrival of the Romanesque in Ireland and on the advanced designs employed in the construction of Cormac's Chapel. The frescoes of which traces can still be seen in the chancel are also the earliest 63, 64

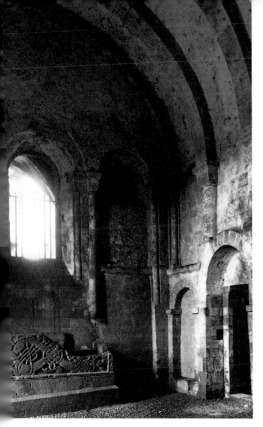

64 Looking north-west in Cormac's Chapel; on the left is the sarcophagus with Urnes ornament, probably carved about 1138.

surviving instances of this medium in Ireland. The chancel arch, placed off-centre, is heavily decorated with chevrons and with a number of single heads, the upper ones placed radially, those lower down following the line of the arch. As mentioned above, other heads appear in the form of corbels under the eaves.

One further feature deserves mention. Lying against the inside of the west wall is a stone sarcophagus which is not in its original position. It is broken, but the design of the two crossing slender quadrupeds intertwined by even more slender beasts can be seen carved in false relief. It represents the finest example of Urnes ornament in stone in Ireland, and may have housed the remains of the founder of the church who died in 1138, a date which would suit the style of the ornament. 64

Cormac's Chapel is the only Romanesque church in Ireland which can truly be dignified with the name of architecture. Admittedly, when measured by the standards of contemporary cathedrals and churches in Britain and on the Continent it is almost miniature in stature, but when it is compared with its predecessors and immediate Romanesque successors in Ireland its monumentality and the significance of its achievement can be appreciated. It is unsurpassed in Ireland in the articulation of its surfaces and its flair for ornamentation, as well as in the presence of its square towers. In its original state, with its walls painted and decorated with frescoes, it must indeed have inspired awe.

It is not a typically Irish church, and owes much to foreign stimulus. Its twin towers have often been compared to those of the first church of St Jakob (the Schottenkirche, or church of the Irish monks) at Regensburg in Bavaria, which was built shortly after 1120, when monks from the monastery there had come to Ireland to collect alms for its erection, and possibly implanted ideas for the design of the Cashel church. The tympanum now above the north doorway finds its closest parallels in England, and, as intimated above, many of the decorative features of the church owe their inspiration to English churches of the time.

The interesting eclectic amalgam represented in Cormac's Chapel was too much for Irish masons to digest in its entirety. While it may be the earliest surviving Irish church to have been built in the Romanesque style, and a sensation in its day, other Irish churches tended only to borrow individual features from it. The stone roof, for instance, is found in a number of churches which, though undatable in themselves, are unlikely to be earlier than the twelfth century. One of these is the church at Glendalough known as 'St Kevin's Kitchen', which has a small round tower inserted into its roof. Another, geographically nearer to Cashel, is St Flannan's Oratory at Killaloe. The blind arcading was imitated inside the church at Kilmalkedar at the end of the Dingle Peninsula. The west façades of the churches at Roscrea in Co. Tipperary and Ardfert in Co. Kerry also owe a debt to Cormac's Chapel, though the reticulated masonry in one of the arcades of the latter church may also have connections with western France. The use of individual heads was copied on many other Irish churches. Those on the doorway at Dysert O'Dea may have been modelled on western French prototypes, though one of the animal heads grasping a rolled moulding is similar in style to that grasping the foot of the roughly contemporary Cross of Cong. Animal heads are often found in Irish Romanesque decoration, for instance on the doorway of the Nuns' Church at Clonmacnoise, dating possibly from 1180, which is a good example of the normal size of non-Cistercian Irish Romanesque churches. 61 65 **18**

As we can see by looking at the decoration of Irish Romanesque architecture, the stonemasons were not prepared simply to copy slavishly the Norman forms from which much of it is derived. Their fancy led them to lend a great variety to the chevron ornamentation, and the doorway and the chancel arch of the Nuns' Church at Clonmacnoise demonstrate the virtuosity of the craftsmen in giving 66

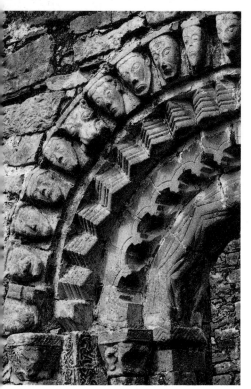

65 Detail of the former west door of the church at Dysert O'Dea, Co. Clare, 12th C. (reassembled, probably in the 17th C.). The heads in the outer order include that of an animal biting a rolled moulding.

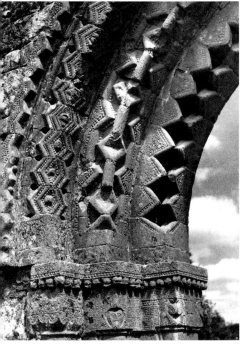

66 Detail of the chancel arch of the Nuns' Church at Clonmacnoise, Co. Offaly, possibly 1180.

us its permutations and combinations. Here, as in other contemporary Romanesque churches of the midlands, we see a number of other features which give Irish Romanesque its own peculiar characteristics. The architectural elements begin to be decorated in a flat incised ornament of foliage, fretwork and interlacing motifs which have a kinship with contemporary metalwork. Another link with the metalwork is the use of Scandinavian animal motifs of Urnes type, seen to advantage at Killeshin, Co. Laois, and Kilmore, Co. Cavan. A further feature is the use on capitals of human and animal masks or faces in which the hair and beard intertwine, as at Dysert O'Dea, Rahan in Co. Offaly 65 and Kilteel in Co. Kildare. The church at Kilteel is also of interest in having the chancel arch supports adorned with figure sculpture. In the arcades in the west gable of the cathedral at Ardmore, Co. Waterford, there are a number of scriptural scenes reminiscent of the high crosses, though it is not certain if the arcades were part of the original design of the cathedral as built around 1200. Ox or dragon heads were popular for the ends of drip-mouldings, as on the doorway of the Nuns' Church at Clonmacnoise. The dragon heads seen on the capital of the innermost order of the chancel arch there are further developed on a fine 66 doorway inserted into the north-west corner of Killaloe Cathedral in Co. Clare and continue to flourish well into the first quarter of the thirteenth century in Connacht, where they emerge out of the top of rounded shaft mouldings, for instance on the inner side of the windows of Ballintubber Abbey, Co. Mayo. 72

Many of the features just described are combined on the doorway of Clonfert 67 Cathedral in Co. Galway which, although probably dating from after the Norman invasion of Ireland in 1169, shows no direct traces of Norman presence in Ireland. It represents the apogee of the Irish Romanesque mason's love of ornamentation: it can indeed be described as 'baroque' in its riot of ornamentation, which covers almost the whole surface and calls to mind the Celtic artist's horror of empty spaces. The innermost order of the doorway, inserted in the fifteenth century, cannot hide the fact that the portal retains the inclining jambs of the pre-Romanesque doorways. The columns bear Irish 58 variations of the Romanesque chevron filled out with stylized foliage of Classical derivation, framed on the outermost order by a panel of Urnes ornamentation and by an interlace of Irish descent which is also found on the rolled moulding forming the outermost order of the arch. Other orders of the arch are adorned with prominent bosses covered with foliage and animals biting a rolled moulding of a kind already noted on the Dysert O'Dea and Clonmacnoise doorways. The doorway terminates in a pointed gable. This feature is known from other Irish churches, and doubtless derives from Cormac's Chapel, if not from further afield, but here it is given a unique treatment. Immediately above the arch is a blind arcade again reminiscent of Cormac's Chapel, a stimulus also 62 reflected in the use of individual heads under the arches. Above it is a pattern of triangles, alternately bearing foliate ornament or filled almost entirely with a head, the one in the middle being the nearest an Irish Romanesque carver ever came to naturalistic portraiture.

The arrival of the new monastic orders

During the period in which the Romanesque churches just discussed were being built, an event took place which was to have a profound effect on Irish monasticism and on the history of Irish building until the Suppression of the Monasteries in the sixteenth century. This was the introduction of new Continental monastic orders, which soon outdid the old Irish monasteries in popularity. Prime among them were the Cistercians, though the Augustinians,

67 Doorway of Clonfert Cathedral, Co. Galway, probably late 12th C.

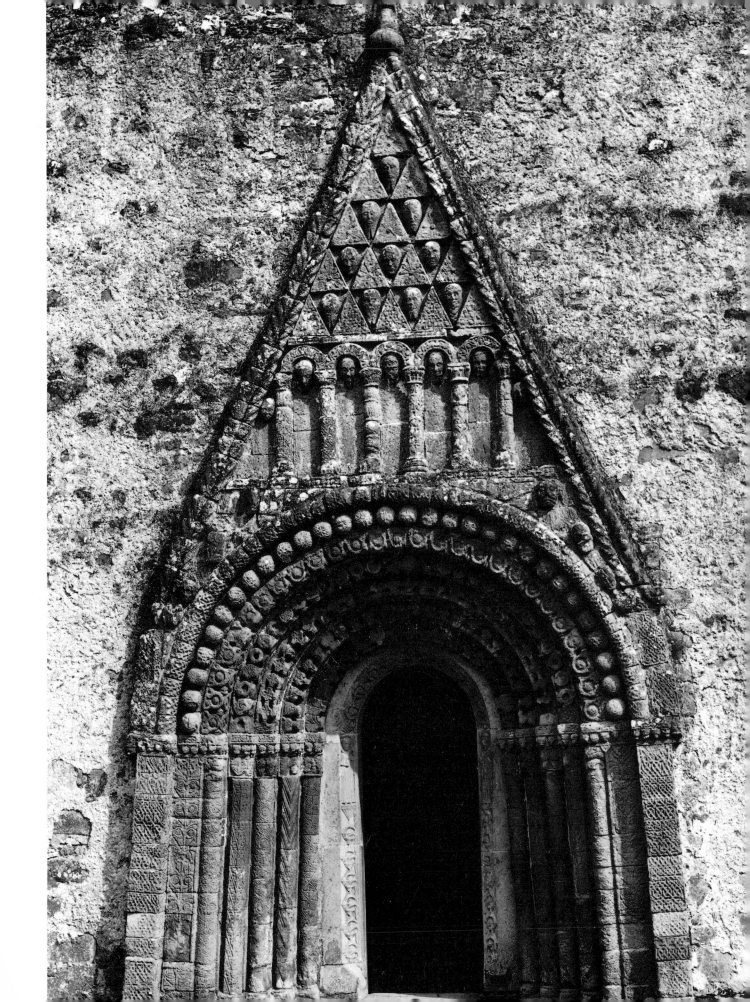

Benedictines and later the Dominicans and Franciscans were to play an important role. Some of the old monasteries got a new lease of life by adopting the Augustinian rule. It was St Malachy of Armagh who had invited the Cistercians to make their first Irish foundation at Mellifont in 1142. Little 68 remains of the first church there, which was built in the Romanesque style, and it is in the daughter foundation at Baltinglass, Co. Wicklow, and its foundation at Jerpoint, Co. Kilkenny, as well as at Boyle, Co. Roscommon, and Monasteranenagh, Co. Limerick, that we can best study the new form of 71 architecture introduced by the Cistercians. These churches were built in the second half of the twelfth century in a late Romanesque or Transitional style, with a tendency towards pointed arches, and they provide us with some of the best Irish examples of the style. The size and form of the churches differed radically from their Irish predecessors, with the probable exception of St Malachy's Church at Bangor, mentioned above as dating from about 1140. Their plan was that of a cross, with a large vaulted chancel, and a basilican nave with side aisles separated from it by an arcade. This arcade rests on fat piers whose capitals are decorated with geometrical designs and later with foliage.

Generally, the domestic quarters of the monks lay to the south of the church, grouped around a square or rectangular cloister garth. On the eastern side of these buildings was the chapter house, usually with a highly decorated doorway through which the monks came to assemble to hear readings from the holy scriptures. On the south side were the kitchen and refectory, while the western range had what were probably stores on the ground floor, and a long single dormitory for the monks on the first floor, from which steps led down to the western end of the nave for the night office. Around the cloister garth was an arcade like the partially reconstructed example of around 1200 at Mellifont, 68 beside which is the only example of a lavabo or washing place to survive in Ireland. This ordered group of buildings, practically entirely enclosed from the outside world except for one or two doorways, and forming a self-sufficient architectural and living unit, stands in complete contrast to the flimsy nature of the domestic buildings of the early Irish monasteries and also to what we can only presume was their unplanned and haphazard layout.

68 The washing place or fountain house and part of the cloister arcade at Mellifont Abbey, Co. Louth, probably early 13th C.

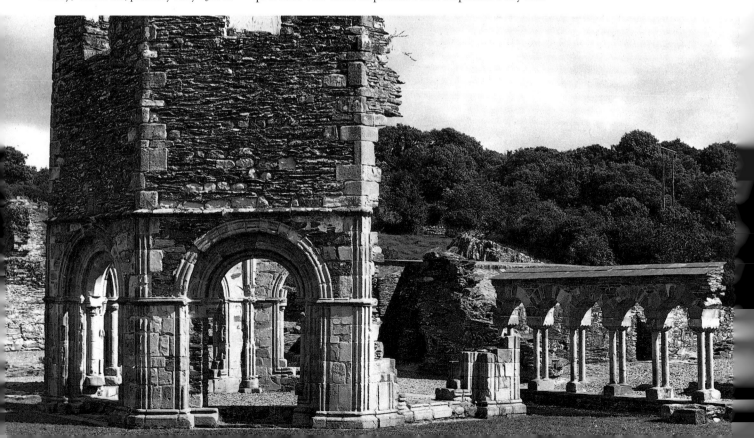

NORMAN AND LATER MEDIEVAL GAELIC IRELAND, 1170–1600

Two events were to change the whole building history of Ireland, from the twelfth century onwards: the arrival of the new monastic orders, and the arrival of the Normans from England and Wales in 1169/70. By the end of the century, the Normans had brought considerable areas of the country under their control, and they began to set in motion a spate of building activity which was shortly to introduce the Gothic style. By 1235 the Normans had reached as far westwards as Connacht, thus leaving only comparatively small areas of the country, for instance the north-west and the Dublin and Wicklow hills, in Gaelic hands. But gradually, throughout the second half of the thirteenth and the first half of the fourteenth century, the native Irish began to fight back and successfully to rout the Normans from areas such as Co. Clare, which they had occupied around 1250. This constant fighting did mean that less money and leisure were available for fostering artistic and architectural enterprises.

The Bruce invasion of 1315–18 devastated much of the country, and the Black Death of 1348–50 struck particularly hard in the Norman centres of population while leaving the native Gaelic population comparatively unscathed. This enabled a certain resurgence in Gaelic culture, and more particularly literature, to take place in the second half of the fourteenth century. The fifteenth century saw the continuation of this revival, and at the same time it experienced the rise to power of some of the great Anglo-Norman families, such as the Geraldines, in those parts of the east and south-east of the country which lay between the English-dominated 'Pale' in the east, and the Gaelic areas of the west and north. In their struggle to gain a certain independence from the English Crown, these Anglo-Normans had, as the saying goes, 'become more Irish than the Irish themselves', and they were responsible for a considerable amount of building and sculptural activity in their areas until their power was drastically curbed by Henry VIII in the 1530s. In the native Irish areas, too, there was an almost feverish building activity in the fifteenth and early sixteenth centuries, a fact reflected not only in the foundation of a number of friaries, particularly of the Franciscans, but also in the amount of alterations carried out to existing structures. Many of the parishes in the country got new, small churches at this period too.

The reigns of Henry VIII and more particularly of Queen Elizabeth brought with them the Suppression of the Monasteries and also a considerable degree of religious oppression, which went hand in hand with the confiscation of land which was then given to planters introduced from England and later from Scotland. The second half of the sixteenth century saw a continuing struggle by the English Crown to suppress any ideas of religious or political independence throughout the country. This led to the erection of a number of smaller castles or tower-houses, particularly in the Gaelic areas, but it also led to a gradual decline in **6** architecture and art in the country. By the first decade of the seventeenth century the armies of the Crown had forced the Irish into complete submission or emigration, and the abolition in 1606 of the Brehon Laws, by which the Irish had lived for well over a thousand years, meant the political defeat of Gaelic Ireland and the beginning of a sad decline in the Gaelic social order and its civilization.

The ecclesiastical architecture of the Normans; cathedrals in Dublin

The advent of the Normans brought about a considerable change in building style in Ireland. It is not unnatural that they should have brought with them the type of architecture practised in their homeland, particularly in Wales and the west of England, and it was largely due to Norman benefactors that churches were built in the new Gothic style with pointed arches. While some categories of buildings, such as the Franciscan friaries of the fifteenth century, were of a type 78, peculiar to Ireland, it is true to say that most Irish architecture from the late 79 twelfth to the sixteenth century – even in the Gaelic parts of the country – was strongly influenced by England, and was generally a reflection of the English structures of the period.

The majority of the country's existing cathedrals owe their existence to the Normans. Some, such as Kilkenny and Lismore, totally replaced small Irish 75, Romanesque structures which must have been less than a century old. The 76 greater size of the new buildings was no doubt due both to their role as status symbols and to the necessity to house larger numbers in the new Norman towns which were growing up around them. It is particularly in Dublin that we notice the new building style establishing itself in strength and producing in the two cathedrals, Christchurch and St Patrick's, some of the best early Gothic archi- 69, tecture in Ireland in a style which in Britain would be called 'Early English'. 70

Christchurch Cathedral was begun not long after Henry II had handed over Dublin to the men of Bristol for colonization in 1172. Possibly its most unusual feature as far as Ireland is concerned is the late twelfth-century crypt beneath the choir which has an ambulatory with three chapels leading off it, a plan which was probably repeated in the original choir above, and which was unique for Ireland though used in England and on the Continent. The now much-altered choir and the better-preserved transepts were finished by the end of the century in a Transitional style, with bold or undercut chevron decoration in the arches and capitals bearing human and animal ornament. The masons who carved these decorative features had probably been imported from the west of England, as was some of the oolite stone used in the building.

Those few parts of the nave (e.g. the upper storeys of the north wall and the archivolts of the arcade) which were little affected by the heavy reconstruction 69 programme in 1872–78 are in the early Gothic style of the first half of the thirteenth century, and in the words of H. G. Leask, their details 'make the richest piece of architecture ever to be raised in Ireland'. The pillars have eight shafts attached to a round core and from them a single slender shaft leads up to the springing of the vault. The horizontal contrast is well provided by the string-course over the arcade and, above it, the triforium and clerestory, each with a grouping of three openings and both bracketed together under an arch. This nave elevation is even more advanced and graceful than that at Pershore Abbey in Worcestershire, to which it is related, and the capitals bearing grimacing heads among foliage were clearly carved by a mason from the west of England.

The richness of detail in Christchurch may have been spurred on by the desire of its builders to outshine another cathedral-building project in progress at much the same time only a short distance away outside the city walls – St Patrick's Cathedral. Almost 100 m. (330 ft) in length, St Patrick's is the longest Irish cathedral church and the only one which approaches any of its English 70 counterparts in size. Having vied with Christchurch during its construction between 1220 and 1254, it vied with it again in the nineteenth century in the extent of its Victorian restoration. Like Christchurch, it is cruciform in plan.

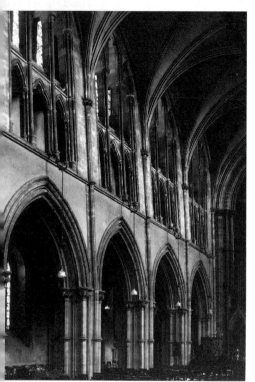

69 North side of the nave of Christchurch Cathedral, Dublin, early 13th C., restored in the 19th C.

70 Looking east in St Patrick's Cathedral, Dublin, 1220–54, restored in the 19th C.

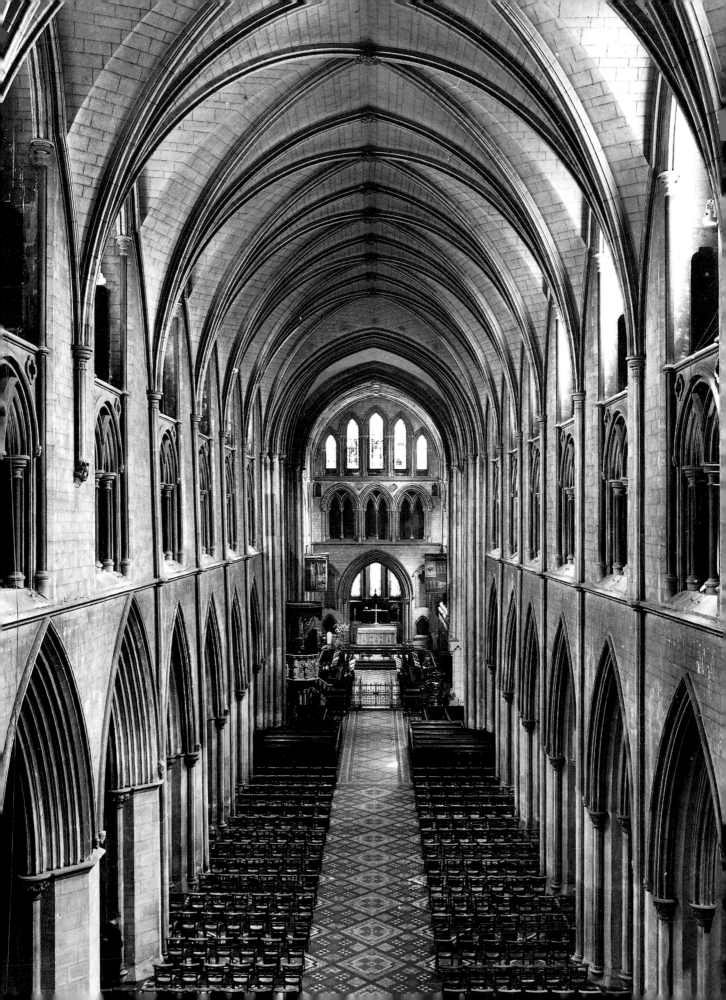

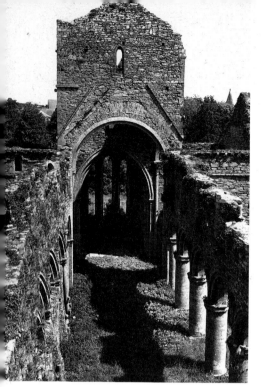

71 Looking across the nave towards the transepts, crossing tower and chancel of Boyle Abbey Church, Co. Roscommon, late 12th–early 13th C.

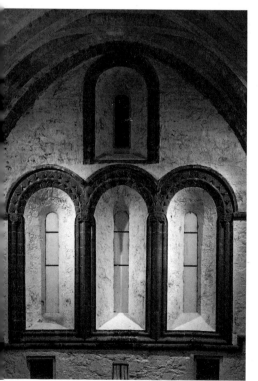

72 The chancel of Ballintubber Abbey Church, Co. Mayo, *c.* 1220.

While it lacks the richness of detail of its rival, and has a less subtle grouping of the divisions of its triforium and clerestory, it triumphs over Christchurch in having a greater spaciousness and uniformity of design. It too owes a great deal to English architecture, and together with Christchurch it offers Ireland's finest response to the 'Early English' style on the other side of the Irish Sea.

Transitional architecture: the 'School of the West'

While the Normans were at work on the earlier parts of Christchurch Cathedral, Donal Mór O'Brien was making a number of ecclesiastical foundations in his Thomond kingdom, despite the heavy demand on his resources made by his campaign to keep the Normans out of it. His most important structure was the Transitional-style St Mary's Cathedral in his own city of Limerick (*c.* 1180–95), its cruciform shape and lack of decoration being possibly due to the influence of the Cistercians whom Donal fostered. He may also have been responsible for the foundation, though scarcely for much of the building, of the cathedral at Killaloe, Co. Clare. His family and that of the O'Conors, kings of Connacht, were responsible for a most successful continuation of the late Romanesque or Transitional style of building in north Munster and Connacht, which withstood competition from the encroaching Gothic style into the second quarter of the thirteenth century.

The progress of this western school of building can be traced in the Cistercian abbey at Boyle in Co. Roscommon. The presbytery or chancel was built not 71 long after the foundation in 1161, though it was altered in the thirteenth century by the insertion of three lancet windows. After its completion with a low pointed arch, there was a change of plan to a more grandiose scale, as can be seen in the taller arches of the crossing, above which rose a tower planned from the beginning (more as a structural medium than as a belfry). Some time about twenty years after the foundation, work began on the construction of the south side of the nave, characterized by round arches resting on cylindrical piers. Two further changes in style – the first in the north side of the nave, and the second at the west end – took place before the church was consecrated in 1218. The decoration on the capitals, which includes human figures, shows a disregard for the simplicity of Cistercian church decoration sought by the order's great preacher, St Bernard of Clairvaux.

The curling leafage and the spiral pattern of a hen-bodied dragon seen on capitals at the west end of the nave of Boyle Abbey are also found in the presbytery at Ballintubber Abbey, Co. Mayo, built shortly after the foundation 72 of the monastery in 1216. The plan and many of the details of this Augustinian church were influenced by Cistercian architecture, and the recent restoration of the church now gives us a good picture of a typical thirteenth-century abbey in the west of Ireland. The same sculptor who worked at Boyle and at Ballintubber also worked on the east wndow of Clonfert Cathedral, which shares with Ballintubber the use of a moulding to surround the three lancet windows of the chancel, thus bonding them into a gracious unity. This feature is also found in slightly earlier churches in the west of England, whence the idea was probably borrowed.

The quality of the stonework in many of these western buildings of the late twelfth and early thirteenth centuries is quite remarkable, the individual stones being beautifully fitted together. This can be seen at the Cistercian abbey at Corcomroe at the northern end of the Burren in Co. Clare, and also at Annaghdown on the shores of Lough Corrib in Co. Galway. Here a beautiful east window of around 1200 shows the continuation of Romanesque decoration 74

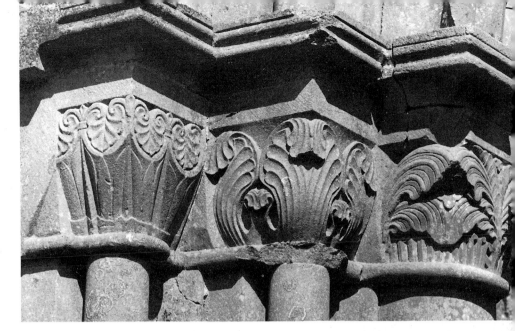

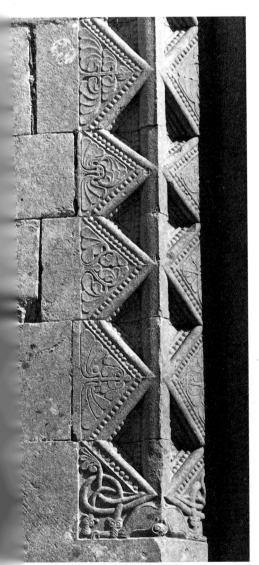

73 Capitals of a doorway in the cloister of Cong Abbey, Co. Mayo, c. 1225.

74 Detail of a jamb of the east window built into the later cathedral at Annaghdown, Co. Galway, c. 1200.

in the west of Ireland, with the triangles filled out with a never-ending variety of foliate motifs carved in the shallow relief typical of Irish Romanesque work, and terminating in weird dragon heads.

Certain features of the architectural decoration of these western churches, such as elaborate chevrons, show that although the work was carried out in areas not yet dominated by the Normans, influences from the west of England were incorporated in the design. A building in the east of Ireland, like Christchurch Cathedral – which has such elaborate chevron decoration – could have acted as the intermediary between the west of England and the west of Ireland for details such as these chevrons or the moulding used to surround three lancet windows.

Some of the finest of the western Irish architectural sculpture of this period is found at another Augustinian monastery, rebuilt after 1203 at Cong in Co. Mayo. There, on the capitals of the inserted north doorway of the church, and in particular on those of the east range of the claustral buildings, grooved leaves 73 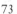 blossom forth into great undulating waves inspired by the Classical acanthus. The doorways at Cong are among the last works of the school of sculptors who continued the late Romanesque and Transitional tradition in the west of Ireland after it had already become obsolete in other parts of the country. It was probably brought to a standstill in Connacht when the O'Conors banished craftsmen from the province in 1228. (At least one of these would appear to have fled as far as Regensburg in Bavaria as a result.) Although work was carried out subsequently at Tuam and Athenry, both in Co. Galway, it was executed under Norman patronage, and two centuries passed before another native school of masons could develop to work on churches in the area.

Major early Gothic buildings outside Dublin

Once the Normans had begun to establish themselves, their influence came to be felt outside Dublin, both in the use of the Gothic style in Cistercian churches and in the size and style of the cathedrals which were started, even in those areas not yet under Norman control. Two Cistercian houses in Co. Down, Inch and Grey Abbey, founded in 1187 and 1193 respectively by John de Courcy, the conqueror of East Ulster, can be counted among the first purely Gothic churches to have been built in Ireland, the influence in this instance having come from northern England.

Interesting examples of early Gothic architecture are the cathedrals which were built outside the capital city in the course of the thirteenth century. While attractive in their own way, they are not quite so rich in decoration or articulation as the two Dublin cathedrals. The finest, and the one which preserves best the atmosphere of a thirteenth-century structure, is St Canice's Cathedral in Kilkenny, which was under construction for many decades before it was finally completed in the last quarter of the thirteenth century. It has a simple rectangular plan with small transepts and an extensive choir flanked on each side by a chapel. The elevation of the nave has a neat set of widely-spaced pointed arches with small windows above each one, while light floods through the choir from a number of tall lancet windows typical of the early Gothic style in Ireland. The cathedral is low set in comparison to the Dublin cathedrals and, unlike them, it had a wooden roof more common to Irish churches of the period. 'Dogtooth' ornament dominates the interior decoration, while on the outside the west and north doorways are reminiscent of English work (e.g. Wells Cathedral). Smaller churches in much the same style were built at Thomastown and Gowran in the same county.

75, 76

While these edifices were largely created under Norman patronage, the cathedral at Cashel was built by three different Irish prelates who occupied the see between 1224 and 1289. The choir there is extraordinarily long in comparison to the nave, but this is presumably due to the fact that the original intention to create a much longer nave had to be curtailed due to lack of money. The walls of the choir are lit by the usual tall lancet windows, those in the north wall having very unusually shaped openings fitted in between their spandrels. The windows of the transepts have a small quatrefoil above the central lancet – a feature common at the time. The capitals are decorated with heads and foliage. The Irish-controlled dioceses doubtless wanted to emulate those ruled by English bishops, though they had less means at their disposal, a fact resulting in a simplicity of plan and paucity of decoration seen in the cathedral at Ardfert, Co. Kerry, on which the nearby Franciscan friary was modelled.

62

Parish churches of the thirteenth and fourteenth centuries

It is remarkable that Irish medieval parish churches are very small and lacking in ornamentation in comparison to their English counterparts. There are only a few large parish churches of the period, and these were constructed chiefly in the Norman towns. Among the most important are St Mary's in New Ross, Co. Wexford, and in Co. Cork St Mary's in Youghal and St Multose in Kinsale. They are generally, though not always, cruciform in plan and have fine lancet windows.

Monastic buildings of the thirteenth and fourteenth centuries

The Cistercians continued their building activity in the thirteenth century, and while the typical Cistercian layout of the monastery is retained, the style of building accords well with that of contemporary Irish cathedrals. Graiguenamanagh, Co, Kilkenny (c.1212–40), must have been one of the finest, though it has suffered sadly with time, and its cloister is largely smothered by modern buildings. Other examples, more austere in style, are Dunbrody and Tintern Minor, both in Co. Wexford, the latter unfortunately also disfigured by more recent building activity.

Orders other than the Cistercians were also erecting impressive piles for themselves in the thirteenth century. The Augustinian priory at Athassel, Co.

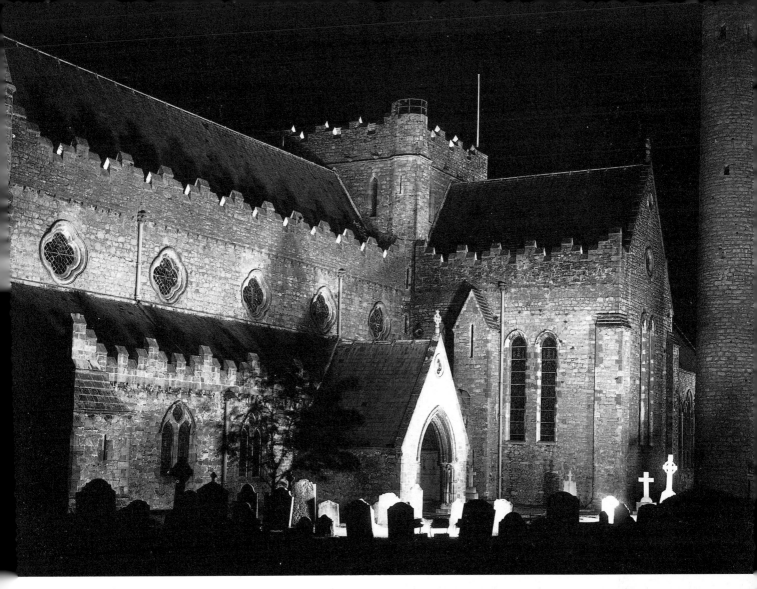

75, 76 St Canice's Cathedral, Kilkenny,
built in the second half of the 13th C.:
interior looking east, and a view of the
nave and south transept and the adjacent
round tower.

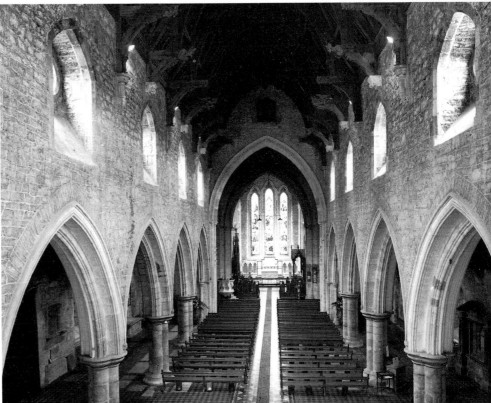

Tipperary, forms one of the largest monastic sites in the country, and the same order later erected an imposing set of fortifications beside its church at Kells in Co. Kilkenny. At the very end of the century, the Dominicans built a beautiful friary at Kilmallock in Co. Limerick, much of the east wall of which was taken up with six well-proportioned windows divided by slender mullions. Unlike England, variations of this window type were practised in Ireland in the early fourteenth century, at the friary of St Francis in Kilkenny and in the Franciscan friary at Ennis in Co. Clare, into which Turlough O'Brien put painted blue glass. It is sad to reflect that nothing remains of this, and the few fragments of other medieval coloured glass, including those from the great window of St Canice's Cathedral in Kilkenny (later coveted by Rinuccini), are not sufficient to give us any idea of the nature or quality of this artistic medium in Ireland.

Mullions bifurcating upwards and known as 'switch-line' tracery appear around 1300 at Castledermot friary, and slightly later at the 'Black Abbey', the former church of the Augustinians or Black Canons, now the Church of Ireland church at Adare in Co. Limerick. More complicated geometrical designs, including trefoils, quatrefoils and pointed cusps, can be seen in the Dominican church at Athenry, Co. Galway (after 1324), and in the east window at Jerpoint, but their finest forms are found in the south window of the transept of the 'Black Friary', another house of the Dominicans or Blackfriars in Kilkenny, and in the east window of Tuam Cathedral, Co. Galway (c. 1312). In this tracery we see Ireland beginning to blossom out into a Decorated style which was, however, less profuse than that found in England at the time.

It is probable that the Irish form of stepped battlements first embellished the tops of churches in the fourteenth century, and tall slender towers were either added to or began to be built into friary churches at this period, as evidenced by those of the Magdalene at Drogheda, Co. Louth, and of St Francis in Kilkenny. The latter building seems to have been built in the shadow of the Black Death of 1348–50, which wrought havoc particularly in the Anglo-Norman towns, and reduced the church-building urge in Ireland, thus contributing to a decline which had already begun after the disastrous Bruce Invasion of 1315–18. Although Archbishop Minot is reputed to have built the tower and repaired the nave of St Patrick's Cathedral in Dublin in 1372, there are very few churches other than those at Clonmines and Tomhaggard, both in Co. Wexford, which can be attributed with any degree of certainty to the second half of the fourteenth century, though further research may help to bring more to light.

Cloisters would appear to have been part of the monastic orders' buildings in Ireland from the start. The remains of one at Mellifont, dating from around 1200, bear leaf-shaped capitals carried by two narrow columns, and the chapter house of St Mary's Abbey in Dublin is an early example of a claustral building. Even though many of the early cloisters do not survive, we can see particularly in western monasteries such as Cong and Ballintubber how decorative doorways led off from the cloisters into the surrounding buildings, the chapter house doorways receiving special treatment.

The majority of surviving cloisters date from the fifteenth century and will be discussed briefly below. One of the few examples probably intermediate in date between the early Gothic cloisters and these later examples is that at Jerpoint. It is remarkable in that the supports bear a rich variety of figure sculpture, which John Hunt has recently dated to around 1400, although Rae suggests a date more than a century later. Figures of knights and their ladies intermingle with those of saints, interspersed with curious imaginary beasts. Its only imitator in Ireland was the early sixteenth-century cloister at Inistioge, Co. Kilkenny, of which only fragments survive. The Jerpoint cloister is important not only because of its rich

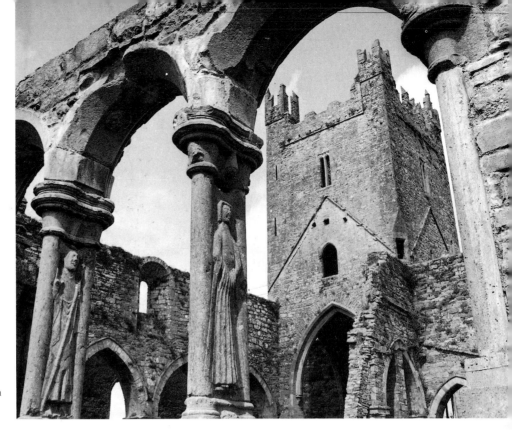

77 Part of the cloister arcade of Jerpoint Abbey, Co. Kilkenny, *c.* 1400 or 16th C. In the background are the late 12th-C. nave and the 15th-C. crossing tower.

figure sculpture, which distinguishes it from other Irish cloisters (which bear mouldings but very little figure sculpture other than a representation of the founder of the order), but also because it is one of the very few pieces of Irish architecture which may be assignable to the beginning of the fifteenth century.

The Gaelic building revival: western Ireland in the fifteenth century

The Black Death which had braked building activity in the Norman towns does not appear to have affected the population of Gaelic Ireland to the same extent. Western Ireland had not been particularly noted for architectural achievements after the second quarter of the thirteenth century, yet it was in these areas that the revival of building activity seems to have started in the fifteenth century, no doubt considerably aided by the recovery of Gaelic Ireland against Norman domination which had been growing since about 1340–60. This renascent architectural spirit is nowhere more evident than in the Franciscan friaries which sprang up in the western half of the country in the fifteenth century. Among the earliest was Quin in Co. Clare, begun by Maccon Macnamara around 1433. Its siting, on top of the foundations of a Norman castle largely destroyed by one of Maccon's ancestors, was no doubt seen as symbolizing the rise of the phoenix of Gaelic Ireland out of the ashen ruins of the castle representing the earlier domination of the area by the Normans. Quin had already been preceded by construction work at Askeaton, Co. Limerick, started around 1420, and other Franciscan buildings followed in quick succession: Muckross near Killarney, begun around 1448, and Adare, Co. Limerick, before 1464. Kilconnell, Co. Galway, although founded in 1414, dates largely from the second half of the century, as do Moyne and Rosserk in Co. Mayo. Seen from a distance, these fifteenth-century friaries can nearly always be identified by a narrow and tall 78, 79

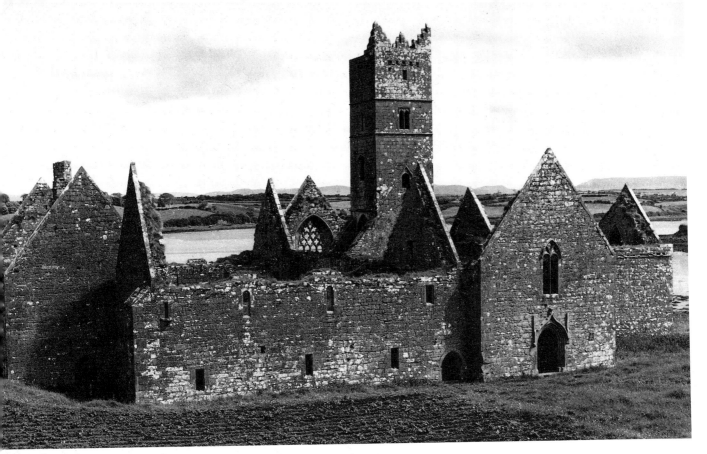

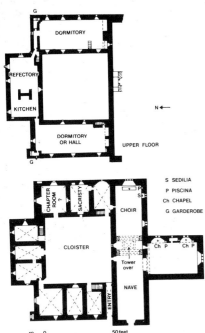

78, 79 Rosserk Friary, Co. Mayo, built in the second half of the 15th C., seen from the north-west and in plan. The entrance range is in the foreground (bottom, in the plans), between the kitchen (left) and the church with its tall tower. (The plans are based on H. G. Leask, *Irish Churches and Monastic Buildings, III*, 1960.)

battlemented belfry tower, the horizontal element often stressed by string-courses dividing the tower into a number of storeys. The towers stand just to the east of the mid-point of the long friary churches; large transepts often open off the south side of the nave (as at Quin and Muckross), and sometimes the nave was given a further aisle.

As befitted a mendicant order, the decoration of the friaries was normally simple, and they lack the rich ornament of English churches of the period. Mouldings, where used, are either archaic in character or imitate English fifteenth-century work, though in some instances a considerable amount of ornament can be found in the portals, where mouldings are grouped closely together, as seen for instance at Quin.

Tomb-niches are found occasionally in the western friaries, Kilconnell in Co. Galway having two notable examples with geometric and flamboyant tracery dating from the second half of the fifteenth century (see also below, p. 109). Very imposing are the cloisters, where the arcade has a storey on top of it rather than a lean-to roof. The arcade is made up of slightly pointed arches, arranged in rows or grouped into twos or threes, and separated by well-carved columns with moulded bases and capitals.

While the Franciscans were building these friaries, and the Dominicans were building in a somewhat similar style at Sligo, the Cistercians were doing very considerable reconstruction work on two of their houses in Tipperary, Holycross and Kilcooley. Holycross Abbey, which has now been restored to its former glory for use as a parish church, is probably the finest piece of fifteenth-century masons' work in the country. With the exception of certain parts of the nave, almost all the church and cloister date to the middle or third quarter of the fifteenth century – a time when the alms of pilgrims to the shrine of the True Cross which the monastery housed enabled it to be rebuilt to a high standard. The

80 The chancel, transepts and crossing tower of Holycross Abbey Church, Co. Tipperary, mid-15th C., seen before restoration. Note the rich window-tracery.

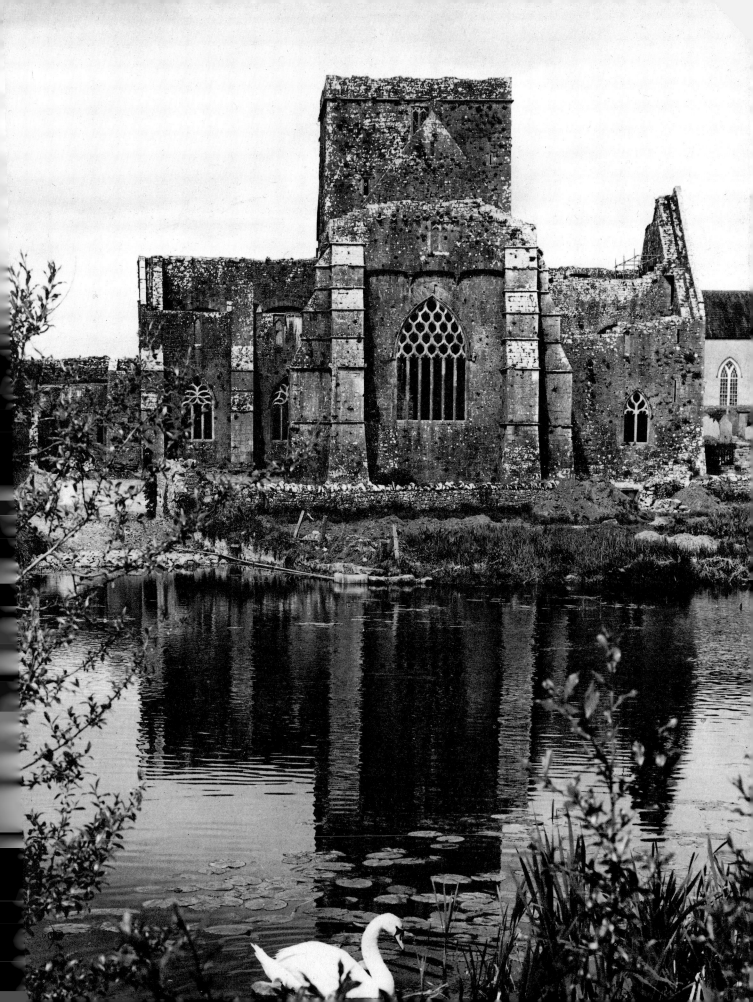

chancel, north transept, crossing and two chapels in the south transept are roofed by beautifully worked rib-vaulting. One unusual feature in the chancel is what is commonly known as the 'Tomb of the Good Woman's Son', but which is more likely to have been sedilia (seats for the clergy), with cusped arches terminating in crockets. It bears shields of the Butlers and the kings of England in the fifteenth century, and as well as much foliage on the bottom it has a stone canopy on the top which seems to imitate some heavy cloth hangings. Other slightly less decorative sedilia survive at Callan and Ballylarkin, both in Co. Kilkenny. Another really ornate piece of stonework at Holycross is what is known as 'The Waking Place', which divides the two chapels of the south transept. It may once have housed the shrine of the True Cross, though there is no evidence for this assumption. Its north and south sides consist of three arches divided by fluted columns, and it is entered by an arched doorway from the west. The roof of this structure has ribbed vaulting as intricate as that used elsewhere in the church.

81

Another interesting feature of Holycross Church is that the north transept preserves one of the few medieval Irish frescoes which remain in any way intact. It shows a symbolic hunting scene: two archers, one with a short and the other with a long bow, and a horn-blowing huntsman with a dog on a leash, are all trying to trap a stag on its knees on the other side of a tree. The only other later medieval frescoes to survive in recognizable form are at Abbeyknockmoy in Co. Galway, where the medieval tale of the Three Live Kings and the Three Dead Kings is depicted, and on Clare Island, Co. Mayo, where the only coherent story which can be made out represents St Michael weighing souls.

The tower of the church at Holycross is of a heavier and more squat form than that used by the Franciscans. A number of other Cistercian foundations, including Jerpoint and Dunbrody, Co. Wexford, added somewhat similar towers at around the same time. Holycross also had extensive domestic quarters built in the fifteenth century, of which an infirmary and what may have been the abbot's house are at the back of the east range of the cloister. The cloister arcade bears a shield and an inscription saying that it was erected by Abbot Denis O'Conghail, whose reign the Papal Letters give as 1448–55, though other historical records suggest that one Dermit O'Heffernan was abbot at the time. A mid-fifteenth-century date does seem likely for the arcade, which has cusped arches of a kind used also by the Cistercians at Bective, Co. Meath, by the Augustinian friars in the 'Black Abbey' at Adare and by the Benedictines at Fore in Co. Westmeath. Unlike the Franciscan arcades, which usually bore a storey above them, the Holycross arcade had a lean-to roof.

80
78
77

The windows at Holycross show a wide variety of types. Throughout the whole of the fifteenth century the various religious orders used windows varying from survivals of the earlier lancet type to those of 'switch-line' type, as well as those with curvilinear tracery of the reticulated and flowing varieties. The windows of fifteenth-century buildings in Ireland show a mixture of the Perpendicular designs used in England at the time and of features more common to the Decorated style as used in England in the fourteenth century. This presence of certain fourteenth-century elements in Irish structures of the fifteenth century, reminiscent of what happened to armour in Ireland at the same time, could suggest that the revival of architecture after the disastrous blow struck by the Black Death may have already begun in the later part of the fourteenth century, even though we have no dateable examples to prove it.

Some of the churches in the western half of the country have heavily-moulded doorways, a few bearing figure sculpture. One of these is the sacristy door at Kilcooley, the two other remarkable examples being that erected by Dean Odo in the north wall of the cathedral at Clonmacnoise in 1461, and that inserted ten

22

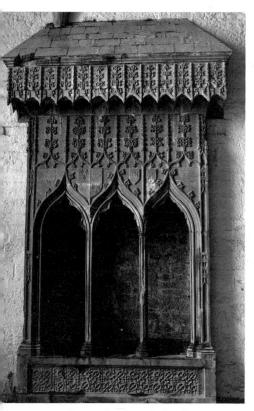

81 Sedilia in the chancel of Holycross Abbey Church, mid-15th C.

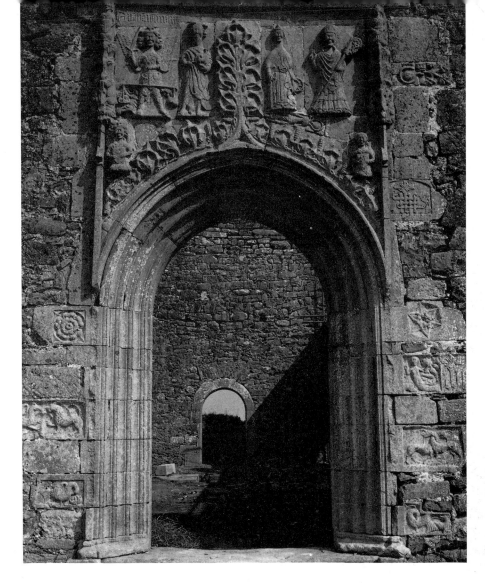

82 West doorway of Clontuskert Priory
Church, Co. Galway, 1471.

years later in the west wall of the Augustinian monastery at Clontuskert in Co. 82
Galway by Matthew, Bishop of Clonfert and Patrick MacNaughton, canon of
Clontuskert. The Clontuskert portal bears figures of St Michael, St John the
Baptist, St Catherine and an unidentified bishop as well as two angels above the
door, while on either side of the doorway are, among other things, a rosette, a
lion fighting a griffin (good versus evil – a common medieval motif), the pelican
in her piety (the Church feeding its flock), a mermaid representing vanity, and
two quadrupeds with interlocking necks (to remind one of or to ward off evil?).
More simple doorways were erected by the Augustinians at this period at Lorrha,
Co. Tipperary, Dunmore, Co. Galway and Ardnaree in Co. Sligo.

Cathedral additions, parish and family churches of the fifteenth and sixteenth centuries

The best Irish architecture of the fifteenth century is undoubtedly to be found in
the buildings of the monastic orders just discussed. There were no cathedral
foundations after the thirteenth century, and the few additions made to
cathedrals in the fifteenth century all occurred in the western half of Ireland.
Limerick Cathedral had a number of chapels added to it, some of them possibly

restorations of earlier work, while at Clonfert, Co. Galway, the innermost order of the great Romanesque west doorway was added during this time, along with a new chancel arch, both bearing some figure sculpture showing affinities to the Clontuskert doorway not far away.

Some of the major parish churches of the country also had parts added to them in the fifteenth and sixteenth centuries. Prime among these is St Nicholas' Church in Galway, which had a tower, a south porch, a new north aisle and a unique three-gabled frontage added at various times in the sixteenth century. Other enlarged churches include that of SS. Peter and Paul at Kilmallock and that of St Mary at Callan in Co. Kilkenny. The great majority of the country's smaller parish churches appear to have been built between 1400 and 1600, but other than a simply decorated door or window, they are of little architectural interest, consisting of a simple rectangular area, occasionally with living quarters at the west end as at Templecross, Co. Westmeath, and sometimes with towers of a fortified character as at Newcastle, Co. Dublin, or Taghmon, Co. Westmeath.

In comparison to the western half of Ireland, there was little building in the east in the fifteenth and sixteenth centuries. A number of churches in Leinster had towers of considerable size erected at their west ends, as at Slane, Co. Meath, and Dundalk, Co. Louth, while the churches at Lusk and Duleek in Co. Meath were built beside or partly incorporated earlier round towers. Among the more interesting architectural contributions in eastern Ireland at this time are a group of smaller churches in Co. Meath which served primarily as family churches and burial places. These are the Plunket churches at Killeen, Dunsany and Rathmore, which are characterized by having a nave with a slightly smaller chancel, a sacristy tower at the north-eastern corner, and one or two towers at the western end. They were built around the middle of the fifteenth century or slightly earlier, and seem to have been influenced by English churches of the period. They have or had some finely decorated traceried windows with well carved heads. The churches at Slane, Co. Meath, and Howth, Co. Dublin, had 'colleges' built in the sixteenth century to house the clergy of the church nearby.

As most of Ireland's later Gothic architecture was monastic, the spate of building which had begun apparently in the first third of the fifteenth century and which continued into the early sixteenth century (as instanced by Creevelea, Co. Leitrim) came to an abrupt end with the Dissolution of the Monasteries in the years after 1536. While many of the western Irish friaries, in particular, continued in use for many years afterwards, no building work was carried out except for a few alterations when some of the buildings were re-occupied in the second quarter of the seventeenth century. Maintenance also was discontinued after the Suppression, so that the monastic structures became dilapidated, their decay accelerated by the removal of lead from the roofs which tradition ascribes to the Cromwellian period. With all too few exceptions, the only medieval churches still in use in Ireland are those which are now used as cathedrals by the Church of Ireland (the Protestant Episcopal church).

Castles and town walls of the thirteenth and fourteenth centuries

The first fortifications which the Normans built to secure their bridgeheads in the first thirty years after their invasion of the country were mottes, earthen mounds looking like plum-puddings, to which baileys – crescent-shaped enclosures for cattle and horses – were sometimes added. The mottes had wooden towers, or breteshes, built on top of them, but none of these survives. Shanid Castle in Co. Limerick, with its polygonal stone tower standing inside a

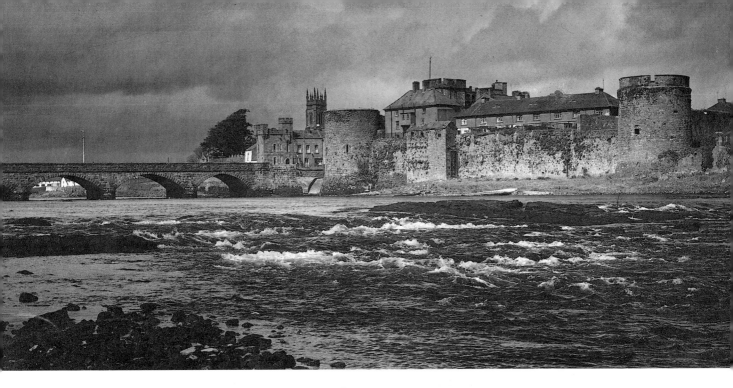

83 King John's Castle, Limerick, c. 1200, which defended the town bridge across the River Shannon. The gatehouse rises beyond the later outbuildings that fill the courtyard. The towers have been reduced in height. On the left is the Thomond Bridge (rebuilt by James Pain in 1836).

stone curtain wall, comes closest to giving an idea in stone of the original appearance of these early Norman fortifications.

In the late twelfth and early thirteenth centuries the Normans began to build strong fortresses for themselves in stone, such as those at Carrickfergus, Co. Antrim, and Trim, Co. Meath. Carrickfergus, beside the shore of Belfast Lough, **7** was probably the first to be built, having been started already at the very end of the twelfth century. The square keep of Trim Castle, which has smaller towers projecting from the middle of each of its four sides (one has disappeared), was begun in the first quarter of the thirteenth century. Its extensive curtain walls with D-shaped turrets and two strong fortified gate-towers, and a moat outside now devoid of water, were probably not added until the middle of the century. The designs of these early Norman castles drew heavily on fortificatory ideas which had been developing in western Britain not long beforehand. The castle at Adare was built on a man-made island in the first quarter of the thirteenth century, and in its outer ward there are two halls of the same period.

Not all the early Norman castles had square keeps. The keep at Dundrum, Co. Down, is round. The castle at Athlone still retains the core of an isolated polygonal *donjon*, and although the top of the cylindrical tower which dominates the town of Nenagh in Co. Tipperary was added in the nineteenth century, the rest of it and the twin-towered entrance gate which formed part of the curtain wall of the courtyard date from the beginning of the thirteenth century.

The curtain wall system, interspersed by towers, was also used to fortify some of the Norman towns. Although little remains of the original Norman fortification of Dublin except for the Record Tower, the base of the Bermingham Tower and parts incorporated in eighteenth-century buildings and small sections of the old town walls, Limerick and Kilkenny still retain **83** considerable portions of the old fortifications. At Limerick the gate-towers as well as three other towers of the curtain wall, two of them overlooking the river Shannon, date from the early thirteenth century, while three of the towers forming Kilkenny Castle are early structures behind later exteriors. A thirteenth-century barbican known as St Laurence's Gate still survives from the town fortifications at Drogheda. Roscrea preserves a tall keep of late thirteenth-

century date, though some of the rest of the wall of which it formed part may be later. The old town walls at Athenry may in part date back to 1316 and the fragments of others at Drogheda may be even earlier, but the oft-repaired walls surviving in other places, in particular at Youghal, Co. Cork, and Fethard, Co. Tipperary, seem to consist largely of somewhat later medieval work. Carlingford and Castleroche, both in Co. Louth, and Dunamase, Co. Laois, are the finest examples of strong Norman castles splendidly sited on rocks.

In the west of Ireland, square or rectangular Norman castles without any keeps at all were built at Roscommon and Ballymote, Co. Sligo, and at Ballintubber, Co. Roscommon, after the Norman invasion of Connacht in 1235. The castle at Quin on which the Franciscan friary was later built is of the same type, dating from shortly before 1280. Within the territories conquered earlier by the Normans there are a number of keepless castles dating from the second half of the thirteenth century, such as Liscarroll, Co. Cork, and Ballyloughan in Co. Carlow, and in the latter county the type continued to be built into the early fourteenth century, as can be seen at Ballymoon.

One early type of castle remains to be mentioned which seems to be peculiar to Ireland. It is the rectangular keep with round turrets or towers at each corner but without a central courtyard, of which Carlow, Ferns in Co. Wexford, Lea in Co. Laois and Terryglass, Co. Tipperary, are good examples. The castle at Enniscorthy, Co. Wexford, which now houses the County Museum, gives the 84 best idea of the complete state of such castles, although it is largely a reconstruction of around 1586 based on the old plan, with the insertion of modern windows. Rathumney in Co. Wexford, Kindlestown in Co. Wicklow and Inchiquin in Co. Clare are among the few surviving castles of a type consisting of one long hall with apartments above it, dating from the thirteenth and fourteenth centuries.

Tower-houses and castles of the fifteenth and sixteenth centuries

The Irish fortifications of the fifteenth and sixteenth centuries are generally smaller than those of the thirteenth century – a tendency which seems to have

84 Enniscorthy, Co. Wexford, a 13th-C. castle rebuilt in 1586.

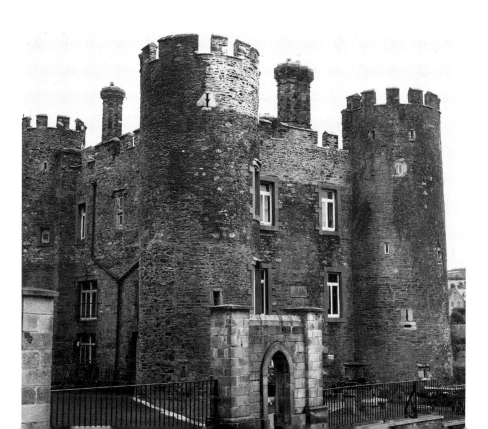

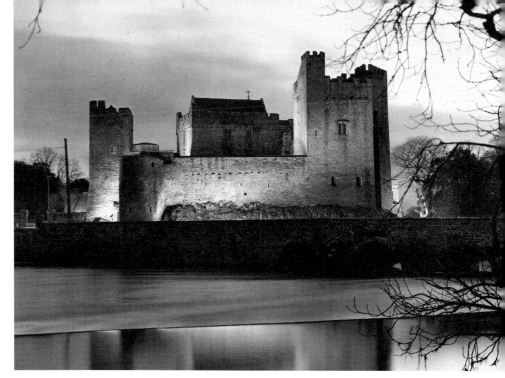

85 Cahir Castle, Co. Tipperary, 15th C., seen across the River Suir. The upper part of the central tower is visible in the middle; in front of it and to left and right is the curtain wall with its towers.

followed the general European trend. The tower-houses, four or five storeys high with gabled roofs, stand on one side or occasionally in the middle of a courtyard or bawn surrounded by a bawn wall with one or more turrets. A good sixteenth-century example is Dunguaire, Co. Galway. The keeps find their closest counterparts in Scotland. Most of the towers of these fortifications are rectangular, though some few are cylindrical. The uppermost storey – the main living room of the castle, which was probably only sparely provided with furniture – was usually supported by a pointed stone vault below, and the first floor was also sometimes similarly supported. Other floors were held up by large wooden beams of the kind still surviving at Clara, Co. Kilkenny. One or more of the rooms of the later tower-houses, which were placed one above the other and linked by a stone staircase, were often provided with fireplaces, from which the smoke rose to chimneys on the roof. The windows in the earlier tower-houses of this type are narrow and pointed, while those of the later towers have squared drip-mouldings and sometimes mullions. The windows were, of course, narrow for defensive reasons, and resulted in ill-lit interiors.

It is thought that these tower-houses originated in the '£10 castles' which were ordered to be built by an act of Henry VI in 1429 to defend the Pale against the native Irish; but if this was so, the native Irish were quick to adopt and adapt the style for themselves. They continued to build towers in much the same style for almost two hundred years, one of the latest dated examples being that at Derryhivenny, Co. Galway, which was built in 1643, and which seems so archaic when compared with Portumna Castle nearby which was built some decades before it.

Not all the Irish and Anglo-Irish fortifications of the fifteenth century were as small as Dunguaire. The massive pile of Blarney Castle was erected by the MacCarthys around 1446, and Bunratty Castle, now restored to its former splendour, was built by the Macnamaras at around the same time. The largest of all the fifteenth-century castles is the Butler stronghold at Cahir in Co. Tipperary, where the attacker had to penetrate through an intricate system of defences before reaching the main tower, though these proved no match for the

112

6

111

85

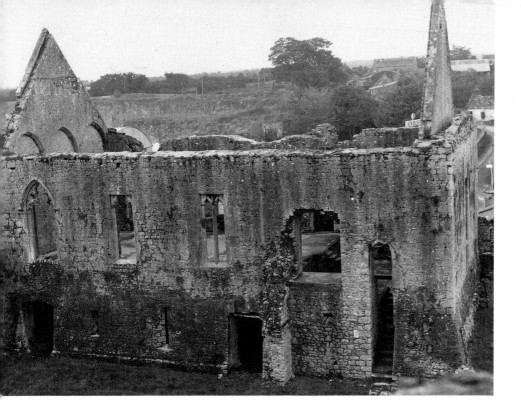

86 The two-storeyed hall of Askeaton
Castle, Co. Limerick, mid-15th C.

cannon of the Earl of Essex in 1599. The wooden roof of Dunsoghly Castle, Co.
Dublin, another of the larger castles, was preserved completely until recently
when part had to be replaced. Some of the castles had large halls built beside
them, like those in the earlier period at Adare. That at Newcastle West in Co.
Limerick has not one but two such halls, one of which incorporates a thirteenth-
century structure. A fine fifteenth-century example (although also retaining
earlier portions) is at Askeaton, Co. Limerick, where the hall is of two storeys, 86
the upper one having some traceried windows.

Houses, and the adoption of the Tudor mansion in Ireland

Unfortunately, very little domestic architecture survives from the period before
1600. Of the many fine merchants' houses which must once have lined the streets
of the larger towns, Rothe House in Kilkenny, built in 1594 and now a museum, 88
is one of the few relatively intact examples, and it has recently been excellently
restored. On the ground floor arcades open on to the street. A central arch leads
in to two successive courtyards, from the first of which access was gained to the
first floor. This was the main living room, lit by mullioned windows, the one
over the door being an oriel window from which a view of the street could be
obtained. The uppermost floor, now restored with a splendid wooden roof
constructed in medieval style with wooden dowels, has a gabled front over a
string-course at the level of the first floor ceiling. In its details, Rothe House
echoes the kind of urban architecture which was common in England in the
latter half of the sixteenth century.

A system of gables similar to that of Rothe House was also employed in one of
the earliest surviving free-standing mansions in Ireland, that built at Carrick-on- 87
Suir, Co. Tipperary, by Black Tom, 10th Earl of Ormond, during the reign of
Queen Elizabeth, whose monogram ER recurs in the stucco work on the first
floor of the mansion. There are three gables on the front façade, which makes

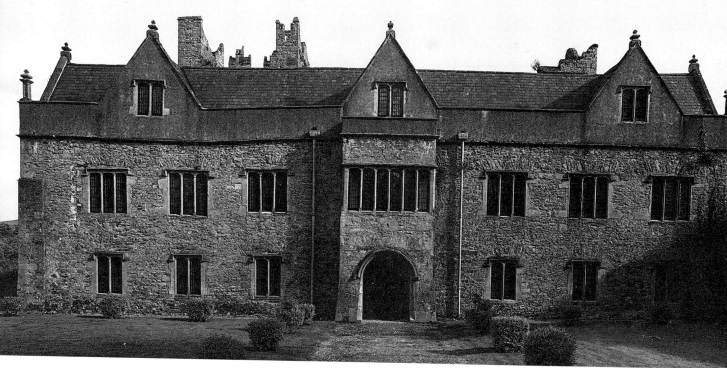

87 The Ormond 'castle' at Carrick-on-Suir, Co. Tipperary, late 16th C. Behind it are the towers of the mid-15th-C. castle.

88 The street façade of Rothe House, Kilkenny, 1594.

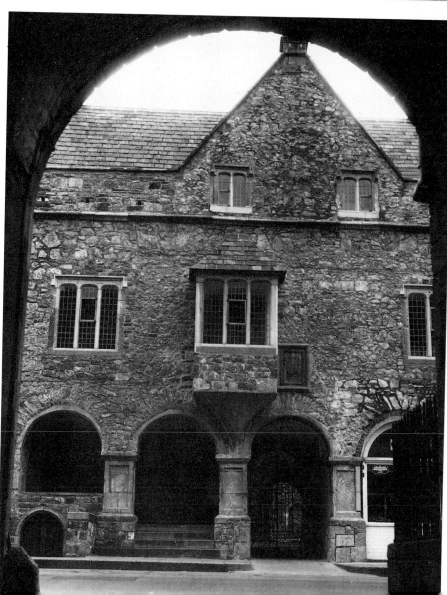

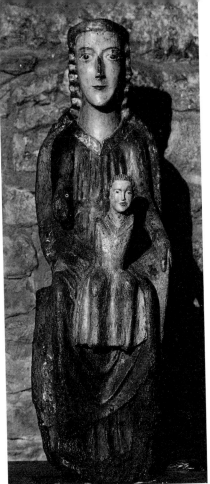

89 Statue of the Virgin and Child from Kilcorban, Co. Galway, 13th C. Painted wood, H. 90 cm. (3 ft.). Diocesan Museum, Loughrea, Co. Galway.

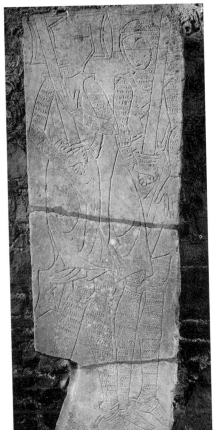

90 Memorial slab of two knights known as 'The Brethren', in Jerpoint Abbey Church, Co. Kilkenny, second half of the 13th C.

extensive use of mullioned windows, and the frontage is broken by a projecting porch carrying an alcove in the first floor above it. The new 'castle' forms three sides of a courtyard, the fourth side being made up of an earlier castle behind. The contrast between the two parts shows how the Earl of Ormond was departing from the medieval idea of the fortified dwelling in building a mansion flooded with light and designed for a more gracious style of living. Although Black Tom's example, imitating the great Tudor manors of England, was not immediately followed by other Irish nobles, it looked forward to unfortified mansions which were to emerge gradually in Ireland in the course of the following century.

SCULPTURE IN STONE AND WOOD

1200–1350

In discussing ecclesiastical buildings above, occasional mention was made of architectural sculpture, which normally plays a subordinate role in the building it decorates. There is relatively little of it in comparison to tomb-sculpture, which forms the most important corpus of medieval stone sculpture in Ireland. To judge by the surviving remains, it was the bishops who first had carved effigies of themselves erected over their tombs, a custom which had already been practised for some time on the Continent and in England. The great Norman foundations of Christchurch and St Patrick's in Dublin and also Jerpoint house effigies of bishops, some of them dating from the first half of the thirteenth century. These effigies, which are carved in high relief, are modelled on Norman examples in England. Some of the western bishops and abbots, as at Ardfert, Co. Kerry, and Corcomroe, Co. Clare, seem to have aped their Norman *confrères* in the east by having somewhat stiff representations of themselves carved on their tombstones. Together with the effigies alleged to be of King Felim O'Conor at Roscommon and Conor na Siudaine O'Brien at Corcomroe, carved apparently around 1300 – some decades after their deaths – the western bishops' tombs are among the few surviving effigies made for native Irishmen in the thirteenth and fourteenth centuries. (The Roscommon effigy may possibly have been carved in the east of the country.) Wooden effigies, of course, may once have existed in Gaelic Ireland, but if so they have not survived. The use of wood in Gaelic statuary of the period is however confirmed by a few interesting survivals, including an elongated thirteenth-century statue of St Molaise of Inishmurray (National Museum of Ireland) and the Kilcorban Madonna, now at Loughrea, which is 89 carved in Romanesque style with the Child on the Virgin's lap, both wearing long robes with simply falling folds.

The Norman knights were quick to follow in the steps of bishops in having effigies of themselves carved above their burial places. The rather amateurish effigy at Timolin, Co. Kildare, possibly of Robert FitzRichard de Valle, is probably the earliest, dating from the first half of the thirteenth century, but the better specimens date from the later thirteenth and early fourteenth centuries. Two which show an interesting contrast in styles are the slab bearing the two knights known as 'The Brethren' at Jerpoint and the effigy of a Cantwell knight 90 at Kilfane, also in Co. Kilkenny. The double effigy of 'The Brethren' is the earlier 91 of the two, dating from the later thirteenth century. The knights, wearing different helmet types, are drawn with an assured style in an incised technique of a kind practised in England but also copied in the west of Ireland, as shown by the crude effigy of a bishop or abbot at Kilfenora, Co. Clare. The Cantwell knight, on the other hand, of c. 1320, is carved in high relief, resting with his legs crossed

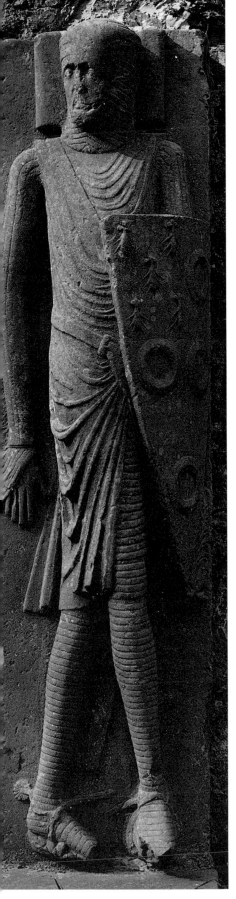

on his tomb-slab, and showing in a lively style the kind of well-accoutred Norman conqueror whose superior arms and tactics had been able first to conquer and then to hold at bay the native Irish warriors. The latest of the series of high relief effigies of knights is that of *c.* 1330 in Christchurch Cathedral, Dublin, which is commonly though erroneously identified as Strongbow, the first and mightiest Norman baron in Ireland.

Like the ecclesiastical figures, the knightly effigies were also modelled on western English sculpture, and some of the early Norman carvings, such as the tomb-front with knights formerly at Athassel, Co. Tipperary, and part of a civilian effigy at New Ross, Co. Wexford, may have been imported in their finished state from Bristol or the surrounding area. Almost all the early Norman effigies are found in an area east of a line from Dundalk to Youghal, and we can presume the existence of important workshops in major centres such as Dublin, Kilkenny and New Ross. The effigies of better-off civilians in the later thirteenth and early fourteenth centuries were carved, often competently, in the same Norman-dominated areas, while the less well-off contented themselves with slabs bearing heads in relief and floreate crosses incised below, or with cross-slabs without any figure sculpture at all.

1350–1450

As with architecture, the Black Death dealt a disastrous blow to Norman sculpture, which had already been wilting since the carving of the 'Strongbow' effigy two decades earlier. The crouched corbel figures supporting the vault in the tower of the friary of St Francis in Kilkenny, of 1347 or later, seem almost to be symbols of the crippling blow struck by the plague. In fact this decline in Norman sculpture corresponds in time with the nascent Gaelic revival, which had already begun shortly after 1330. In Gaelic Ireland, and particularly in Connacht, there was no very strong school of native stone sculpture after the banishment of the 'artists' by the O'Conors in 1228, and the few rather pedestrian native effigies of the thirteenth and early fourteenth centuries from places like Ardfert in Kerry and Corcomroe and Kilfenora in Clare are the exceptions which prove the rule. But Gaelic Ireland, while it too felt the effects of the Black Death, was as we have seen not so hard hit, and artistic production must have continued at least in a small way. The lost effigy of Bishop Cornelius O'Dea, who died in 1434, and for whom the mitre and crozier mentioned below 102, were made, would have given us a better inkling of Gaelic stone sculpture in the 103 bleak century after 1350, and we have to content ourselves with isolated pieces such as the stone heads from Kilnanare in Co. Kerry. The work on the Franciscan friaries at Askeaton and Quin suggests that after 1420 stone sculptors once more became active in the west, two or three decades before the second major period of sculptural activity began in the Anglo-Norman lands in the decade 1440–50.

The century after the Black Death was not entirely barren in the lands of the Pale. The effigies of Bishop de Ledrede (who inserted stained glass, now lost, in the east window of Kilkenny Cathedral, where he was buried in 1361) and of Sir 76 Thomas de Tuite (of 1363, at Kentstown, Co. Meath) show that the art of carving effigies was not entirely dead, although the quality shows a decline over the work of the preceding century and a half. The work which can be seen as possibly the greatest achievement of this period is the cloister arcade at Jerpoint, 77 discussed above, which (if Hunt's dating is correct) stands out as a unique sculptural monument in the Ireland of the century after the Black Death. The Ormond lands in the Kilkenny area had to wait for almost another century before sculpture was revived again.

91 Tomb effigy of a knight of the Cantwell family, in Kilfane Church, Co. Kilkenny, *c.* 1320.

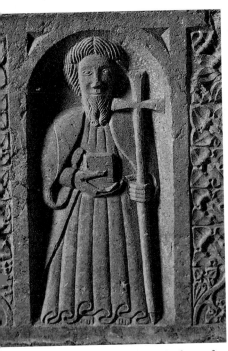

It was the same Plunkets who had built the English-derived churches at Killeen, Dunsany and Rathmore in Co. Meath around or shortly before the middle of the fifteenth century who were the first patrons of a school which revived tomb sculpture in the east of Ireland at around the same time. The best examples of its work are seen in the family's own churches and also at other places in counties Dublin and Kildare. This school specialized in producing effigies in medium-high relief of knights and their ladies, and it also made popular the custom of placing these effigies on top of a tomb-chest, the sides of which were carved with scenes of the Crucifixion and Flagellation, as well as with saints, angels and coats of arms. Though common in England for more than a century, this arrangement had scarcely ever been used in Ireland before: its appearance in Meath and Dublin from around 1440 onwards was doubtless inspired by similar tombs in England. The saints portrayed included Catherine of Alexandria, Peter, Michael and Lawrence, the last a patron of the Plunket family. It is not until the early sixteenth century that Apostles appear as 'weepers' on the long sides of tomb-chests, as at Castlemartin, Co. Kildare.

The use of Apostles in tomb-surrounds had however just begun to be popular towards the end of the fifteenth century in the south-east of the country, as exemplified by the Rice memorial in Waterford Cathedral. It became the norm in most of the tombs carved in the first three quarters of the sixteenth century in the Ormond lands, centred on Kilkenny, though it seems strange that the Ormond earls only adopted the use of decorated tomb-chests after these had already been known for half a century in Dublin and Meath. In Kilkenny two schools competed in carving the Apostle-laden tomb-surrounds and the fine effigies in medium-high relief which they bore. One school consisted of the O'Tunney family, whose members were among the only stone sculptors prior to 1600 who signed their works. Though their sculpture was somewhat stylized, it had more variation than that of the other major workshop, which is known as the 'Ormond School' from the unsigned effigies of the earls of Ormond in St Canice's Cathedral, Kilkenny, and other works executed in the earls' lands. The Ormond School produced slightly more naturalistic works, as seen in the effigies

92 Figure of an Apostle from the front of a tomb in Jerpoint Abbey Church, Co. Kilkenny, first half of the 16th C. – a product of the O'Tunney workshop.

93 Tomb of Bishop Wellesly, *c.* 1539, removed from Great Connell and reconstructed in Kildare Cathedral.

92

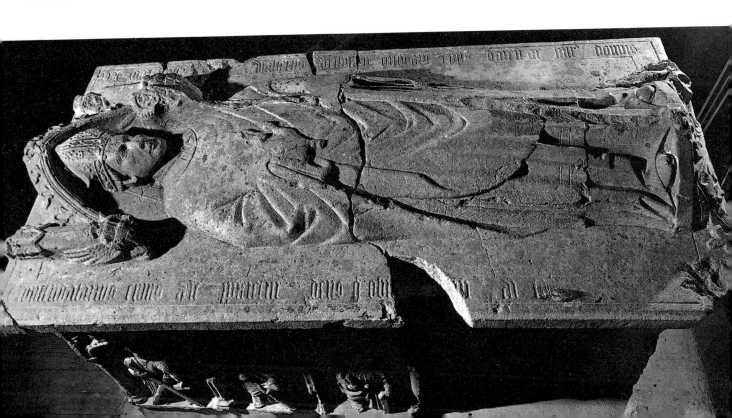

of the 8th Earl of Ormond and his wife, but the somewhat inane expressions of 95
some of the Apostle figures in the tomb-surrounds carved by them shows a
considerable provinciality in style which is shared by the products of the
O'Tunneys. A third school was also active at the time, producing works which
survive in Thurles and Cashel in Co. Tipperary. The tomb-surrounds produced
by all these schools bear rather squat figures which are pedestrian in style
compared to the much finer work being carried out at the same time in England.

The first half of the sixteenth century did, however, produce one really fine
monument in Ireland, the tomb of Bishop Wellesly (c. 1539), formerly at Great 93
Connell and recently removed to Kildare Cathedral. The figure of the Bishop is a
very noble and well-proportioned work, of a quality far above that of all the
other contemporary sculptures in Anglo-Norman Ireland.

In western Ireland the figure of a knight at Glinsk in Co. Galway is the only
stone effigy of the later medieval period. In this region the tomb-chest of the Pale
was replaced by a tomb-niche with fine tracery, such as those at Kilconnell in Co.
Galway, and with a tomb-front of figures of various kinds. There seem to be two
different tomb-front styles represented at Ennis in Co. Clare, both of the second
half of the fifteenth century. One has scenes from the Passion of Christ modelled
on English alabaster sculptures, and the other shows Christ and the Apostles. It is
interesting that the Apostles here, carved probably around 1470, ante-date those
found in the east and south-east of the country. Of the same period are the figures
on a tomb-front at Straide, Co. Mayo, which show a remarkable quality in 94
comparison to the somewhat stiff representations seen on the Clontuskert 82
doorway. Mercenary soldiers, known as gallowglasses, are shown on tomb-
fronts at Dungiven, Co. Derry, and at Roscommon, both dating from the second
half of the fifteenth century. Although some reasonably good examples of
slightly later tomb-niches survive at Athenry and Galway, the O'Craian tomb of
1506 at Sligo shows the decline in quality of figure sculpture in the western
school early in the sixteenth century.

Figure sculpture of religious subjects is also found on monuments other than
tombs in the fifteenth and sixteenth centuries. Although baptismal fonts in the
late Romanesque style survive at such places as Killucan in Co. Westmeath,

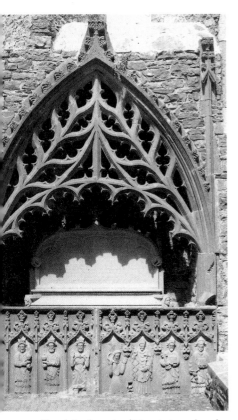

94 Tomb in the ruined Dominican church
at Straide, Co. Mayo, second half of the
15th C.

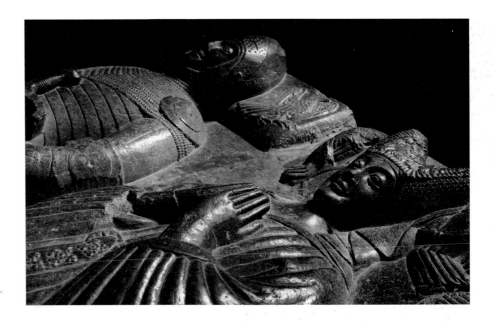

95 Effigies of Piers Butler, 8th Earl of
Ormond, and his wife Margaret in
St Canice's Cathedral, Kilkenny, c. 1539 –
a product of the Ormond School.

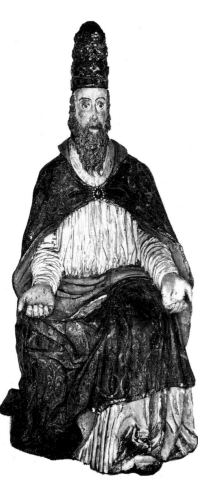

Clonfert in Co. Galway and Killaloe in Co. Clare, most fonts with figured sculpture date from the later Middle Ages. Those in Meath are above the normal Irish standard, some of them – such as the font now in the church at Curragha – having fine carvings of the Crucifixion and the Apostles. Very few of the market crosses of medieval Ireland survive: That still in position at Athenry, Co. Galway, is but a tragic fragment of its former self. Of the wayside crosses popular in Meath an example is that at Balrath on the Dublin–Slane road, which shows a Pietà and bears an inscription requesting a prayer for John O Broin. Around 1600 a number of crosses were erected in the Duleek area of Co. Meath by Dame Jennet Dowdall in memory of one of her three husbands, William Bathe.

Irish wooden statuary of the later Middle Ages was undistinguished. The St Catherine figure from Kilcorban (in Loughrea Museum) is small and stiff, while the monumental statue of God the Father with papal tiara from Fethard in Co. 96 Tipperary rather lacks expression. But the misericords in St Mary's Cathedral in 97 Limerick show that Irish woodwork of the later fifteenth century could almost equal that found in England. These carvings, showing animals copied from the bestiaries, represent the only major group of woodwork to survive from the Middle Ages in Ireland.

The beginnings of Renaissance ornament in Ireland

Although monuments such as the Duleek crosses continued to be erected in the early seventeenth century in a Gothic style, Renaissance ornament had already begun to creep in before that date, albeit in a small way. Possibly the earliest example of all is the table formerly at Maynooth and now in the grounds of 98 Kilkea Castle, Co. Kildare, which was carved for the Earl of Kildare in 1533. On the legs we can see Italianate *putti* bearing plant ornament. The surrounds of the

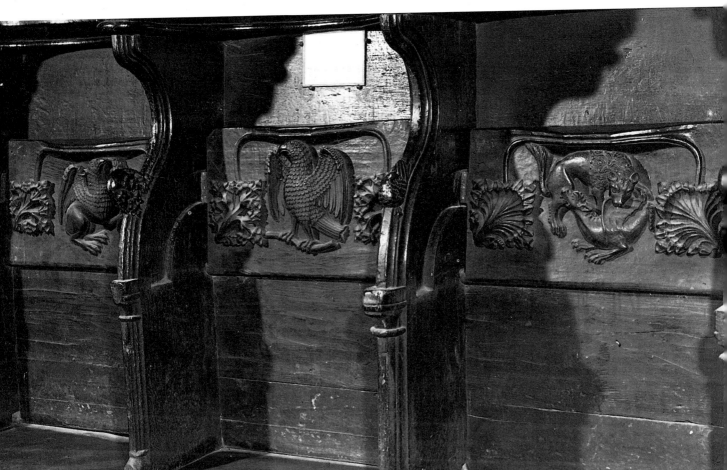

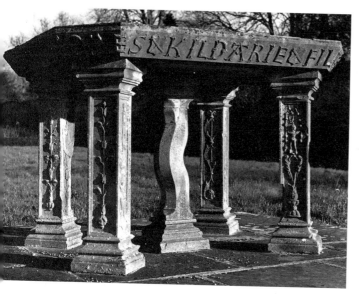

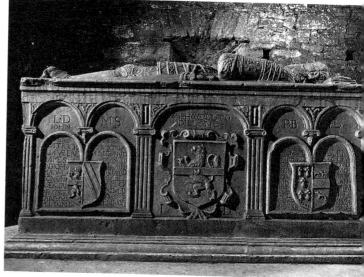

98 Stone table with Renaissance ornament from Maynooth Castle, carved for the Earl of Kildare in 1533. Kilkea Castle, Co. Kildare.

99 Front of the Barnewall tomb in the tower of Lusk Church, Co. Dublin, 1589.

Opposite

96 Wooden statue of God the Father from Fethard, Co. Tipperary, 16th C. H. about 1.50 m. (5 ft.). National Museum of Ireland.

97 Three carved oak stalls with misericords showing a griffin, an eagle, and a lion and dragon fighting, in St Mary's Cathedral, Limerick, late 15th C.

tomb of Bishop Wellesly, mentioned above, which dates from 1539, have Renaissance ornament of not quite the same quality, while others of the same period elsewhere in the region show mannerist representations of the Crucifixion which are of Italian inspiration. Some tombs were erected in the Tudor style in the second half of the sixteenth and early seventeenth centuries, often showing family figures kneeling in prayer. The earliest is the tomb of Sir Thomas Cusack and his family at Trevet, Co. Meath, dating from 1571. Some of these tombs show a further infiltration of Renaissance ornament. A front of the Barnewall tomb of 1589 at Lusk, Co. Dublin, has one of the earliest Irish examples of arcades and Classical pilasters of Renaissance inspiration, which only begin to come into their own in Ireland in the following century.

APPLIED ARTS

Strange as it may seem, the Anglo-Norman lands in the eastern half of the country, which can show a considerable amount of architecture and stone sculpture of the later medieval period, have handed down to us practically no metalwork or decorated manuscripts. It is thanks to the institution of hereditary keepers of ecclesiastical antiquities in Gaelic Ireland that the few pieces of later medieval (and indeed also earlier medieval) metalwork which survived the ravages of time and the burnings of the Reformation have been preserved for us. What little we know of the metalwork of the earlier Gothic period comes largely from repairs and additions to older shrines. For instance, the eleventh- or twelfth-century Bell-Shrine of St Seanan from Scattery Island in Co. Clare, known as the Clogán Óir, which was kept by the O'Keane family until the present century, was given a new outer covering in the fourteenth century consisting of gilt silver plates, of which three survive. They bear incised representations of symbolic animals from the bestiaries – a lion, a siren and two wyverns or dragons with interlocking necks and foliate tails – set against an intensively cross-hatched background. The lion and the siren each have a somewhat primitive mitred head in relief above them, and all three motifs are framed by a running frieze of stylized foliate ornament.

As a contrast to this flat incised technique, the new work which John O Karbri, Abbot of Clones, got the artificer John O Barrdan to apply to the much older

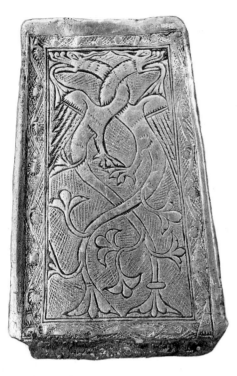

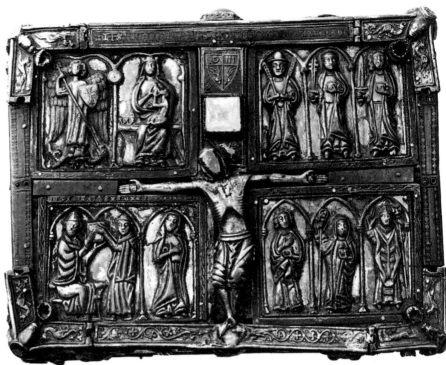

100 Gilt silver panel showing two interlaced dragons, added to the Clogán Óir in the 14th C. National Museum of Ireland.

101 Front of the Domhnach Airgid book shrine, made by John O Barrdan *c.* 1350 (see also pl. **21** and ill. 25). Silver gilt, L. 23 cm. (9 in.). National Museum of Ireland.

Opposite
102 Head of the crozier made in 1418 for Cornelius O'Dea, Bishop of Limerick. Silver gilt decorated with coloured enamel, L. about 60 cm. (24 in.). Above the knop are figures of saints (see pl. **23**); at the top is the Annunciation, and just below it the pelican in her piety, symbol of Christ's sacrifice and the Church feeding its flock. St John's Cathedral, Limerick.

103 Mitre made for Cornelius O'Dea, Bishop of Limerick, in 1418 by Thomas O Carryd. Leather, covered with silver-gilt plaques decorated with jewels and pearls. The *infulae* (hanging 'ties') are 19th-C. replacements. St John's Cathedral, Limerick.

reliquary known as the Domhnach Airgid around 1350 is dominated by human 25, figures in relief. Nailed to its centre is a figure of the crucified Christ with crossed 101 legs. The four panels surrounding Him show St Michael the Archangel fighting the devil in the form of a dragon, and the Virgin with the Christ Child at her breast, as well as St John the Evangelist and SS. Peter and Paul in the top row, and six figures in the bottom row which cannot be identified with certainty. One of these unidentified figures hands another a square object, which may represent the shrine itself, although its actual shape is more rectangular than square. The archbishop may represent St Thomas of Canterbury, while the figure beside him could be St Brigid. These figures are spread over a total of four silver-gilt panels, and all stand under pointed Gothic arches supported by slender columns, except for the two figures involved in the presentation scene, where the column is absent. Above the head of Christ is an enamelled bird, a square crystal which may have covered a portion of the True Cross and the shield of the arms of the Passion. At each corner of the shrine-front human and animal heads are surrounded by fabulous animals executed in the same repoussé technique as the human figures, and copied, like those on the Clogán Óir, from medieval 100 bestiaries. The feet of Christ rest on a strip bearing foliate scrolls of a more stylized form than those on the Clogán Óir. A somewhat similar style was adopted on the panel which was applied to another ancient reliquary, the *Cathach* **22**, (which contained the manuscript bearing this name, discussed above), at around 21, the same time. 22

The Limerick bishop Cornelius O'Dea was responsible for the creation of two of the finest ecclesiastical works of art to survive from medieval Ireland. These are the Limerick Crozier and Mitre, both made in 1418. The silver gilt crozier bears a touching Annunciation scene in the crook, which is further decorated 102 with crockets. Above the knop are two rows of figures. The lower and more **23** important row stand free on pedestals and under crocketed canopies. They represent the Trinity, the Virgin and SS. Peter, Paul, Munchin (a local saint) and

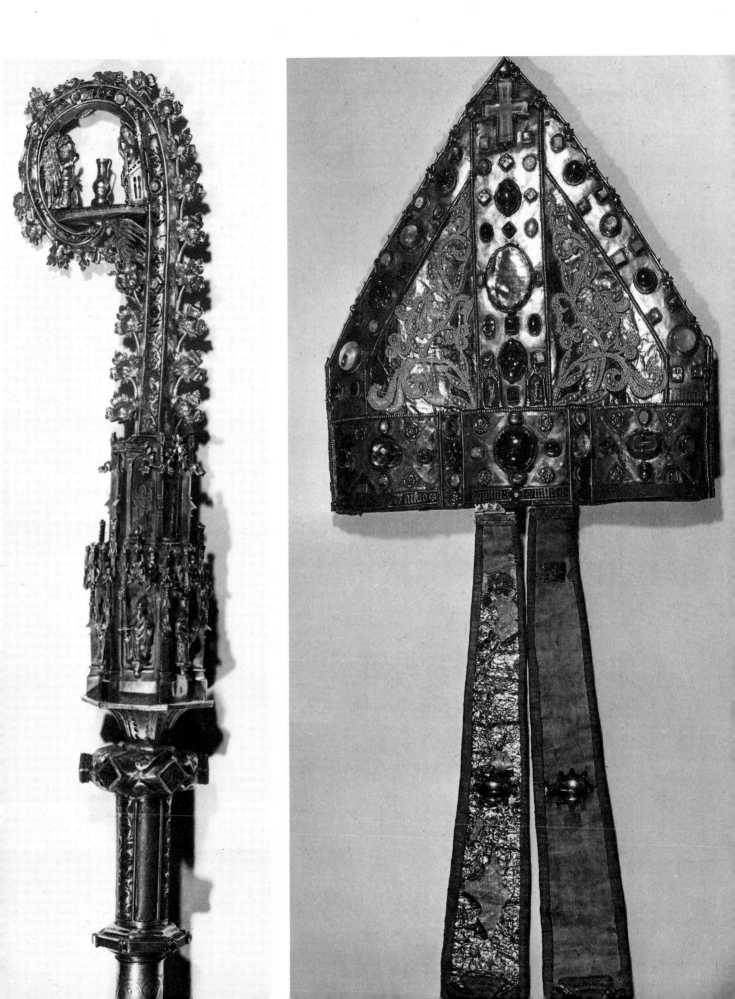

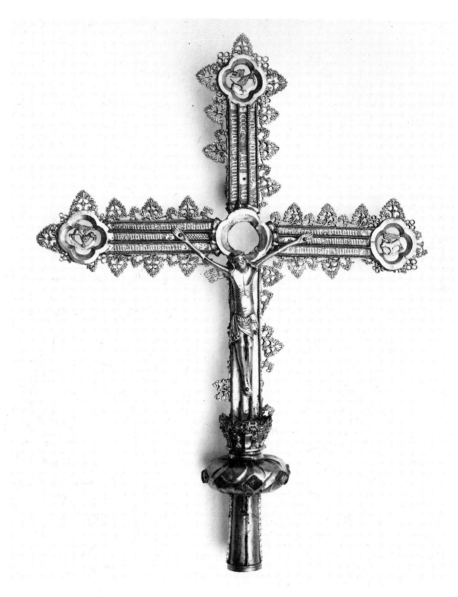

104 Processional cross from Ballylongford, Co. Kerry, 1479. The arms of the cross display the Evangelists' symbols – from left to right, the lion of St Mark, the eagle of St John and the ox of St Luke; the angel of St Matthew would presumably have been above the head of Christ. Silver, H. about 68 cm. (26 in.). National Museum of Ireland.

Patrick. The figures in the upper row are engraved on silver-gilt plates with enamel backgrounds, and represent St John the Evangelist, St Margaret of Antioch, St Catherine of Alexandria and the two St Barbaras, one of Kildare and the other of Sweden. Some panels on the Arthur Cross date from the same period, and may even be from the same workshop. The Limerick Mitre, executed by Thomas O Carryd, is another masterwork, and the only mitre to survive almost intact from the medieval period in Ireland or England. It is heavily ornamented with semi-precious stones, and a flowing foliate ornament on the two silver-gilt panels which they enclose is made with a multitude of small pearls. On the vertical panel in the centre there is a cross of rock crystal at the top and at the bottom figures of a bishop (presumably Cornelius O'Dea himself) and the Virgin. Of slightly earlier date is the seal of Bishop Thomas of Elphin, who died in 1404. This is possibly the best of the Irish medieval seals which have survived, and while its quality may not be of the highest, its figure of the Virgin and Child shows the same continuation of artistic endeavour in the Gothic style in the west of Ireland which we saw on the metalwork of the fourteenth century.

103

105

The end of the fifteenth century saw the execution of two fine pieces of Irish metalwork which, together with the Limerick Crozier, are among the few known pieces made wholly in the medieval period and not merely added to earlier work. The first of these is the cross from Ballylongford, Co. Kerry, which 104 was made – as the inscription on the limbs tells us – by William (son of) Cornelius for John O'Conor and Avlina daughter of the Knight of Kerry in 1479. The figure of the crucified Christ is nailed on to the shaft of the cross, and the quatrefoils on the extremities contain the Evangelists' symbols – an arrangement common at the time in many parts of Europe. The openwork acanthus designs which give the cross its interesting outline are only one of a number of instances of the use of this Classical motif in fifteenth-century Ireland. The other work is the less elaborate De Burgo O'Malley Chalice of 1494 (also in the National Museum of Ireland). Very little remains of Irish metalwork of the sixteenth century, but the plaques decorating the Dalway Harp of 1621 show how Gothic decoration with bestiary animals continued to be used for metalwork in the west of Ireland into the seventeenth century.

The 'Harp of Brian Boru' in Trinity College Library shows the continued use 106 on woodwork dating from near the end of the medieval period of earlier Irish motifs such as interlacing, coupled with roundels enclosing bestiary animals of

105 Impression of the seal of Thomas, Bishop of Elphin, *c.* 1400. The Bishop is shown praying below the figures of the Virgin and Child. National Museum of Ireland.

106 The 'Harp of Brian Boru', of uncertain date between the 13th and 16th C. Oak and willow, with brass fittings and a finial of silver set with a rock crystal, H. 86 cm (34 in.). Trinity College Library, Dublin.

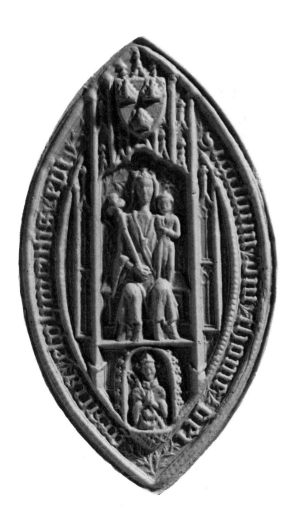

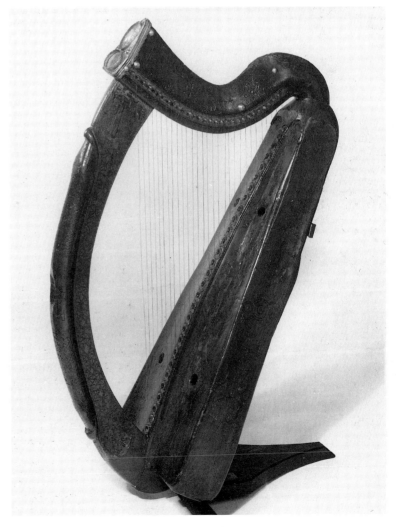

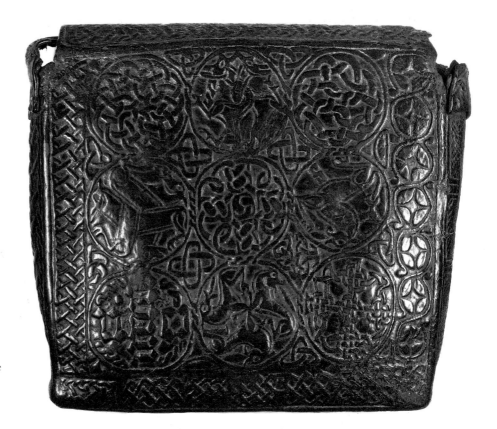

107 Budget or satchel made to contain the
Book of Armagh (see pp. 52–53), 15th C.
Stamped leather, H. 32 cm. (12½ in.).
Trinity College Library, Dublin.

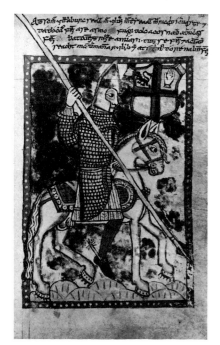

medieval type. The budget or book satchel of the *Book of Armagh* shows the same 107
range of motifs in use on leatherwork of the fifteenth century, though the design
of single and triskele animals and interlace in circles lacks clarity through an over-
fussy filling of all the available spaces.

Manuscript illumination of the later Middle Ages in Ireland shows but a pale
shadow of the interlacing animals of earlier codices. The most striking and
colourful manuscript of the period is the *De Burgo Genealogy* (Trinity College 108
Library, Dublin), dating from about 1583. On its many-coloured pages we see
various De Burgo knights, some dressed in Elizabethan battle garb and others in
a more archaic style, going out to fight battles which were shortly afterwards to
lead to the collapse of native resistance and the downfall of the old Gaelic order
and society early in the seventeenth century.

108 A knight of the De Burgo (Burke)
family, in medieval armour of chain
mail and pointed helmet, on f. 24r of the
De Burgo Genealogy, c. 1583. Trinity
College Library, Dublin.

PART TWO

The seventeenth and eighteenth centuries

by Homan Potterton

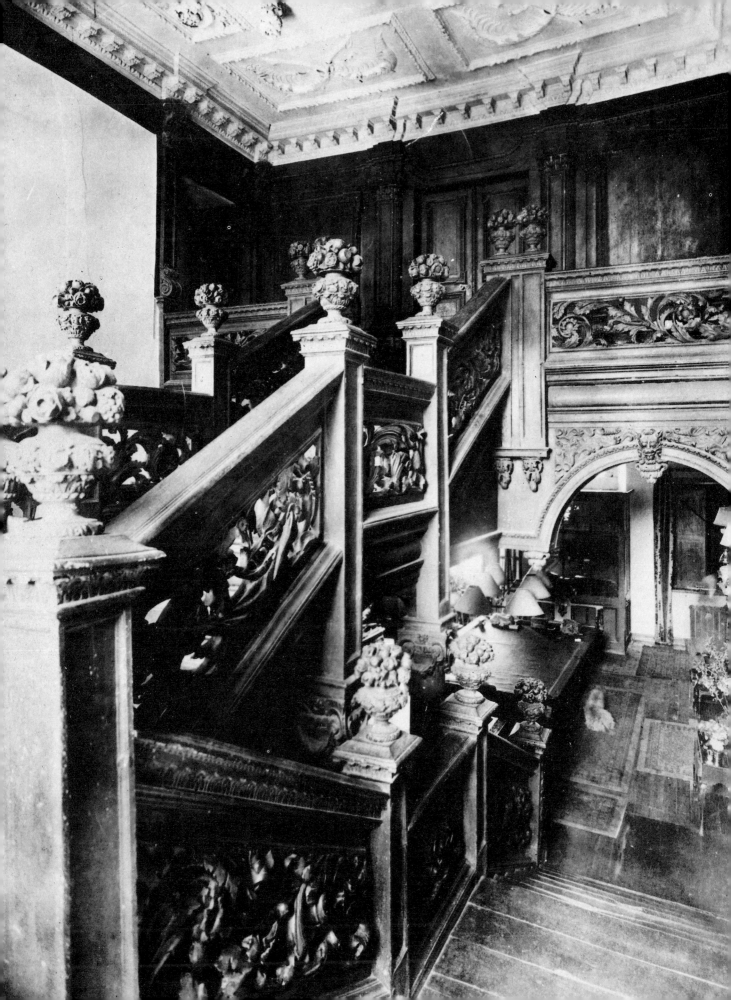

THE SEVENTEENTH CENTURY

Ireland's history in the seventeenth century, a history of successive land confiscations, plantations, religious revivals and repressions, has, not surprisingly, left its mark on the art and architecture of the period; but it is difficult, because of the scarcity of surviving evidence, to draw any coherent picture of the development of the arts as such.

In the early years of the century, following the forfeiture of the huge Desmond estates in the south, English settlers were planted in Munster lands. Then, with the flight of the Catholic Earls Tyrone and Tyrconnell in 1607, after their defeat by the forces of the Crown at Kinsale, came the plantation with Scots settlers of their deserted territories in Ulster. After the accession in 1603 of James I, the son of the Catholic Mary, the Old English in Ireland hoped to practise in freedom their Catholic religion. Their optimism was ill-founded: James added to the Statute Books further anti-Catholic laws similar to those passed under Elizabeth. During the next decades, when the Old English and Irish allied themselves, thus creating a Catholic population of some power, the policy of the English government in Dublin was one of toleration towards the practice of a religion which was in fact outlawed.

After the Ulster Rising of 1641 there followed a decade of war which ravaged the entire country and culminated in the nine months' horror of Cromwell's progress through Ireland, and the subsequent persecution of Catholics under the Commonwealth. The Settlement Acts passed under Charles II confirmed many Cromwellian settlers in their lands and led to further discontent on the part of Catholics, so that when the Catholic James II landed in Ireland in 1689 he could be sure of considerable Irish support. His defeat by the Protestant William of Orange at the Battle of the Boyne in 1690 signalled the final demise of the Catholic Old English and Irish and secured the supremacy of the Protestant New English settlers. The passing of further Penal Laws, denying Catholics both civil and religious rights, introduced the long period of relative peace that was the eighteenth century and the years of the Protestant Ascendancy.

Naturally one looks in Munster for the earliest of Irish seventeenth-century buildings, and then later in Ulster for the developments in architecture which the Scots settlers brought with them to that province. Practically all domestic buildings erected in the war-torn Ireland of the earlier seventeenth century have some provision for defence; and because those wars so often developed out of religious conflict there is little ecclesiastical architecture or sculpture of note.

The period of the Restoration in England and the arrival in Dublin in 1662 of the Duke of Ormonde as Viceroy marked the beginning of an age which was to be one of the greatest in the history of Irish civilization. The last decades of the seventeenth century saw the rise of buildings in Dublin and elsewhere which were in a new and unsure but nevertheless Classical style, and one finds the same quality in the random remains of carving in both stone and wood which still survive from those years. Finally, with the dawn of this new age painting took its place among the arts in Ireland.

109 The staircase of Eyrecourt, Co. Galway, the richest example of Irish 17th-C. woodwork, carved probably in the 1660s. The house is now ruined, and the staircase is in the Detroit Institute of Arts. In this historic photograph, we are looking from the half-landing down one of the two flights that rise from the hall and then join and turn back as a central bridge (left) to the first floor. Note too the plasterwork of the ceiling, with palm fronds contained in frames and a pendant swag.

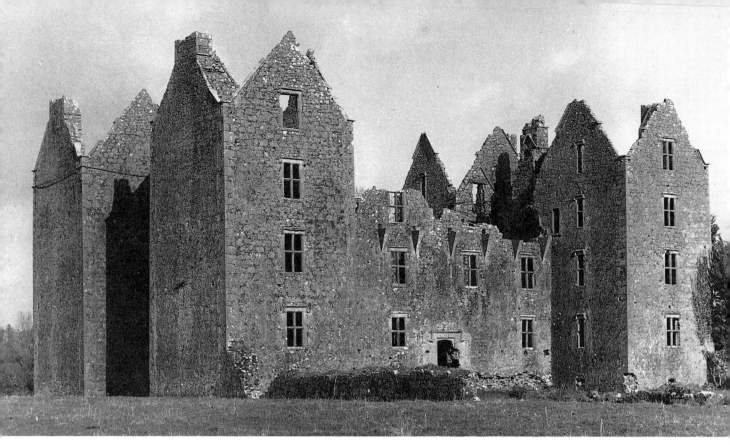

110 Burncourt, Co. Tipperary, built in 1641 and a ruin since 1650.

111 Portumna Castle, Co. Galway, built before 1618, seen from the arch leading into the outer courtyard.

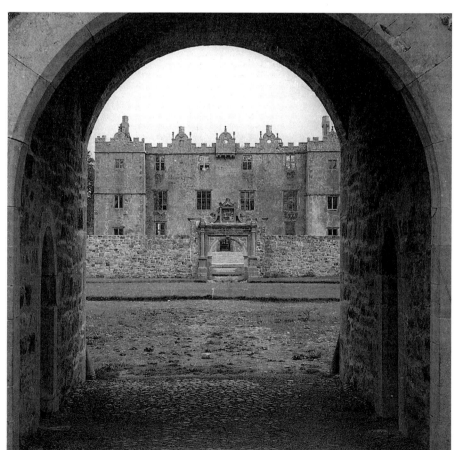

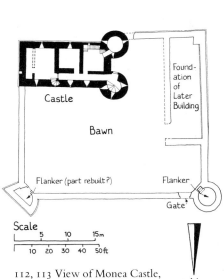

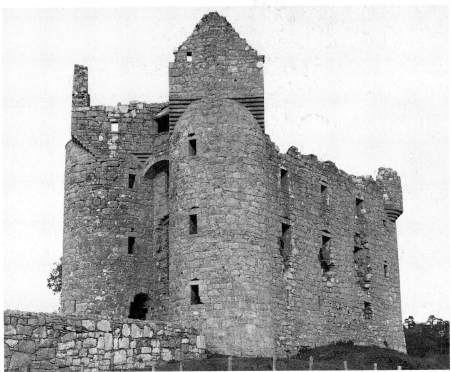

112, 113 View of Monea Castle, Co. Fermanagh, and plan of its complex, 1618–19.

N

ARCHITECTURE

Castles and houses

A number of early seventeenth-century mansions were built as additions to earlier fortified houses. The house of the Earl of Ormond at Carrick-on-Suir, Co. Tipperary (*c.*1600), Donegal Castle (*c.*1616), Lemaneagh, Co. Clare (1643), and others have similar architectural details such as square-headed mullioned windows with hood-moulds, gabled rooflines and chimneystacks often arranged in lozenge-shaped clusters. Houses entirely built in this period generally incorporate some form of defence provisions such as battlements and turrets: a favourite ground plan consists of a rectangular living block which provided domestic comfort with towers at each of the four corners for safety. Kanturk, Co. Cork, built about 1610, and the slightly later Burncourt, Co. Tipperary, are examples of this type. Both have windows with stone mullions and transoms surmounted by hood-moulds. The overall coherence and order which characterize the plans and elevations of these houses demonstrates an advance towards Renaissance architecture. A sophisticated house built on a similar plan is Portumna Castle, Co. Galway, which was erected some time before 1618. The Classical gateway to the courtyard, with its Doric columns, is one of the earliest surviving instances of the use of such motifs in Ireland; and the gables on the skyline are curvilinear in form, in line with contemporary architecture in Jacobean England.

Tower-houses, similar to those erected in earlier centuries, continued to be built in the seventeenth century: Derryhivenny, Co. Galway, as has already been pointed out, dates from as late as 1643.

With the Plantation of Ulster many dwellings were erected in the province which are now referred to as plantation castles. Monea, Co. Fermanagh (1618–19), is both typical and impressive and consists of a rectangular enclosure

or bawn with towers at the corners and a long dwelling house against one of the side walls. As the builders of these plantation castles were mostly Scottish in origin, it is scarcely surprising that several of the architectural details, such as the small round turrets at the tops of walls, are also Scottish in character.

Completely unfortified houses dating from the earlier part of the seventeenth century are rare. Jigginstown, Co. Kildare, now very much ruined, was an enormous long house built in brick with wings at each end. It was optimistically erected some time in the 1630s by the Earl of Strafford, whom Charles I appointed Lord Deputy in Ireland in 1632. A contemporary but much smaller unfortified house was Brazeel, Co. Dublin, which has recently been demolished. It was a simple rectangle with many gables, but of added interest as one of the earliest of Irish houses to have wooden window frames.

Vernacular architecture and churches

The majority of Irish people in the seventeenth century lived in much humbler dwellings than those just described. Some vernacular houses and cottages from the period survive. Built of solid stone or clay, they are generally narrow rectangles in plan, no more than one room deep, with whitewashed walls, small windows and a thatched roof. The type continued to be built with very few 21 modifications in succeeding centuries (see pp. 208–09).

Many Irish churches received additions in the seventeenth century, just as they had done earlier, but complete seventeenth-century churches are rare. Often those which were built in their entirety are in a late Gothic style: examples are Kilbrogan, Bandon, Co. Cork, built in 1610, and more notably Derry Cathedral, which was completed in 1633. More typical of the seventeenth century are the simple barn churches which were erected mainly in the northern part of the country. The most perfect surviving example is that at Upper

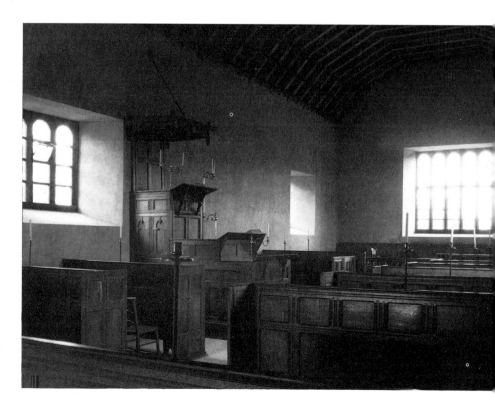

114 The Middle Church at Upper Ballinderry, Co. Antrim, consecrated in 1668. The furnishings are original: on the left is the tall pulpit; in the right background, below the large window, the communion rail and one of the clergy chairs are visible. The Church is still lit by candlelight.

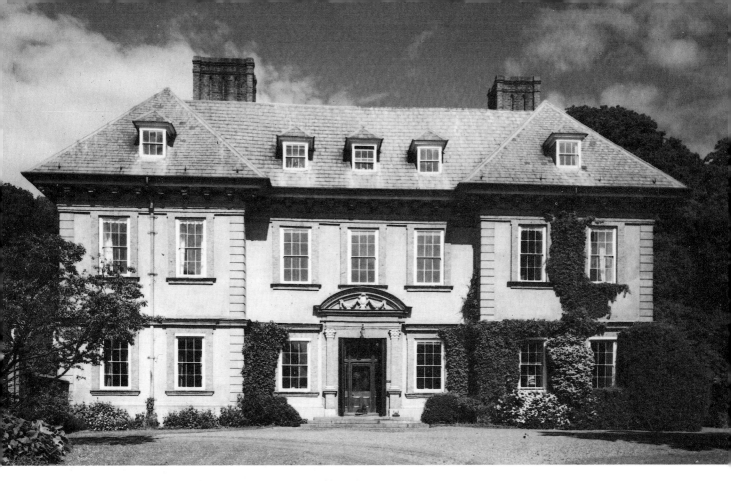

115

115 The entrance front of Beaulieu, Co. Louth, probably built in the 1660s. The window and door-surrounds, cornice and string-course are all of fine red brick.

Ballinderry, Co. Antrim, which was consecrated in 1668. It is rectangular in 114 plan with a gabled roof, simple windows, and no tower or spire but a small bell-turret at one end. In the last decades of the century several Dublin churches were either built or rebuilt and a 'Classical' rather than a Gothic style was favoured. Of these St Michan's, an old foundation which was rebuilt in 1685–86, preserves its seventeenth-century character best. With round-headed windows and a Classical west doorway, it announces that Ireland's ecclesiastical architecture had at last succumbed to the spirit of the Renaissance.

The establishment of Classical architecture

It was only after 1660 that it became common for purely domestic (as opposed to semi-fortified) houses to be built. Some patrons were now definitely conscious of 'Taste', and naturally they looked to neighbouring England for examples of the latest architectural styles. Restoration England favoured a Dutch-inspired house, generally built in red brick, with shaped gables at the roofline or else with a hipped roof containing dormer windows and supported by a large cornice. Window sizes, shapes and positions were made to conform to an overall pattern, and stone mullions and transoms were universally replaced by wood.

Comparatively few of these houses survive. Eyrecourt, Co. Galway, is now a 109 ruin but Beaulieu in Co. Louth, which is thought to have been built in the 1660s, 115 remains as an outstanding example. Here all the new architectural features are present: a hipped roof with dormers supported on a wide eaves cornice, wooden window frames, and red brick used as a building material. The sculpture in the segmental pediment over the door is also Dutch-inspired, as will be seen from the discussion of seventeenth-century sculpture.

A few years later than Beaulieu is Richhill, Co. Armagh. The gabled roofline gives it a Dutch look, and there are other tentative expressions of a Renaissance or Classical style: the string-courses which bind the wings and the centre block, the chaste Doric doorway and the detailing of the chimneystacks. Curved gables also became popular for town houses, which were built – as in Holland – with a single gable facing the street. Such houses, called in Ireland 'Dutch Billys', were built in the Liberties of Dublin and elsewhere.

Architecture gained a new impetus with the building in the 1680s of the Royal Hospital at Kilmainham near Dublin. It is one of the earliest Irish buildings for which a single, named architect, in the modern sense of the word, is known. Sir William Robinson (d. 1712) was Surveyor General in Ireland from 1671, and architect of the massive Charles Fort in Kinsale (begun about 1677). The Royal Hospital, largely completed between 1680 and 1684, was, like its architectural prototype, Les Invalides in Paris, built as a home for retired soldiers: It consists of ranges around four sides of a courtyard. Each of these four ranges is punctuated by a central pedimented projection on the outside, where the three end bays of each side are also made to project; but the strong line of the cornice continues unbroken around the building. On the north or principal front, the central feature is made more powerful still by the fact that Corinthian pilasters rise the height of the building to support the pediment, above which soars a tower and spire. Inside, the courtyard is surrounded on three sides (and part of the fourth) by an open loggia of round-headed arches. Several of the Classical details, such as the Corinthian pilasters which have no bases, are not quite convincing; but nevertheless in the coherence of its plan, the symmetry of its elevations and the use of an order Robinson's design may be said to have provided the first great Classical building in Ireland.

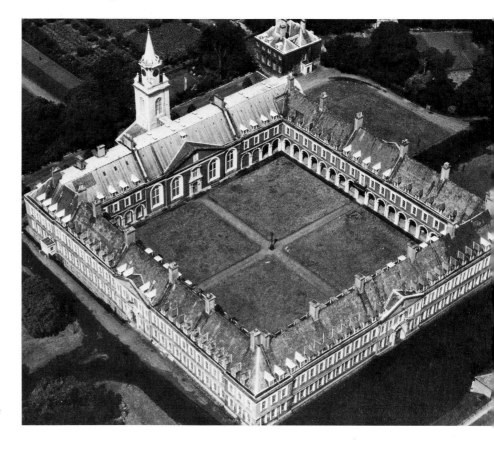

116 Royal Hospital, Kilmainham, Dublin, by Sir William Robinson, mainly built in 1680–84. The hall, in the centre of the north side, is marked by a large pediment and by the tower and spire, completed in 1701. To the right of it is the chapel, to the left the Master's lodgings.

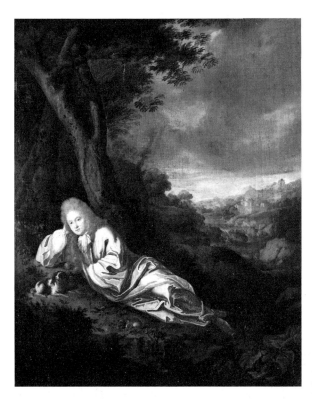

117 Garrett Morphey: *Baron Bellew of Duleek.* 68.6 × 61 cm. (27 × 24 in.). Private Collection.

PAINTING

It is unlikely that many of the inhabitants of the seventeenth-century semi-fortified houses appreciated the aesthetic qualities of painting. Painting developed out of historical rather than æsthetic interest. Thus, portraits of one's ancestors were admired more for whom they represented than for how they were painted, and similarly maps were appreciated because of what they showed – one's territory, one's country, seas to be sailed or lands to be conquered – rather than for how they were drawn. From this primarily historical interest Irish painting developed throughout the eighteenth and nineteenth centuries. An interest in maps led to interest in topography; and from that interest developed the school of landscape painting which will be described later.

The earliest surviving Irish portraits date from the last years of the sixteenth century. Throughout the seventeenth there were isolated attempts at portraiture, both by native painters and by foreign artists visiting the country. Gaspar Smitz (d.1707) was a Dutch artist who worked in Dublin from 1681 probably until his death. Two English painters, John Michael Wright (b.1617) and Joseph Wright (fl. *c.*1690), also seem to have painted portraits in Ireland during these years. A fashionable Dublin portraitist at the time was Thomas Pooley (1646–1723), whose work is mentioned in the correspondence of various contemporaries. It was not until the eighteenth century, however, that there was any consistent development in Irish painting.

Garrett Morphey (fl.1680–1716) and Thomas Bate (fl.1692) are two artists who worked in Ireland in the later years of the seventeenth century. Of the two Morphey is the best known, but their portraits have certain characteristics in common. Morphey's painting of Baron Bellew of Duleek (Private Collection) is 117 strikingly unusual, as the sitter is presented lying in a landscape setting with hauntingly evocative distant views. The portrait is influenced by Dutch paintings of the period, in particular the work of such artists as Caspar Netscher

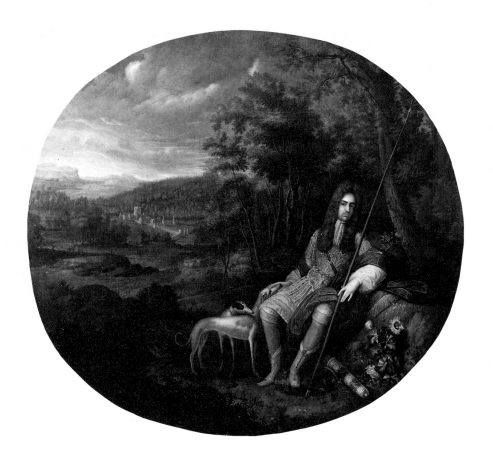

118 Thomas Bate: *Lord Coningsby*, 1692.
76.2 × 87.6 cm. (30 × 34½ in.). Ulster
Museum, Belfast.

and Adrian van der Werff. Morphey was almost certainly familiar with the
traditions of Dutch painting, for his teacher, probably in Dublin, was Gaspar
Smitz. Smitz himself was famous for his paintings of Penitent Magdalens (so
much so that he was referred to as 'Magdalen Smith'); and in looking at the
painting of Baron Bellew it is not difficult to see its compositional relationship to
paintings of the Penitent Magdalen by any number of artists. The composition
was also popular in English Elizabethan and Jacobean miniatures a century
earlier, and was again adopted by Romantic portraitists at the end of the
eighteenth century. In the portrait of Lord Coningsby by Thomas Bate (Ulster 118
Museum), of 1692, one sees something of the same evocative Romantic quality.
Lord Coningsby is out hunting and rests a moment under a tree, leaving his
quiver on the ground. To the left is a distant view of Lord Coningsby's castle.
Thomas Bate, who is recorded as having 'lived mostly in Ireland', is little known,
but he was most probably a miniaturist.

SCULPTURE

As in preceding centuries, sculpture was used for commemorative and
decorative purposes. Religious sculpture became less important, and whereas
decorative sculpture dating from earlier periods is found generally in churches
and abbeys, one invariably finds that of the seventeenth century in private houses
and castles. Coats-of-arms, door-surrounds and in particular chimneypieces
provide examples of the sculptor's work; and in these details one finds a growing
awareness of Classical or Renaissance style.

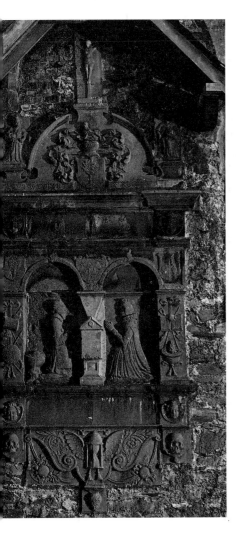

In the field of commemorative sculpture traditional concepts still applied. The deceased is shown in effigy, and his mourners are also represented on the tomb. But those earlier knights in armour recumbent on their backs now always raise 91 themselves up, and lean on their elbow or kneel in prayer. Similarly their 'weepers', now dressed in contemporary costume, emerge from their Gothic niches, and kneel, life-like, also in prayer. In the seventeenth century these weepers are not the bishops, Apostles and saints they were on earlier tombs, but 94 are the children and wives of the deceased. Gothic architecture is replaced by Renaissance, and as the century progressed the use of Renaissance ornament, first noticed in some sixteenth-century tombs such as that of Bishop Wellesly in 93 Kildare Cathedral, gathered momentum.

The most splendid seventeenth-century tomb in Ireland is undoubtedly that 120 erected shortly after 1614, in Carrickfergus Church, Co. Antrim, to commemorate Sir Arthur Chichester. Its sculptor is unknown, but such is the sophistication of both the design and the carving that he cannot have been native, and the tomb is quite unlike anything else in the country. The monument to the Great Earl of Cork in Youghal Church, Co. Cork, completed in 1620 by the 123 sculptor Alexander Hills of Holborn, London, was also imported. The Gothic architectural frame of earlier monuments is here replaced by a Classical one with Ionic and Corinthian columns, niches and obelisks. Lord Cork is represented, not as dead, but as alive: wearing his peer's robes, he lies comfortably in an attitude of reflection. He is surrounded by his first and second wives (on either side), his mother-in-law (above) and his children (below).

Less wealthy families had more modest tombs, which, rather than standing on the ground, are sometimes attached to the wall of a church; but they are designed in the Jacobean manner of the Youghal tomb. The monument to O'Connor Don in Sligo Abbey shows the deceased kneeling at a fald-stool facing his wife. 119 The monument is probably by an Irish sculptor, and though it dates from 1624, and is thus four years later than the Cork tomb, it is much more old-fashioned. The cherub's head on the memorial symbolizes immortality, the skull

119 Monument to O'Connor Don in Sligo Abbey, 1624.

120 Sir Arthur Chichester (d. 1625) and his wife, on their monument in St Nicholas's, Carrickfergus, Co. Antrim, made by an unknown sculptor probably in England and erected *c.* 1614.

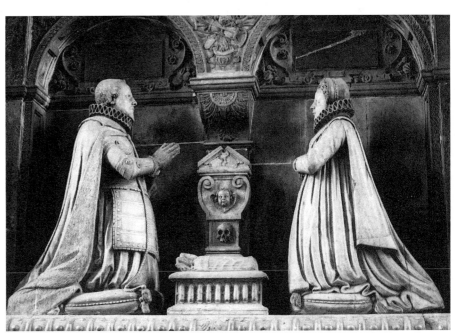

121 Memorial to Joseph Cuffe (d. 1679) in Castleinch mausoleum, Co. Kilkenny.

death, the winged hour-glass the swift passage of time, or life running out, and the bunch of grapes redemption.

In many seventeenth-century castles there are the remains of carved doorcases and elaborately designed chimneypieces. That in Donegal Castle (c.1616) is, like contemporary tombs, strongly architectural. Indeed Renaissance architecture 122 and ornament were introduced to Britain and Ireland first and foremost as a form of decoration rather than as an overall style for an entire building. In the Donegal chimneypiece there are architectural details such as pilasters, cornices and consoles. The strapwork (carved decoration recalling curling or plaited straps) supporting the coats-of-arms is a particularly Jacobean feature. It is seen again in the decorative plaster frieze of the great hall in Carrick-on-Suir Castle. Other surviving seventeenth-century plasterwork is in the chapel at Bunratty, Co. Clare. A more ambitious chimneypiece than that in Donegal Castle comes from Oldbawn, Tallaght, Co. Dublin, and is now in the National Museum of Ireland. It dates from about 1635 and is in plaster with miniature full-length figures almost in the round and a bas-relief of the rebuilding of the walls of Jerusalem.

The Dutch influence which inspired the red brick gabled houses of seventeenth-century Ireland also made an impact on sculpture. Carving became more lively, and in a work such as the memorial to Joseph Cuffe (c.1679) at Castleinch, Co. Kilkenny, foliated scrollwork at the sides replaces the strapwork 121 found in earlier carving. The design of this memorial is much surer, with highly decorative Corinthian columns supporting an entablature which is correctly

122 Chimneypiece in the ruined great hall of Donegal Castle, c. 1616.

123 *Opposite* Alexander Hills: monument erected by the Earl of Cork (d. 1643) to himself and his family, in Youghal Church, Co. Cork, completed in 1620. The Earl reclines in the centre, below his family tree.

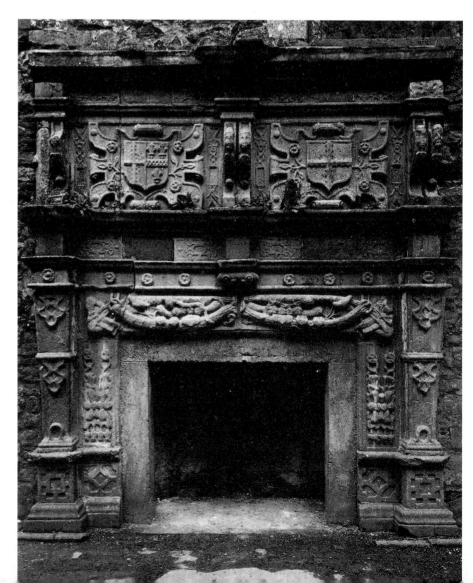

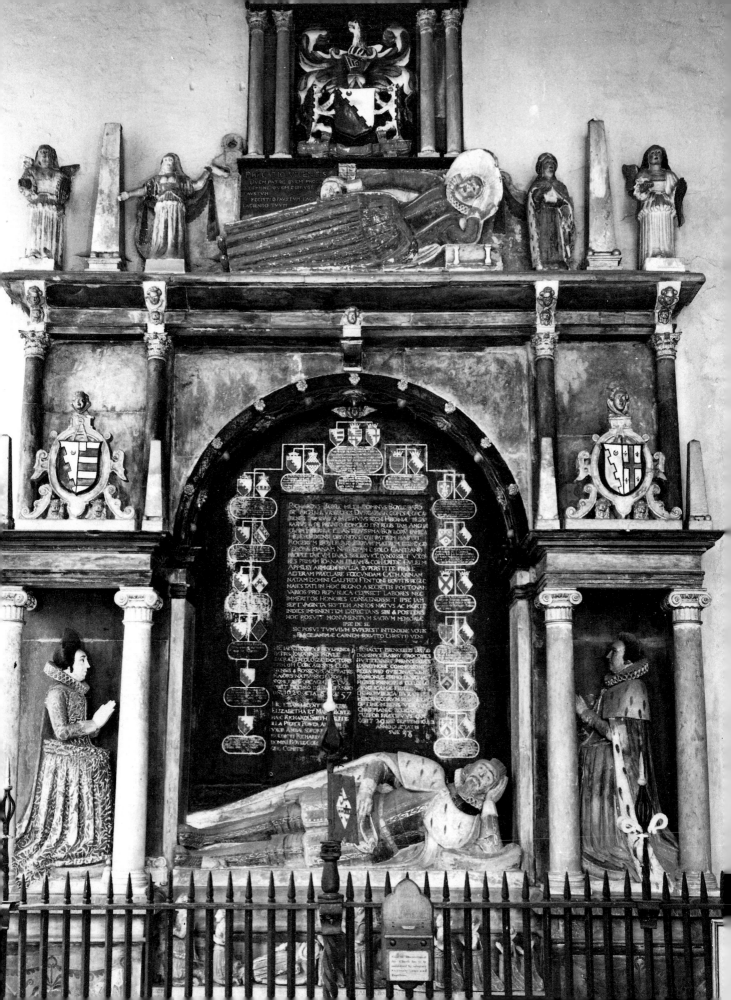

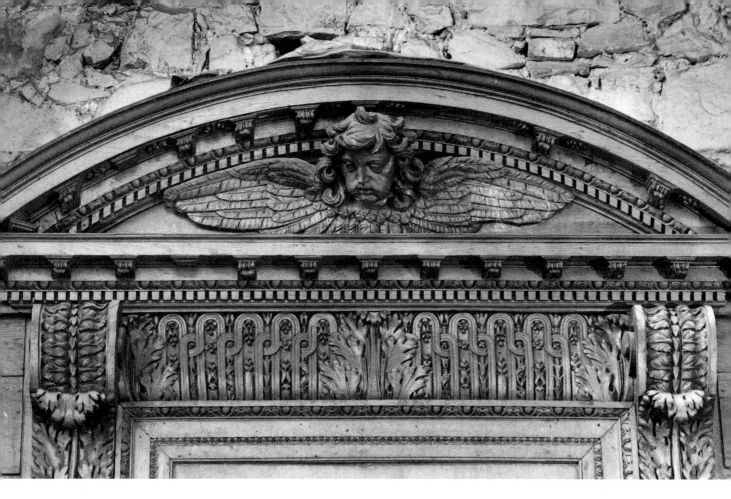

124 Woodcarving over a door in the chapel of the Royal Hospital, Kilmainham, Dublin (see ill. 116), probably by a Huguenot craftsman working in Dublin, James Tabary.

proportioned, and, the ultimate sophistication for the period, a swan-necked open pediment with recumbent Classical figures and a coat-of-arms. Although the carving of the monument is relatively provincial, it does convey a much greater sense of movement than earlier sculpture, and as such prepares the way for the Baroque tombs of the succeeding decades.

Sculpted swags of fruit and flowers, executed in both wood and stone and carved in the most naturalistic fashion, became popular in the later seventeenth century and may be seen in the chapel of the Royal Hospital at Kilmainham, and also in the pediment over the front door at Beaulieu. The most sumptuous surviving example of this type of carving is probably the staircase from the ruined Eyrecourt, which is now in the Detroit Institute of Arts.

124

109

125

125 Grotesque faces on the stair at Eyrecourt, Co. Galway, carved in the 1660s (photographed before dismantling: see ill. 109). The central head recalls those seen on Irish Georgian furniture (ill. 192).

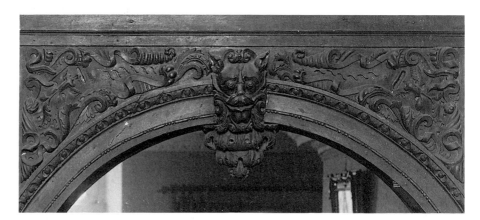

THE EIGHTEENTH CENTURY

During the eighteenth century the Irish Parliament met regularly in Dublin for the first time. But it was a Protestant parliament, and, moreover, its legislation was subject to approval from Westminster – a factor which led to discontent on the part of many of the Irish members. Restrictions on Irish trade and manufactures in the period were also a source of dissatisfaction. The fear of a French invasion in the 1770s led to the formation of groups of Protestant volunteers who took up arms in preparation for the country's defence. As the likelihood of a French attack receded the Volunteers applied themselves to the **32** causes of Free Trade and legislative independence. In 1779–80 many of the restrictions on Irish trade were removed and in 1782 the British Parliament renounced its powers to veto Irish laws. The last years of the century, the years of Grattan's Parliament, saw an increase in Ireland's prosperity. But still further reforms in Parliament were sought, in particular those which would give similar rights to both Catholics and Protestants. Inspired by the success of the French Revolution, the United Irishmen formed to pursue those rights, a pursuit which led to the Rebellion of 1798 and ultimately to the Act of Union in 1800. Thereafter Irish MPs travelled to London, and their magnificent Parliament 126, House became a bank. 145

Ireland's prosperity in the eighteenth century depended largely on the linen, wool and provisions trades. Encouraged by the government in England, the linen industry developed particularly in such northern towns as Derry, Dundalk, Banbridge, Belfast and Coleraine. Until 1785, when a linen-hall was opened in Belfast, most linen was exported to England through Dublin. Woollen yarn, mainly from such towns in the south as Carrick, Clonmel, Bandon, Kilkenny and Carlow, was also exported to England. The export of provisions, particularly salted beef and pork in enormous quantities from the southern ports of Cork, Waterford and Limerick to Europe and the West Indies, developed with the prohibition of live exports to England.

Evidence, first of all of Ireland's peace and then of her prosperity in the eighteenth century, is supplied by the art and architecture of the time. Not only in the major cities of Dublin, Cork, Waterford and Limerick but also in smaller towns throughout the country one finds a market house here, a fine street there or some other edifice which reflects the wealth and elegance of the age. Patronage of the arts (including architecture) was for the most part in the hands of the rich Protestant minority, but, with the exception of architects, the artists and craftsmen were almost exclusively native Irish. In the fields of painting and sculpture many Irish artists emigrated, attracted by the prospect of success in London or Rome.

One body in particular, the Dublin Society, contributed much to Ireland's eighteenth-century civilization. It was founded in 1731 for the improvement of 'Husbandry, Manufactures and other Useful Arts' in Ireland and by sponsoring research and awarding premiums it encouraged any number of industries and crafts from fish-curing and fruit-growing to tapestry-weaving and delft-manufacture. It also established a drawing school in which, as will be seen, most Irish artists and architects received their initial training.

ARCHITECTURE

Palladianism

The Classical style of architecture, evolved in Renaissance Italy, was interpreted by many architects in the most liberal fashion by the late seventeenth century. Classical motifs were used in a great variety of ways, and very often bore little resemblance to their original prototypes. At the beginning of the eighteenth century a reaction to this abuse set in and artists strove for a purer interpretation of Classical idiom. A new style was evolved, referred to in the case of English and Irish architecture as Palladianism. Andrea Palladio (who lived and worked near Vicenza in northern Italy in the mid-sixteenth century) had studied and measured the remains of antique buildings and had published his findings, together with his own architectural designs, in a book, *I quattro libri dell'architettura* (The four books of architecture) in 1570. Together with other sixteenth-century books on ancient Roman architecture, it was used as the manual for the new purified Classical manner. Another source of the Palladian style was the work of the English architect Inigo Jones (1573–1652), who had visited Italy and looked at both Roman buildings and works by Palladio. The chief protagonists of the style in England were Lord Burlington (1694–1753) and Colen Campbell (d.1729), and it was the architecture which they and others evolved which spread to Ireland in the early years of the eighteenth century.

The Palladian style was used more often for country than town houses, and many of the features adopted from Palladio's own architecture are those that he had employed in designs for country houses or villas. One of the earliest Palladian houses in Ireland is of the villa type. It is Bellamont Forest, Co. Cavan, 127 which was designed about 1730 by Sir Edward Lovett Pearce (?1699–1733). Bellamont has two stories above a basement and, as in the case of contemporary

126 The Parliament House (now Bank of Ireland), Dublin, by Sir Edward Lovett Pearce, 1729–39. James Malton's aquatint of 1793 shows the grand colonnaded front, and conceals the curved wings added after Pearce's time (see ill. 145). On the right is the Palladian façade of Trinity College, built in the 1750s to the designs of Theodore Jacobson.

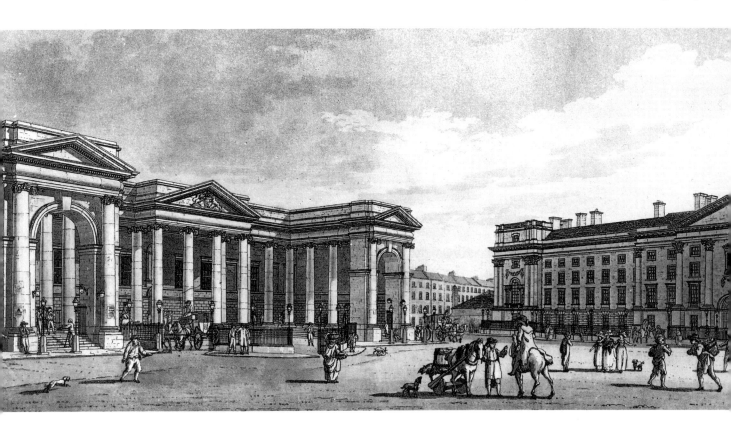

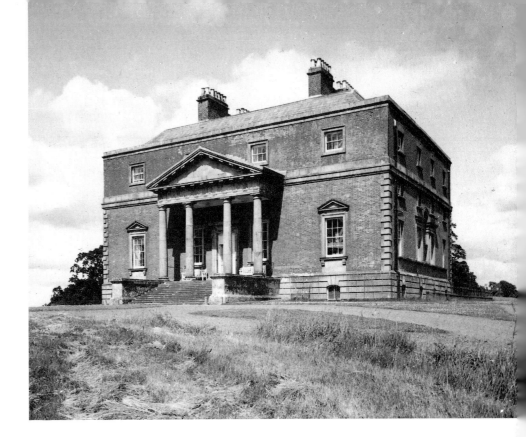

127 The entrance front of Bellamont Forest, Co. Cavan, by Pearce, c. 1730.

English 'villas', emphasis is placed upon the horizontal divisions of the elevations. The basement is rusticated and a deep string-course divides the top floor from the *piano nobile*, the principal floor. A pedimented Doric portico is the centrepiece of the five-bay façade and is flanked by pedimented windows supported by consoles. On the return walls of the house, which are four bays wide, Pearce has joined the two central windows of the principal floor so that they loosely resemble a Venetian or Palladian window, that is a tripartite opening, round-headed in the centre and flat-topped at the sides. This is a motif adopted by many eighteenth-century architects and found on Georgian houses throughout the country. Pearce's variant of the theme, which was taken up by later architects including Richard Castle (at Bellinter and elsewhere), has a blank niche in the centre. Inside, the hall, which rises through a mezzanine floor, is top-lit by a cupola, and surrounded on three sides by the principal rooms of the house.

Pearce, whose father was a first cousin of the English architect Sir John Vanbrugh, was descended on his mother's side from an Irish family. He travelled in Italy in the early 1720s, had contact with Lord Burlington in London, and by 1726 was settled in Ireland where he became the most important Palladian architect of his day. Apart from Bellamont, he designed Cashel Palace, Co. Tipperary (c.1731), and was associated with the building of Castletown, Co. Kildare; but his most famous building was the Parliament House (now the Bank of Ireland) in Dublin. Built between 1729 and 1739, it is the earliest large-scale Palladian public building in all Britain and Ireland. Its assertive grandeur, with a splendid piazza-forecourt surrounded on three sides by Ionic colonnades, proclaims the confidence of the Irish ruling class – a confidence which during the course of the century to come was to make Dublin one of the very finest cities in Europe.

Castletown, Co. Kildare, was the largest house ever built in Ireland at the time of its construction in the late 1720s. Its scale was an indication of things to come,

126, 145

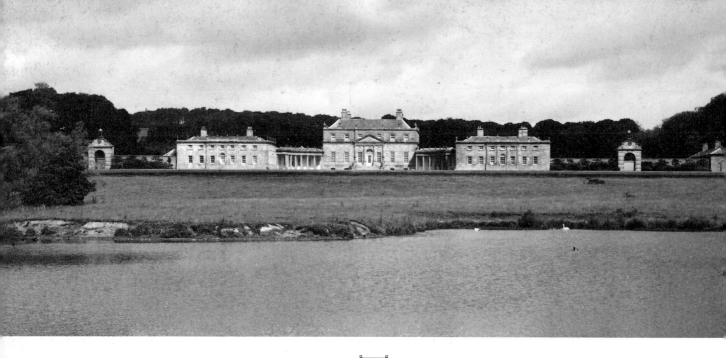

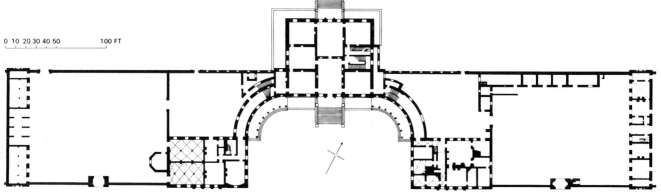

128, 129 Russborough, Co. Wicklow, by Richard Castle, 1742. The end pavilions (one of them hidden by the trees on the left in the photograph) served as kitchen and stable block.

130 The saloon at Carton, Co. Kildare, part of the house rebuilt by Richard Castle in 1739–45. The plasterwork of the ceiling, executed by the Francini brothers in 1739, includes *putti*, busts, and groups representing the Loves of the Gods: in the centre above the organ are Venus and Mars (see ill. 189).

for in the first half of the eighteenth century a remarkable number of enormous country palaces were created (often by magnificent alterations to existing houses) throughout the country. Of these, Westport, Co. Mayo (designed in 1731), Powerscourt, Co. Wicklow (1731), Carton, Co. Kildare (1739), 13 Russborough, Co. Wicklow (1742), and Bellinter, Co. Meath (1750), were designed by Richard Castle (d.1751), a German-born architect who was almost certainly brought by Sir Edward Lovett Pearce to Ireland. Russborough, an 12 immense Palladian complex, is the grandest of Castle's buildings. It consists of a 12 central block connected to flanking pavilions by quadrant colonnades. The layout is extended further by two additional buildings which are linked to the pavilions by straight walls with arched entrances as centrepieces. The façade of the main house has the same emphasis on horizontals as was found in Pearce's 12 Bellamont.

A portico which does not project but is applied to the façade of the building, as at Russborough, is a feature of several of Castle's buildings, including Leinster 26 House (1745) and the Rotunda Hospital (1751) in Dublin. In both, Castle 13 continues the basic three-storey formula of the Palladian type; the effect of the ground storey being the weight-bearing floor of the building is created by rustication. The Rotunda, which takes its name from the round room attached to it (built by John Ensor in 1764 and modified by Gandon in 1786) where

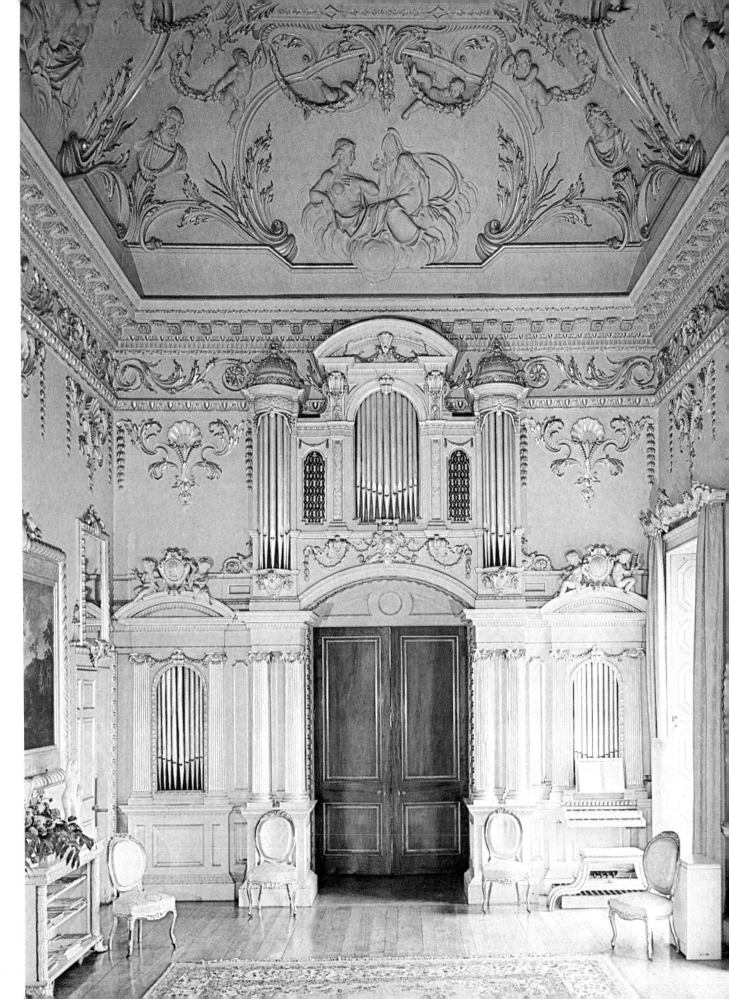

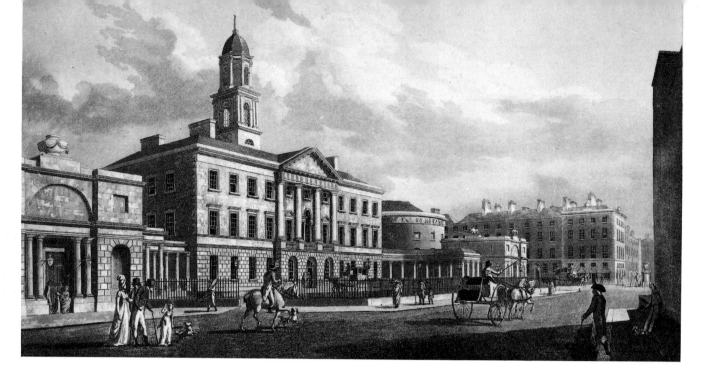

The complex of the Lying-in or
Rotunda Hospital in Dublin, seen in an
aquatint of 1795 by James Malton, before
the raising of the left-hand wing. In the
centre is the hospital with its curving
colonnades, designed by Richard Castle in
1751; beyond it is the Rotunda, built by
John Ensor in 1764 and given its external
appearance by James Gandon in 1786. In
the distance are typical Georgian houses,
some of which survive in what is now the
corner of Parnell Street and Parnell Square.

assemblies that financed the hospital were held, is surmounted by a three-storey
tower and cupola. This feature, with Ionic pilasters and Corinthian attached
columns, proclaims the public nature of the building.

A native Palladian architect was Francis Bindon (c.1690–1765), who was also
an undistinguished portrait painter. It was probably he who in 1731 designed
Furness, Co. Kildare, a house which is on a much more modest scale than the 132
palaces of Richard Castle, but nevertheless has a small three-bay, three-storey,
central block connected by straight walls to two-storey wings. The complex is
extended further on either side by quadrant-linked stable and kitchen buildings.
The coupled columns on either side of the door supporting an entablature (but not
a pediment) are a motif associated with Bindon's houses.

Palladian architecture remained popular in Ireland until late in the century.
Colganstown, Co. Dublin, was built in the 1760s and was possibly designed by 133
the gentleman-architect and friend of Castle, Nathaniel Clements (1705–77).
Colganstown is an example of a type of Palladian complex quite common in
Ireland, in which farm buildings are linked to the main residence, as the pavilions
are in grander houses. Such a design, referred to as an 'economic layout', is found
in the work of Palladio but not in the buildings of any of the English Palladians.
In Ireland several of the houses thought to have been designed by Nathaniel
Clements, including Newberry Hall (1760s), Williamstown (c.1760–65) and
Lodge Park (1775–77), all in Co. Kildare, were planned in this way. The central
block of Colganstown consists of two storeys above a basement and has a three-
bay façade, the central bay of which projects. A feature of the façade, also found
on other houses associated with Clements, is the Diocletian or thermal window,
segmental in shape and tripartite. It is a fitting complement to the Venetian
window arrangement of the door.

The last Palladian architect in Ireland was a Sardinian, Davis Duckart
(d. c.1785), who arrived in the 1760s and designed several houses in the
Cork/Limerick area – among them Kilshannig, Co. Cork (c.1766), and the
former Mayoralty House in Cork City (completed in 1773 and now the Mercy
Hospital). His first known commission was for the Limerick Customs House in 13.
1765. The building is basically Palladian in style with a five-bay façade of two
storeys above a heavily rusticated ground floor. A sense of grandeur is created by

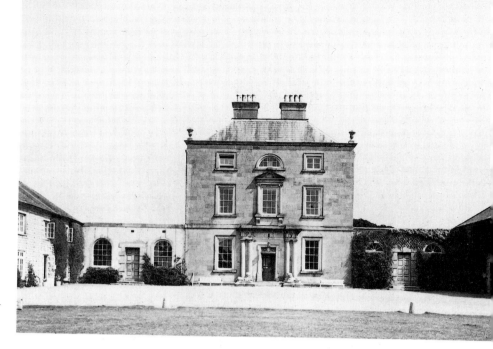

132 Furness, Co. Kildare, designed in 1731 probably by Francis Bindon. (A later upper storey on the left has been touched out, to restore the house's original appearance.)

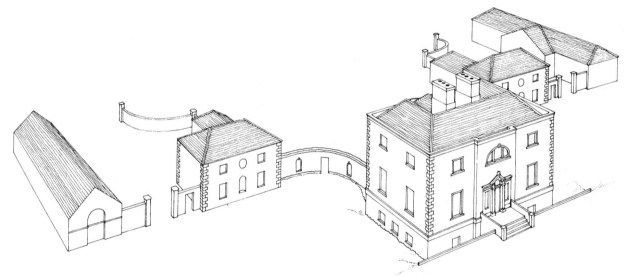

133 An 'economic layout' of house and farm-buildings, arranged in Palladian symmetrical form: Colganstown, Co. Dublin, designed in the 1760s perhaps by Nathaniel Clements. (Drawn by Maurice Craig and Derry O'Connell)

134 Limerick Customs House, by Davis Duckart, 1765–69.

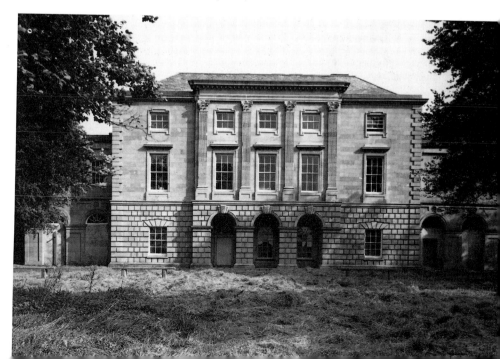

the three-bay pilaster frontispiece – a motif much favoured by Duckart. It is here carried on arches, but it appears in other forms at Kilshannig and Castletown Cox, Co. Kilkenny (*c*.1767).

Palladianism to Neo-Classicism

In the period between Castle's death in 1751 and about 1769 no single architect monopolized the profession in the way that he had done. The architectural and building professions in Dublin were dominated by several families, notably the Darleys, the Semples and the Ensors, who were responsible for the building of the red-brick streets and squares which to this day give the city its character. 142

The Palladian tradition was kept alive in the Dublin work of a native architect, John Smyth (fl.1758–69). Smyth looked directly to Palladio for models for the church of St Thomas in Marlborough Street (1758–62, destroyed in 1922) and the Provost's House of Trinity College (1759). St Thomas's was based on Palladio's design for the church of the Redentore in Venice, and the Provost's House on a design by Palladio which had been used by Lord Burlington for a house for General Wade in London earlier in the century. Less strict adherence to Palladio's buildings is noticed in the work of other architects.

The central block of the Blue Coat School in Dublin (1773) by Thomas Ivory 135 (*c*.1732–86) repeats several of the features found on the Palladian façade of Castle's Rotunda Hospital of some twenty years earlier. The school is essentially a 131 Palladian complex of central block with quadrant links and flanking wings, in this case used as a chapel and schoolroom. Ivory's unexecuted design for the central tower (illustrated by Malton) was, however, not Palladian, and owed more to English Baroque architecture: it is noticeably more complex and richer than the Rotunda tower. Rustication is carried through the central block, links and wings, where it is broken only in the central bay. Round-headed niches which puncture the rustication of the central block are repeated in the link walls; and the *oeil-de-boeuf* windows in the towers are recalled by the oval niches in the wings. Balustrades under the windows support a string-course which runs the length of the building. The façades of the wings complement in their general arrangement that of the central block; but they are very different in spirit, and that they are intended to be seen as such seems indicated by the fact that the link walls return before joining them. The wings also contain new and unfamiliar details: blank niches on the principal floor, windows without mouldings, and decorative niches with swags, similarly severe in outline.

These details herald the style which was to replace Palladianism in the last decades of the century. The new style, called Neo-Classicism, was also based on Classical architecture, and, to an extent, on the Palladian style which preceded it. The pavilions reveal Ivory's concern for the massing of forms: their façades are composed of three blocks which fit together, an effect created by the projection of the central bay and the lack of rustication on its base. The architect's interest in form is further expressed in his puncturing of the façade with various recesses, including the relieving arch which surrounds the central window. The resulting building is at the same time both more monumental and more decorative than a Palladian building.

Whereas Palladian architects had looked to Palladio's interpretation of antiquity and to the architecture of sixteenth-century Italy, Neo-Classical architects looked directly to ancient Rome. They were assisted in this by the increased number of Classical antiquities which were engraved and published in books from the mid-century onwards. The most popular of these illustrations were by the architect and artist Giambattista Piranesi (1720–78), who worked

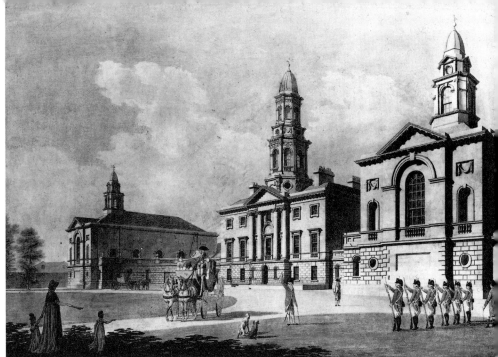

135 The Blue Coat School, Dublin, by Thomas Ivory, 1773–80. This watercolour by James Malton includes the unexecuted design for the central tower. On the left was the schoolroom, on the right the chapel; the central block contained offices and apartments for the school's administrators. (52.1 × 74.9 cm. (20½ × 29½ in.). National Gallery of Ireland)

in Rome. Architects derived antique motifs from his etchings and those of others. Thus a building such as the Temple of Vesta at Tivoli was the basis for the Mussenden Temple at Downhill, Co. Derry, by Michael Shanahan (fl.1770–95), and the dome of the Pantheon in Rome lies behind the design of the dome on Gandon's Four Courts in Dublin. A Roman triumphal arch, like the Arch of Constantine, was also a popular motif, and appears adapted as the north portico of the Custom House in Dublin. In addition to this use of engravings, some architects (and some of their patrons as well) actually visited Rome. This was the age of the Grand Tour, when many young gentlemen completed their education by travel on the Continent. The tour often lasted several years, and Rome was always the principal stop.

An Irishman, Lord Charlemont, returned to Ireland in the 1750s from Rome where he had been painted by Pompeo Batoni in much the same guise as Robert Fagan painted Sir George Wright – that is, as a cultured young connoisseur with an antique Roman building in the background indicating his interest in, and appreciation of, such things. Charlemont indeed knew Piranesi, whose *Antichità Romane* was originally dedicated to him. It is not surprising that when Charlemont, Wright and others returned from the Grand Tour they would want to build on their own estates buildings which approximated in style to what they had seen in Italy. Charlemont commissioned the most prominent English architect of the day, Sir William Chambers (1723–96), to design for him a town house in Dublin and a villa in the country nearby. The town house (1762), now the Hugh Lane Municipal Gallery, is in Parnell Square; the villa, known as the Marino Casino, is at Clontarf.

The Marino Casino was built mainly during the 1760s and is quite unlike any building hitherto erected in Ireland. It was built more for the joy, on the part of both the architect and his patron, of creating an architectural gem than for any practical purpose, and like most gems it was very expensive. It is, in fact, considerably larger than it at first appears, for there is a second storey above the cornice. In plan it consists of a Greek cross inscribed in a Doric colonnade. It sits upon a podium which is stepped on the north and south sides and balustraded on the east and west. The columns support a heavy entablature which is pedi-

138

161

137,
172,
178

mented on two sides, with an attic storey running from north to south. The building is obsessively architectural, with rusticated walls providing a foil for the columns and superb decorative carvings (by Simon Vierpyl: see p. 174). From every side and every angle it is just as perfect. 178

The influence of English Neo-Classicism on Irish architecture is clear in the work of an architect such as Ivory. His Blue Coat School combined both 135 Palladian and Neo-Classical elements, but his later Newcomen's Bank in Dublin (c.1781) is more simply Neo-Classical, with sheer walls punctuated by windows within relieving arches (as on the wings of the Blue Coat School) and decorative effects such as a frieze of swags below the balustrade on the roofline.

When a new Royal Exchange was required in Dublin in 1769, no native architect was sufficiently prominent to secure the commission. A competition was organized and architects in England and Ireland were asked to submit designs, the best of which would be rewarded by a prize and the commission. The competition was won by an Englishman, Thomas Cooley (1740–84), who came to Dublin to see his design executed and remained in Ireland for the rest of his relatively short life. Some of the features of Cooley's Royal Exchange (now the City Hall) are similar to those which Chambers employed at the Marino Casino: the emphatic use of both free-standing columns and pilasters (here running through two storeys), and rustication of the main wall of the building which in turn emphasizes the placing of the orders. The interior was a particularly remarkable Neo-Classical design, with a circular hall surrounded by 136 columns supporting a deep entablature with a coffered dome rising above. Almost as important as the building itself, in the introduction of Neo-Classicism into Ireland, were the other unsuccessful competition designs: they were put on public exhibition, and patrons and architects alike were able to see at first hand the latest in architectural ideas from England. Cooley did other work in Dublin, including a Public Offices building which was later incorporated in Gandon's Four Courts. He was also employed extensively by Primate Robinson in

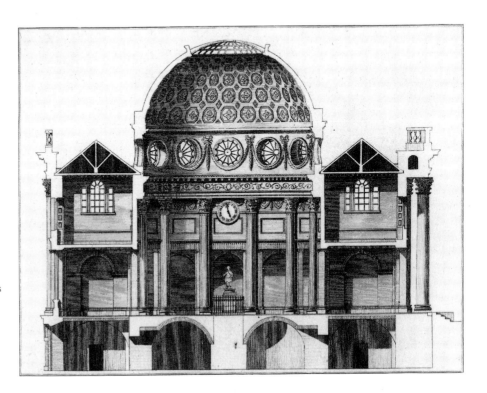

136 Section from east to west of the Royal Exchange (now the City Hall), Dublin, built by Thomas Cooley in 1769. In the centre is the domed hall where business was transacted (the statue is that of George III by Van Nost: see ill. 176); upstairs, a room on the west where merchants kept samples was balanced by a committee room on the east. (R. Pool and J. Cash, *Views of the most remarkable Public Buildings . . . in the City of Dublin*, 1780)

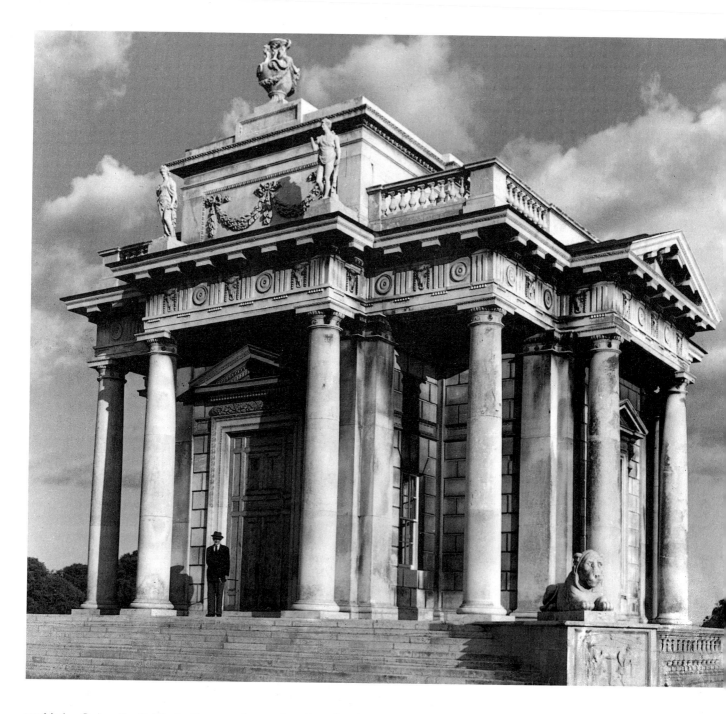

137 Marino Casino, Co. Dublin, by Sir William Chambers, begun by 1759. The sculpture, by Simon Vierpyl (see p. 174), includes urns on the skyline – a ruse to disguise the chimneys, needed in the north but without Classical precedent.

Armagh, where he designed the Archbishop's Palace (1770), the Royal School (1774) and the Palace chapel (1781).

James Gandon

James Gandon (1743–1823) was born in London and trained in the office of Sir William Chambers, before coming to Dublin in 1781 to build the Custom House. He remained to design, among other buildings, the Four Courts (1786) and the King's Inns (planned in 1795), and to add to Pearce's Parliament House by creating a portico facing College Street for the House of Lords (1785). He is

therefore the great architect of eighteenth-century Dublin. The south façade of the Custom House, facing the river, is long and continuous and articulated by having its central and end bays slightly projecting. Further variety is achieved by the use of columns both free-standing and recessed, the use of an attic storey in the centre, and the superb skyline sculptures by Edward Smyth at each end (and originally above the portico as well). A dome supported by a columned drum, slender in effect and Baroque in inspiration (it is in fact derived from similar towers at Greenwich Hospital by Sir Christopher Wren), rises, perhaps uneasily, above the building. 139 181

The Four Courts by comparison is much more massive. A square central block contains a great circular domed hall with the four courts opening off it on the diagonal axes of the square. This block is flanked by wings to which it is linked by arcaded screens with triumphal arches as centrepieces. Gandon started work on the Four Courts in 1786. He inherited from Cooley (who had died in 1784) a Public Offices building which he modified to form the west wing, and duplicated as an east wing, of the courts block. The edifice has a stark awe-inspiring quality not found in the earlier buildings which have been described. The great brooding dome achieves its effect by the huge columned drum – the dome part in fact is but a saucer; and the niches in the central block almost appear as though they had been excavated in the walls after the building was completed. This part of the façade is also derived from Wren and closely resembles the lower part of the west front of St Paul's Cathedral in London. 138

Outside Dublin Gandon's most important designs, dating from 1784, were for a courthouse and gaol in Waterford (now demolished). He also designed some

138 The Four Courts, Dublin: the wing on the left is part of the Public Offices building begun by Cooley in 1777; after 1786 Gandon duplicated it on the right and filled the centre with his monumental courts building. The photograph shows the building before its bombardment in 1922 and subsequent rebuilding.

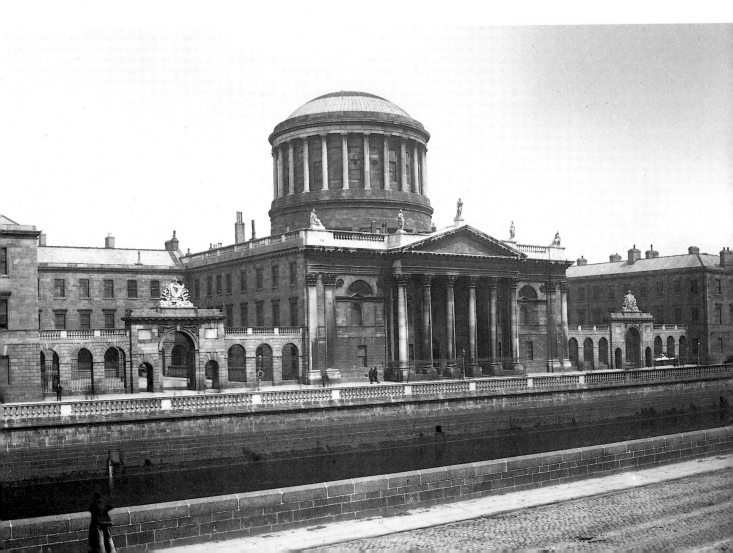

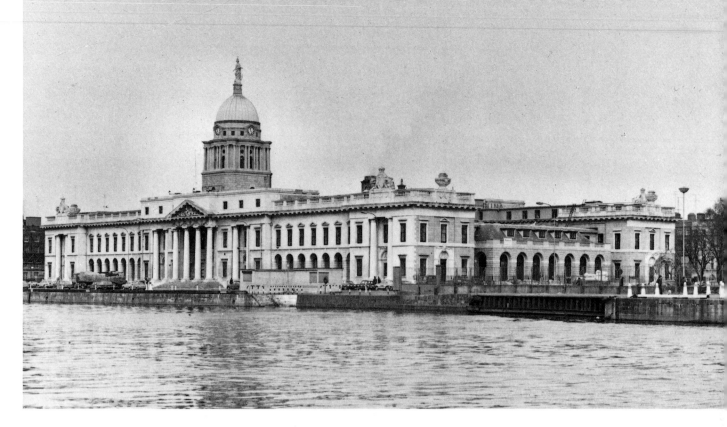

139 The Custom House, Dublin, by James Gandon, begun in 1781.

houses, generally for earlier patrons and friends, including Abbeville at Malahide, Co. Dublin, for John Beresford who had helped persuade him to come to Ireland in the first place, Sandymount Park, Dublin, for his friend the painter William Ashford, and Emo Court, Co. Laois (c.1790). He died in 1823 172 aged eighty at his house, Canonbrook, Lucan, Co. Dublin.

Country houses of the late eighteenth century

In contrast to the large country palaces which Richard Castle had designed in the 1740s, Irish country houses dating from the later part of the century are on a much smaller scale. Subsequent to his work for Lord Charlemont, William Chambers provided designs for alterations and renovations to existing houses and plans for Lucan House, Co. Dublin. Thomas Ivory designed country houses of which Kilcarty, Co. Meath (1770–80), an individual and ingenious 'economic layout', is an example. However, his contribution to domestic architecture lay more in his role as Master of the Dublin Society's Schools of Architecture. He was appointed in about 1759 and it is known that the school was well attended from the start. The work of his pupils remains for the most part anonymous; but as they came from all parts of Ireland, it is to be expected that they had a hand in the designing of many of the more modest late eighteenth-century houses found throughout the country. These are generally of two storeys above a basement, with a three-bay façade and a hipped roof. Classical motifs, if they exist at all, are generally limited to decorative window and door surrounds and possibly a Venetian window adapted as a front door. Most of the glebe houses which were built throughout Ireland by the Protestant Church as residences in the late eighteenth and early nineteenth centuries are of this type.

Many of the more important architectural commissions of the late eighteenth century consisted in the modification of an older house, and the architect most

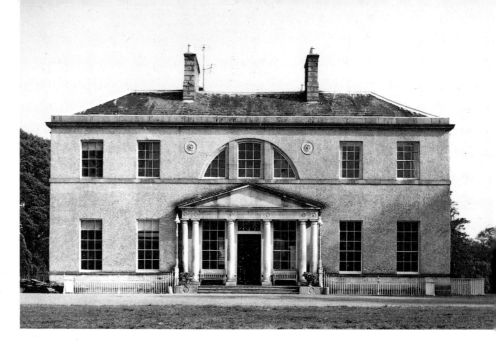

140 Mount Kennedy, Co. Wicklow, designed by James Wyatt in 1772 and built about ten years later.

frequently employed was an Englishman, James Wyatt (1746–1813). He submitted decorative schemes for Ardbraccan, Co. Meath (1773), Curraghmore, Co. Waterford (late 1770s), and Westport, Co. Mayo (1781), as well as designing Castlecoole, Co. Fermanagh (completed in 1793). While Gandon dominated public architecture, Wyatt dominated the domestic sphere. His earliest Irish design was in 1772, for Mount Kennedy, Co. Wicklow – a house which was not built until a decade later. The characteristics of its Neo-Classical façade are best 140 appreciated by comparing it with that of Palladian Bellamont. In both façades 127 the horizontals are emphasized; but whereas at Bellamont there is an interplay between all three floors, at Mount Kennedy each floor is strictly contained within itself. For example, the pediment of the portico does not protrude into the floor above, but is rigidly repressed by the Diocletian window of the upper storey. The windows are severely plain and treated similarly throughout.

Neo-Classicism, in so far as it was inspired by a nostalgic longing for the glories of a former age, had a Romantic side, and a similar Romantic nostalgia was expressed in the late eighteenth-century revival of Gothic architecture. Houses were built in a Gothick style (spelt with a 'k' to distinguish it from the more serious later Gothic Revival), and earlier Classical houses were sometimes made Gothick by the addition of towers and battlements. Wyatt furnished designs for the Gothicizing of Slane Castle, Co. Meath, in 1785, but the Classical house underneath those eighteenth-century towers and battlements is all too apparent in the proportions and planning of the windows.

Churches

Surviving eighteenth-century churches are far from common in Ireland. This is probably due to the fact that a great number of Protestant churches were rebuilt in the early years of the nineteenth century, while few Catholic churches were built at all. The Catholic South Parish Church in Cork (1766) is a notable exception.

In Dublin, St Mary's and St. Werburgh's (later altered) were both built in the early years of the century to the designs of Thomas Burgh (1670–1730), who was also the architect of Trinity Library (1712) and Dr Steevens's Hospital (1720). St 252 Catherine's dates from the 1760s and was designed by John Smyth. Cork

churches of the period include St Anne's, Shandon (1722), Christ Church (1720) and St Peter's (1783), while in Belfast the most important architect of his time, Roger Mulholland (1740–1818), designed Rosemary Street Presbyterian Church, which was completed in 1783.

The Georgian church is generally Classical in form with a handsome three-bay west front surmounted by a tower and spire. The ground plan is a simple rectangle divided into a nave and two side aisles. Columns separate the nave and 141 aisles and may support the ceiling, or galleries (above the aisles and at the west end), or sometimes both. Windows are large and round-headed and originally contained clear glass. Interior furnishings – box-pews, organ cases and pulpits – are of wood and generally display excellent workmanship. Occasionally, as in the case of St Peter's at Drogheda (1753), there is also elaborate stuccowork. The architects of some of these churches are known: Richard Castle designed Newtownbreda, Co. Down (1737); Gandon, Coolbanagher, Co. Laois (1785); Francis Johnston (1760–1829), Ballymakenny, Co. Louth (1785–93); Richard Morrison (1767–1849), part of Cashel Cathedral (completed in 1788); and the talented local architect John Roberts (d. c.1796) designed both the Protestant and Catholic cathedrals in Waterford, completed respectively in 1779 and 1796.

Town and village

As was the case with houses, most of the more important Irish towns were fortified until the beginning of the eighteenth century. Many, like Athlone in Co. Westmeath, Derry, and Kinsale and Youghal, both in Co. Cork, maintained garrisons and were surrounded by massive walls within which lived the English settlers while the native Irish lived without. To this day, this distinction is recalled by the existence in several towns such as Limerick and Kilkenny of a quarter referred to as 'Irishtown'.

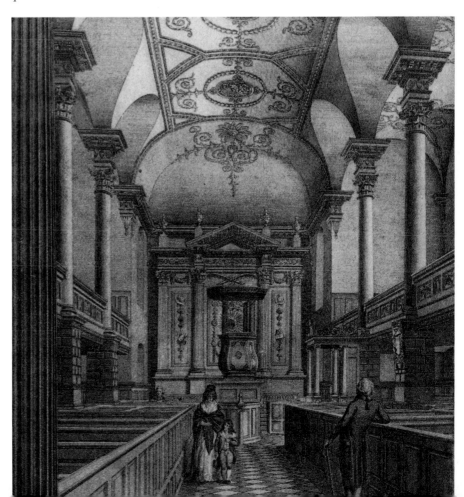

141 Protestant Cathedral, Waterford, built by the local architect John Roberts in 1773–79. The furnishings (removed in the last century but recorded in this late 18th-C. engraving) included box pews, galleries, an elaborate reredos with carved swags, and a high free-standing pulpit placed centrally, reflecting the Georgian emphasis on the sermon rather than the altar.

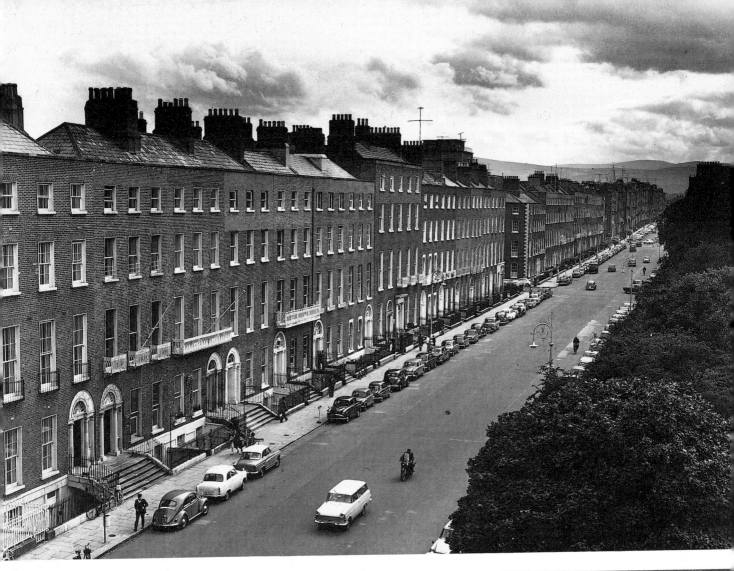

Georgian Dublin

142 Looking along Fitzwilliam Street
(bottom right in the map, opposite) from
Merrion Square, where its construction
began about 1780, towards Fitzwilliam
Square, reached about 1820.

143 The staircase of Belvedere House, in
Great Denmark Street, built in 1786
by the stuccodore Michael Stapleton.
His rich, symmetrical plasterwork even
decorates, unusually, the underside of the
stairs.

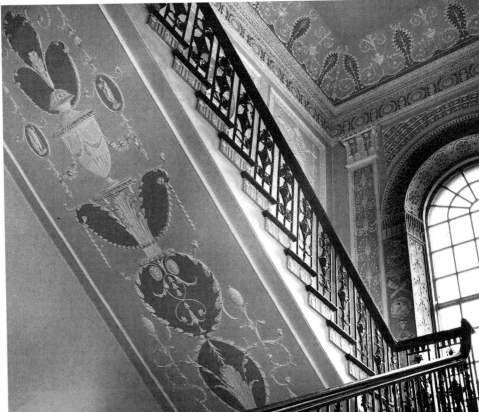

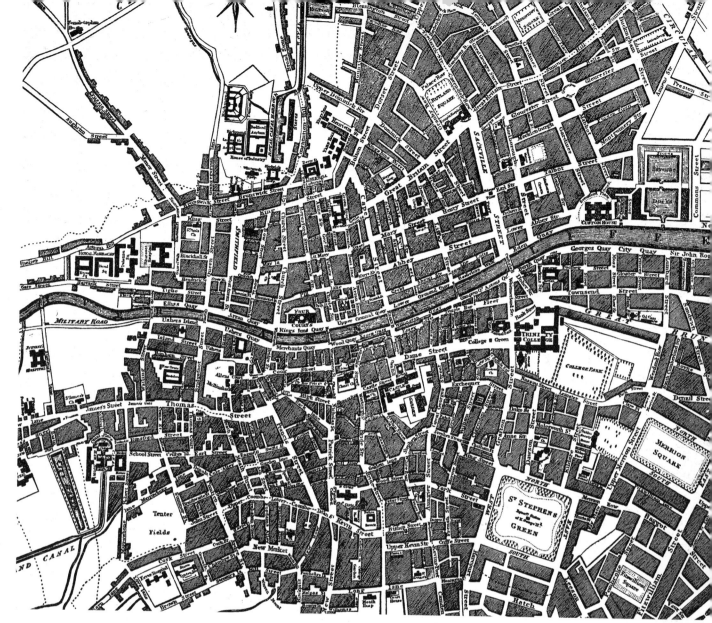

144 Central Dublin at the end of the age of Georgian planning. At the centre are Trinity College and the Bank of Ireland (the former Parliament House: ill. 126); to the west Dame Street leads to the Castle and Exchange (ill. 136) in the old town; to the north a new bridge and widened Sackville (now O'Connell) Street lead to the Rotunda Hospital (ill. 131) in Rutland (Parnell) Square. Other squares are Mountjoy on the north and Merrion and Fitzwilliam on the south. The Blue Coat School (ill. 135) is to the west.

145 The great Georgian axis: looking north from the Bank (left foreground) and Trinity College up Westmoreland and D'Olier Streets, across the Liffey (by the bridge widened in 1880), and along O'Connell Street, then still punctuated by the Nelson Pillar opposite the Post Office, to the Rotunda Hospital and Parnell Square.

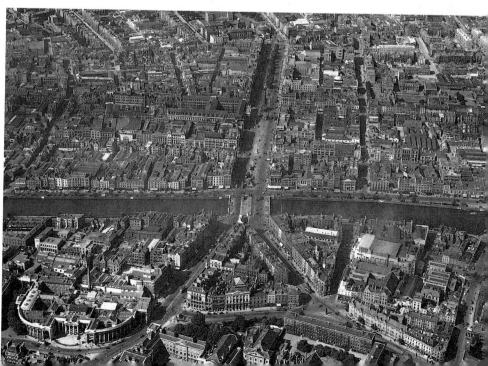

In the northern part of the country many towns which had been laid out during the Plantation of Ulster in the seventeenth century, generally on a formal plan, like Derry and Coleraine, continued to develop. But in the south it was during the eighteenth century that most inland towns grew up. This was usually due to the introduction of some aspect of the linen or wool industry, or to the town's establishment as a local centre of exchange or marketing. The latter role is proclaimed by the many handsome eighteenth-century market houses, which are rectangular in plan and consist of a large room above an open loggia. Sometimes the market house doubled as a courthouse or assembly rooms. Examples are at Wexford and neighbouring New Ross in Co. Wexford, Portarlington, Co. Laois, Kildare, and Portaferry, Co. Down. 146

The eighteenth-century plans of both Dublin and Cork were much affected by the activities of the Wide Streets Commissioners appointed in each city. As their name implies, they were responsible for the widening of certain streets, and their powers, which included compulsory purchase, were considerable. Their work in Dublin, where they were first appointed in 1757, included the widening 144, and extension of Sackville (now O'Connell) Street to the river, where it was 145 linked to the south city by a new bridge and the elegant and spacious D'Olier and Westmoreland Streets. The latter led to College Green, bordered by Trinity College and Parliament House, and from there the newly widened Dame Street connected Parliament with the Castle to the west. Another new straight street and bridge led from the Castle and Royal Exchange (now the City Hall) back to the north bank.

The eighteenth-century pattern of development of large towns like Waterford and Limerick followed to an extent that of Dublin and Cork. They saw the building of churches, schools, hospitals and, later in the century, customs 134 and market houses. Mostly from the second half of the century date the Georgian residential developments, which are generally in the form of spacious streets and squares lined by red brick houses, whose elegantly simple façades contrast 142, markedly with the sumptuousness of their interiors. These developments, 143, centering in Dublin on Mountjoy, Rutland (now Parnell), Merrion and 144 Fitzwilliam Squares, and in Limerick on St John's Square and Newtown Pery, are for the most part the results of private speculation. The Gardiner family (later Lords Mountjoy) laid out most of the streets on the north side of the city of Dublin, while the Fitzwilliams fulfilled the same role for the south side. Limerick's Georgian developments were built on the lands of the Pery family. Belfast only developed into a city in the later eighteenth century, when the 5th Earl of Donegall, who owned the land, fostered several town planning schemes on a grid pattern including Donegall Street and Donegall Place. Many of the buildings, which were entrusted largely to the local architect Roger Mulholland, have now disappeared.

Some towns and cities like Armagh, Sligo and Kilkenny have a Georgian residential development consisting of a wide street lined by elegant houses and known as The Mall. Slightly less grand towns may have a centrally planned space from which streets radiate. This is generally a square, but sometimes, particularly in Ulster, it is called a 'diamond' (for instance at Clones in Co. Monaghan, and at Coleraine and Derry). The plan of most of the simpler towns consists of a single wide street, lined by buildings which contain shops on the ground floor and dwellings above, to which further streets may be added at random. Most of the more attractive small towns and villages are those which were laid out and built by local landlord families, such as Birr in Co. Offaly, Westport in Co. Mayo, Abbeyleix in Co. Laois, and Tyrellspass in Co. Westmeath, where there is always some evidence of formal planning – vistas, tree-lined walks or a village green.

146 Market house at Portarlington, Co. Laois, c. 1800.

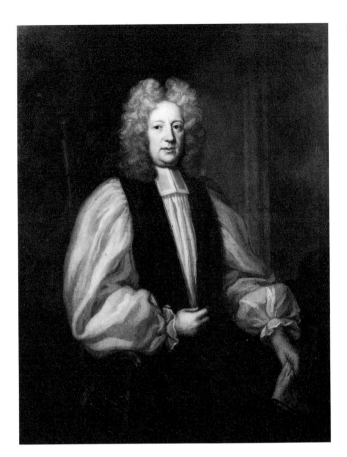

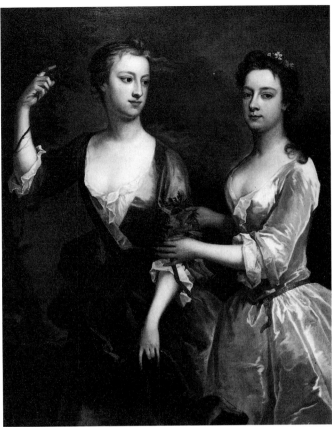

147 Hugh Howard: *Bishop Browne*, 1710. 127 × 98.5 cm. (50 × 38¾ in.). Trinity College, Dublin.

148 Charles Jervas: *Martha and Teresa Blount, c.* 1715. 127 × 102 cm. (50 × 40 in.). Mapledurham House, Oxfordshire.

PAINTING

Early eighteenth-century portraits

In the early years of the century portrait artists fulfilled a slightly different role from that of later portraitists. They were often well-to-do and the social equals of the people they painted. It was the age of Swift and Berkeley, of Congreve and Pope, an age when a greater emphasis was placed on learning than at any time later in the century. Hugh Howard (1675–1738) and Charles Jervas (*c.*1675–1739) were two such gentlemen painters. Both moved in the highest literary and social circles and both travelled abroad. Howard, whose family was Irish, went to Holland in 1697 in the suite of the Earl of Pembroke and later visited Rome, where he studied painting under Carlo Maratta. He worked in London but paid visits to Ireland. Jervas was also London-based, but he too had studied in Rome in the early years of the eighteenth century and only returned to London in 1709. Of the two Howard was the less talented, but his style, serious and sure, suited the learned clerics, medics and academics whom he painted. Bishop Peter Browne sits stiffly while the painstaking Howard records him in a 147 portrait (in Trinity College, Dublin) that is competent and dull. Jervas has a much more graceful style and shows an interest in painting beautiful costumes of satin and silk. His sitters enjoy being painted rather more than Bishop Browne; and the designs of his portraits often betray his sophisticated training. In his *Portrait of Martha and Teresa Blount* (Private Collection) the sisters, who were 148 friends of the painter, and also of Pope, have a certain liveliness and carry branches of olive and a wreath of myrtle as symbols of peace and love.

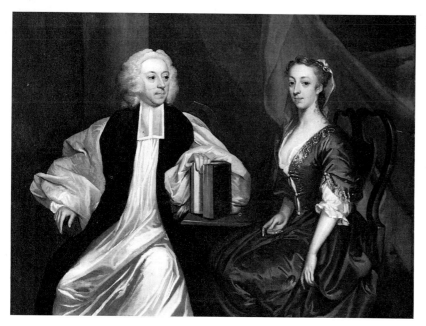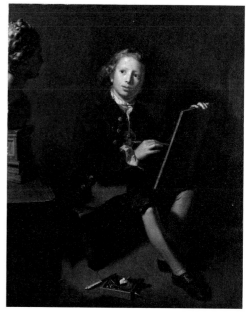

149 James Latham: *Bishop Clayton and his Wife*. 128 × 175 cm. (50⅜ × 68⅞ in.). Representative Church Body, on loan to the National Gallery of Ireland.

150 Nathaniel Hone: *A Boy Sketching* (probably the artist's son Horace), ?1766. 128 × 104.6 cm. (50½ × 41½ in.). National Gallery of Ireland.

With James Latham (1696–1747), who also trained abroad – in Antwerp – Irish portrait painting is firmly within the eighteenth-century tradition; but his work, while echoing that of his contemporaries in England, in particular Hogarth, has a distinct quality of its own. While Howard's portraits of academics are dull, and Jervas's of pretty girls often over affected, Latham captures the image of the Irish better than any artist before him had done. *Bishop Clayton and his Wife* (Coll. 149 Representative Church Body, on loan to the National Gallery of Ireland) shows Latham's affinities with Hogarth, particularly in the rather elegantly painted surplice of the Bishop. The group is also well composed, with simple but clever use made of gesture and props. The jewel, which is here part of Mrs Clayton's headdress, is almost a *sine qua non* of Latham's female portraits.

Although Stephen Slaughter (b.1697) lived until 1765, his style is such that one associates him with the painters of the earlier part of the century rather than with **24** his real contemporaries. Its essential element is his extremely pretty colours, delicate blues and pinks, and added to this a seeming naïvety. Slaughter was English, but his sense of colour is almost certainly due to the fact that he worked in Paris and Flanders, where a tradition of colour was important. He is known to have visited Dublin in 1734, and, as there are numerous Irish portraits by him, this cannot have been the only time. The known work of Phillip Hussey (1713–83), who came from Cork, is refined in style, though also slightly naïve.

Joseph Leeson was the rich son of a successful brewer. With his money he was 151 to build Russborough, Co. Wicklow, in the 1740s to the designs of Richard 128 Castle. It was natural, therefore, that when he was painted in 1735 (National Gallery of Ireland) the artist, Anthony Lee (fl.1724–67), should place him in an architectural setting, indicating Leeson's interest in the fashionable architecture of his day. This is the earliest portrait by Lee, about whom very little is known.

Just as in architecture sixteenth-century Italian prototypes were adapted to eighteenth-century English and Irish usage, so too in painting: an artist such as Joshua Reynolds, faced with the problem of making each of his portraits look different, conceived the idea of basing them on Old Master paintings, and as architects used engravings of sixteenth-century buildings, so he used engravings after works by the great painters of the sixteenth and seventeenth centuries. An

eighteenth-century mother and her daughter are depicted in the same pose as a *Madonna and Child* by Raphael. Reynolds was criticized for this, and by no-one more than by the Irishman Nathaniel Hone (1718–84). Hone's picture *The Conjurer* (National Gallery of Ireland), painted in 1775, shows a magician about to create a picture with his magic wand. From the flames in the bottom left-hand corner he conjures up Old Master engravings upon which the picture will be based. One of them, inscribed 'Pietro da Cortona', shows part of the composition employed by Reynolds for *Three Ladies adorning a Term of Hymen*, exhibited at the Royal Academy in 1774 (and now in the Tate Gallery, London). Hone's painting was clearly a reference to Reynolds, and as such it created a scandal when it was first exhibited in London, where Reynolds was President of the Royal Academy. **26**

Hone, born in Dublin, settled in London, and was the first of a dynasty of Irish painters which survives to this day. Several of his self-portraits are in the National Gallery of Ireland: from all of them he looks out at the spectator with an alert questioning look. He uses something of the same expression in his portrait of a boy sketching (National Gallery of Ireland). The boy may be his 150 son, Horace (1756–1825), who was subsequently a miniature painter of note. 152

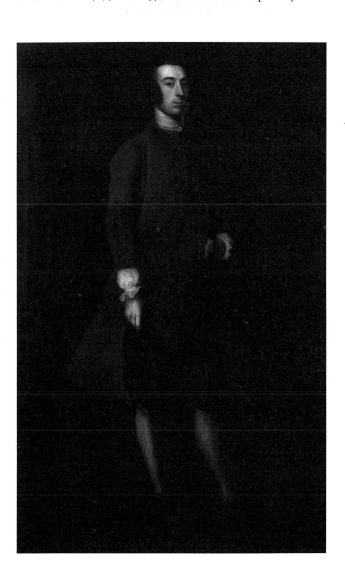

151 Anthony Lee: *Joseph Leeson*, 1735. 197 × 122 cm. (77⅝ × 48 in.). National Gallery of Ireland.

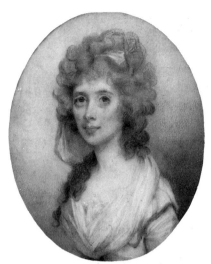

152 Horace Hone: *Miniature portrait of a Lady*, 1791. Watercolour on ivory, 6.5 × 5.2 cm. (2⅝ × 2 in.). National Gallery of Ireland.

Nathaniel Hone himself also painted miniatures, small portraits about five to eight centimetres (two to three inches) high, painted either in watercolour on ivory or in enamels on a metal support, which became very popular as mementos in the eighteenth century.

Later portrait painters and engravers

John Lewis (fl.1740–57) was a painter associated with the Dublin theatres where he painted scenery. It is unusual, therefore, to find that rather than being a landscape painter as well he was in fact a portrait painter. Many of his portraits are, not surprisingly, of people associated with the theatre, among them the actress Peg Woffington (National Gallery of Ireland) This is an accomplished 155 picture, and it should be noted how Lewis has 'composed' a portrait within the self-imposed limits of a painted oval. He creates a horizontal emphasis in the lines of the fingers, the shore-line in the background, and the brim of the hat, and the manner in which the actress turns towards the spectator is also engaging, so that out of a simple head and shoulders portrait Lewis has made an interesting picture.

Thomas Frye (1710–62), who was born in Ireland but spent most of his life in England, is one of the more important figures in the history of Irish painting. He was talented as a portraitist in oils, in pastel and in miniature, and was also a celebrated engraver in mezzotint. His *Portrait of John Allen* (National Gallery of 154 Ireland), in which the subject stands by an elaborate marble-topped Italianate table with Palladian corridors stretching behind him, superbly reflects the spirit of the age. Frye's pastel portraits have the soft delicate effect achieved by that medium, where a stick of dry powdered colour is applied to paper. Much the same effect is achieved by mezzotint engraving, a technique particularly 153 associated with the eighteenth century, were fine gradations of tone are obtained by the use of thousands of tiny dots. Mezzotints have a much more subtle effect of light and shade than ordinary line engravings. It was by his mezzotint portraits that Frye was until recently best known.

A contemporary Irish artist, less well known than Frye, who achieved success with mezzotint is Charles Exshaw (d.1771). He was a gentleman, a painter and also a much travelled dealer in pictures. His own paintings are indifferent although his mezzotints have a real charm.

Neither Frye nor Exshaw was associated with the 'Dublin Group' of mezzotint engravers. The group comprised a number of Dublin-born artists, including Richard Houston (fl.1721–75), James McArdell (fl.1728–65), John Brooks (fl.1730–56), James Watson (c.1739–90) and others, who became the most prominent mezzotinters in London for about twenty-five years from the middle of the century. Their work is known chiefly through their superb engravings after both Old Master and contemporary paintings.

Robert Hunter (fl.1750–1803) seems to have worked all his life in Dublin although he was born in Ulster. His *Portrait of a Gentleman* (National Gallery of 156 Ireland) reflects the same social circumstances which one noticed in the Frye portrait of John Allen. The sitter was a member of the La Touche family from 154 Co. Wicklow, who had made money in banking in Dublin and could afford the life of country gentlemen, and it is in that role that he is portrayed.

The Dublin Society's Schools

An important event in the history of Irish art was the founding of the Dublin Society's Drawing Schools. Robert West (d.1770), an artist who had trained in

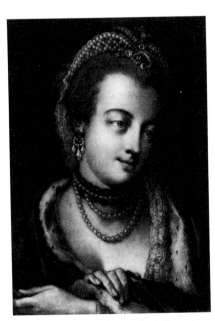

153 Thomas Frye: *Portrait of a Lady*, 1761. Mezzotint, 35.4 × 50.8 cm. (14 × 20 in.). British Museum, London.

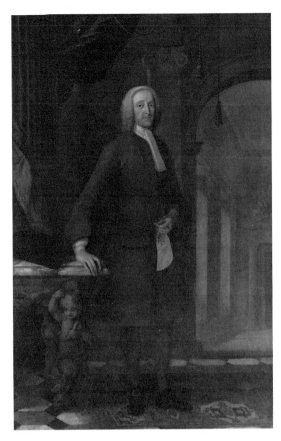

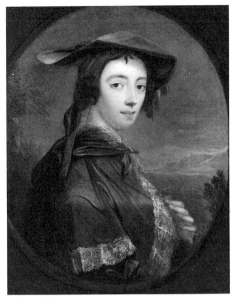

154 Thomas Frye: *John Allen*, 1739. 237 × 154 cm. (93¼ × 60⅝ in.). National Gallery of Ireland.

155 John Lewis: *Peg Woffington*, 1753. 73.7 × 61 cm. (29 × 24 in.). National Gallery of Ireland.

156 Robert Hunter: *A Gentleman of the La Touche Family*. 152 × 198 cm. (59¾ × 78 in.). National Gallery of Ireland.

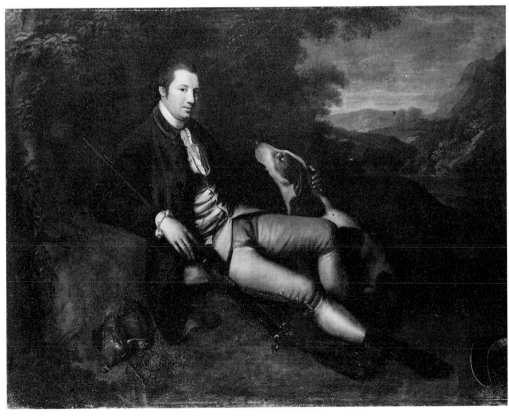

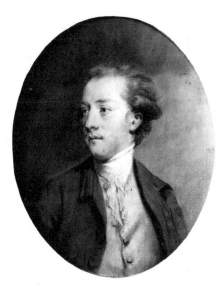

157 Hugh Douglas Hamilton: *Denis Daly, MP*. Pastel, 24 × 20.3 cm. (9½ × 8 in.). National Gallery of Ireland.

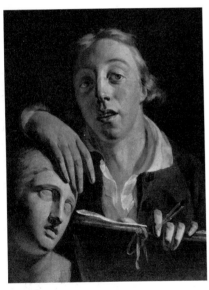

158 Robert Healy: *Self-portrait*, 1766. Black and white chalk, 57.8 × 44.4 cm. (22¾ × 17½ in). National Gallery of Ireland.

Paris, had a small drawing school in Dublin which the Dublin Society took over some time early in the 1740s, retaining him as teacher of Figure Drawing. James Mannin (d.1779), a French artist then living in Dublin, was appointed teacher of Ornamental and Landscape Drawing, and later, about 1759, Thomas Ivory took over the teaching of Architectural Drawing. The drawings done by the pupils were exhibited annually and premiums awarded. Most Irish artists from this time onwards received some training in the Schools. The legacy of West's own training in Paris which he passed on to his pupils was a delicate sense of colour, and, more important, a proficiency in the art of pastel, a medium associated with French eighteenth-century artists. West does not seem to have instructed his pupils in oil painting, which may account for the considerable number of Irish pastellists in the eighteenth century. It is a tribute to West that one of the best known pastellists in the British Isles was his pupil: Hugh Douglas Hamilton (*c*.1739–1808). Hamilton specialized in small oval portraits executed in delicate **157** colours, and there was hardly a person of fashion in either England or Ireland who did not sit to him for such a portrait. He was also a history painter. By 1764 he had settled in London, and he only returned to Dublin in 1791, after some twelve years in Italy where he figured prominently among the foreign artists resident in Rome. It is not clear whether James Mannin taught oil painting, but certainly the pupils whom he instructed in landscape drawing reached a remarkably high standard in their later landscapes in oil.

While in the Schools the pupils seem to have practised extensively in black and white chalks, as drawings of this type survive by several artists, among them Robert Healy (fl.1765–71) and his brother William (fl.1770), Charles Forrest (fl.1771–80), Matthew William Peters (1741–1814), Thomas Hickey (1741–1824), and Hamilton himself. Robert Healy seems to have used only black and white chalks, a medium which he employed successfully for the drawing of animals, in particular horses. His *Self-portrait* (National Gallery of Ireland), **158** probably executed while he was at the Society's Schools, is exquisite, and shows the really high standard that could be achieved by West's pupils. A much less successful picture that survives from the Schools is a self-portrait of Matthew William Peters with his teacher West (National Portrait Gallery, London). Peters, who had a fine sense of colour, later became a successful portrait painter, and specialized to some extent in subject pictures. The best known of these show pretty women in beguiling poses; but his talents are perhaps better displayed in a picture such as *The Gamesters* (Dublin Castle), which was engraved in 1786. **29**

After his training under West, Thomas Hickey achieved success as an artist in **27** England, and later in India and China. In a painting such as *An Actor between the Muses of Tragedy and Comedy* (National Gallery of Ireland) one sees something of the delicacy in colouring and design which one associates with French art. The composition of the picture, which derives loosely from Old Master paintings of *Hercules at the Crossroads*, is particularly successful, as is also the beautiful landscape which recedes to the right. The picture is witness to the overall training which an artist received at the Society's Schools, and surpasses the work of many contemporary artists in England who were trained either as landscape or portrait painters.

Neo-Classical painting

If one thinks of Neo-Classical architecture, and how it differed from earlier architecture of the eighteenth century, chiefly in the sources from which it sprang, Neo-Classical painting will be more easily understood: it is in emulation of antique sculpture that much later eighteenth-century painting was conceived.

James Barry (1741–1806) was born in Cork and was brought to London in 1764 by Edmund Burke (author of the highly influential 'Philosophical Enquiry into ... the Sublime and Beautiful', 1756), who also financed the painter's travels in Italy between 1765 and 1771. Barry set himself up in London and in 1782 became Professor of Painting at the Royal Academy, but was expelled from office in 1795 because of his verbal attacks on fellow-members. In his *Self-portrait* **28** (National Gallery of Ireland) he depicts himself at the base of a Classical statue of *Hercules trampling on the Snake of Envy* (the foot of Hercules is just visible above his head), and holds in his hands one of his own pictures, *The Cyclops and Satyrs*. Thus in this single picture the ideals of Neo-Classical painting are stated: a dependence on antiquity for subject and design alike. Barry paints himself in a Romantic vein: there is vigour and passion in the staring eyes and open mouth. But what is this nostalgic longing for the glories of a former age which the Neo-Classicists indulged in, if it is not Romantic? Barry's *Adam and Eve* (National **159** Gallery of Ireland) was painted in Italy, and one can almost imagine that it is a painting of a sculptural group, where a rhythm of contour is established by the poses of the figures.

This love of contour and outline is a feature associated with Neo-Classicism. In Hugh Douglas Hamilton's picture of *Cupid and Psyche in the Nuptial Bower* **25** (National Gallery of Ireland) the effect of outline is even more striking. In Rome Hamilton had been a friend of Antonio Canova, the most important Neo-Classical sculptor of his day. In 1787–93 Canova had sculpted the subject of Cupid and Psyche, and Hamilton later included Canova's group in one of his portrait paintings. When he came to treat the same subject himself a few years later (the picture was exhibited in Dublin in 1800) Hamilton must certainly have recalled the sculpture, and though he has not copied its composition elements of the design, such as the near kiss of the lovers and the use of drapery and embracing arms, are similar in both.

Barry insisted on the importance of subject painting throughout his life and almost refused to paint portraits, which he considered an inferior form of art. He

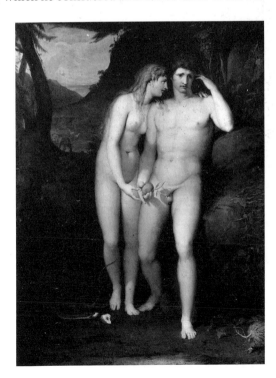

159 James Barry: *Adam and Eve*. 233 × 183 cm. (91¾ × 72 in.). National Gallery of Ireland.

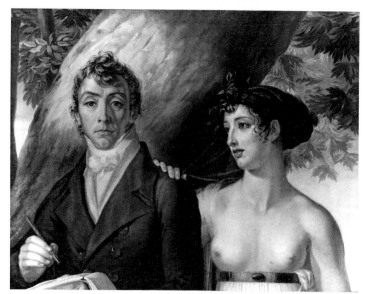

160 Robert Fagan: *Self-portrait with his second Wife, c.* 1803.
68.6 × 91.4 cm. (27 × 36 in.). Private Collection.

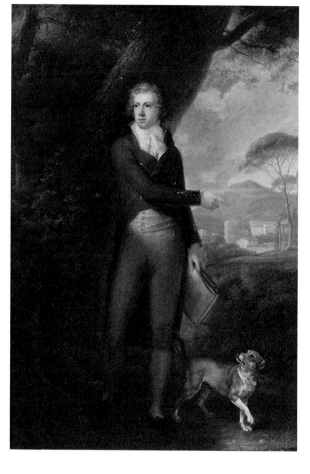

161 Robert Fagan:
Sir George Wright.
213 × 145 cm. (84 × 57 in.).
National Gallery of Ireland.

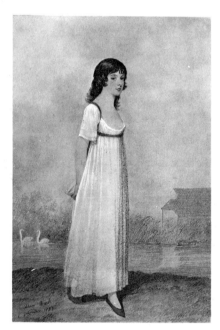

162 Adam Buck: *Portrait of a Girl.*
Watercolour, 37.6 × 25.9 cm.
(14¾ × 10¼ in.). National Gallery of Ireland.

24 *Opposite* Stephen Slaughter: *Portrait of a Lady and Child,* 1745. 130 × 104 cm.
(51½ × 41 in.). National Gallery of Ireland.
See p. 150.

died in poverty. Hamilton only occasionally painted pictures such as the *Cupid and Psyche*, and made his living from portraits. Apart from theatre scene-painting, there was little else an artist who wished to survive could do in the eighteenth century. Neo-Classical ideals were, therefore, adapted to portraiture. The *Portrait of Sir George Wright* (National Gallery of Ireland) by Robert Fagan (1767–1816) is a picture of a young gentleman on the Grand Tour. He walks in the environs of Rome with his sketching pad, and gestures towards the Colosseum in the background. The portrait expresses the abiding passion of the connoisseur in the late eighteenth century for antiquity, and in particular Roman antiquity. Hundreds of similar young men were painted by similar artists of the time in similar poses.

Robert Fagan was born in London, the son of a prosperous baker who in all probability came from Cork. By 1784 the artist was in Italy, where he later became famous as a dealer in pictures and antiquities and somewhat fashionable as a portrait-painter. His *Self-portrait with his second Wife* (Private Collection), painted about 1803, is, like Barry's *Self-portrait,* Romantic. He paints his wife in the fashion of the day, a topless dress. Antiquity now influenced lifestyle as well, and dictated that women should resemble their Classical forebears, just as buildings and paintings had been earlier made to do. Mrs Fagan has all the air of a Classical statue. Less daring women were painted in more modest gowns by Adam Buck (1759–1833), a miniature painter who came from Cork. He specialized in small-scale portraits, particularly of women in Neo-Classical (or Empire) costumes, many of which were engraved.

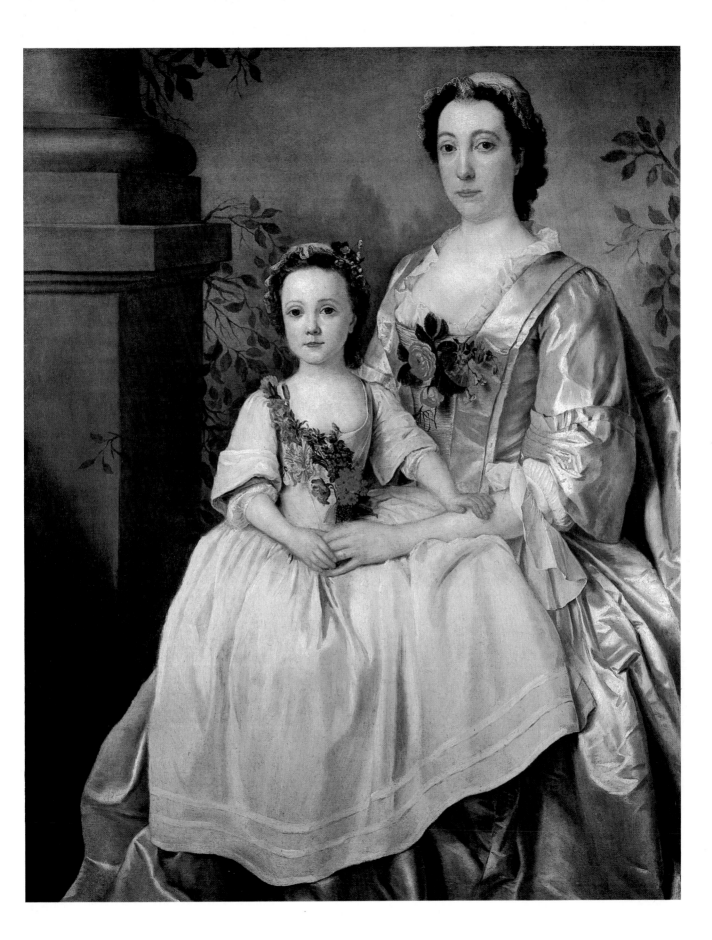

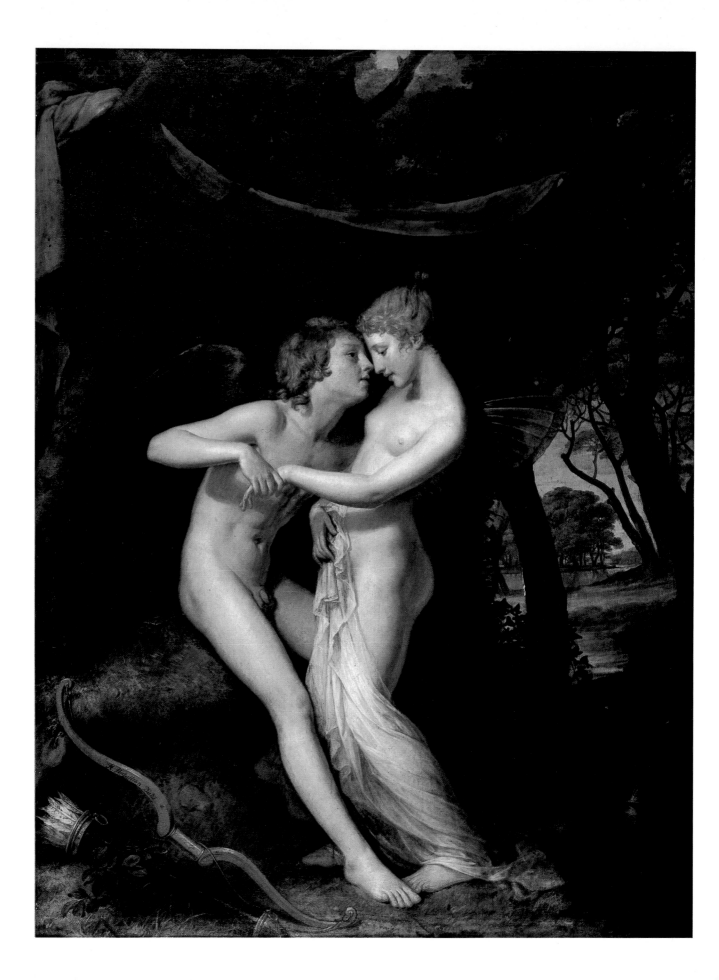

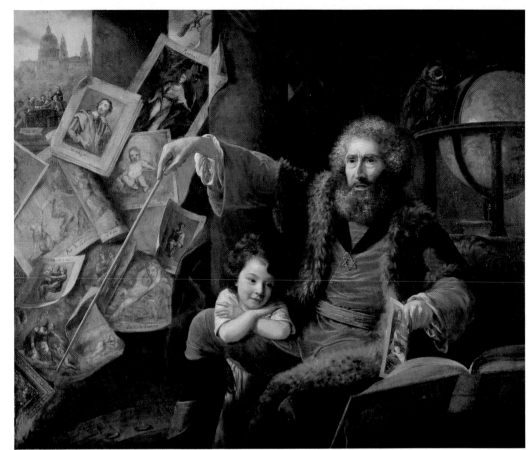

25 Hugh Douglas
Hamilton: *Cupid and
Psyche in the Nuptial
Bower*, exhibited in 1800.
198 × 151 cm.
(78 × 59½ in.). National
Gallery of Ireland. *See
p. 155.*

26 Nathaniel Hone:
The Conjurer, 1775.
145 × 173 cm. (57 × 68 in.).
National Gallery of
Ireland. *See p. 151.*

27 Thomas Hickey: *An
Actor between the Muses of
Tragedy and Comedy*, 1781.
102 × 128 cm.
(40 × 50⅜ in.). National
Gallery of Ireland. *See
p. 154.*

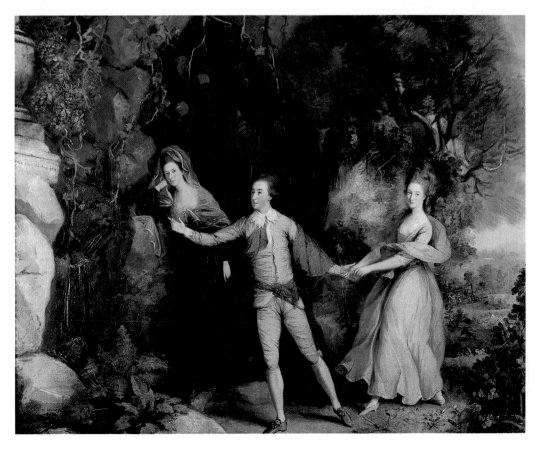

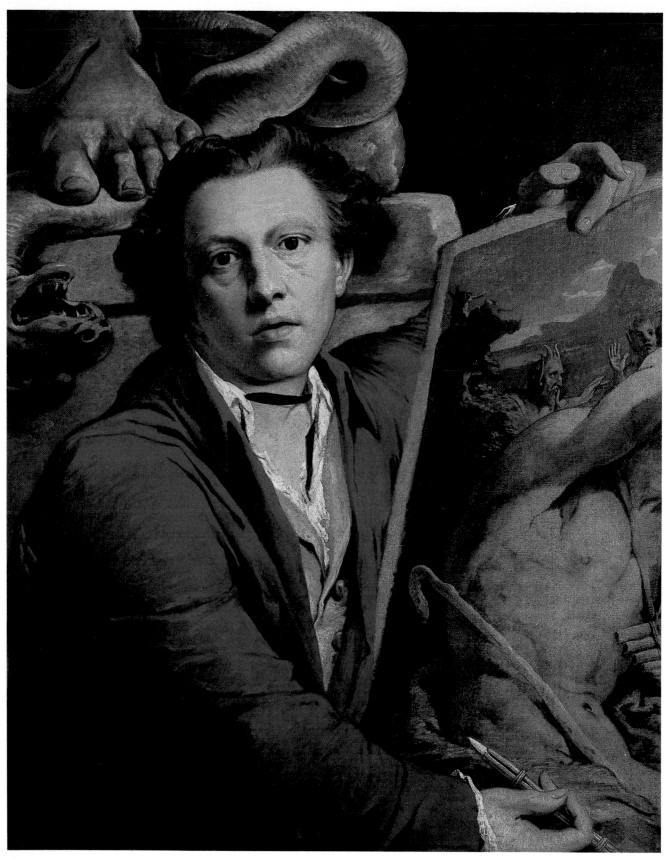

28 James Barry: *Self-portrait*, 1804. 76.2 × 63 cm. (32 × 25 in.). National Gallery of Ireland. *See p. 155.*

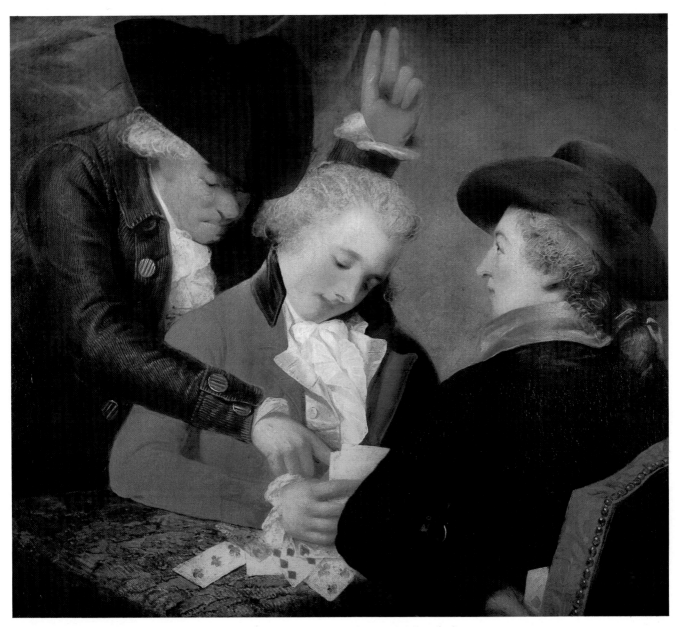

29 Matthew William Peters: *The Gamesters*, engraved in 1786. 84 × 97 cm. (33 × 38 in.) Board of Works, Dublin. *See p. 154.*

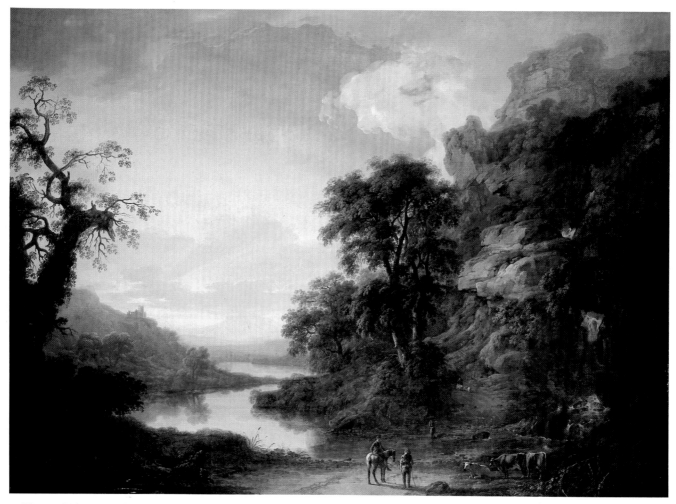

30 Thomas Roberts: *Landscape*, 1770s. 112 × 153 cm. (44 × 60 in.). National Gallery of Ireland. *See p. 169.*

31 George Mullins: *Landscape*, 1760s. 175 × 116 cm. (69 × 45¼ in.). Board of Works, Dublin. *See p. 169.*

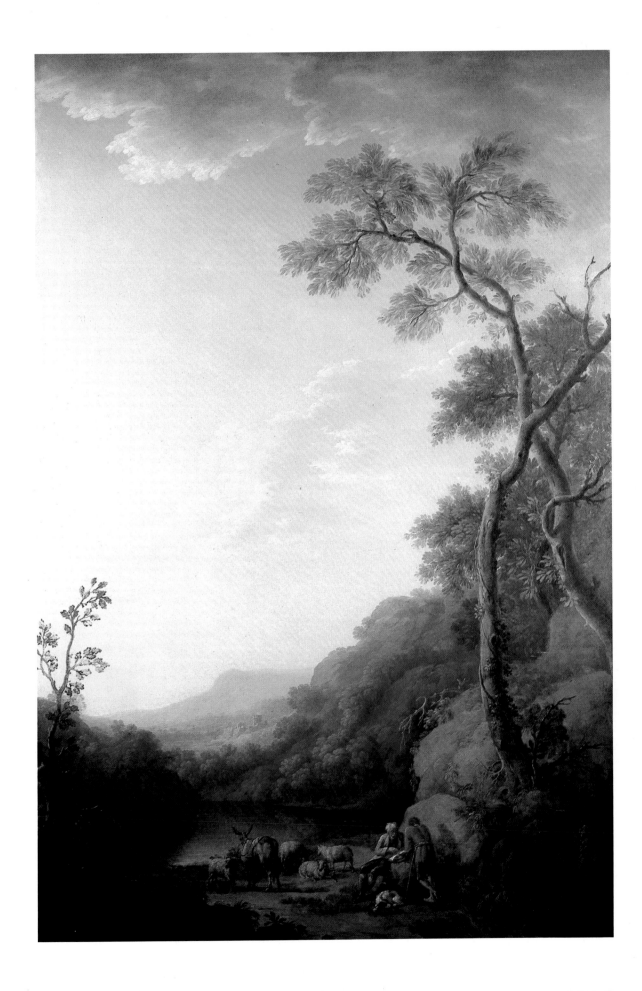

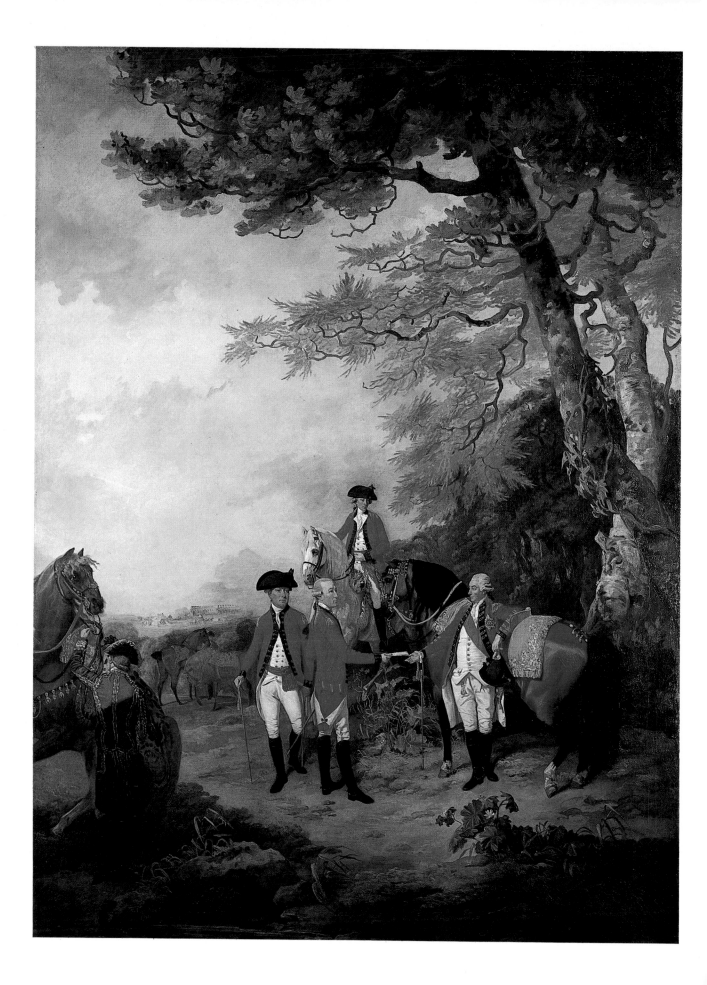

32 *Opposite* Francis Wheatley: *A Review of Troops in Phoenix Park, Dublin*, 1781. 244.5 × 182.2 cm. (96¼ × 71¾ in.). National Portrait Gallery, London.

Some visiting portraitists and the end of an era

The last thirty years of the eighteenth century are notable for the work of some visiting painters: two Englishmen, Francis Wheatley (1747–1801) and Robert Home (1752–1834), and Gilbert Stuart (1755–1828), born in America. All these painters spent some time in Dublin, where they enjoyed a certain success. It was not that Ireland did not produce good artists in the period: she did, but the prospect of greater distinction in London and elsewhere seems to have encouraged men like Barry, Hamilton, Peters and Adam Buck to emigrate. It is hardly arguable that there was insufficient patronage in Ireland, as Wheatley, Home and Stuart all found no difficulty in immediately establishing themselves. Home, the least talented of the three, arrived in 1779 and rapidly built up a fashionable practice. Wheatley, who arrived in the same year, remained in Ireland for about four years and is chiefly remembered for his pictures of the Volunteer movement (see p. 131), in which he delicately captured the elegance of **32** the Volunteer uniform. He also included attractive landscapes in several of his paintings. Home's popularity was eclipsed by the arrival in 1789 of the much more talented Gilbert Stuart. Stuart vividly conveys the Irish personality in a portrait such as that of William Burton Conyngham (National Gallery of **163** Ireland): there are no affectations, no dogs, no splendid Palladian hallway, no Roman Colosseum; just Conyngham's ruddy complexion and everyday suiting with the buttons strained across his well-fed stomach.

Another artist working in Ireland at this time was the Englishman George Chinnery (1774–1852). He arrived in 1795, married an Irish wife, and left in 1802. He subsequently worked in India and China and it is by the pictures painted then that he is perhaps best known. The age ends with the work of Sir Martin Archer Shee (1769–1850), who, like so many others, after a training at the Dublin Society's Schools emigrated to London, where in 1830 he achieved the distinction of being made President of the Royal Academy in succession to Sir Thomas Lawrence. In the portrait of his son (Royal Academy of Arts, London) **164** one sees something of the simplicity of a Neo-Classical portrait, but there is also a hint of sentimentality.

163 Gilbert Stuart: *William Burton Conyngham*. 91 × 71 cm. (36 × 28 in.). National Gallery of Ireland.

164 Martin Archer Shee: *The Artist's Son William*. 73.7 × 61 cm. (29 × 24 in.). Royal Academy of Arts. London.

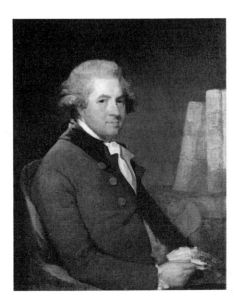
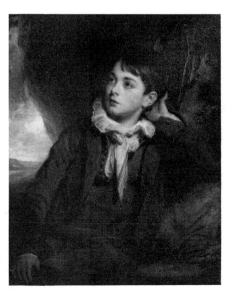

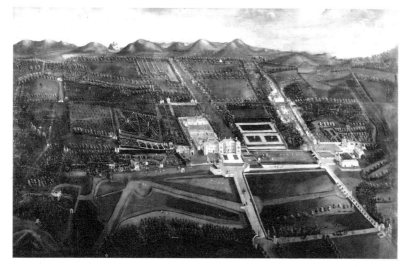

165 *View of Stradbally Hall, Co. Laois*, probably 1740s. 159 × 244 cm. (62½ × 96 in.). Private Collection.

166 Anthony Chearnley: *View of Kinsale, c.* 1750. 100 × 125 cm. (39¼ × 48¾ in.). Private Collection.

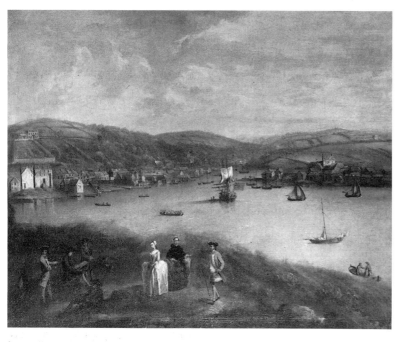

The beginnings of landscape painting

The bird's-eye *View of Stradbally Hall, Co. Laois* (Private Collection), by an unknown though possibly native painter, probably dates from some time in the 1740s. It is one of several similar early eighteenth-century pictures of Irish houses which were clearly painted more for their topographical than their aesthetic appeal. At Stradbally Hall the extensive gardens and buildings which are the subject of the painting had been laid out by the Cosby family over the previous forty years or so. Almost contemporary with the *View of Stradbally* is a *View of Waterford* (Corporation of Waterford) by a Dutch artist, William van der Hagen (fl.1720–45), who worked in Ireland. Van der Hagen takes a lower but still distant viewpoint, for he too is intent on including a great deal on his canvas. Joseph Tudor (d.1759) painted *Dublin Bay* (National Gallery of Ireland) in much the same manner.

The *View of Kinsale* (Private Collection) by Anthony Chearnley (fl.1740–85) 166
has a much more decorative quality than any of these pictures. Kinsale is
recognizable in the distance, but it is only half the composition. On the near bank
of the estuary a walking party dressed in the latest fashions dally, while one of
their number is sketched. The figures gesture one to another so that our attention
is drawn to them and the actual view seems of secondary importance. The
painting suggests that artists employed to paint topographical views were also
interested in creating pictures. From this time hence imaginary landscape
painting and topographical painting pursued separate paths.

Imaginary landscape painting

From the time of the founding of the Dublin Society's Schools in the 1740s, as has
been said, most Irish artists received some training there. From its inception the
Society offered an annual premium for a landscape painting, and this incentive
may lie behind the development of such a competent school of landscape painters
in eighteenth-century Ireland.

That view-painting could be taught in a drawing school studio indicates that
topographical pictures were not the only type of landscape painting required in
the eighteenth century. Also popular were imaginary landscapes which evoked
subtly, rather than recorded precisely, the Irish countryside. In a *Landscape* in the 167
National Gallery of Ireland Robert Carver (fl.1750–91) evokes a natural country
scene of humble rustics bargaining beside a tumbling stream; but he also employs
artistic licence, for instance by enlarging the weeds in the foreground in order to
make the small house in the distance look farther away. Carver, who was also a
scene painter at the Dublin theatres, was a pupil of Robert West in the Dublin
Society's Schools.

A contemporary of Carver in the Schools was George Barret (1732–84),
whose landscapes reflect the influence of Edmund Burke's essay on the Sublime

167 Robert Carver: *Landscape*, 1754.
128 × 160 cm. (50¾ × 63 in.). National
Gallery of Ireland.

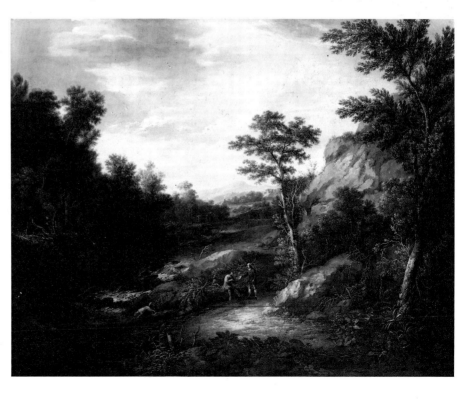

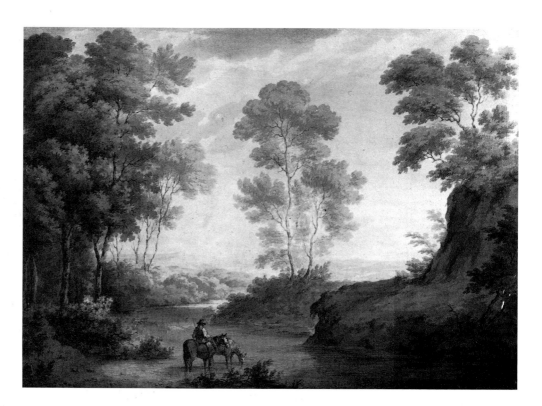

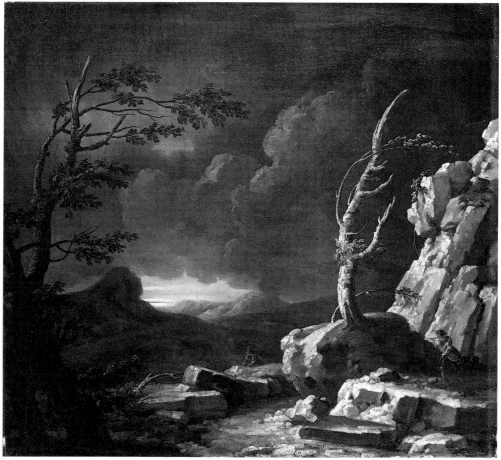

168, 169 Landscapes by George Barret reflecting the Beautiful and the Sublime. *Above: Horses Watering.* Watercolour, 37.1 × 53.3 cm. (14⅝ × 21 in.). Victoria and Albert Museum, London. *Below: Stormy Landscape*, a free copy after a painting by the Italian 17th-C. artist Salvator Rosa, whose pictures were extremely popular with British collectors in the later 18th C. 55 × 60 cm. (21½ × 23½ in.). National Gallery of Ireland.

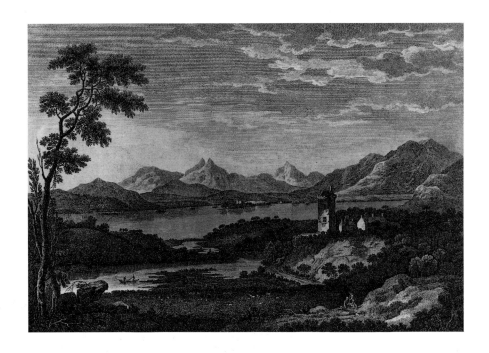

170 Picturesque principles applied to the portrayal of a real landscape: Jonathan Fisher's *View of the Lake of Killarney from near Dunlow Castle*, 1770. Line engraving, 40 × 52.5 cm. (15¾ × 20⅝ in.). National Gallery of Ireland.

and the Beautiful, published in 1756. Burke in fact met Barret in Dublin and advised him to paint in the Dargle Valley in Co. Wicklow. Burke's Sublime in landscape stands for terror, vastness and obscurity; his Beautiful for gentleness and smoothness. Barret's watercolour of *Horses Watering* (Victoria and Albert Museum, London) is all smoothness and gentleness: it is, therefore, Beautiful by Burke's criteria. His *Stormy Landscape* (National Gallery of Ireland) is Sublime, with enormous black clouds, wind-bent trees and a mountainous background, while figures flee before the impending storm. Barret's Sublime landscape is also the Romantic landscape of a poem such as Wordsworth's *Tintern Abbey*, and Sublimity is a more tortured form of Romanticism.

Of the pictures brought back from the Grand Tour in the eighteenth century, those of Claude Lorraine, a French artist who worked in Rome in the seventeenth century, were among the most popular. Claude is credited with the foundation of Classical landscape painting – landscape composed according to rules, just as Classical architecture was – and not unnaturally other artists were stimulated to imitate him. Three Classical landscape painters in the vein of Claude were George Mullins (fl.1763–75), Thomas Roberts (1748–78) and William Ashford (1746–1824). Mullins and Roberts both trained under James Mannin in the Dublin Society's Schools, and Roberts, the younger of the two, was for a time a pupil of Mullins. Both achieved a remarkably high standard in their landscapes, as did Ashford, who was born in England but settled in Ireland at an early age. Thomas Roberts' younger brother, Thomas Sautell Roberts (1760–1826), was also a landscape painter, in a later, more Romantic style.

The rules of Classical landscape painting dictated that the foreground should be painted in dark colours, the background in light tones. From either side of the picture clumps of trees or prominences of land project towards the centre, one behind the other like stage sets (they are known as *coulisses*, from the French for 'wings'.) Animals probably amble down from between these *coulisses* towards the river which often meanders through the centre of the picture towards the distance. All these effects combine to create an effect of depth. Claude's landscapes were inspired by the Roman Campagna, the countryside south and

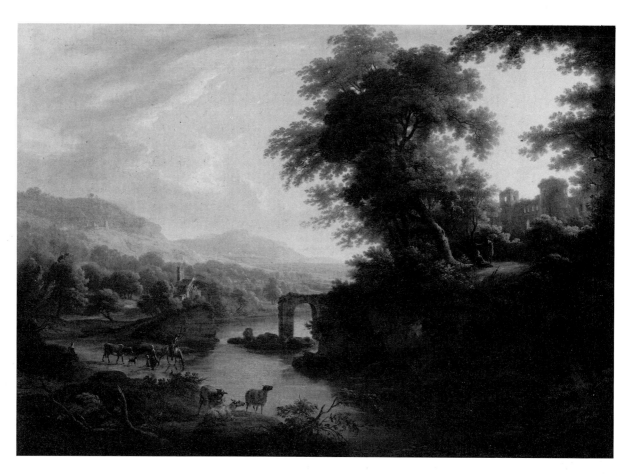

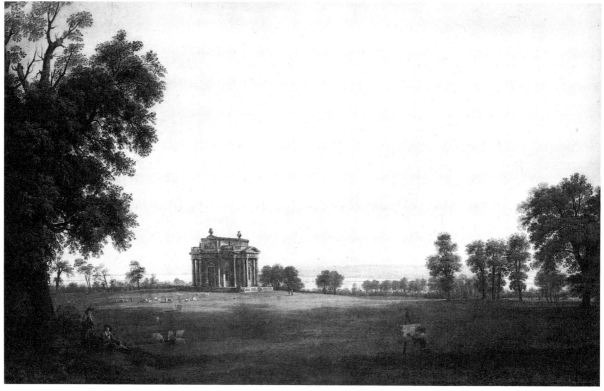

171 William Ashford: *Classical Landscape*, 1796. 74.3 × 100 cm. (29¼ × 39½ in.). Private Collection.

172 William Ashford: *The Marino Casino, Dublin*. The artist suggests his own presence in the right foreground. 62.2 × 96.5 cm. (24½ × 38 in.). Whitworth Art Gallery, Manchester.

east of Rome, so Classical ruins play their part in the scenes depicted; in English and Irish pictures the ruins were often Gothic. 171

Topographical painting in the later eighteenth century

Many of the painters of imaginary landscapes painted real views, and indeed depended largely on topographical pictures for their living. The houses which Richard Castle had designed earlier in the century had merged into the Irish countryside, trees and gardens had matured, and men such as Barret, Ashford and Roberts were employed to paint pictures of them. Ashford's *Marino Casino* 172 (Whitworth Art Gallery, Manchester) is a typical example of the genre, where the house, depicted accurately in its setting, in fact occupies a relatively small area of the canvas. The appeal of these pictures of houses was such that prints were often made after the original paintings. Books of topographical prints were compiled and sold. Thomas Milton's *Views of Seats*, published from 1783 onwards, includes engravings after pictures by Ashford, Thomas Roberts and Francis Wheatley, and Francis Grose used the landscapes of Ashford and Wheatley in his *Antiquities*, published in the 1790s. A talented watercolour painter, James Malton (1761–1803), painted views of Dublin which were also 135 published as aquatints in the 1790s. (Many of the original drawings for the plates 126, are in the National Gallery of Ireland.) Small watercolours of country houses by 131 Malton are also known. Jonathan Fisher (d.1809) was strictly a view painter, and he is remembered chiefly for the series of views he made of Killarney, and later of 170 Carlingford, which he engraved and published in the 1770s.

SCULPTURE

William Kidwell

The sense of movement felt to some extent in the Joseph Cuffe memorial at 121 Castleinch (c.1679) is much more dramatically demonstrated in the monument to Sir Donat O'Brien (d.1717) in Kilnasoolagh, Co. Clare. Winged cherubs 174 perched on an entablature raise with dramatic gestures curtains that issue from a tester. In doing so they reveal the figure of the deceased, resplendent in contemporary costume, his curly wig tumbling about his shoulders, as he lies in meditation upon a rolled-up mattress. The monument is, to say the least, theatrical and as such is the most spectacular Irish example of the type of Baroque art that one associates with seventeenth-century Rome. The architectural details of the memorial, superbly carved fluted Corinthian columns and pilasters supporting an elegant entablature, are executed in black and white marbles and add to the drama of the piece. Sir Donat's costume seems to rustle as he settles, while the cherubs prepare to tie the curtains aloft with ropes.

The sculptor of this monument was William Kidwell (1662–1736), who had trained in London with the most able English Baroque sculptor of his day, Edward Pierce, before coming to Ireland in 1711. He remained until his death and is known by the many church memorials he executed, particularly in the southern part of the country at Waterford, Fiddown in Co. Kilkenny, Cloyne and Dunmanway in Co. Cork, and other places. The O'Brien tomb is his most elaborate monument in Ireland: more typical is the memorial to Garret Wesley 173 (d.1728) in Laracor, Co. Meath. Kidwell frequently employed the type of winged cherub-head which here supports the tablet, and the gadrooned ledge at the base as well as the swan-neck pediment with rosettes are also found on many of his monuments.

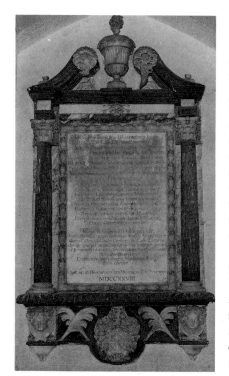

173 William Kidwell: memorial to Garret Wesley (d. 1728) in Laracor Church, Co. Meath. H. about 2.50 m. (8 ft.).

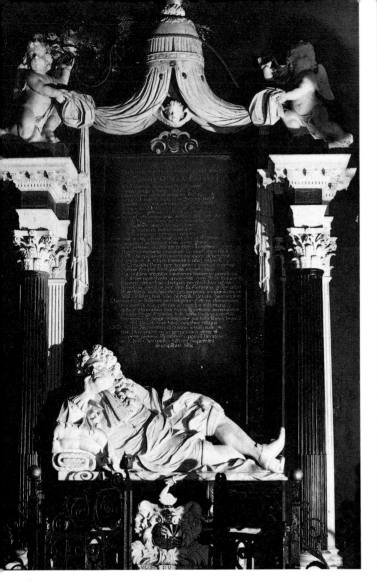

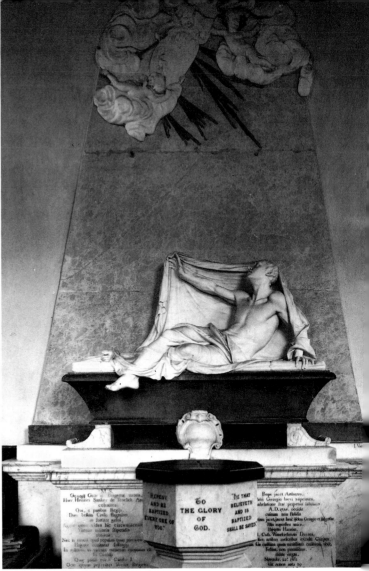

174 William Kidwell: monument to Sir Donat O'Brien (d. 1717) in Kilnasoolagh Church, Co. Clare. H. about 5.50 m. (18 ft.).

175 John Van Nost: monument to Judge Gore (d. 1753) in Tashinny Church, Co. Longford. The design is derived from a celebrated memorial by Roubiliac at Wrexham in Wales.

Classical sculpture

In reaction to the flamboyancy of Kidwell's type of exuberant Baroque, artists in the earlier part of the eighteenth century, sculptors among them, resorted to a more Classical style which nevertheless retained many Baroque elements. Like architects, sculptors in the period made increasing use of motifs borrowed from antiquity. The monument to Judge Gore (d.1753) in Tashinny, Co. Longford, is 175 very different from any of the memorials which have hitherto been discussed. Judge Gore is not in contemporary costume as was Sir Donat O'Brien: instead he 174 is depicted in a shroud which approximates to a Roman toga. He rises from his tomb, which has the shape of a Roman sarcophagus, and gestures towards the cameo portrait of his wife above. The cameo is also derived from antiquity. The whole scene is presented against the backdrop of a pyramid, which like the obelisks on Elizabethan tombs is an antique commemorative symbol. The Gore monument is thus composed entirely of Classical motifs which are combined in a new non-architectural way. Nevertheless there is a tremendous sense of Baroque drama about the pose of the Judge as he rises from his tomb. Also interesting is the eighteenth-century attitude towards death that it expresses. Gore is not represented as being dead (as in sixteenth-century monuments) or alive and

praying (as in Elizabethan and Jacobean tombs) or alive and meditating (as in the Baroque O'Brien monument): rather he is represented as neither dead nor alive, but in a state of transition, about to leave this world for the next. Thus he gestures towards the portrait of his wife who had predeceased him. [119]

The Gore monument is by John Van Nost (d.1780), who like Kidwell came to Ireland from England and settled about 1749. In London he had trained with a well-known sculptor, Henry Scheemakers, and upon his arrival in Dublin he was immediately taken up by the Dublin Society. He executed busts of several of the founder members and several pupils were apprenticed to him by the Society. He was also responsible for all the large-scale church memorials erected in Ireland in the mid-century, with the exception of those which were imported. Some, like those in Tullamore and Waterford Cathedral, are now damaged; but it is still perfectly possible to appreciate Van Nost's very real talents both as a carver and as a designer. Many of his statues have been destroyed, but his figure of George III (1765) survives in the Dublin Mansion House. The King is represented in the pose and armour of a Roman general, imbued by the sculptor with an appealing liveliness. [176]

Patrick Cunningham (d.1774), a native Irishman, was a pupil in the Dublin Society's Schools and later of Van Nost. Few works by him are known, those which are being exclusively portraits. An example is his posthumous bust of Dean Swift (1766), now in St Patrick's Cathedral, Dublin. Much more exciting is the bust of William Maple (1753) in the Royal Dublin Society. Not surprisingly, its style reflects the portrait style of Van Nost, and the vigour of the carving gives the sitter a down-to-earth quality that is most pleasing. [177]

In medieval times sculpture was used as a decorative embellishment for architecture, and also for devotional and commemorative purposes. In the eighteenth-century Ireland of the Protestant Ascendancy there was little patronage for devotional sculpture, but the portrait bust became extremely popular. It represents in sculpture what Classical landscape represented in painting and Palladianism in architecture, a revival of antiquity, for it had been extremely popular in Roman times. The pattern of patronage established in the early eighteenth century continued on into the nineteenth, and sculptors in both

176 John Van Nost: *George III*, 1765, from the Royal Exchange in Dublin (see ill. 136). Bronze, life size. Mansion House, Dublin.

177 Patrick Cunningham: *William Maple*, 1753. Marble, H. 76.2 cm. (30 in.). Royal Dublin Society.

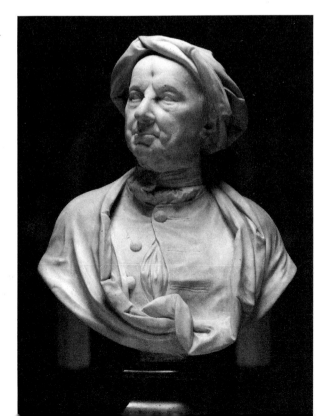

centuries were employed largely in the execution of portraits, monuments and carved ornaments for architecture.

Neo-Classical sculpture

As the Marino Casino, designed by William Chambers and built by Lord Charlemont in the 1760s, had heralded the Neo-Classical style in architecture in Ireland, so its carved decorations introduced Neo-Classical sculpture. By the late eighteenth century many antique sculptures had been excavated in Rome and elsewhere, and the sculptor was in a position to imitate them directly, rather than having to depend chiefly on a sixteenth-century view of antiquity as his predecessors had done. Lord Charlemont brought from Rome in 1756 an English-born sculptor, Simon Vierpyl (*c*.1725–1810), who was to execute the 178 urns and statues that are so important a feature of the Casino. Vierpyl was well versed in the antique, for Lord Charlemont had employed him in Rome to copy no less than seventy-eight antique busts and twenty-two statues, which he later imported into Ireland. (They are now in the Royal Irish Academy.) Vierpyl's most important other work in Ireland was the decorative carving on the Royal 130 Exchange (now the City Hall) in Dublin.

Neo-Classical architects placed more emphasis on sculptural decoration than the Palladians had done, and their decoration was derived from antique sources. The sculptural frieze around the Rotunda (*c*.1786), for example, by Edward 13▮ Smyth bears a very close resemblance to that on the tomb of Cecilia Metella outside Rome: it is that favourite Neo-Classical motif, an oxhead frieze, the oxheads linked by swags of drapery, and within the loops of the drapery carved roundels with lion heads in the centre.

Christopher Hewetson (*c*.1739–94) was probably the best Irish-born sculptor of the eighteenth century, but because he worked in Rome from as early as 1765 until his death he is less well known than Edward Smyth (to whom we shall return). He received some training from Van Nost in Dublin before leaving in

178 Sculpture of the Marino Casino, Co. Dublin (see ill. 137), 1760s. The urn is by Simon Vierpyl, the lion by the English sculptor Joseph Wilton.

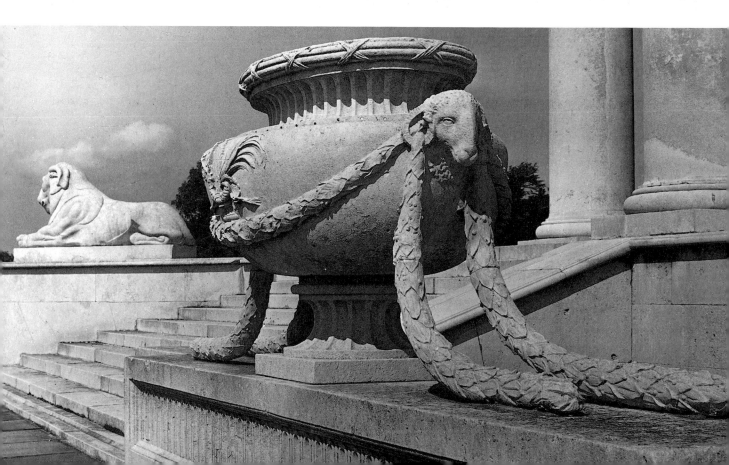

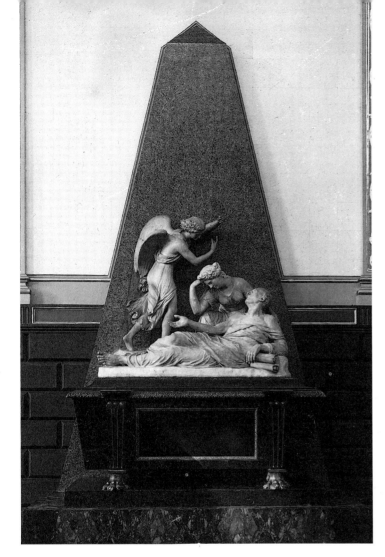

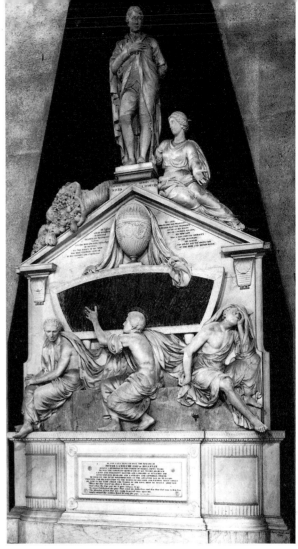

179 Christopher Hewetson: monument to Provost Baldwin in the Examination Hall of Trinity College, Dublin, installed in 1784. Hewetson itemized the marbles used: the figures are of Carrara, the base of antique 'Africano', the sarcophagus of Porto Venere; the pyramid is of red oriental granite, and the sarcophagus is trimmed with gilt bronze.

180 John Hickey: monument to David La Touche in Delgany Church, Co. Wicklow, c. 1787. The total composition is over 7 m. (24 ft.) high.

his early twenties for Rome, where he worked mainly on portrait busts. It is fitting that what is perhaps his finest work should have found its way to Ireland: the monument to Provost Baldwin, executed in Rome, which was set up in 1784 179 in the Examination Hall of Trinity College, where it still stands. It recalls Van Nost's monument to Judge Gore, but the clouds and cameo portrait are 175 dispensed with, so that the pyramidal backdrop creates a starker effect. The scale of the sarcophagus and pyramid (which is of red granite) give the monument a quality of imposing grandeur not found in Van Nost's design, a simplicity and starkness characteristic of Neo-Classicism. The figures compare with those in the Neo-Classical paintings of James Barry and Hugh Douglas Hamilton: just as 159 Barry and Hamilton established outline curves with the arms and legs of their **25** painted figures, so Hewetson does in his sculpted ones.

John Hickey (1756–95) was the brother of the painter Thomas Hickey (see p. 154). Like him he trained at the Dublin Society's Schools and then emigrated at an early age. His monument to David La Touche (c.1787) in Delgany Church, 180 Co. Wicklow, is in its scale one of the most imposing monuments in Ireland. It has the elements which one associates with Neo-Classicism, sarcophagus, urn and Classical draperies, together with the very Roman-like portraits of David La Touche's three sons, and Hickey has sculpted them all with a certain power. Less successful is the overall design of the memorial, which is rather fussy. Hickey

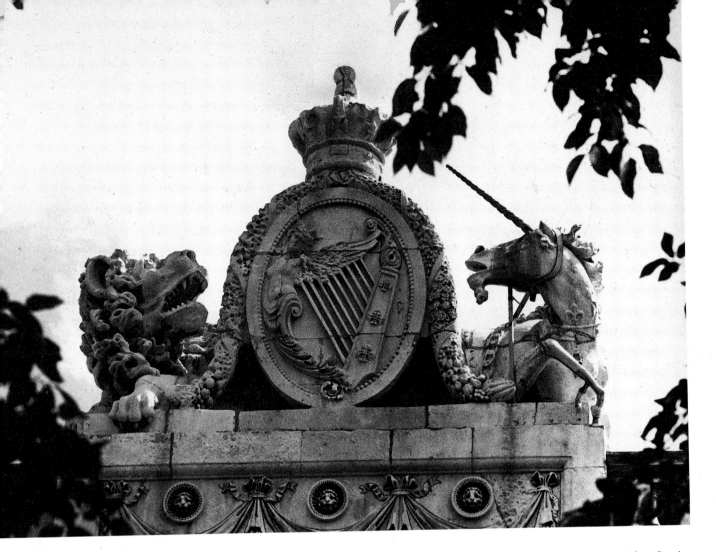

181 Edward Smyth: the arms of Ireland, on the Custom House in Dublin (see ill. 139), after 1781.

succeeded better when working on a smaller scale, as in the memorial to Justice Singleton (1787) in St Peter's Church, Drogheda.

Edward Smyth

Edward Smyth (1749–1812) was a native of Co. Meath, and a pupil of Simon Vierpyl. Just as Gandon was fortunate in coming to Dublin at the time when the city required new, large-scale public buildings, so Smyth was fortunate in being a contemporary of Gandon, for Gandon, shortly after his arrival in Dublin, 'discovered' Smyth, and thereafter employed him on all his buildings. Smyth's riverine heads on the Custom House are famous; the arms of Ireland, also on the 139 Custom House, less so. The frieze on the base of this group is reminiscent of that 181 on the Rotunda (see p. 174), but it is the group itself which Smyth is primarily concerned with. This is sculpture to be seen from below, and its purpose is to add dramatic interest to the skyline of the building. The knobbly mane of the lion and the craned neck of the unicorn are silhouetted against the sky as they seem to turn in anger towards the crown surmounting the harp of Ireland. Smyth was at his best in this type of carving, but unfortunately much of his work on the Custom House and the Four Courts was destroyed in 1922. The drama created in the group of the contorted lion and unicorn is also apparent in his statue of Charles Lucas (1772) in the City Hall, Dublin. Lucas's right foot is extended, and 182

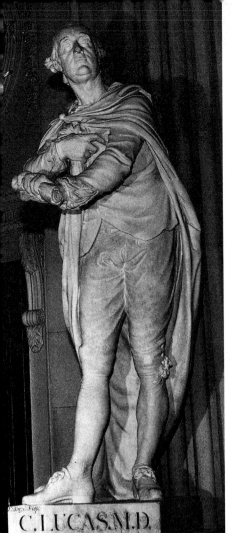

182 Edward Smyth: *Charles Lucas*, 1772. Marble, life size. City Hall, Dublin.

he gestures with his left hand in the same direction; but his head is turned towards his left, creating a sense of balance and counter-balance within the figure.

Edward Smyth was assisted by his son, John Smyth (*c.*1773–1840), and probably employed other sculptors as well. His workshop is likely to have executed a number of the late eighteenth-century chimneypieces of the type which are today universally referred to as 'Adam chimneypieces'. That in the hall at Mount Kennedy, Co. Wicklow, with its lions' masks, swags and even the Irish harp in a roundel as on the Custom House, is almost certainly by Smyth. The bust of George III in the National Gallery of Ireland is simply signed 'Smyth Dublin': in all probability it is the one exhibited in Dublin in 1809 as the joint work of Edward Smyth and his son John. It would not have been executed from the life, and the sitter is not glamorized. That is consistent with Edward Smyth's portrait style, and busts by him, though fully competent, lack the swagger of those by Van Nost or even Cunningham. For a sculptor of such talent, his church memorials are surprisingly poor in design and execution. There are examples in Lisburn, Co. Antrim, Gowran, Co. Kilkenny, and Athlone, Co. Westmeath.

Later Georgian sculptors

The Classical tradition in sculpture did not die with the passing of the eighteenth century: rather it continued on into the nineteenth, so that it is appropriate to describe the work of some early nineteenth-century sculptors as Georgian, remembering that George IV did not die until 1830.

Although sculpture itself was not taught in the Dublin Society's Schools until 1809, artists seem to have been instructed in modelling, probably in clay, from the time of the founding of the Schools, and premiums were awarded for sculpture from the same date. Laurence Gahagan (fl.1756–1817) won one of those premiums in 1756. He was the eldest of a family of sculptors all of whom

183

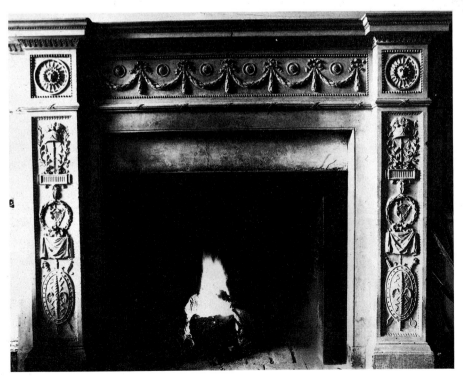

183 Edward Smyth?: chimneypiece at Mount Kennedy, Co. Wicklow, early 1780s.

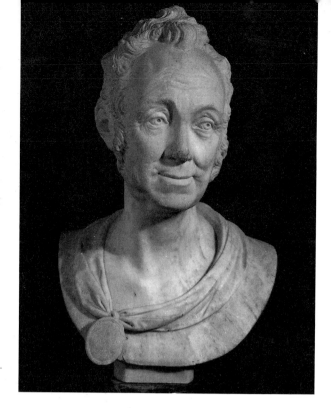

184 Laurence Gahagan: *Bust of a Man*, 1807. Marble, H. 52 cm. (20½ in.). National Gallery of Ireland.

emigrated to England. In his *Bust of a Man* in the National Gallery of Ireland, dated 1807, Gahagan presents an informal image of the sitter. Instead of the imposed Roman grandeur of eighteenth-century busts, we see an immensely human image with receding hair, wrinkles about the eyes and an engaging smile.

John Smyth, unlike his father, excelled at church memorials, and there are a number of large-scale monuments by him throughout the country, in Armagh, Ferns, Co. Wexford, Goresbridge, Co. Kilkenny, and elsewhere. One notices an increased use of allegory: on the monument to Major-General Henry Davis (1819) in Newry, Co. Down, winged Fame blows her trumpet while crowning a medallion portrait of the deceased with a wreath of laurel. She has just descended and stands with one foot on a sarcophagus, much smaller than those on earlier tombs. More important than the sarcophagus are the symbols of war flanking it – banners, swords, cannons and cannon-balls – for it was in war that Davis achieved his fame. Smyth's considerable powers are perhaps most readily assessed in the pert statue of George Ogle (d.1814) in St Patrick's Cathedral, Dublin.

Two contemporary Irish-born sculptors who had successful careers abroad were Peter Turnerelli (1774–1839) and James Heffernan (1785–1847). Heffernan came from Cork and emigrated to London at about the age of twenty. After some study, which included a trip to Rome in about 1817, he worked all his life in the studio of Sir Francis Chantrey. Turnerelli, who came from Belfast and who was much patronized, occupies approximately the same position in sculpture as does Martin Archer Shee in painting (see p. 165): his works are still eighteenth-century or Georgian in concept, but they show at the same time streaks of the sentiment which one associates with the Victorian era. In his monument to Father Betagh (1817) in SS. Michael and John, Arran Quay, Dublin, the costumes and urn are Classical, but piety and sorrow (as distinct from the more eighteenth-century ideals of religion and grief) are the emotions that are so strongly expressed by the affecting figures of Faith and the orphan which she so touchingly consoles.

185 John Smyth: monument to Major-General Henry Davis, in Newry Church, Co. Down, 1819.

186 Peter Turnerelli: memorial to Father Betagh, in SS. Michael and John, Arran Quay, Dublin, 1817.

187 John Smyth: memorial statue of George Ogle, MP for Wexford (d. 1814), in St Patrick's Cathedral, Dublin. Marble, life size.

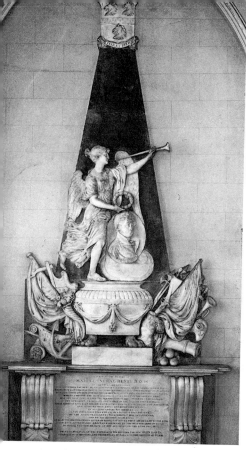

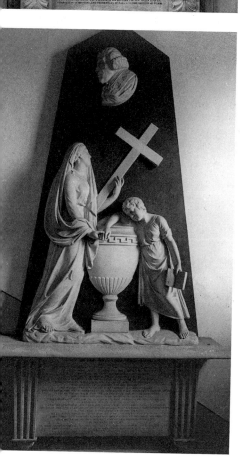

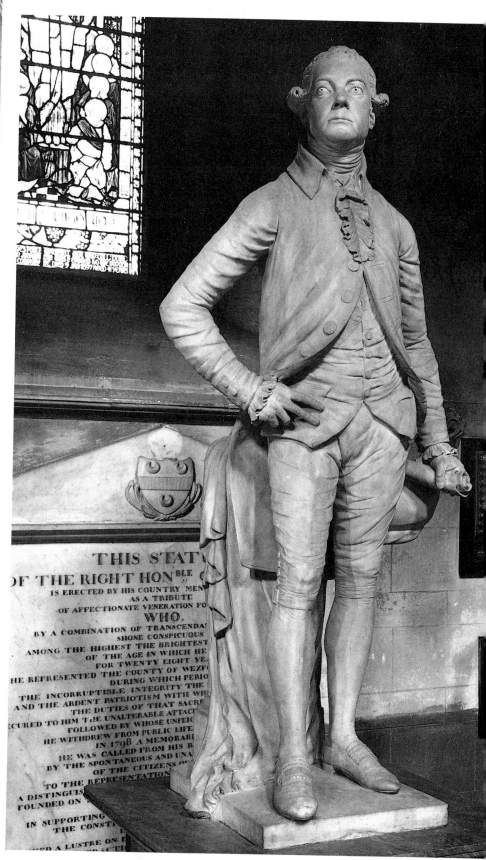

THIS STAT
OF THE RIGHT HON^{BLE} C
IS ERECTED BY HIS COUNTRY MEN
AS A TRIBUTE
OF AFFECTIONATE VENERATION FO
WHO.
BY A COMBINATION OF TRANSCENDA
SHONE CONSPICUOUS
AMONG THE HIGHEST THE BRIGHTEST
OF THE AGE IN WHICH HE
FOR TWENTY EIGHT YE
HE REPRESENTED THE COUNTY OF WEXFO
DURING WHICH PERIO
THE INCORRUPTIBLE INTEGRITY THE
AND THE ARDENT PATRIOTISM WITH WH
THE DUTIES OF THAT SACRE
ECURED TO HIM THE UNALTERABLE ATTAC
FOLLOWED BY WHOSE UNFEIG
HE WITHDREW FROM PUBLIC LIFE
IN 1798 A MEMORABI
HE WAS CALLED FROM HIS R
BY THE SPONTANEOUS AND UNA
OF THE CITIZENS O
TO THE REPRESENTATIO
A DISTINGUIS
FOUNDED ON
IN SUPPORTING
THE CONSTI
ED A LUSTRE ON

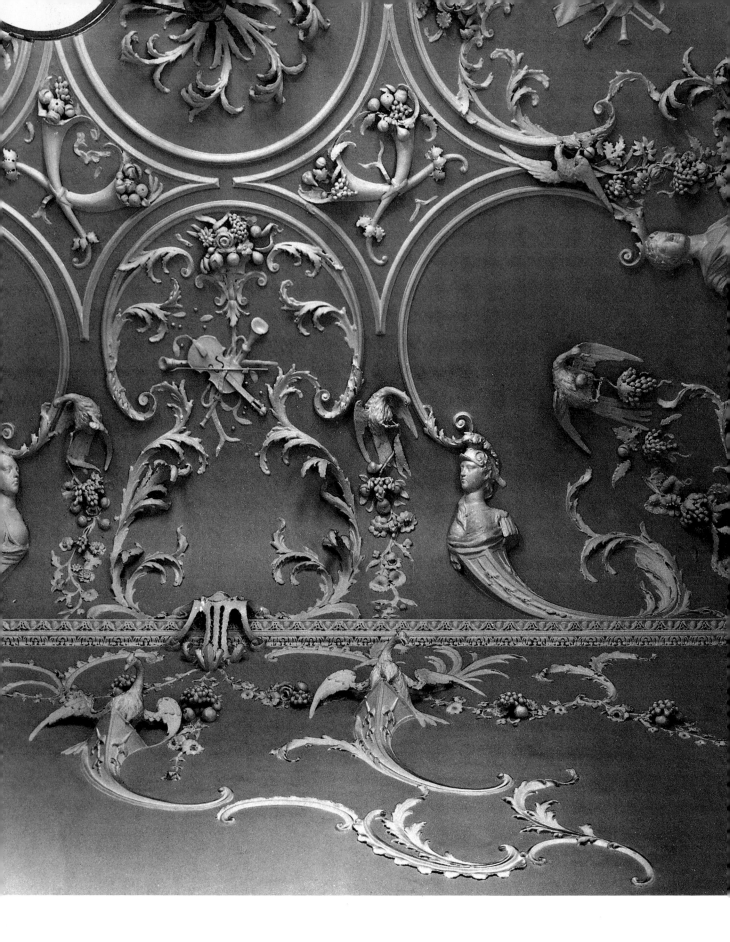

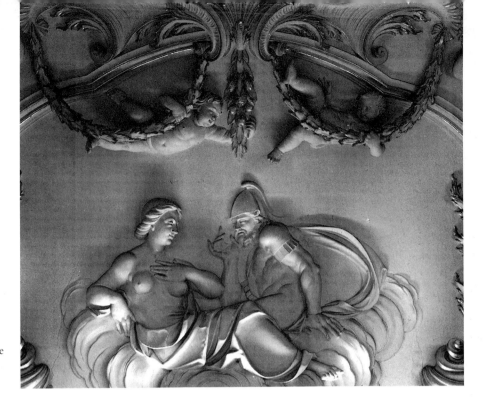

189 The Francini brothers: plasterwork in the saloon at Carton, Co. Kildare, 1739 (see ill. 130). Venus and Mars gaze into each other's eyes while *putti* swing in the swags above.

188 Robert West: plasterwork in the staircase hall of No. 20 Lower Dominick Street, Dublin, the house which the stuccodore built for himself in 1755. We are looking up the wall (where some of West's famous birds perch on brackets) at the ceiling.

APPLIED ARTS

Plasterwork

Plasterwork decoration had been used in the interiors of Irish houses from at least as early as the first years of the seventeenth century; but just as the houses built in 109 the eighteenth century were more lavish than those of the preceding century, so too was their stucco decoration.

The first really important stuccodores (from the Italian *stuccatore*, plaster-worker) in Ireland were two Italian brothers called Francini. This fact led to the mistaken belief, until recently universal, that all Irish plasterwork was Italian. The Francini brothers, who worked at Riverstown House, Co. Cork, Castletown, Co. Kildare, and elsewhere in the 1730s and 1740s, are notable for their introduction of life-size human figures into Irish plasterwork. In a ceiling such as that in the saloon at Carton, Co. Kildare, the figures are surrounded by a 130, wealth of swirling detail in high relief – festoons, garlands and tumbling *putti*. 189

In the 1750s the large-scale plasterwork of the Francini was superseded by the more delicate stucco of a native Irishman, Robert West (d.1790). West – not 188 to be confused with the painter of the same name – was the greatest of all Irish plasterworkers. His style is marked by a riotous use of scrollwork, fruit, flowers, musical instruments and above all superbly modelled birds, which are perched in lively attitudes and found in several Dublin houses.

The second great native stuccodore was Michael Stapleton (d.1801), who, like West, was probably master of a considerable workshop. He was active during the Neo-Classical period, which was dominated in Ireland and Britain by two exponents of the style in decoration, Robert Adam and James Wyatt. Of the two, Wyatt was much more influential in Ireland, supplying designs for interior decoration in several houses, including Slane Castle, Co. Meath, Curraghmore, Co. Waterford, and Westport, Co. Mayo. Unlike the Rococo decoration of West, Neo-Classical plasterwork schemes are extremely ordered and in much lower relief, with certain motifs combined and repeated in a logical and

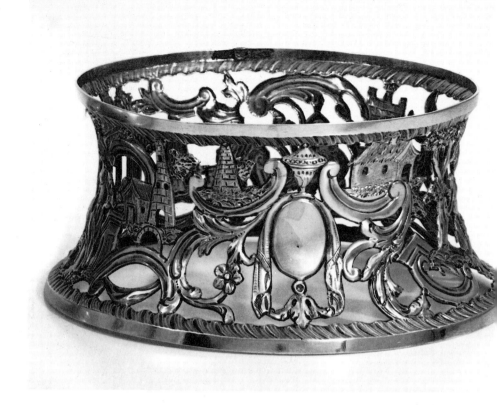

190 Silver dish–ring made in Dublin in 1780. D. 19.6 cm. (7¾ in.). Courtesy Sotheby & Co.

191 Waterford glass serving bowl with turnover rim, late 18th C. Private Collection.

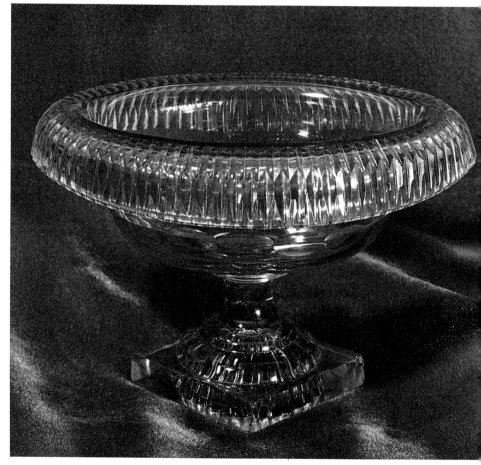

geometric manner. The plasterwork at Belvedere House in Dublin, by
Stapleton, is composed of several patterns linked to each other and made up of
repeated motifs which are all derived from antiquity, such as urns, cameo
portraits and scenes, and dancing figures.

143

Silver, glass and furniture

Irish silver, which was made in quantities in the eighteenth century in Dublin,
Cork and Limerick, generally followed in style that of England but with a time
lag of about five or ten years. Thus Early Georgian lasted until about 1740,
Rococo from 1740 to 1780 and Neo-Classical from 1780 to 1815. There were,
however, manifestations in both form and decoration that were peculiarly Irish.
A large decorated ring used for supporting a hot dish and called a dish-ring was 190
rarely manufactured in England. Three-legged sugar bowls and helmet-shaped
cream jugs were also peculiarly Irish. The dish-rings gave perhaps the greatest
scope for decoration, which in Ireland included not only the scrolls and stylized
fruit and flowers of English decoration but also bucolic farmyard and other
scenes. Such decoration was particularly popular between 1760 and 1780.

Irish glass prior to 1780 was almost indistinguishable from its English
counterpart. But in England at about that time excise duties were imposed on the
materials used for making glass which resulted in glass vessels that were lighter in
weight, making the glass-cutter's work more difficult, if not impossible. At the
same time the English Parliament eased the restrictions previously imposed on
the Irish glass industry, and both factors led to a migration of many English glass
workers to Ireland. After 1780 new glasshouses were established in Dublin,
Cork, Belfast and, most important, in 1783 at Waterford. Irish glass was thicker
than English, with a consequent deeper cutting of the pattern. A characteristi-
cally Irish piece dating from after 1780 is a large serving dish with a turnover rim, 191
elaborately cut.

From the time in the eighteenth century when mahogany (imported from the 192
West Indies, with which Ireland did considerable trade) replaced oak as the wood
most often used in furniture, the Irish carver and cabinetmaker evolved a style of

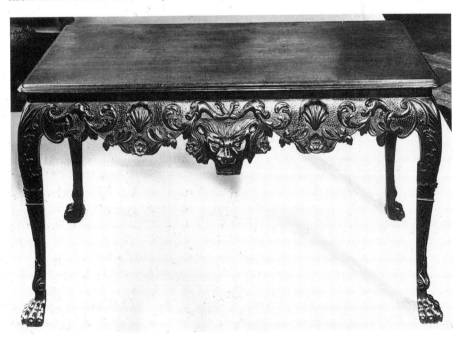

192 Carved mahogany side table, c. 1735.
National Museum of Ireland.

design which was perhaps the most vigorous statement of an unmistakably Irish art. Chairs, cabinets and in particular side tables were decorated with superb carving: foliage, animals and masks – human, lion-faced or grotesque – are the hall-mark of Irish furniture.

Book-binding, delftware and linen-printing

Other crafts and manufactures, such as book-binding, delftware, linen-printing and wallpaper manufacture also achieved a high standard of artistic excellence in the period, and generally flourished after the lifting of unfavourable trade restrictions. The most sumptuous bookbindings were those of the 149 volumes of manuscript journals of the Irish Lords and Commons, in crimson morocco and elaborately tooled. Believed to have been 'probably the most majestic series of bound volumes in the world', they were all destroyed in the burning of the Four Courts in 1922; but their designs, which were distinctively Irish though ultimately derived from English prototypes, are known through photographs. Delftware, generally blue and white and decorated with painted landscapes or floral patterns, was manufactured in several Irish centres. The most outstanding pieces are those produced between 1753 and 1769 in the Dublin factory of the Delamain family. An octagonal dish is a characteristically Irish form. Linen-printing from copper plates, using a variety of fast colours, was probably invented about 1750 in Drumcondra near Dublin; other Irish factories existed at Leixlip, Co. Kildare, Coleraine, Co. Derry, Ballsbridge, Co. Dublin, and elsewhere. Designs, which were highly sophisticated, often included the manufacturer's name. Peculiarly Irish are the fabrics printed with scenes of the Volunteer movement.

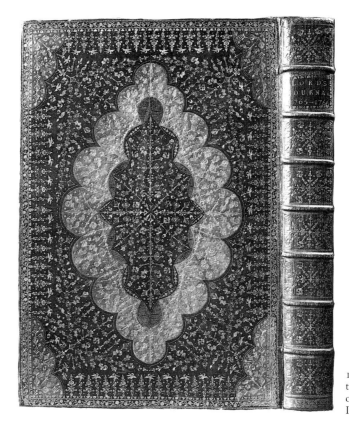

193 Leather binding of the Journal of the House of Lords for 1765–66. Destroyed.

PART THREE

The nineteenth and twentieth centuries

by Jeanne Sheehy

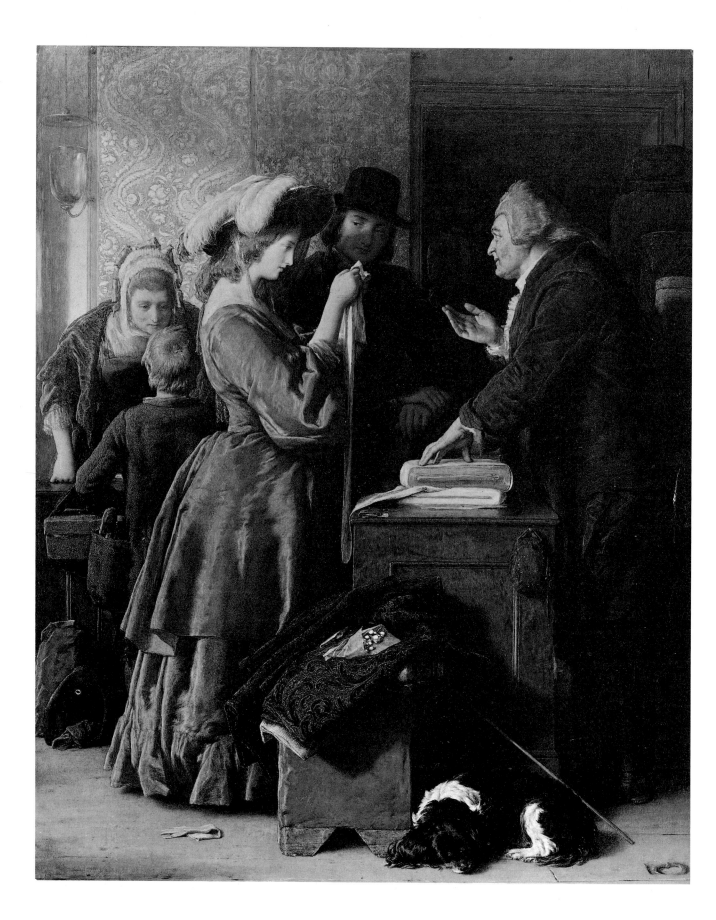

THE NINETEENTH CENTURY

The Act of Union, passed in 1800, amalgamated the Irish Parliament with that at Westminster, and put an end to Dublin as a centre of parliamentary government. It has generally been assumed that this was the cause of an immediate decline in art and architecture in Ireland. In fact, that does not seem to have been the case. Painting and sculpture continued, if not to flourish, at least to exist, though the professional middle classes gradually replaced the aristocracy as patrons of the arts. True, Ireland's best artists made careers for themselves abroad, but they had already done this in the eighteenth century, not, apparently, for lack of patronage, but because success abroad was the surest path to respect at home. For example, no less than four Irish sculptors, Foley, MacDowell, Lawlor and Lynn, worked on the Albert Memorial in Hyde Park, London. Art education was 239 sufficiently advanced for three of them to have got an excellent early training in Ireland, yet it was in England that they found professional success. Once established abroad, however, none lacked for commissions at home.

The applied arts suffered a gradual decline. The spate of country-house building early in the century gave employment to cabinetmakers and stuccodores, and work was produced which was in no way inferior to that of the eighteenth 196 century. Gradually, however, these skills, like those of the silversmith and the book-binder, were adulterated by methods of mass production. Architecture was the only one of the plastic arts which had sufficient economic support to flourish throughout the century. Except for lulls in the 1820s and during the Famine years, the building trade was continuously active. Ireland supported an impressive number of native architects in the nineteenth century, and several English architects had considerable practices there.

Building activity intensified in Ireland after 1800, though its location changed. Whereas the emphasis in the late eighteenth century had been on Dublin, particularly the great public buildings, in the early nineteenth century it shifted to the provinces. A large number of building programmes, generally promoted and encouraged by the government (the Irish landlords being, with some exceptions, unconscious of their obligations in this respect) were undertaken. Gaols (to new and improved designs), courthouses and barracks were built; the 197 Poor Law of 1838 produced numbers of bleak and oppressive workhouses; lunatic asylums, fever hospitals, dispensaries, schools and market houses were put up. The monumental character of Irish country towns was determined by this building programme early in the century. However forbidding the kinds of building erected, and however unwelcome gaols and workhouses, it is notable that this was building, not for private individuals, but for the people in general, especially the poor, and that it was organized and controlled by central boards, and designed on progressive lines.

A striking feature in the nineteenth century is the number of churches put 199– up. The Roman Catholic Church, in particular, carried out a vast building 201, programme – increased efficiency, and the freedom following on Catholic 206– Emancipation in 1829, enabling it to do so. It was paid for by the pennies of the 211 faithful, and also by the prosperous Catholic merchant class who were willing to

194 William Mulready: *Choosing the Wedding Gown*, 1845. 53.3 × 45 cm. (21 × 17¾ in.). Victoria and Albert Museum, London.

invest money in church building. For the Church of Ireland, too, the Board of First Fruits, and later the Ecclesiastical Commissioners, undertook substantial building. Other denominations, particularly Presbyterians in the North of Ireland, made their own contributions.

The spread of a large number of branch banks throughout the country is an indication of commercial development. The Bank of Ireland had a monopoly until 1821 (1845 in Dublin), but when the restriction was lifted branch banks spread throughout the country, so that each town had, as well as its church denominations, its different denominations of bank – Provincial, National (founded by Daniel O'Connell), Ulster and so on.

Domestic architecture, apart from the cabins in which a large proportion of the population lived, followed a more erratic course. There was a great deal of country-house building early in the century, when great houses such as Ballyfin, Co. Laois, were put up, but this later gave way to opulent villas for merchant princes on the outskirts of towns, and to suburban terraces. A few extravagant castles were built later in the century – for example Dromore in Co. Limerick and Humewood in Co. Wicklow – but they were exceptional.

In Ireland, as elsewhere, new institutions connected with the arts were founded, and old ones consolidated. The Royal Hibernian Academy was inaugurated in 1823 and held its first exhibition in 1826. From then on, with the exception of a bad patch in the middle of the century, it held an annual exhibition, as it still does. It was open to painters, sculptors and architects, and ran a school for the training of artists, which flourished well into the present century.

The Schools of the Dublin Society (it became the Royal Dublin Society under the patronage of George IV in 1820) continued to turn out talented artists, pastellists and particularly watercolourists. In 1849 they were reorganized as a Government School of Design, part of an official drive to improve design for manufacture. As a result, responsibility for training fine artists fell almost entirely on the schools of the Royal Hibernian Academy. Late in the century the School of Design became the Metropolitan School of Art, and was a vigorous centre for the Arts and Crafts movement, making notable contributions in lace-making, and later in metalwork and stained glass.

Schools of Design were also opened in Cork in 1849 and in Belfast in 1850. An earlier school, run by the Royal Cork Institution, where Daniel Maclise got his early training, flourished from about 1820 until 1845. Among its assets was the collection of casts, taken under the supervision of Canova, from antique sculpture in the Vatican. The casts had been sent by the Pope as a present to George III, who was persuaded to present them to the Institution. One story has it that the ship bearing the casts from Italy was beaten off course and foundered in Cork harbour, and that rather than bear the cost of retrieving them the King presented them to the City; but this is unfortunately untrue.

The National Gallery of Ireland was opened in 1864. It was revolutionary in being lit by gas, so that it could be visited after dark. The original collection consisting of 105 pictures was gradually added to in the course of the century, the main emphasis being on the Italian and Dutch schools.

ARCHITECTURE

Stylistically Irish architecture followed developments in England, though the changes were slower to come and there were occasional local digressions. Fitzwilliam Square, Dublin, not completed until the 1820s, is not very different from its eighteenth-century predecessors. Various forms of Neo-Classicism were popular early in the century, though the Greek Revival never dominated as it did

in England. Fairly severe Neo-Classical buildings are to be found as late as the 1850s. Sir Charles Barry's Italianate manner spread to Ireland in the 1840s, when it became a respectable alternative to more directly Classical styles. Classicism in its various forms suffered a decline in the middle of the century, but came back triumphantly at the end.

'Gothick' survived as a style for castles well into the century, though it took on a more archaeological character. When the Board of First Fruits began its programme of church building in the late eighteenth century it adopted Perpendicular Gothic, which continued to be used for the first quarter of the following century. The influence of Pugin and the Ecclesiologists coincided with an upsurge in church building towards the middle of the century, and established a mode of ecclesiastical building which was not really superseded until our own time. Various forms of Tudor and Jacobean were adopted for domestic architecture, and even, occasionally, for such functional buildings as railway stations. Ireland was stylistically in the van in the 1850s, when Benjamin Woodward, under the influence of Ruskin, developed a Venetian polychrome medieval style. From the 1860s onwards there were attempts to give a national character to architecture by the use of motifs from the Hiberno-Romanesque style.

Neo-Classicism

The Neo-Classicism apparent in Gandon's Four Courts, Dublin, gained ground 138
in the nineteenth century. It is a building which is Roman in inspiration, and architects continued to draw on the architecture of Classical Rome with which they were familiar from visits, or, more probably, from the etchings of Piranesi.

Gradually, however, elements from Greek architecture began to appear, made available through such publications as Stuart and Revett's *Antiquities of Athens* (1762, 1790). Elements from both styles are to be seen in the work of Sir Richard Morrison and of Francis Johnston, who succeeded Gandon as Dublin's most important architect. There is a certain severity in Johnston's work which is intensified by his borrowings from Greek architecture. At Townley Hall, Co. 195
Louth (designed in 1794), the repressive severity of the exterior of the house is by no means diminished by the Greek Doric columns of the entrance portico. The coffered dome of the magnificent central hall, on the other hand, is Roman in inspiration and opulent in effect.

The work of Sir Richard Morrison, Johnston's most serious rival, shows that he, too, was capable of restraint and understatement, though in general his buildings are more subtle and less severe. Morrison benefited from the spate of building in the early nineteenth century, and designed many country houses, as well as a number of courthouses. His courthouse at Galway (begun in 1812) has an austerity which befits a building representing the power of the Law, but also a certain elegance. The grandest of his country houses, Ballyfin, Co. Laois (c.1821), is relatively plain in its exterior treatment, but not as austere as Johnston's work. The entrance front has a fine Ionic portico, flanked by three bays on either side, a further two bays at each end being stepped back, giving a pleasant rhythm to the composition. There are mouldings round the windows, which, on the ground floor, are surmounted by segmental and triangular pediments. The interior decoration, of a richness unequalled in any other Irish country house, is 196
derived from a variety of Classical sources, Greek and Roman alike.

Some architecture, however, went exclusively to Greece for inspiration. Rome had always been accessible, so Greece was perhaps more of a novelty and appealed to Romantics, as well as to those in quest of knowledge. Widespread in

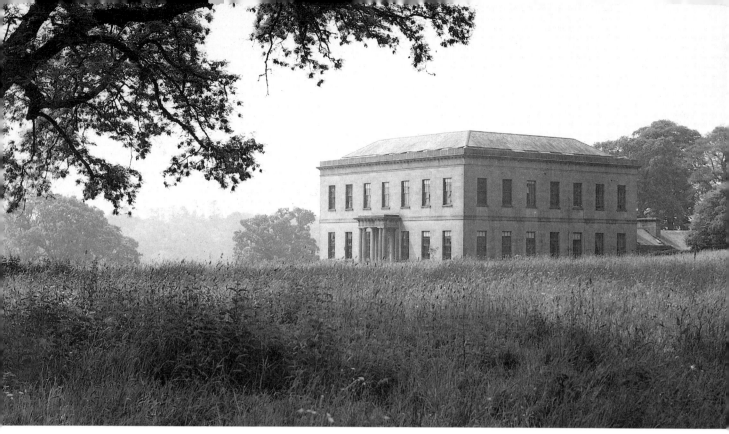

195 Townley Hall, Co. Louth, by Francis
Johnston, designed in 1794.

196 The hall of Ballyfin, Co. Laois, by Sir
Richard Morrison, *c.* 1821.

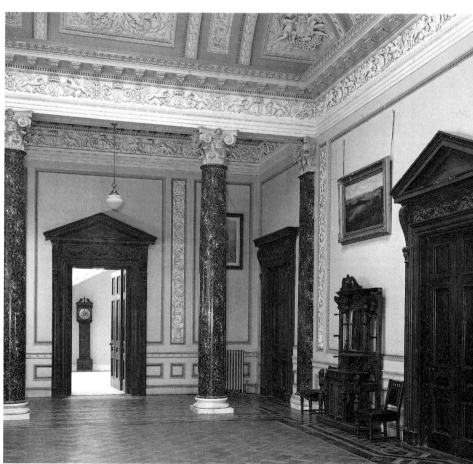

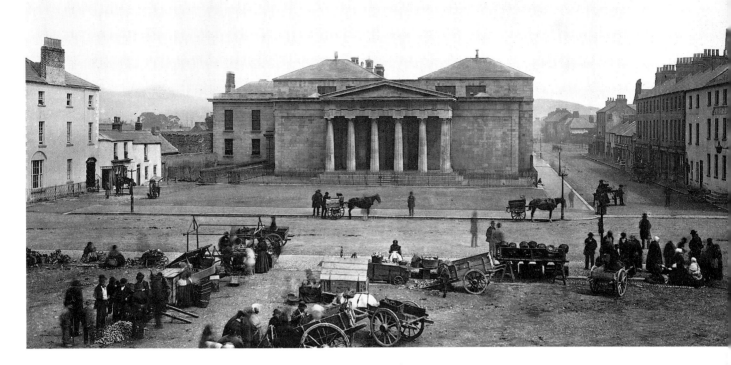

197 The Courthouse, Dundalk, Co. Louth, by Edward Park and John Bowden, begun *c.* 1813.

Europe, and in the United States, the Greek Revival was popular in England and to a lesser extent in Ireland. It involved as close an adherence to the forms of Greek architecture as the function of the building, and (on an even more practical level) the money available and the competence of the architect, would allow. The style is severe, even stark, and was well suited to a serious-minded age which felt architecture to have a moral as well as a practical function. We find it used, therefore, for public buildings, courthouses and prisons in particular. It was also used, and for much the same reasons, for certain types of ecclesiastical architecture, especially Nonconformist.

One of the salient characteristics of Greek Revival architecture is its structural use of free-standing columns. Another is the logic and clarity of its arrangement – simple geometric shapes set one against the other so that our satisfaction in the appearance of a building comes from the relationship of the various parts. In the Greek Doric courthouse at Dundalk (by Edward Park and John Bowden, begun *c.*1813) there is no decoration to distract the eye: the building is a series of juxtaposed units – portico, hall and two courtrooms – each part clearly distinguished from the other. The portico itself is composed of a series of the simplest shapes – triangle, rectangle, cylinder. The result is not pretty or graceful, yet it is very satisfying to look at, and its stark simplicity is beautiful. This is particularly true of Greek Doric, which we find again in the portico added by G. R. and J. Pain (see pp. 196–97) in 1818 to the old Cork County Gaol, with its squat columns and plain capitals. Greek Doric is less common, however, than other orders. We find William Vitruvius Morrison (1794–1838) using the more graceful Ionic about 1830 for his Kerry courthouses at Tralee and Carlow. The arrangement remains clear and logical and the effect is quite imposing.

Because it was awe-inspiring, and because it symbolized an established order, Neo-Classicism was also much favoured by church builders in the early part of the century, particularly by the Presbyterian and Unitarian churches in Ulster.

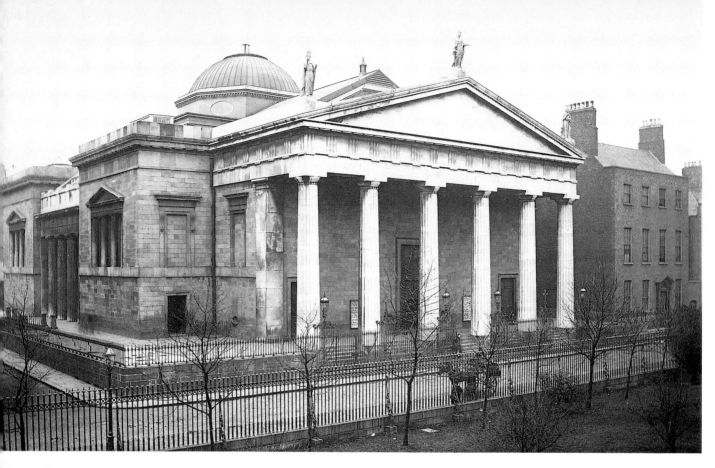

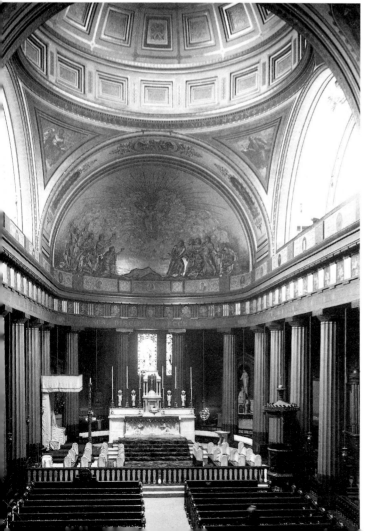

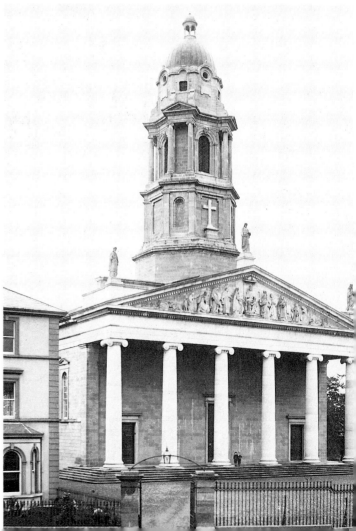

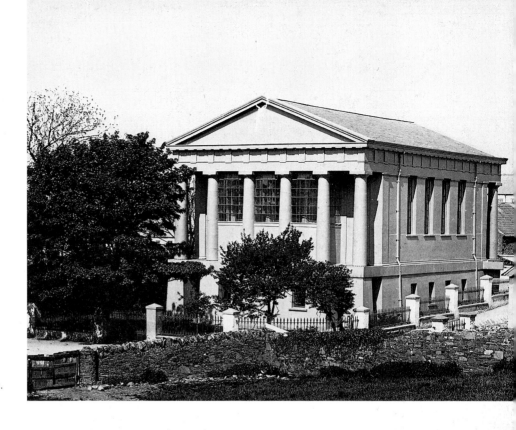

201 Presbyterian Church, Portaferry, Co. Down, by John Millar, *c.* 1840.

198, 199 St Mary's Roman Catholic Pro-Cathedral, Dublin. The main body of the church, with its domed interior, was designed in 1815 by an unknown architect, who used the Greek Doric order throughout, including unfluted columns in the pedimented niches on the side wall. The large portico was added in the 1840s by J. B. Keane, using a Doric order with slightly different details.

200 St Mel's Roman Catholic Cathedral, Longford, built between 1840 and 1893 by J. B. Keane, John Bourke and G. C. Ashlin.

The façade of Portaferry Presbyterian Church, designed by John Millar (*c.*1812– 76) about 1840, has a Doric colonnade surmounted by frieze and pediment. The fact that the whole building is set on a base gives even it more authority. The style was also used, though more rarely, for Church of Ireland and Roman Catholic churches. The façade of the Church of the Holy Trinity at Kircubbin, Co. Down, of the same date and probably also by Millar, is based directly on an engraving of a Doric temple at Sunium from *The Unedited Antiquities of Attica* (published by the Society of Dilettanti in London in 1817).

The hexastyle Doric portico of the Pro-Cathedral in Dublin, added in the 1840s by J. B. Keane (fl. 1829–50), has the same quality of awesomeness as Cork Gaol. The church itself was designed in 1815 by an architect whose identity remains uncertain. There is considerable serenity in the clear spaces of the interior, with its majestic Doric colonnade. Here, however, the inspiration came not directly from Greece but from one of the powerful centres of Neo-Classicism, Paris, and in particular from Chalgrin's church of St Philippe-du-Roule. The Pro-Cathedral is a rarity among Catholic churches, whose builders usually went to Baroque French or Italian models. The preference for European models was probably due to the travels of the Roman Catholic clergy, many of whom were educated abroad; and it also served to emphasize the links between Ireland and Catholic Europe. Many of the early Catholic churches are Classical, but they owe a great deal to buildings like Mansart's Val de Grâce in Paris or the great Jesuit churches in Rome, and are generally less austere than the buildings of the Greek Revival. The cathedral of St Mel at Longford was begun in 1840 and consecrated in 1893: during its long construction three architects worked on it successively – J. B. Keane, John Bourke (d. 1871) and G. C. Ashlin (1837–1921). It has a vast Ionic portico surmounted by an ornately sculptured pediment. The front is crowned by an octagonal bell-tower in four stages topped by a little

201

198

199

200

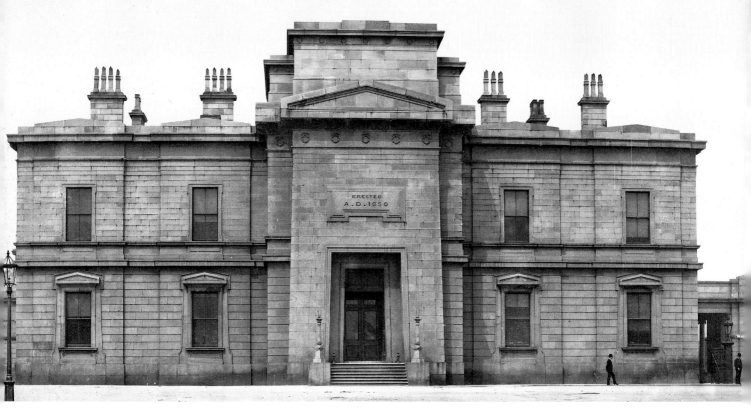

202 Broadstone Station, Dublin, by John Skipton Mulvany, 1850.

dome. A tower rising above the main front is a feature also to be found on several Dublin churches – for example St Paul's, Arran Quay (1835–37), by Patrick Byrne (1783–1864). The Dominican church of St Mary at Cork, begun in 1832 by Kearns Deane (1804–47, brother of the eldest Sir Thomas Deane), has a graceful Ionic portico added in 1861. A richer, more opulent effect is achieved by the use of the Corinthian order in the church of St Audoen in Dublin (by Patrick Byrne, 1841–46, with a portico added in 1902), both on the front and for the interior plasterwork. As the century progressed the severity of the original Neo-Classicism was softened, but the use of a chaste (to use a favourite nineteenth-century critical term) Neo-Classical idiom continued particularly late in Ireland.

Cork Savings Bank, built in 1841–42 by Sir Thomas Deane (1792–1871) and Kearns Deane, has a clarity and simplicity which were already beginning to go out of fashion. The Broadstone Railway Station in Dublin, built in 1850 by John Skipton Mulvany (c.1813–70), is in a style which was described as 'Graeco-Egyptian' ('Egyptian' because the central section, with its doorway, tapers towards the top, and the cornice is curved underneath). Its plainness is in marked contrast to the contemporary Dublin stations at Amiens Street (now Connolly Station: see below) and Kingsbridge (now Heuston Station: see p. 207). The choice of style for all these buildings was not unconnected with the fact that both banks and railway companies needed to inspire confidence, particularly that of investors, by evoking an established order.

Towards the middle of the century, when Neo-Classicism was rather too severe for the increasingly florid taste of the early Victorians, the Italian style made its appearance. It was adapted from Italian palaces and villas of the High Renaissance, and was characterized by a certain richness and grandeur. Italianate architecture is sculptural, with heavy cornices and string-courses giving a strong horizontal accent, sometimes balanced by arcaded towers, called belvederes. It exploits the rich effect of rustication for quoins, basements and other wall areas. It

215

202

204

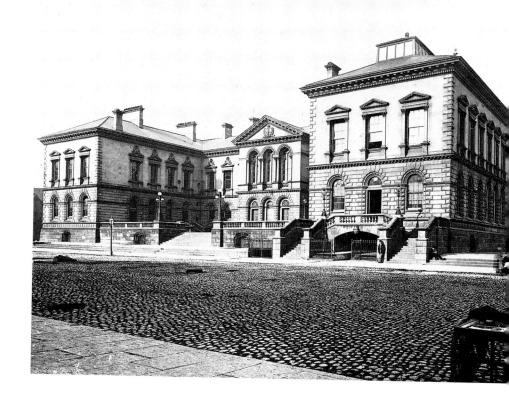

203 The Custom House, Belfast, by Sir Charles Lanyon, 1857.

made its appearance in England in the work of Sir Charles Barry (for example the Travellers' Club, London, of 1829), and was taken up in Ireland in the 1840s. Its first appearance in Dublin seems to have been in the design of Amiens Street 204 Station (now Connolly Station), begun in 1844 by William Deane Butler (fl. 1830–49). Its chief exponent in Ireland was the Belfast architect Sir Charles Lanyon (1813–89), who used it for that splendid example of self-confident civic architecture, the Custom House in Belfast (1857). He also developed it for a series 203 of grandiose country houses, such as Ballywalter Park, Co. Down (c.1844–46). The Italian style became the accepted alternative to the more chaste forms of Classicism, and it is to be found in all varieties of building from pubs and high-

204 Amiens Street (now Connolly) Station, Dublin, by William Deane Butler, begun in 1844.
(*Handbook to the Dublin and Drogheda Railway*, 1844)

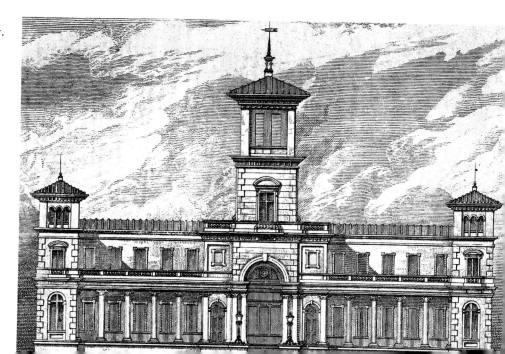

class grocers to banks and public buildings, in materials ranging from crumbling stucco to carved stone.

The Gothic Revival

The 'Gothick' castle, so appropriate to the wild and romantic Irish scene, continued to be fashionable in the early nineteenth century, and several architects carried on the tradition inaugurated in the previous century by Wyatt and Nash. Charleville Castle, Co. Offaly (begun in 1801), is an essay in Gothick by Francis 206 Johnston. It has a picturesque skyline, with towers and turrets, bartizans and machicolations. Though it has an irregular and picturesque grouping, its large flat-looking areas of wall, with regularly spaced windows (even though these are mullioned and hood-moulded in Tudor manner), give it the sham appearance of early Gothic Revival. The Pain brothers, James (1781–1878) and George Richard, who came to Ireland to work with Nash on Lough Cutra Castle, Co. Galway, set up practice in Cork and Limerick, and often worked in a Gothick idiom: theirs is the pretty toy-fort-like Blackrock Castle (c.1830) on the estuary at Cork; the Gothick folly at Cork known as Father Mathew's Tower (1843–45) was designed by George Richard Pain on his own.

In the first half of the century Elizabethan and Jacobean styles were popular for domestic architecture, especially as they provided opportunities for picturesque arrangements without the chilly (and often damp) romanticism of the Gothick castle. Salient features of the Jacobethan style, such as we see at Kilruddery, Co. Wicklow (by W. V. Morrison, c.1820), are Dutch or shaped gables, bow and oriel windows, usually mullioned, and tall, decorated chimneys. Stepped gables are also common, and are to be seen at Muckross House, Killarney, built in 1843 by the Scottish architect William Burn (1789–1870). The style was used for schoolhouses, estate cottages and other village architecture, and even served to give a reassuring appearance to railway stations, as, for example, at Carlow, on the Great Southern and Western Railway, built in 1846 by Sir John Macneill (1793–1880).

Gothic is a style which we more readily associate with churches than with other kinds of building, yet, paradoxically, when Gothic was revived it took longer for it to be accepted for ecclesiastical architecture than for domestic. In Ireland it made its appearance in the churches put up by the Board of First Fruits, which was responsible for Church of Ireland building from the late eighteenth century until its duties were taken over by the Ecclesiastical Commissioners in 1833. These early buildings have aptly been described by C. P. Curran as 'spiky little churches of dessicated Gothic'. Their spikiness is due to the fact that they generally have towers with tall, thin spires, often flanked by four tiny pinnacles, with pinnacles topping the buttresses at each corner of the main body of the church, and frequently those along the north and south walls as well. Their pointed windows have simple tracery, an intersecting pattern (like curved railway tracks crossing) being especially popular. They often have battlements. Simple in shape – a rectangular plan, with a square western tower – they are to be seen in many towns and villages in Ireland.

Among the great number of these by no means unattractive little churches are to be found some of distinctly superior quality, notably by the Pain brothers, who designed many in Munster, and by Joseph Welland (1798–1860), who worked in Ulster. The most outstanding of the Board of First Fruits architects was John Semple (fl.1820–31). His parish church at Kilternan, Co. Dublin (1820), is not unlike the basic type in its elements, but these elements are handled with much greater delicacy, particularly in the mouldings, which are unusual, and in

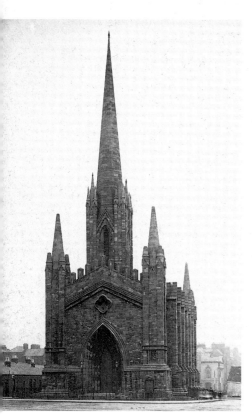

205 St Mary's Chapel of Ease (the Black Church), Dublin, by John Semple, designed in 1828.

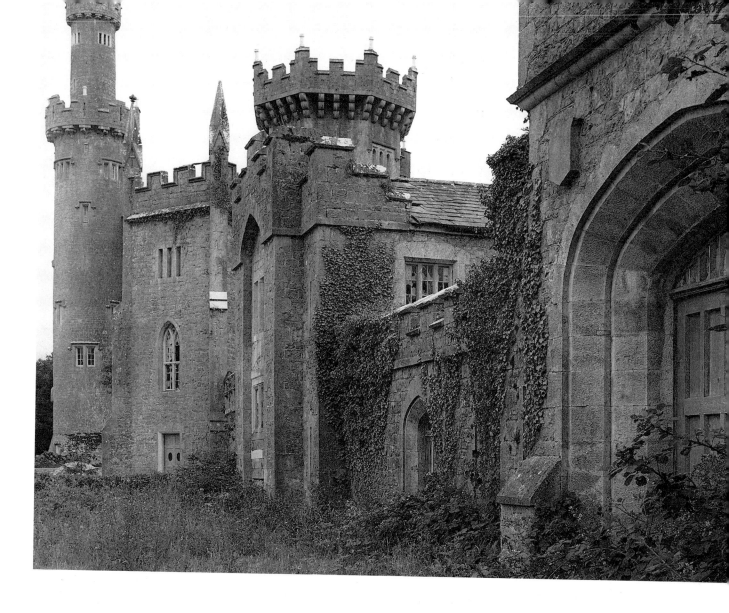

206 Charleville Castle, Co. Offaly, by Francis Johnston, begun in 1801.

the tall, pretty spire. His Black Church, Dublin (1828–30), is extremely powerful 205
in its massing, and has an exciting parabolic stone vault.

Having become the established style of the Church of Ireland, Gothic soon began to find favour with the Roman Catholic Church as well. It had been the style of ecclesiastical building before the Reformation, and was felt to symbolize historical continuity. Gradually, from the 1820s onwards, more and more Roman Catholic churches were Gothic – generally Perpendicular or Tudor, rather than the earlier forms which were to be advocated by the English champion of the Gothic Revival, A. W. N. Pugin. The cathedral at Carlow, built about 1820 by Thomas Cobden (fl.1820–42), is Perpendicular – in fact rather 'Gothick' in appearance. For the cathedral of St Patrick at Dundalk, built in the 1830s, Thomas Duff (d.1848) went for inspiration to the chapel of King's College, Cambridge, a building of the late fifteenth and early sixteenth centuries. The church of St Malachy, Belfast (1844), by Thomas Jackson (1807–90), has a 207
distinctly Tudor façade and the interior plasterwork is an imitation of the pendant vaults of Henry VII's Chapel in Westminster Abbey. The Roman Catholic Cathedral at Tuam (1827–37), by Dominic Madden, has some of the

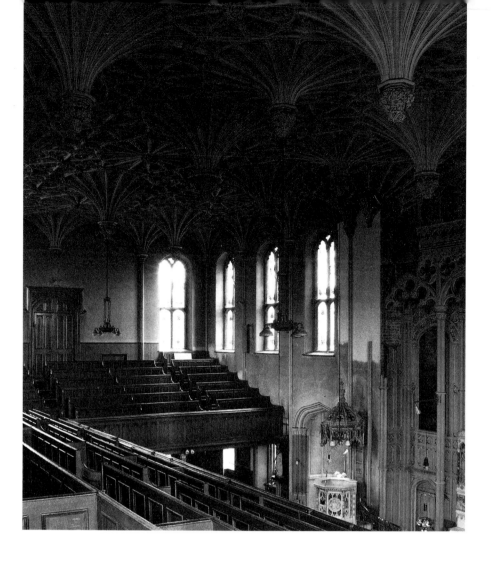

207 St Malachy's, Belfast, by Thomas Jackson, completed in 1844.

spikiness of the early Church of Ireland churches: Caesar Otway, in his *Tour in Connaught* (1839), commented that 'its multitude of little spires, spiking up into the air put me in mind of a centipede or scorpion thrown on its back and clawing at the sky'.

The church of St Patrick, Blackrock, Dublin (*c.*1842), shows an architect of the Classical tradition, Patrick Byrne, turning to Gothic, influenced, it is said, by the writings of Pugin in *The Dublin Review*. Pugin's influence began to make itself felt in the 1840s, and affected church building for the rest of the century. Exhorted by him, architects turned from Perpendicular and Tudor to earlier styles such as Early English and Decorated.

Augustus Welby Pugin (1812–52) was an English architect, a convert to Catholicism, whose writings, not less than his buildings, had a powerful influence on nineteenth-century architecture. He equated Gothic with truly Christian architecture, and reviled Classical churches as pagan. He idealized the life of the Middle Ages, contrasting it with the urban squalor of the nineteenth century. He regarded the great architecture of the Middle Ages as the result of a good society, and felt that, in his own times, the reform of architecture should go hand-in-hand with the reform of society. He enunciated two basic rules of design: that there should be no features about a building which were not necessary for convenience, construction or propriety, and that all ornament should consist of enrichment of the essential construction of a building.

Consequently, he was violently against 'sham', which is how he could have anathematized the pretty plaster ceilings of St Malachy's, Belfast, or St Patrick's, Blackrock. They were only imitations of real stone vaults, and had no structural function. Traditional medieval decoration was permissible, even desirable, but it must be in wood or stone, and a logical part of the building it adorned. In Pugin's churches, and in Gothic Revival churches after his time, instead of a plaster ceiling, and in the absence of the stone vaults familiar in the greater medieval churches but generally too expensive in the nineteenth century, we see open timber roofs with beams whose supporting function is clearly apparent.

Pugin built a considerable number of churches in Ireland in the 1830s and 1840s. He believed that Irish churches, in keeping with the country, should be rude and simple. The results are rather austere, but satisfying in their use of native materials and clear uncomplicated forms. Even his more magnificent Irish churches, such as St Mary's Cathedral at Killarney (begun in 1842), have 208 considerable simplicity.

Pugin gave a good deal of thought to the problems of designing a church to suit the ceremonies which it was expected to accommodate (adequate space for processions in larger churches, a proper baptistery, a clear distinction between nave and chancel) and to the ancient symbolism of church design (windows with three divisions symbolizing the Trinity, nave and transepts forming a cross). This branch of learning, called 'ecclesiology', was much studied in the nineteenth century, and had a very great influence on the Gothic Revival. Each part of the church had its own distinct place in the general arrangement, and these distinctions, it was felt, should be made clear as they had not been in the box-like churches of the earlier period. At Killarney, as, indeed, in most medieval churches, it is possible to stand outside and work out the internal plan from what one sees – the long nave, flanked by lower aisles (enabling light to get directly at the nave through clerestory windows), the transepts at right angles to the nave forming a cross, and the great crossing tower, marking the division between nave (laity) and chancel (clergy).

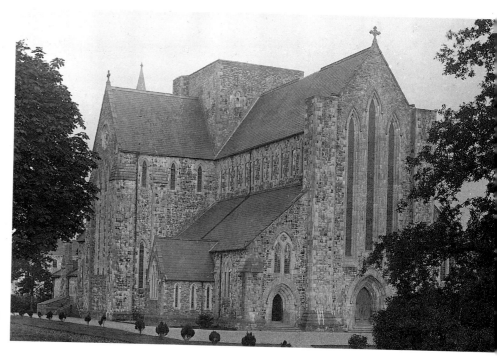

208 St Mary's Roman Catholic Cathedral, Killarney, Co. Kerry, by A. W. N. Pugin, begun in 1842. Pugin had intended a spire, but the one built after this photograph was taken (c. 1900) is not to his design.

The Irish architect most strongly influenced by Pugin's teaching was J. J. McCarthy (1817–82). In the church of St Agatha, Glenflesk, Co. Kerry, we see his principles applied to a small country church. It is built of limestone, the chancel is carefully distinguished from the nave in a manner clearly visible from the outside, there is a small south porch, a north aisle, and a north-west tower, unfinished. Poverty prevented many of McCarthy's churches from being completed, or as richly decorated as he would have wished. St Kevin's, Glendalough, Co. Wicklow (1846–49), was intended to have sedilia, a rood screen, and painted decoration, but none of the scheme was carried out.

High Victorian architecture

In the course of the nineteenth century there was an increasing amount of study of medieval architecture. Architects had more sources to draw on: they were made familiar, through published work, with an ever-growing number of original models. As time went on, greater archaeological accuracy was required of them, particularly in the building of churches. It was no longer permissible to strive for a general effect.

By the middle of the century Gothic had been accepted as a respectable style. Whereas before it had been considered suitable mainly for churches, or buildings with ecclesiastical associations, and for picturesque castles, it was now accepted for banks and public buildings as well. This growing respectability was partly due to the fact that Gothic had been chosen for the new Houses of Parliament in London in 1836. On the whole, however, some form of Classical architecture was preferred for banks, public buildings, and the larger railway termini, whereas Gothic was almost universally used for churches, and was generally used for schools and convents. The adoption of Gothic for the Assize Courts at Sligo, built in 1879 by J. R. Carroll (c.1820–1911), was exceptional. Whatever the style, High Victorian architecture is apt to be overpowering, with a taste for picturesque effects – turrets, cloisters, oriel windows, belvederes – and for the use of carved decorations and different coloured materials. The liberal use of colour

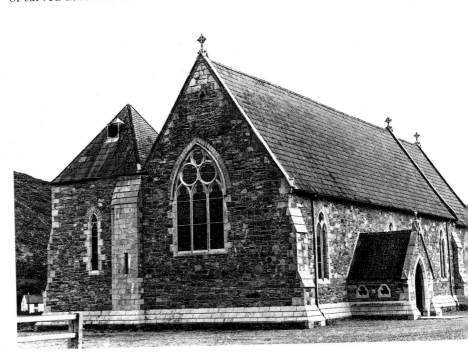

209 St Agatha, Glenflesk, Co. Kerry, by J. J. McCarthy, begun in 1862.

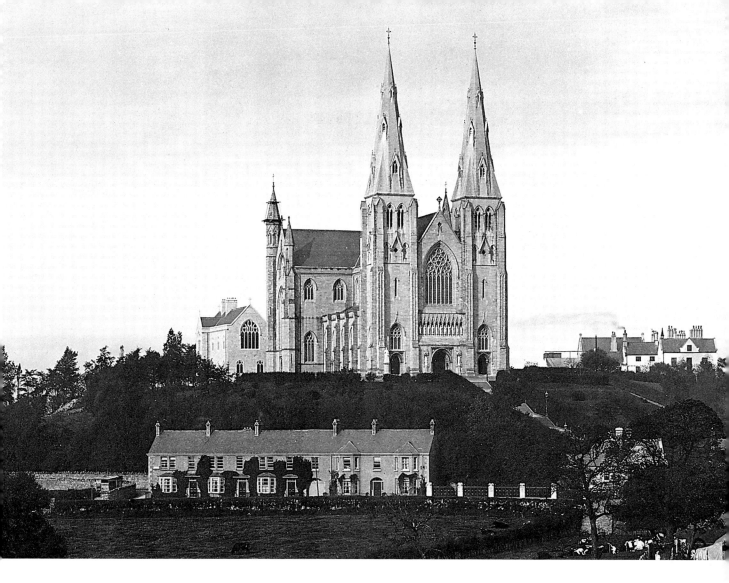

210 St Patrick's Roman Catholic
Cathedral, Armagh, begun in 1838 by
Thomas Duff and continued after 1853 by
J. J. McCarthy.

and ornament can be seen as a reaction against the restraint of the Georgian period.

Perpendicular Gothic, so popular with the first Gothic Revivalists, was replaced under the influence of Pugin and McCarthy by the earlier styles derived from French cathedrals of the late twelfth and thirteenth centuries or from Early English and Decorated churches. The Roman Catholic cathedral at Armagh is a good example of the transition. The foundation stone was laid in 1838 and work began in 1840, to the design of Thomas Duff (designer of St Patrick's, Dundalk), who intended a Perpendicular church. Building was halted by the Famine, and when it was resumed in 1853–54 Duff had died, and J. J. McCarthy was appointed architect. He left the lower portions of the walls as they were, so that traces of Duff's original design can still be seen (the main west doorway, for example, is a wide pointed arch set in a square frame, typical of the Perpendicular style) but redesigned the rest of the church in Decorated Gothic, so that it is taller and more imposing, reminiscent of the French cathedrals of the thirteenth century, with its great western spires and high nave interior complete with triforium and clerestory.

It frequently happened that the ambitions of the church architects went ahead of the money available. This was the case in the parish church of St Andrew, Dublin (opened in 1866), designed by William Henry Lynn (1829–1915) of the

210

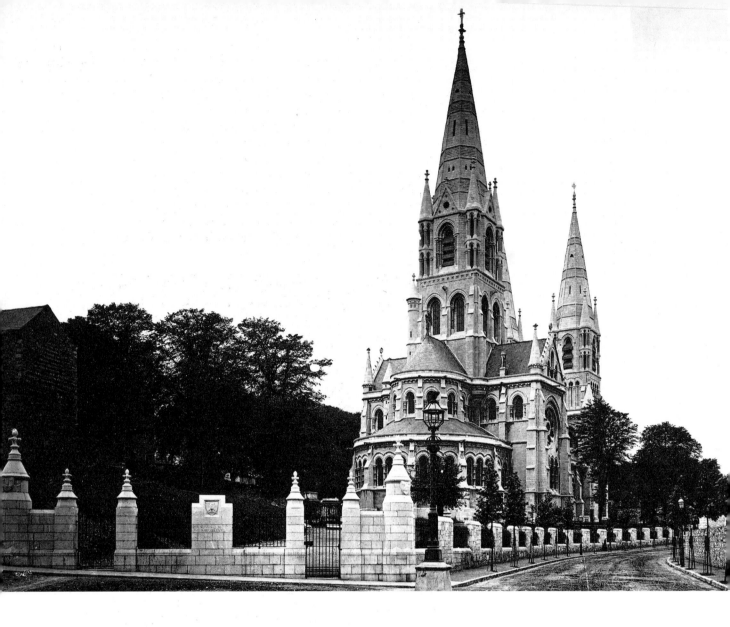

211 St Fin Barre's Protestant Cathedral, Cork, by William Burges, begun in 1867, seen from the east.

firm of Lanyon, Lynn and Lanyon: rough blocks can still be seen where some of the carving remained unexecuted. The church has a picturesque little cloister on the north side, and its extremely handsome tower and spire are arranged so as to be seen to advantage from the surrounding streets.

No shortage of money seems to have hampered the magnificence of the cathedral of St Fin Barre at Cork (1867–79), by the English architect William Burges (1827–81), though its decoration was not completed until this century. It is in French Gothic of the early thirteenth century, and is very profusely ornamented with pinnacles, crockets and carvings. Even such a highly ornate building as this, however, has the characteristic which we noted in the earlier Pugin churches – such great clarity of organization that it is possible to stand outside and see which part of the church is which: looking at the east end of St Fin Barre's, you can easily read the relationships between the transepts and crossing tower, and the curved apse and ambulatory. Inside there are sumptuous and inventive furnishings by Burges.

In 1852 the firm of Sir Thomas Deane, Son and Woodward won the architectural competition for a design for the new Museum (now the

21

Engineering School) in Trinity College, Dublin. It was in a medieval Venetian 212, 252 manner, a style which was advocated by the critic John Ruskin (particularly in *The Stones of Venice*, published in 1851–53). He said later that this building was the first embodiment of the principles he had been trying to teach. Like Pugin, Ruskin was against sham: materials should be what they appeared to be, and there should be no faking. He was in favour of structural polychromy – stones chosen not just for their suitability as building material, but also for the decorative possibilities of their colour. This is particularly striking inside the museum building, where columns and balustrades are of different coloured marbles. Ruskin was also in favour of the craftsman being given an opportunity for individual expression (as medieval craftsmen were): the decorative carving on the museum was executed by the O'Shea brothers from Co. Cork and by a

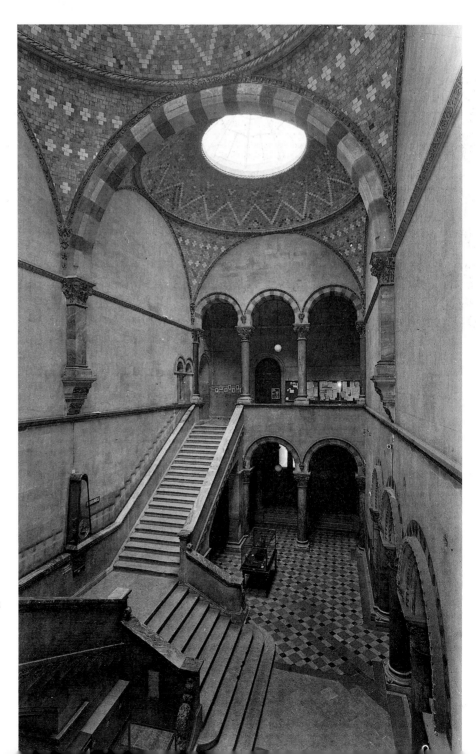

212 Staircase hall of the New Museum (now the Engineering School) of Trinity College, Dublin, won in competition by Sir Thomas Deane, Son and Woodward in 1852 and begun in 1854. The columns are of coloured marble and the domes are covered with coloured tiles.

Mr Rowe of Lambeth, and they were allowed, within certain architectural limits, to carve as they wished. The characteristics of the Venetian medieval style, as it was to be used for the next fifteen years, are all present – structural polychromy, abundant carving, a roof carried on a heavy corbelled cornice, balconies on brackets, decorative shafts at the angles of the building, and windows whose voussoirs are deeper at the top and come to a point, achieving the effect of a pointed opening, though in fact the windows themselves are round-headed.

In 1854, before the museum in Dublin was completed, Deane and Woodward won a competition to design the University Museum at Oxford, and so extended their influence (particularly that of Woodward, who is generally recognized as the genius of the firm) beyond Ireland. In Ireland their style inspired many interpretations. It was taken up by W. H. Lynn for his designs for the offices of the Belfast Bank, Newtownards, as early as 1854. Sir Thomas Deane continued to use it after the death of Woodward in 1861 – for example in his designs for a new front to St Ann's Church, Dawson Street, Dublin (1868), where the polychrome effect is particularly striking, combining granite and limestone and strong horizontal bands of red sandstone. We meet the Venetian style again in the Town Hall, Sligo, designed in 1866 by William Hague (fl.1862–1900), which is interesting because an essential feature, the decorative carving, was left unexecuted, giving the building a raw appearance.

Besides being adopted for ecclesiastical and public buildings, the various forms of Gothic were used in domestic architecture. W. J. Barre (d.1867) adapted the Venetian, with cantilevered balconies, grouped round-headed windows, and coloured stone, to his design for a *palazzo* for a prince of Belfast commerce, on the Malone Road, in 1864. Dromore Castle (1866–73), designed by E. W. Godwin (1833–86) for the Earl of Limerick, shows the use of full-blooded Northern European Gothic in domestic architecture. Its dramatic and now ruinous skyline is dominated by a round tower, an Irish touch of a kind which was to become increasingly popular. Ashford Castle, Co. Mayo (*c.*1870), by J. F. Fuller (1835–1924), is another Victorian mansion with the picturesque attributes of a medieval castle. Great houses such as these gave architects more scope than ecclesiastical buildings.

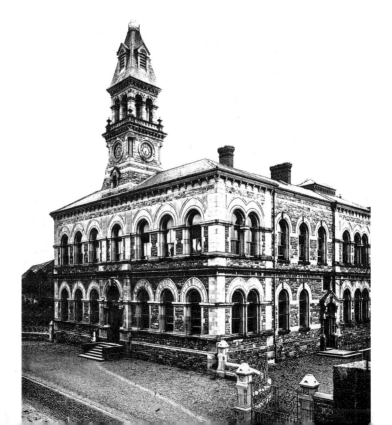

213 Town Hall, Sligo, by William Hague, 1866–*c.* 1870.

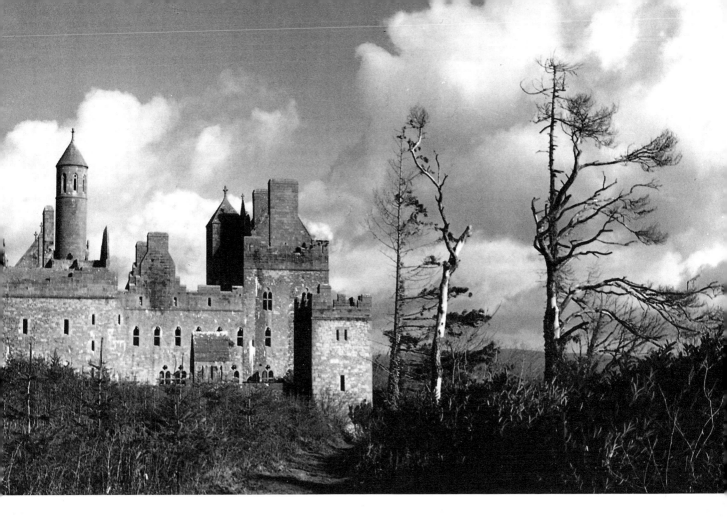

214 Dromore Castle, Co. Limerick, a fantasy based on Irish medieval castles and tower-houses (compare Dunguaire, pl. 6), with a round tower sprouting from its wall, designed by E. W. Godwin for the Earl of Limerick, 1866–73.

Looking around Irish towns and villages it is not difficult to recognize the variations and adaptations of twelfth-, thirteenth- and fourteenth-century Gothic which went on being built throughout the century, and even into this. A less ornate form, which might be called institutional Gothic, was used for schools, convents, warehouses, hospitals – buildings in which it was desired to combine economy with some attempt at an architectural style. (It should be remembered that until this century some form of historical style was considered necessary.) Many of these buildings are handsome and successful in their own way (some convents designed by Pugin, for example) but most are bleak and unfriendly to look at and work in, and are largely responsible for the bad name given to Victorian architecture.

Classicism and Eclecticism

While various forms of Gothic were gaining ground, Classical styles by no means faded from the scene, since they still had an aura of respectability, particularly popular with banks. The rather florid Italianate manner was often adopted, as we have seen; but even buildings directly inspired by antiquity are heavier and more ornate than at the beginning of the century.

The difference between High Victorian Classicism and the more chaste variety of the beginning of the century becomes apparent if you compare the Provincial 215 Bank at Cork of 1865, by W. G. Murray (d. 1871), with the Savings Bank of 1841–42 which faces it across Warren Place. The composition of the later building obviously echoes the first, but whereas the earlier building uses the Ionic

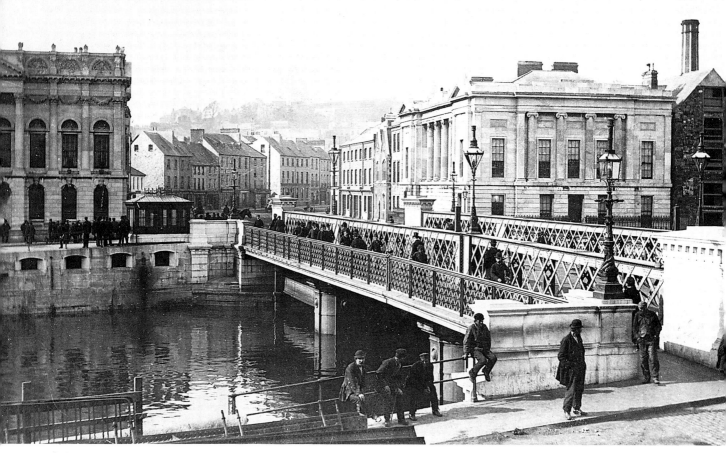

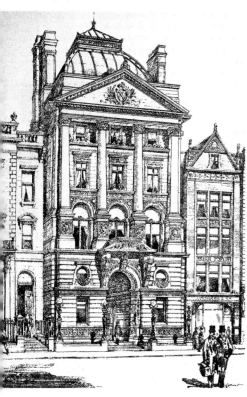

order, the other employs a more florid Corinthian, based on Roman models, and is topped by a heavily carved attic storey. It also has a great deal of sculptural embellishment on the outside, including festoons of fruit and keystone heads.

As time went on Classicism became even heavier and more eclectic, borrowing from all sorts of different sources. Almost Baroque in its elaboration is the Ulster Bank in College Green, Dublin (*c*.1891), by Thomas Drew (1838–1910). Its basement is broken by an ornate doorway with scrolled pediment carried on consoles, flanked by oculi, above which are giant Corinthian columns running through three floors. An iron-and-glass roof and tall chimneys rise above the triangular pediment. Also typical of the heavy style of the late nineteenth century are the Museum and Library buildings in Kildare Street, Dublin, by Sir Thomas Deane and Son (opened in 1890), with their circular colonnaded porticos and profusion of detail filling every available space.

Architects and their patrons became familiar with a growing number of architectural styles which they used either separately or mixed, so that by the end of the century you could choose your architectural style almost as you would your wallpaper. There was a revival of interest in Elizabethan and Jacobean architecture, particularly as it was suitable for building in brick. The necessary ornament, decorative panels and elaborately scrolled gables were mass-produced in cast terracotta by brick manufacturers. One example among many is the Royal City of Dublin Hospital, built about 1892 by A. E. Murray (b.1849), which is not only topped by extremely ornate gables in terracotta but also uses both yellow and red brick to obtain a particularly striking richness of effect.

Building in iron and glass

Some buildings put up in the nineteenth century are particularly exciting and revolutionary: these are the large airy structures of iron or wood and glass, which were designed by engineers rather than by architects. They were built for certain practical purposes – to cover the platforms of the new railway stations, like Sir John Macneill's great passenger shed at Kingsbridge (Heuston Station), Dublin, of 1845; to house the great exhibitions which followed quickly in the wake of the London Exhibition of 1851, like the spectacular domed building on Leinster Lawn, Dublin, built by Sir John Benson (1812–74) for the Exhibition of 1853; as conservatories, like the elegant curvilinear palm houses erected by Richard Turner (1798–1881) in the Botanic Gardens of Belfast (begun in 1839) 217 and Dublin (1842–50).

Unlike other nineteenth-century buildings, their design was not based on any revival of the architecture of past ages, but was a completely new departure. It was a result of the industrial revolution, which made iron and glass available in greater quantities and with greater precision. Industry, in its turn, required large, light, airy buildings, which these materials were used to produce.

Town and village

The main contribution of the nineteenth century to urban development was the laying out of suburbs in the cities (the Ball's Bridge area of Dublin, or the Malone area of Belfast, for example), and, after the spread of the railways in the 1850s and 1860s, the creation or enlargement of holiday resorts such as Bray, Co. Wicklow, Portrush, Co. Antrim, and Killarney, Co. Kerry. This kind of development was commercial, undertaken as speculation by such people as builders and railway directors, and is often identifiable by being neatly laid out on a grid system. In the design of the houses stucco or muted brick, and Georgian

215 Looking across the river towards Warren Place, Cork, at the turn of the century. On the right is the Savings Bank by Sir Thomas Deane and Kearns Deane, of 1841–42, on the left part of the Provincial Bank, built in 1865 by W. G. Murray.

216 Ulster Bank, College Green, Dublin, by Thomas Drew, *c.* 1891, recently demolished except for the façade. (*The Irish Builder*, 1891)

217 Palm House in the Botanic Gardens, Belfast, by Richard Turner. The wings were built in 1839–40, the centre after 1852.

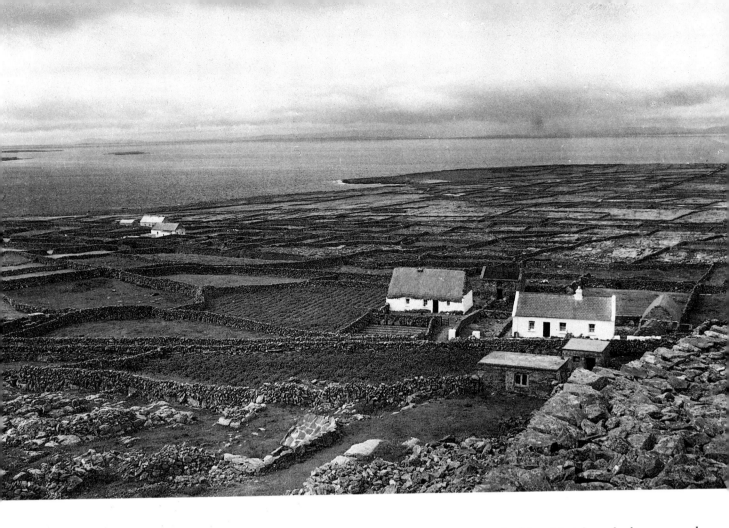

218 Cottages scattered in the landscape of Inishmaan, in the Aran Islands, Co. Galway. The older of the two cottages in the foreground has retained its thatched roof; the others have slates. On the far right are two small traditional outbuildings, with thatched roofs and stone walls left without whitewash.

proportions, gradually gave way to more florid red brick, polychromy, and Gothic doorways. Public buildings were designed according to their nature, taking into account the fashions of the day. Bray, developed by the railway entrepreneur William Dargan in the 1850s and 1860s, had a solid, rather Classical railway station, a vast stuccoed hotel 'after the American fashion', an impressive Gothic church of cathedral proportions, and rather gimcrack Turkish baths complete with onion domes and horse-shoe arches.

The meandering Irish villages did not change much in their basic shape, though some were augmented with solid nineteenth-century buildings in the form of estate cottages and schoolhouses, and nearly all acquired at least one church and one branch bank. A few landlord villages were built – for instance Ardagh, Co. Longford, and Enniskerry, Co. Wicklow – but they are usually distinguished by their particularly un-Irish character, with solid stone cottages, medieval in appearance, arranged around a central clock or green.

In discussing the evolution of architectural styles, we are dealing with buildings of a certain importance, designed by architects, and influenced by a widespread European culture, whether Classical or medieval. The majority of the rural population of Ireland in the nineteenth century, however, lived in cottages. In the first half of the century even in quite substantial towns only the buildings in the main street or square would be of cut stone, slated and of more than one storey, the rest of the town being made up of thatched cabins. These were not designed by architects, but evolved over the centuries in response to a certain way of life. They were built not by specialists but by the cooperative effort of the

21

community. At their worst – which was not uncommon, due to poverty and social conditions such as rack-renting which stifled any incentive to improve – they were hovels sheltering man and beast alike, mud-walled, without even a chimney. At their best – particularly on the western seaboard – they have fitness and simplicity, and blend with the landscape in a way that is very pleasing.

Though there are variations in design from place to place, Irish cottages do not change very much. They are one storey high and one room deep (when more rooms were required, they were added to the length), with a fireplace and chimneybreast at the gable end, or in a partition wall dividing the kitchen (the main living room) from the principal bedroom. There is often a second bedroom opening off the other end of the kitchen. Windows are small and high up, facing away from the prevailing wind: glass was a luxury until quite late. They are built of local materials – stone where it was available, mud elsewhere, with timber dug from the bog and straw thatch. Because of their natural fabric, their pleasing proportions, and the fact that they are usually built in sheltered positions, nestling into the hillside, they look like an organic part of the landscape in which they are set. Many of these cottages survive, though thatch has often been replaced by slate or (less happily) corrugated iron.

Towards the end of the nineteenth century traditional building methods began to give way to more commercial ones, so that the feeling is less of native growth and more of mass production. Construction was, however, governed by various new housing improvement laws, so that what the later cottages lost in picturesque quality they gained in sanitation.

PAINTING

In the nineteenth century painting did not flourish as well as did architecture: some of the best painters went abroad, and among those who stayed there was often apathy. Late eighteenth-century tendencies in landscape and portraiture continued to develop. Topographical landscape was still popular, and was distinguished in the nineteenth century by a growing interest in Irish antiquities. The emergence of a Victorian style is marked, as in England, by an increasing interest in anecdotal subject-matter. Seascapes, too, became popular, and landscapes of the moors-with-highland-cattle variety. What is remarkable, for a country with a strong religious consciousness, is the almost total absence of religious painting. The depression of the middle of the century, when the best painters emigrated, lifted towards the end when a wave of direct Continental influence invigorated Irish art, and several of the more talented Irish painters stayed at home.

Landscape

Two tendencies in landscape painting, the Classic and the Romantic, already apparent in the eighteenth century, continued into the nineteenth. William Ashford (see above, p. 169), who lived well into the century, continued to paint in the Claudian manner. In the early work of James Arthur O'Connor (1792–1841) we find the same ordered quality, wide views with distant blue mountains, and hills, trees and buildings arranged one behind the other, so as to create an illusion of depth. His *Homeward Bound* (National Gallery of Ireland) is carefully composed, with alternating areas of light and shade to carry the eye into the picture. He uses an arrangement of colours employed by landscape painters in Europe since the Renaissance, and made particularly familiar in Britain and **30,** Ireland through the landscapes of Claude Lorraine – green and brown in the **31**

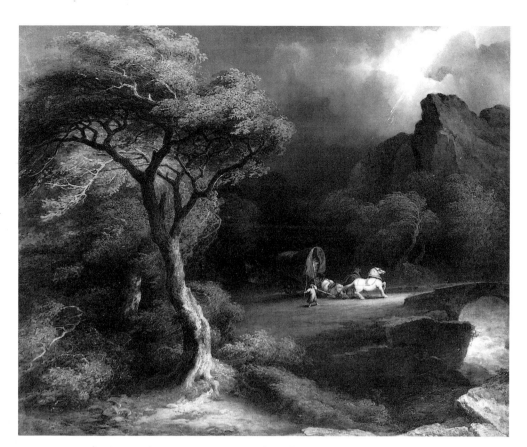

219 James Arthur O'Connor:
*Thunderstorm: The Frightened
Wagon*, 1832. 65 × 76 cm.
(25½ × 30 in.). National
Gallery of Ireland.

220 Francis Danby:
Disappointed Love, 1821.
On panel, 63 × 81 cm. (24¾ × 32 in.).
Victoria and Albert Museum,
London.

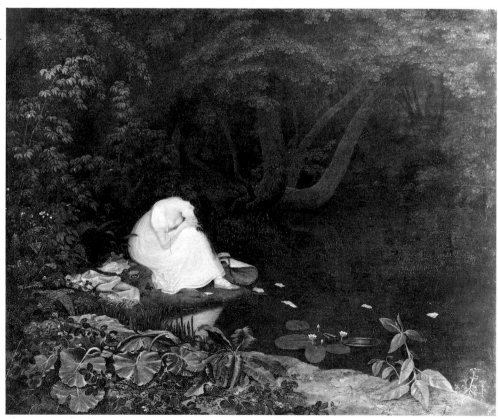

foreground, green in the middle distance, and blue in the distance. From the little figure in the red waistcoat to the clump of oaks this kind of picture has become so conventional as to be almost a formula.

Gradually a Romantic element such as we noted in the eighteenth century in the work of George Barret began to emerge in the works of O'Connor: they become more dramatic, with dark, sinister forests, towering mountains and giant rocks. Nature takes on an awe-inspiring grandeur and scale, and human figures dwindle. Instead of the calm, horizontal lines of the earlier landscapes, these romantic pictures have sweeping, turbulent movement – bent trees, billowing clouds, roaring torrents. All of this excitement is to be seen in O'Connor's *Thunderstorm: The Frightened Wagon* of 1832 (National Gallery of Ireland) and, pushed to even greater limits, in the work of Francis Danby (1793–1861). In his *Opening of the Sixth Seal* of 1828 (National Gallery of Ireland) he uses all the romantic vocabulary at his disposal to evoke the scene – lightning, disintegrating mountains, turbulent skies, mysterious darkness – all menacing the helpless figures in the foreground. In his work we also find intimations of Victorian painting. The charming *Disappointed Love* (Victoria and Albert Museum, London), painted as early as 1821, displays the Victorian preoccupation with sentimental anecdote, and the detailed treatment of plants in the foreground reminds one of the Pre-Raphaelites.

William Sadler (*c*.1782–1839), O'Connor's teacher, was a topographical painter in an older tradition although even he had flashes of Romanticism. His *Burning of Home's Emporium* (National Gallery of Ireland) combines straightforward description with the romantic excitement of a disaster.

Topographical landscape continued to be as important as it had been in the eighteenth century, encouraged by the numerous guidebooks and collections of views that were published. The more picturesque beauty spots, like Killarney or Glendalough, were popular subjects, and so too were Irish ecclesiastical remains, especially as two leading topographical artists, George Petrie (1790–1866) and Henry O'Neill (1798–1880), were also antiquarians. Petrie's *Pilgrims at Clonmacnoise* (National Gallery of Ireland), painted about 1840, combines an

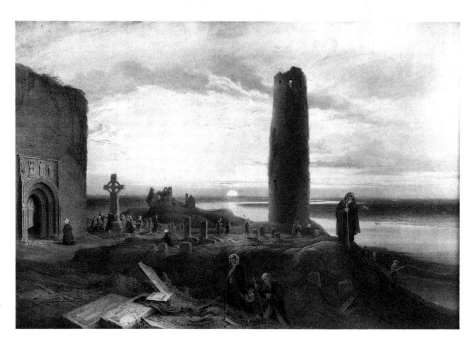

221 George Petrie: *Pilgrims at Clonmacnoise*, *c*. 1840. Watercolour, 67.2 × 98 cm. (26½ × 38½ in.). National Gallery of Ireland.

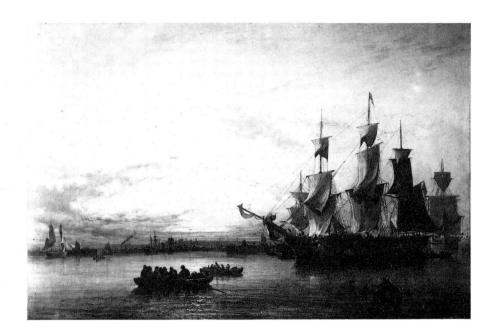

222 Edwin Hayes: *The Emigrant Ship, Dublin Bay, Sunset*, 1853. 58 × 86 cm. (23 × 34 in.). National Gallery of Ireland.

antiquarian accuracy (notice the carved slabs in the foreground) with an exploitation of the picturesque possibilities of the scene – the aspect of the pilgrims themselves, and the romantic ruins standing out against the sunset. O'Neill contributed most of the plates to *Fourteen Views in the County of Wicklow* (Dublin, 1835), showing such popular spots as the Dargle Valley. S.F. Brocas (*c*.1792–1847) is best known for his series of twelve views of Dublin which were engraved by his brother Henry Brocas.

The most talented of the topographical painters was Andrew Nicholl (1804–86). Most of his work is interesting, but particularly exciting is the series in which wildflowers in the foreground form a screen through which we dimly **33** perceive the landscape. The paintings have a sharpness and naïveté which is totally captivating. Together with Petrie and O'Neill, Nicholl contributed to a volume entitled *Picturesque sketches of some of the finest landscape and coast scenery of Ireland* (Dublin, 1835), which contains views of the familiar romantic sites from Antrim to Kerry.

It is noticeable that these topographic artists worked less in oils than in more delicate media such as watercolour or chalks. With the exception of Nicholl they had their training in the schools of the Dublin Society (after 1820 the Royal Dublin Society), where emphasis seems to have been placed on these media rather than on oil painting.

Marine painting gained great popularity in the nineteenth century, possibly because it gave so much opportunity for broad, romantic effects, or dramatic incidents involving storm-tossed ships. The three leading marine painters, Richard Beechey (1808–95), Matthew Kendrick (*c*.1797–1874) and Edwin Hayes (1820–1904), spent long periods of their lives at sea, and painted from a thorough knowledge of shipping and a seafaring life. In *The Emigrant Ship, Dublin Bay,* 22 *Sunset* (National Gallery of Ireland) Hayes obtains a romantic and rather melancholy effect by setting fairly detailed studies of ships, with little boats plying to and fro, against a misty sunset. Beechey is more broadly romantic, with turbulent seas and pitching boats, for example in *Hookers in the Race off the Blaskets* (Private Collection, Dublin), painted in 1873.

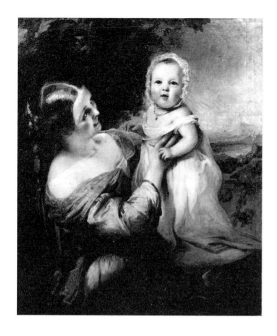

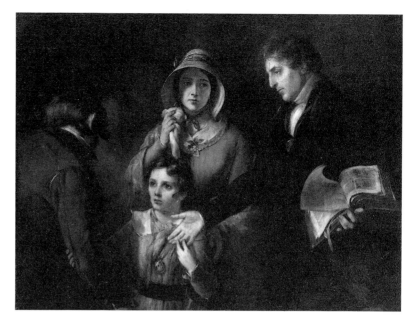

223 Richard Rothwell: *The Young Mother's Pastime*, awarded the Royal Irish Art Union Prize in 1845. 93 × 79 cm. (36½ × 31 in.). National Gallery of Ireland.

224 Joseph Patrick Haverty: *Father Mathew Receiving a Repentant Pledge Breaker*, probably shown at the Royal Academy, London, in 1844. 107 × 137 cm. (42 × 52 in.). National Gallery of Ireland.

Portrait painting

Portrait painting was no longer as brilliant in the nineteenth century as it had been. It was not that there was less of it, just that it became very stodgy – possibly because it was catering for a professional middle class who wanted dignified portraits, and whose dress was considerably more sober than that of the eighteenth-century aristocracy. Among the great mass of portraits only a small number stand out. As with landscape, the eighteenth-century tradition persisted. We see it in the work of Martin Cregan (1788–1870), Dublin's leading portrait painter of the mid-century, who was a pupil of Sir Martin Archer Shee. An example is his portrait of J. Sutherland, gardener at Shane's Castle, painted in 1822 (coll. Lord O'Neill). The change in taste becomes apparent in a certain sentimental sweetness, and an increasing liking for anecdote. Joseph Patrick Haverty (1794–1864) painted straightforward portraits in the older tradition, but his *Father Mathew Receiving a Repentant Pledge Breaker* (National Gallery of 224 Ireland) is, in a more typically nineteenth-century way, also concerned with putting over a message. Richard Rothwell (1800–1868), who, it was said, 'paints flesh as well as the Old Masters', produced some excellent portraits, among them *Mary Wollstonecraft Shelley* (National Portrait Galley, London), of 1841. His sentimental *The Young Mother's Pastime* (National Gallery of Ireland) has a more 223 popular appeal. This rather sugary quality is often seen in the female portraits of Stephen Catterson Smith (1806–72), whose pictures of men are as numerous as they are boring. Nicholas Crowley (1819–57) gave added interest to group portraits by painting conversation pieces with literary associations, such as *Tyrone Power in the Groves of Blarney* (Private Collection), of 1838, which shows a famous actor in a scene from a play.

The High Victorians – Irish painters abroad

The three leading Irish painters of the mid-nineteenth century made brilliant careers for themselves in England. William Mulready (1786–1863) was born in

Ennis, Co. Clare, but his father emigrated when he was six. Daniel Maclise (1806–70) was born in Cork, and had his early training at the Cork art school, working from the famous collection of antique casts there. Frederick Burton (1816–1900), from Corofin, Co. Clare, gained a reputation as the foremost Irish painter of the 1840s, which is remarkable since he worked in chalk and watercolour, and never in oils. He was an antiquarian of some note, and had an exceptional knowledge of the history of art. He became Director of the National Gallery, London, in 1874, and gave up painting at about the same time.

Mulready, Maclise and Burton were all subject painters, fond of elaborately anecdotal pictures, and often taking their themes from literature. Maclise's *Merry Christmas in the Baron's Hall* (National Gallery of Ireland), painted in 1838, is so full of activity that it is impossible to take it in at a glance. It is one of Maclise's faults that his compositions are often over-crowded and awkward. His drawing, however, is very sure, and his handling of paint shows the careful finish which was popular in the mid-century. His skill in draughtsmanship is more apparent in his attractive portrait sketches in pencil, which combine lightness of touch with sharpness of observation. **34**

Burton's *The Meeting on the Turret Stair* (National Gallery of Ireland), of 1864, is obviously a literary painting; its inspiration was the Danish poem *Hellalyle and Hildebrand*. It has a strong romantic atmosphere, and like Maclise's painting is an example of the mid-nineteenth-century idealization of things medieval which also found expression in the Gothic Revival in architecture. Here the colour and handling are very strong for a watercolour, and the variety of textures suggested is remarkable. **35**

Mulready's *Choosing the Wedding Gown*, of 1845 (Victoria and Albert Museum, London) illustrates the passage in Goldsmith's *Vicar of Wakefield* in which Dr Primrose says that 'he chose his wife as she did her wedding gown, not for a fine glossy surface, but for such qualities as would wear well'. Mulready excelled in genre painting, depicting, as here, the doings of everyday life. Like Maclise's work, the picture is carefully finished, and full of lovingly observed detail. In *The Sonnet*, of 1839 (Victoria and Albert Museum, London), he achieved a greater luminosity by painting on a white ground. This was a technique also used by William Davis (1812–73) to give brilliance to his landscapes. In *Old Mill and Pool at Ditton*, of c.1856–60 (Walker Art Gallery, Liverpool), the white priming, bright colours, and detailed handling show an affinity with the Pre-Raphaelites, who admired Davis's work. **194**

Continental influence

Three major painters at the end of the century, Nathaniel Hone (1831–1917), Walter Osborne (1859–1903) and Roderic O'Conor (1860–1940), represent three successive waves of influence from France – Realism, Impressionism and Post-Impressionism.

The Realists reacted against elaborate literary subject matter. Many of them were socially conscious and believed that artists should concern themselves with everyday life. Those who took to landscape painting were accordingly less attracted by the dramatic scenery popular with earlier painters, and turned to more commonplace fields and woods, which they studied from life, though many of their pictures were still finished in the studio. Brushwork became looser, replacing the 'licked' handling of the previous generation. (The word was applied by the Impressionists to the very smooth painting of someone like Ingres, where one brushstroke blends smoothly into the next.) The quality of paint began to matter, and pictures were exhibited which traditionalists

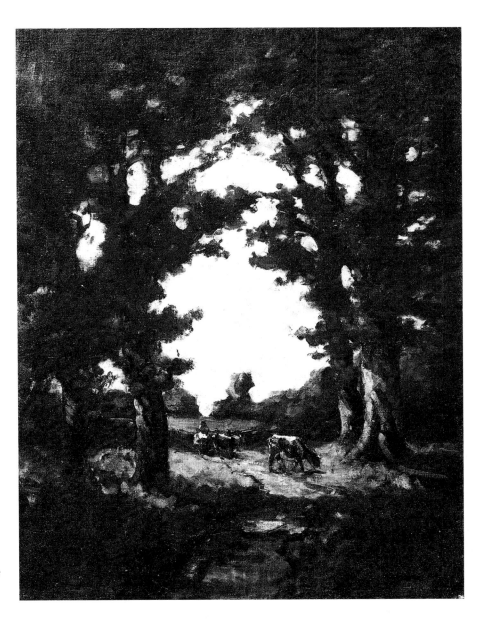

225 Nathaniel Hone: *Cows with Herd under Trees*. 100 × 122 cm. (39¼ × 48 in.). National Gallery of Ireland.

dismissed as unfinished sketches. Nathaniel Hone worked with French Realist painters such as Millet and Harpignies in the forest of Fontainebleau in France. His brushwork is broad and vigorous, and although the subjects of most of his land- and seascapes are not in themselves out of the ordinary, he gives interest by his treatment of them. In *Cows with Herd under Trees* (National Gallery of 225 Ireland) he depicts the most commonplace of sights in a way that sums up the essence of the scene. His seascapes, such as *Off Lowestoft* (National Gallery of Ireland), with its stormy sea and threatening sky, are no less evocative. The anecdotal realism of such painters as Jules Bastien Lepage also had a widespread influence, and was taken up in Ireland by Walter Osborne – see for instance *Cherry Ripe*, of *c.*1889 (Ulster Museum) – and J. M. Kavanagh (1856–1918).

Impressionist painters worked in the open, and in order to render the effect of light as brightly as possible they used colours which the uninitiated might not have discerned – vivid purples in the shadows, for example, or touches of red to increase the luminosity of green. There was no truly Impressionist school in

Ireland, but the movement did contribute to a gradual change in Irish painting. Painters became bolder in their use of colour, their palette became lighter, and their brushwork freer. They grew much more interested in the purely visual aspects of a scene than in storytelling. Osborne's *Tea in the Garden* (National Gallery of Ireland), painted about 1902, is concerned less with the people having tea than with the problem of expressing the effect of sunlight falling through trees. The brushstrokes are very loose – the canvas shows through in places – and the colours bright. **37**

While the Impressionists used new and exciting colours to render what they saw, some Post-Impressionists, such as Gauguin and Van Gogh, adopted them and exaggerated them to express what they felt. Roderic O'Conor was a friend of Gauguin and, like him, used colour as a means of expression. In *Ferme de Lezaver* (National Gallery of Ireland), of 1894, the vivid colours, though based on those of a real landscape, are stronger and more immediate. His brushstrokes – which recall the work of Van Gogh – not only translate lines in the landscape but are used to obtain a luminous effect. Line and colour combine to express the painter's emotions as strongly as possible. This generation of painters also broke away from the Renaissance idea of trying to create the illusion of a third dimension. They accepted the fact that the canvas was two-dimensional, and treated the picture as a flat pattern. **38**

Portrait painting continued on the whole rather dull. John Butler Yeats (1839–1922) was the most outstanding, with a gift for capturing the personality of a sitter. To him we owe in a large measure our images of the literary and political figures of the Celtic revival – his own son W. B. Yeats, John O'Leary, AE, Katharine Tynan, George Moore. His drawings are particularly fresh; he was sometimes inclined to overwork his paintings. Sarah Purser (1848–1943) also contributed to this gallery of national figures, with portraits of Eva and Constance Gore-Booth, Maud Gonne and Edward Martyn. Walter Osborne was for a time at the end of the century Dublin's leading fashionable portrait painter. Many of his portraits are dull, but into some he infused the freshness that we see in the portrait of his friend J. B. S. McIlwaine (National Gallery of Ireland), painted in 1892. He was more talented as a landscape painter, but painted portraits because they sold better, and enabled him to live in Ireland. It was an encouraging sign for Irish art that by the end of the century some of the best painters stayed to work at home.

SCULPTURE *by Homan Potterton*

Classicism persisted in sculpture until almost the end of the nineteenth century. It is understandable that the sculptural decoration of Greek Revival architecture should be in the Greek style; but this allegiance to Greece also governed portrait and subject sculpture. Classical Greek costumes, poses and subjects were adapted to Victorian needs. Greek nudity was invariably made respectable by the judicious use of fig-leaves and drapes. But while the style of Victorian sculpture is almost always Greek, there is an overriding sentimental quality about it which is most un-Greek.

Patronage for sculpture shifted during the century. In Dublin most of the great state and civic buildings had been built; now it was the turn of the commercial world to erect impressive offices, on which architects and sculptors alike were employed. With Catholic Emancipation in 1829 there was a new patronage by the Church for religious sculpture; but the results are disappointing. Most altarpieces were either imported from Rome or executed by inferior Dublin sculpture workshops, so that today their importance as Victorian

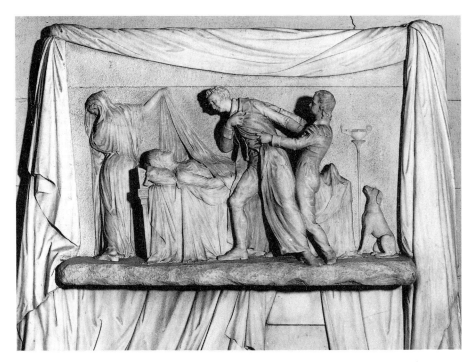

226 Thomas Kirk: detail of the monument to Lady Rossmore (d. 1807) in Monaghan Church. The relief was exhibited in 1843 at the Royal Hibernian Academy, Dublin, as *The Parting Glance*.

227 John Edward Carew: *Adonis and the Boar*, 1824–26. Marble, life size. Petworth House, Sussex.

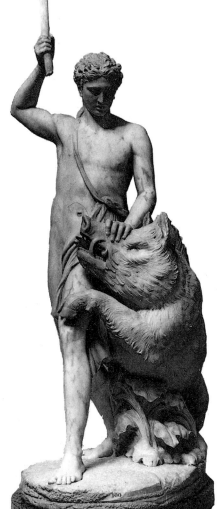

furnishing far outweighs their artistic importance. John Hogan was patronized by the Catholic Church, as we shall see, but to a limited extent; and John Edward Carew executed only one Irish altarpiece, that in Tallow, Co. Waterford.

The Gothic Revival in architecture led to a revival of the artisan craftsman, who was employed to carve the naturalistic details for banks, offices and churches erected in that style throughout the country. The work of craftsmen such as the Harrisons and the O'Sheas will be considered later, under the heading of applied arts.

Although Thomas Kirk (1781–1845), who trained in the Dublin Society's Schools, sculpted some elaborate memorials, he is best remembered for the small-scale reliefs on numerous church monuments throughout Ireland. Of these *The Good Samaritan* was by far the most popular. In his monument to Lady Rossmore in Monaghan Church, a relief of *The Parting Glance* shows Lady 226 Rossmore on her death-bed being visited for the last time by her mourning husband, the anguished Lord Rossmore, who is pulled back by his son. The narrative element in this relief is an innovation, and the sentimentality of the scene enacted associates it with the Victorian era. However, the style of the relief is Greek: the mourning woman who lifts the veil from Lady Rossmore is wearing a Greek costume, and the death-bed approximates in style to Greek Revival furniture. Here is the essence of Victorian sculpture: strong sentimental appeal clothed in Grecian dress. All too rarely, however, are the sentiments expressed as noble as the style by which they were portrayed, so that much of the sculpture of the period, though competently executed, lacks artistic inspiration.

John Edward Carew (c.1782–1868), though born in Waterford, spent all his working life in England. He was fortunate in being patronized almost exclusively and continuously by an English nobleman, Lord Egremont. This enabled him to execute a number of Classical subject groups in marble, unlike most of his contemporaries who were forced to earn their living by modelling endless portrait busts and public statues. His group of *Adonis and the Boar* 227 (Petworth House, Sussex) is Greek in both subject-matter and style.

Next to Carew John Hogan (1800–1858) was the most Classical of all 23 nineteenth-century Irish sculptors. Born in Cork, he lived in Rome from 1823 to 1848. He was the first talented native sculptor working in Ireland after Catholic Emancipation, and he executed several religious sculptures for churches. These are well carved but tend to be over pious. In the *Pietà* in the Loreto Convent, Rathfarnham, Co. Dublin, Christ's face conforms too closely to a Victorian ideal to be of interest artistically, and the Virgin's sorrow is so overstated as to be theatrical. In several of his secular groups Hogan excels. *The Drunken Faun* (Crawford Art Gallery, Cork), executed in plaster, demonstrates 22 well Hogan's modelling ability in the bulging veins of the arm, hands and neck, and the superbly modelled torso. And in the pose itself Hogan conveys the state of drunken collapse of the figure while at the same time suggesting the physical strength of the faun.

In the work of Patrick MacDowell (1799–1870) and John Henry Foley (1818–74) Victorian sentiment is at its best, as both men were extremely good sculptors. MacDowell was born in Belfast but emigrated to London as a boy. Foley trained under John Smyth in the Dublin Society's Schools, before leaving for London in 1834, following in the steps of his brother Edward (1814–74), who was also a talented Dublin-trained sculptor. In addition to public monuments (see below), they executed portrait busts and the subject groups which became so popular in the Victorian period. Foley's *Mrs Prendergast* (1845) is exceptionally 22

228 John Hogan: *The Drunken Faun*, 1825–29. Plaster, H. 99 cm. (39 in.). Crawford Art Gallery, Cork.

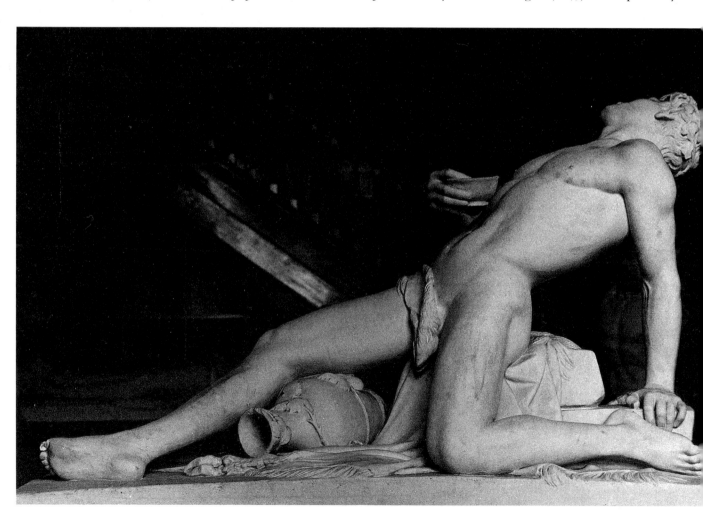

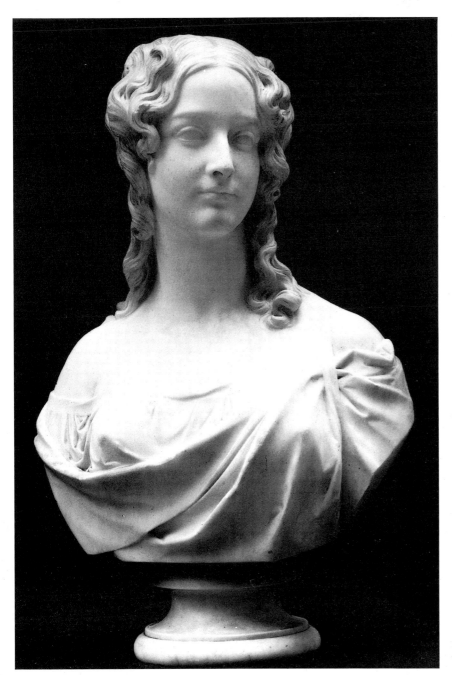

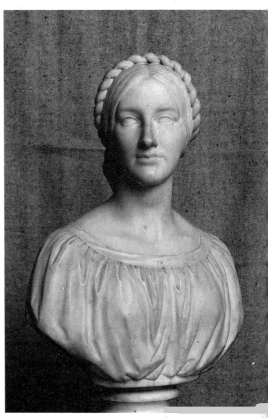

230 Christopher Moore: *Annie Hutton*, 1854. Marble, H. 73 cm. (28¾ in.). National Gallery of Ireland.

229 John Henry Foley: *Mrs Prendergast*, 1845. Marble, H. 61 cm. (24 in.). National Gallery of Ireland.

beautiful, her Victorian prettiness conveyed not with sugary sentiment but with grace. Compare this with the inferior bust by Christopher Moore (1790–1863) of Annie Hutton, carved nine years later, and see how Foley's modelling is much more subtle, and how the rigid folds of Annie Hutton's dress are coarse by comparison with the delicately draped robe of Mrs Prendergast. Mrs Prendergast almost speaks, Annie Hutton only stares. In a sculpture such as *Ino and the Infant Bacchus* (Royal Dublin Society), of 1849, Foley arranges his group in a Classical pyramid composition. There is an exquisite charm about the gestures of both figures, and from the relative fussiness of the base rises the simple

230

231

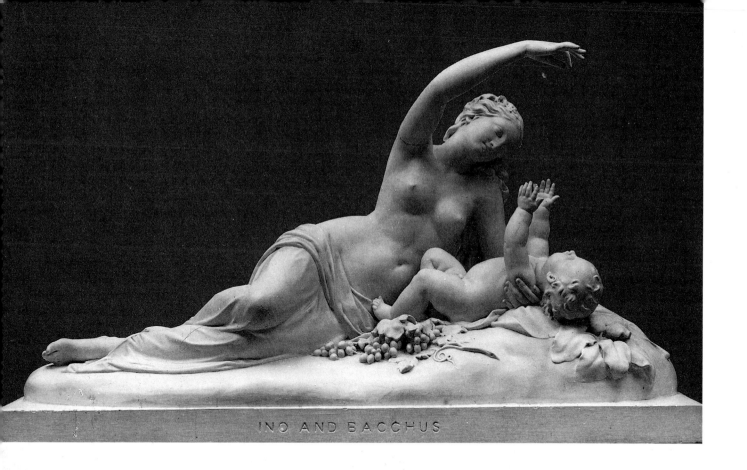

INO AND BACCHUS

231 John Henry Foley: *Ino and the Infant Bacchus*, 1849. Marble, life size. Royal Dublin Society.

beauty of Ino's nude form. MacDowell was as competent as Foley in portraying sentiment without excessive sweetness, for example in the monument to the Earl of Belfast in Belfast Castle Chapel. The Earl, who had died in 1853 of 233 consumption at an early age, is depicted on his death-bed, mourned by his mother. There is nothing of the allegory and Classical allusion found on earlier memorials, only the straightforward appeal to the emotions of the spectator made by the tragic death of a young man. In *Early Sorrow* (Ulster Museum), of 232 1847, MacDowell shows a young girl clutching her dead pet dove. At her feet is a bunch of fruit, no longer of use to the dead bird. The sentiment of the statue is expressed in the gaze of the girl at the fruit, and MacDowell conveys this sentiment in Classical sculptural form.

Thomas Farrell (1827–1900) was the most prominent sculptor to work in Dublin in the late nineteenth century. He became president of the Royal Hibernian Academy and was knighted in 1894. In spite of his popularity, much of his sculpture is dull, although it should be said that he suffered by the nature of the commissions which he received, for portrait busts and statues. What is probably his masterpiece, the frieze of figures on the Cullen Memorial (1881) in 234 the Pro-Cathedral at Dublin, shows him to have been in fact a sculptor of considerable grace, charm and indeed real talent.

Towards the end of the century there was a renewed demand for sculptural decoration for buildings. Banks, insurance companies and other commercial firms all employed sculptors. Samuel Ferres Lynn (1834–76), a former pupil of MacDowell and Foley in London, sculpted the pediment of the Provincial Bank in College Street, Dublin. Sculpture is employed to illustrate the virtues of industry and commerce, as opposed to those of government and the state found in the sculpted pediments of the eighteenth century.

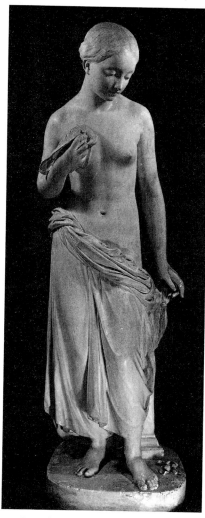

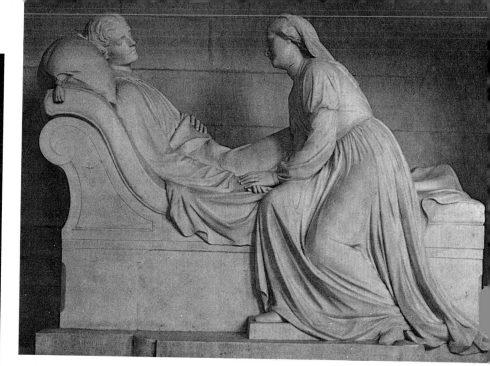

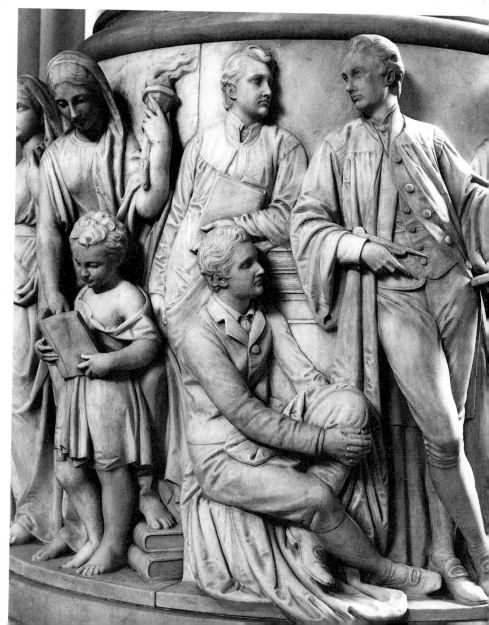

232 Patrick MacDowell: *Early Sorrow*,
1847. Plaster, life size. Ulster Museum,
Belfast.

233 *Above right* Patrick MacDowell:
monument to the Earl of Belfast (d. 1853),
in Belfast Castle Chapel.

234 Thomas Farrell: detail of the memorial
to Cardinal Cullen in the Pro-Cathedral,
Dublin, 1881. Life size.

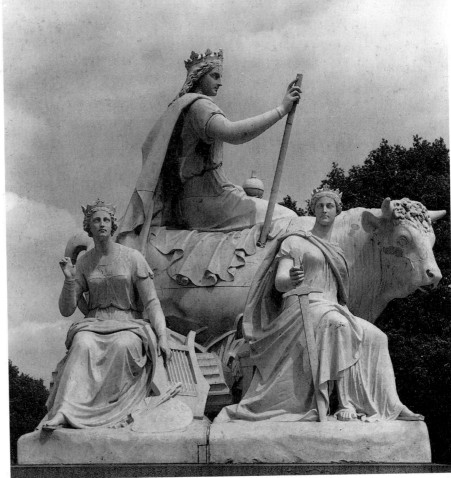

235 Patrick MacDowell: *Europe*, one of the
four Continents depicted on the Albert
Memorial, London, 1871.

236 John Hogan: model for a memorial to
the poet Tom Moore, *c.* 1857. Plaster, H.
46 cm. (18 in.). National Gallery of Ireland.

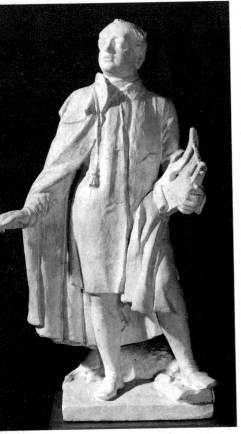

The nineteenth-century public monument

Several of the public monuments erected throughout the country in the first
decades of the nineteenth century took the form of high columns surmounted by
statues, a design derived from antique Roman triumphal columns. The most
famous Irish monument of this type was the now demolished Nelson Pillar in
Dublin (*c.*1809). The statue of Nelson was by Thomas Kirk, who sculpted
several statues for columns. His is the statue of the Duke of Wellington in Trim,
Co. Meath (of which a plaster version was exhibited in 1829), where the
difficulty of appreciating the artistic quality of any sculpture placed on such a
height is all too apparent. Later in the century these lofty heroes were placed at
more modest heights, and the merits of the sculpture are more readily assessed.

However, a public monument, if it is to be an accurate portrayal of a public
figure, limits artistic inspiration; and few sculptors succeeded in making these
solid Victorian worthies into attractive works of art. The most dismal failure of
all was the statue of the poet Tom Moore for College Street, Dublin (1857), by
Christopher Moore. The commission was awarded by competition, and the
unsuccessful model submitted by John Hogan still survives. It is quite delightful 236
and there is a lyrical air in the swinging stance of the figure which expresses
something of the delight of the poet's melodies themselves. In fairness to
Christopher Moore it should be said that Hogan was not always as successful in
his monumental statues.

The two really important nineteenth-century Irish sculptors, MacDowell and 235
Foley, enjoyed successful careers in London, where both achieved the distinction 237

237 John Henry Foley: detail of the
monument to Daniel O'Connell in
O'Connell Street, Dublin, *c.* 1870. Bronze.

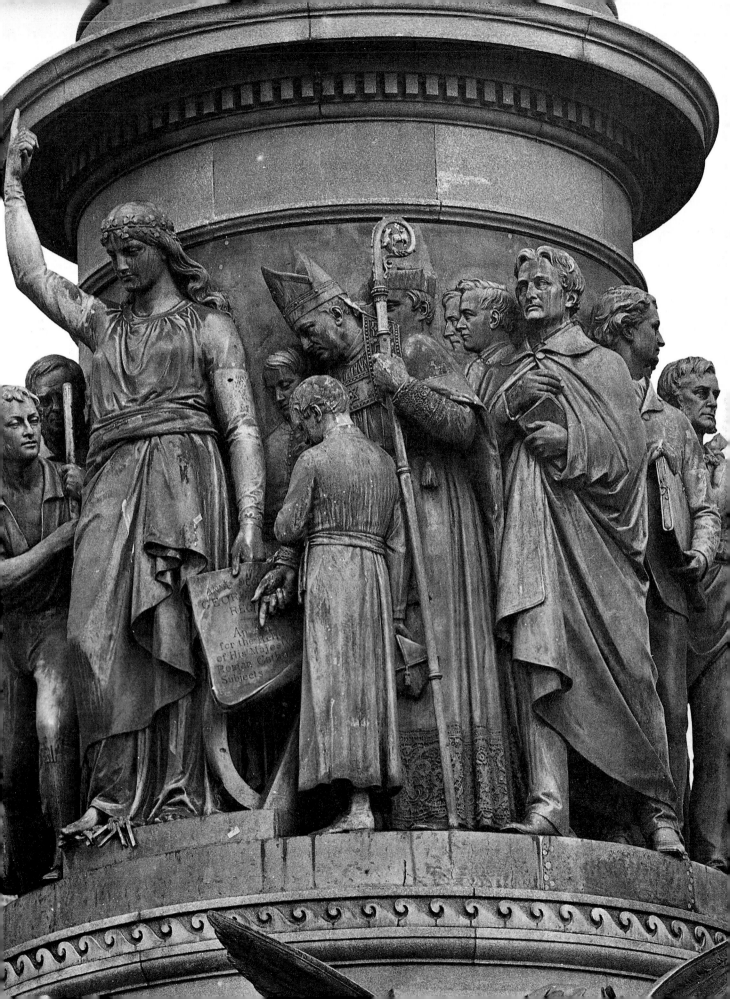

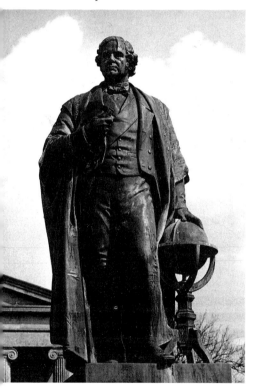

238 John Henry Foley: monument to Lord Rosse, at Birr, Co. Offaly, unveiled in 1876.

239 John Henry Foley: *Asia*, another of the Continents on the Albert Memorial, 1871. Foley surprisingly departed from Classicism, and based his figure of Asia on Indian sculptures.

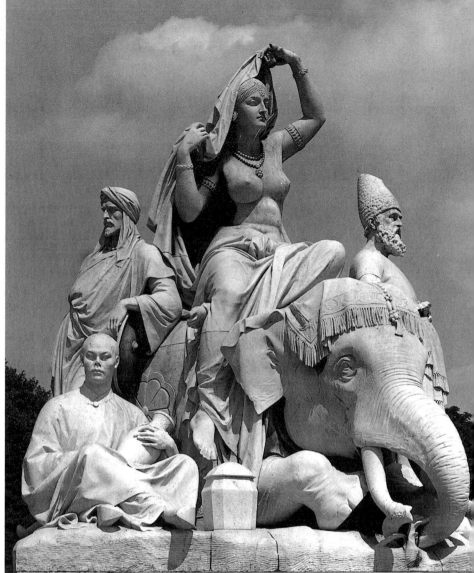

of being commissioned to work on the Albert Memorial in Hyde Park, Foley providing the design for the statue of the Prince himself. They also executed Irish monuments. Unfortunately all of MacDowell's statues in Ireland have been destroyed, but several of Foley's survive. Of these the best single statues are those of Goldsmith (1861), Burke (1868) and Grattan (1876) in College Green, Dublin, which have a superb elegance. All three are eighteenth-century figures, whose costumes perhaps lent themselves more readily to elegance. In dealing with the nineteenth-century astronomer Lord Rosse, in Birr, Co. Offaly, unveiled in 1876, Foley managed to imbue the figure with a calm dignity which is attractive. The sculptor's most elaborate Irish monument is that to Daniel O'Connell in Dublin (c.1870). The frieze of this monument shows Erin as a female figure, trampling on her fetters, holding in her left hand the Act of Emancipation and pointing with her right to the figure of the Liberator above. Towards her hasten Irishmen of every class to see the Charter she holds. All these figures, some sculpted in the round, some in relief, are extremely well modelled, and Foley manages to convey a sense of excitement at Catholic Emancipation by the gestures and movements of the figures throughout. Later in the century the seated figure became popular for monuments: Foley's Sir Benjamin Lee Guinness outside St Patrick's Cathedral in Dublin was erected in 1875.

238

239

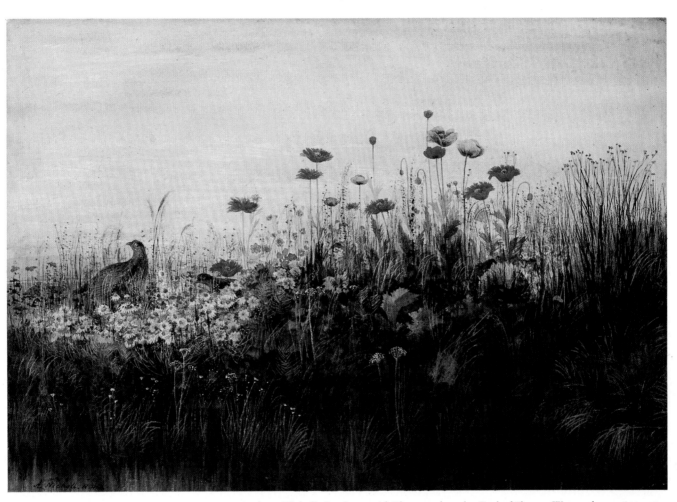

33 Andrew Nicholl: *Landscape with Pheasants through a Bank of Flowers.* Watercolour, 36 × 51 cm. (14 × 20 in.). National Gallery of Ireland. *See p. 212.*

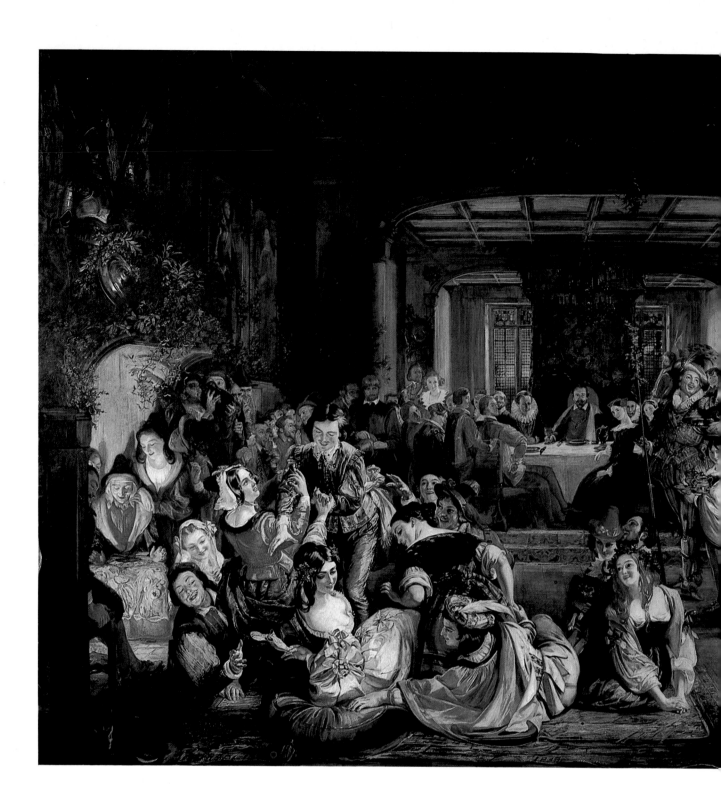

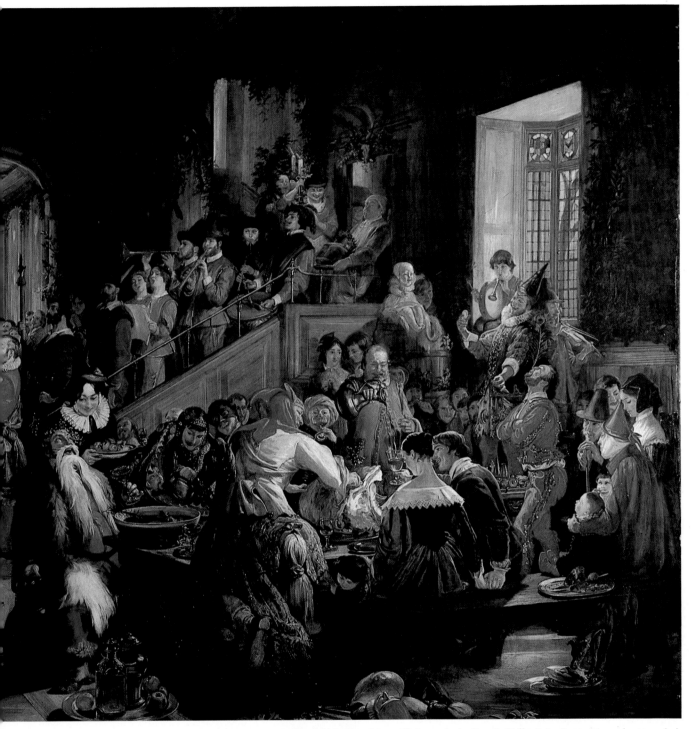

34 Daniel Maclise: *Merry Christmas in the Baron's Hall*, 1838. 183 × 366 cm. (72 × 144 in.). National Gallery of Ireland. *See p. 214.*

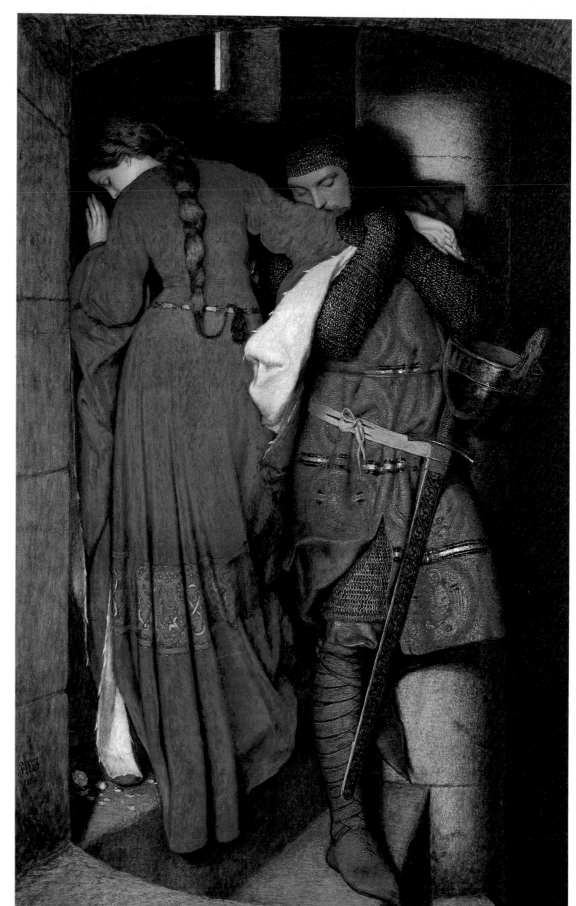

35 Frederick Burton: *The Meeting on the Turret Stair*, 1864. Watercolour, 94 × 61 cm. (37 × 24 in.). National Gallery of Ireland. *See p. 214.*

36 Harry Clarke: detail of a stained glass window in the Honan Chapel, University College, Cork, *c.* 1915. *See p. 263.*

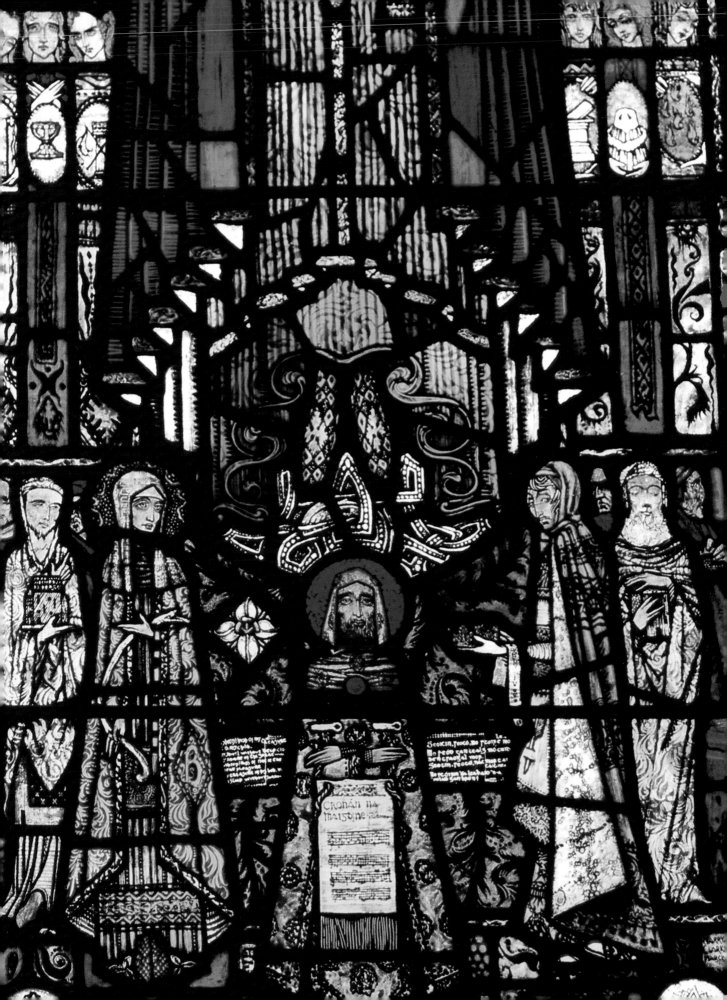

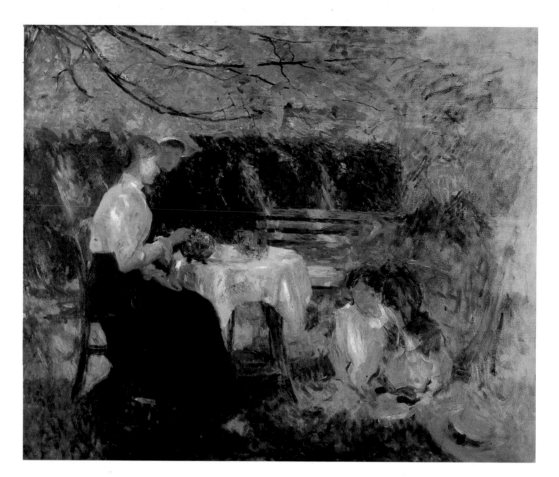

37 Walter Osborne: *Tea in the Garden, c.* 1902. 137 × 171 cm. (54 × 67½ in.). Hugh Lane Municipal Gallery of Modern Art, Dublin. *See p. 216.*

38 Roderic O'Conor: *La Ferme de Lezaver*, 1894. 72 × 93 cm. (28½ × 36½ in.). National Gallery of Ireland. *See p. 216.*

39 John Lavery: *My Studio (Lady Lavery with her daughter and step-daughter)*, 1910–15. 344 × 374 cm. (134¼ × 147¼ in.). National Gallery of Ireland. *See p. 245.*

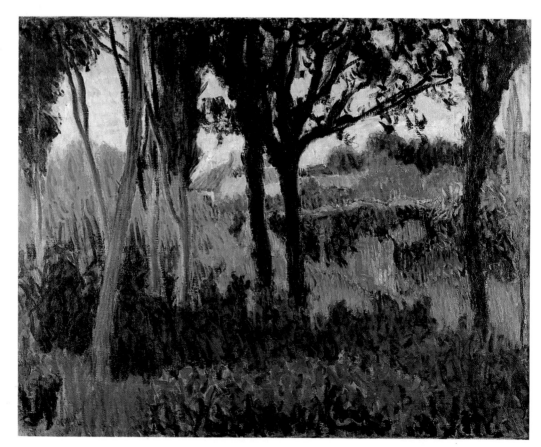

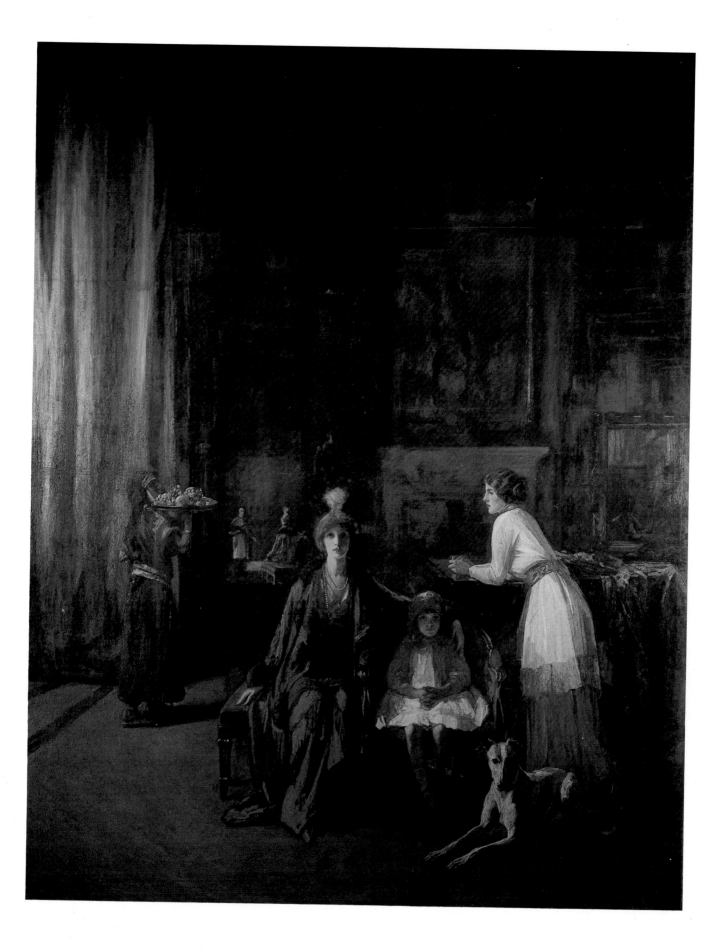

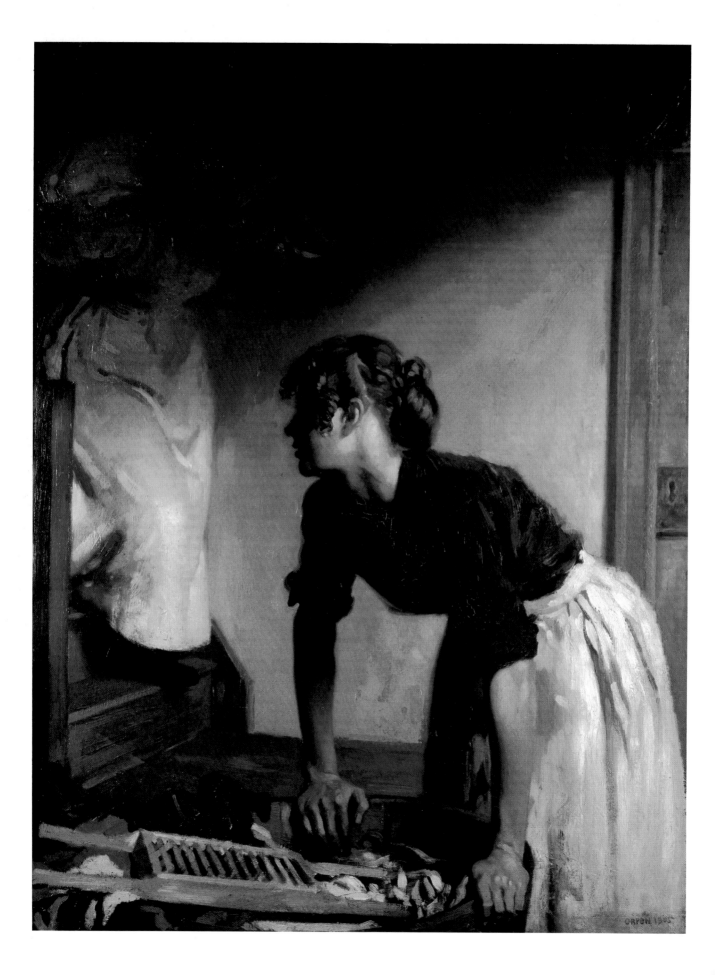

A similar monument to Lord Ardilaun, by Sir Thomas Farrell, was placed on St Stephen's Green, Dublin, in 1892. It is much more successful than either of his earlier marble statues of William Smith O'Brien (1870) and Grey (1876), now in O'Connell Street, Dublin.

A unique Irish monument is the Wellington testimonial in Phoenix Park. This is in the form of a high obelisk, designed about 1817 by the English architect Sir Robert Smirke. On three of the sides are rectangular bronze reliefs, added about 1860, by Terence Farrell (1798–1876), John Hogan and J. R. Kirk (1821–94), the son of Thomas Kirk.

The popularity of the public monument continued throughout the century and most sculptors are represented by at least one example. The commissions for these monuments were often awarded on the basis of a competition, whereby sculptors were invited to submit designs, and the best design was awarded a prize and the sculptor given the commission. Unfortunately many of the monuments have been destroyed in the cause of supposed patriotism; and many fine works by native Irish artists have thereby been irrevocably lost.

APPLIED ARTS

Carving and plasterwork

The craft of stone carving flourished throughout the century. It was necessary for the formal decoration of Classical buildings: an example is the carved decoration of high quality on the portico of the General Post Office building in Dublin. With the revival of Gothic architecture, as we have seen, there was even more work for carvers. Native craftsmen thrived, and a number of others came from England and settled. Among the latter were C. W. Harrison (1835–1903), who did the famous billiard-playing monkeys on the Kildare-Street Club, Dublin, and James Pearse, father of Patrick Pearse. Of native carvers the most famous are the O'Shea brothers, from Co. Cork, who did the fine naturalistic plant carving on the Museum in Trinity College, Dublin (begun in 1854), and 212 Thomas Fitzpatrick, who did the sculptural decoration on the head office of the Ulster Bank, Belfast (completed in 1860).

The carving of tombstones gave considerable employment: the work of local masons, such as the Cullen family, who worked in South Wicklow, is often very fine, and its naïve imagery is intriguing. Tombstones were also produced by the large city firms, and it is interesting to trace in them the evolution of Victorian taste. While more sophisticated than the work of rural craftsmen, they are often more hackneyed and commonplace.

Another area of folk-carving was the small wooden crucifixes, often called penal crosses, common in the late eighteenth and early nineteenth centuries.

Plasterwork continued to be in demand, and for the first twenty years of the century was of very high quality. It tends to be heavier and more sumptuous than that of the late eighteenth century. The interior of Ballyfin, Co. Laois, is a 196 particularly fine example. Methods of mass production later in the century caused the quality to degenerate.

Domestic arts

The design of household objects – furniture, silver, glass, porcelain – was governed by the same fashions that influenced architecture. Like architecture, it became increasingly ornate, reaching a peak during the third quarter of the century.

40 *Opposite* William Orpen: *The Wash House*, 1905. 91 × 73 cm. (36 × 28¾ in.). National Gallery of Ireland. *See p. 245.*

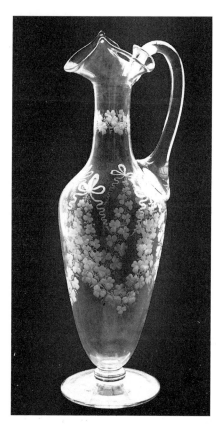

240 Claret jug by Pugh of Dublin, 1882. Glass, H. 34 cm. (13⅜ in.). National Museum of Ireland.

In general the style of furniture kept pace with architectural developments. In the middle of the century, at the period of the great exhibitions, there was a taste for furniture and ornaments in bog-oak with a distinctly Celtic flavour. Celtic motifs – shamrocks, round towers, wolfhounds – are also characteristic of inlaid work, a great deal of which was produced at Killarney.

The quality of design in silver declined, particularly as silversmiths copied the designs of their English contemporaries. As so often, methods of mass production caused further deterioration. In Ireland, as elsewhere, there was a considerable vogue for massive and highly ornamented objects in silver.

The impetus given to the glass industry by free trade in the late eighteenth century continued into the nineteenth, but in 1825 a duty was placed on flint glass made in Ireland, and from then on the industry seems to have been in recession. The production of good flint glass – elaborately cut, and heavier than that of the eighteenth century – was, however, active in Belfast, Cork, Dublin, and Waterford, and continued in Waterford until 1851. Towards the middle of the century glass in free-flowing shapes, with engraved decoration, became popular. 2. A number of Bohemian glass-engravers worked in Dublin in the second half of the century, notably for the firm of Pugh.

The most renowned Irish ware of the nineteenth century is the porcelain made at Belleek, Co. Fermanagh, from the early 1860s onwards. It is distinguished for 2. its fineness, its creamy nacreous glaze, and its use of delicately modelled plant forms.

All these domestic arts had their simpler equivalents in rural Ireland. Furniture in the cottages was of the simplest, and there was never very much of it. Quite a lot of domestic utensils were made out of basketwork (using willow twigs known as sally rods) – creels, potato baskets, lobster pots and so on. The craft still survives in the west of Ireland. Less utilitarian, but quite common, were toys made out of rushes – rattles, for example, with two hazel-nuts inside. Ornamental harvest knots, made out of straw, varied in design from district to district and according to whether they were worn by boys or girls.

Decorative, but useful, wrought iron work, in the form of gridirons, cooking forks, and stands for baking oaten bread, was common in the northern half of the country.

The arts of lace and crochet were actively practised early in the century but gradually faded. They were revived around the time of the Famine to provide employment for women in the poor districts, particularly those in the south and west. Convents took an active part in the teaching of lacemaking, particularly at the end of the century. Crochet was popular, because it could easily be made in cottages. Limerick and Carrickmacross lace were embroidered and appliquéd on manufactured net, unlike point lace which is made entirely with the needle.

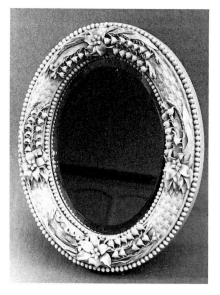

241 Belleek mirror frame. Parian ware, H. 27 cm. (10½ in.). National Museum of Ireland.

THE TWENTIETH CENTURY

The political upheavals of the first quarter of the twentieth century did not have a great deal of effect on the arts. Developments in the visual arts were not, unfortunately, as new or exciting as those in literature. The growing national awareness did find some outlet – in painting in the subject matter of Jack B. Yeats, William Conor, Seán Keating and Paul Henry, in sculpture in a large number of monuments to national heroes (which had begun to be set up in the late nineteenth century), and in architecture, still given to historicism, in the revival of Irish Romanesque.

It is not without significance that the most important cultural event of the early part of the century, the setting up of Sir Hugh Lane's Gallery of Modern Art, had the support of people involved in the literary and political movements, including W. B. Yeats, Lady Gregory and members of the Gaelic League. The Gallery opened in Clonmell House, Harcourt Street, Dublin, in 1908, showing a magnificent collection of modern French and English, as well as Irish, pictures. In 1933, Charlemont House in Dublin was opened as a permanent gallery for the collection. Since that time it has continued to grow, and now, renamed the Hugh Lane Municipal Gallery of Modern Art, it shows a comprehensive collection of modern Irish and some international artists.

The Belfast Museum and Art Gallery was opened in 1929, bringing together the collections of several earlier institutions. In the 1960s it was reorganized as the Ulster Museum, and its magnificent new extension opened in 1972. It has a fine collection of work by Irish artists, and an extremely good one of modern art. The applied arts are also well represented. From the 1920s the Crawford Municipal Gallery, Cork, was able to extend its holdings thanks to the Gibson Bequest. In addition to its special collection of works by Cork artists, it has a good selection of twentieth-century Irish art. The museum set up in Limerick in 1916, and reorganized in 1938, also has a good collection of Irish art.

The buildings of the Royal Hibernian Academy were destroyed in 1916, and for a long time it had no buildings of its own, but held an annual exhibition in the gallery of the Metropolitan School (later the National College) of Art. By the 1940s considerable changes had taken place in Irish art, under the inevitable influence of modern movements in Europe. The Royal Hibernian Academy was a conservative body, however, and younger, more adventurous painters had difficulty in getting a showing there. In 1943 a group of them, frustrated and discontented, organized the first Irish Exhibition of Living Art, in an effort to provide 'a wider survey of Irish Art than has hitherto been made'. In 1972 the committee resigned to make way for younger artists. The Rosc exhibitions of 1967 and 1971, which brought outstanding collections of modern art to Ireland, made enormous contributions to the public awareness and appreciation of modern art.

As the nineteenth century had seen a growth of interest in Irish ecclesiastical remains, so the beginning of this century witnessed a growth of interest in Irish Georgian architecture. The Georgian Society was founded in 1908 for the

purpose of listing, photographing and studying the Georgian architecture of Dublin. The results of these studies were published in five volumes, and the Society disbanded, its task accomplished, in 1915. It is interesting that at about the same time there was a revival of the Georgian style in architecture in Ireland.

ARCHITECTURE

What has been described by Nikolaus Pevsner as the fancy dress ball of architecture continued well into the twentieth century. Architects in search of a means of expression still turned to the past. There was a swing away from Gothic and Tudor styles, and Classicism came back into its own, either in grandiose Baroque form or with Neo-Classical severity. The renewed interest in Ireland's Georgian architecture is evident in the design of many buildings, from town halls to electricity sub-stations. Nationalism also found an outlet in the revival of Hiberno-Romanesque architecture, especially for churches. The Modern Movement came to Ireland in the 1930s initially for domestic building, and then for factories. Irish architecture has since followed international trends, though not without stiff opposition.

Edwardian grandeur

The beginning of the century saw the popularity of an Edwardian manner which was perhaps even more grandiose than anything the Victorians had achieved. Belfast City Hall (completed in 1906), by Sir Alfred Brumwell Thomas 243 (1868–1948), is a great wedding-cake of a building, having a huge central dome and fussy corner towers, derived from Wren, but there is considerable dignity in its rusticated basement and rhythm of coupled columns above.

 The Government Buildings in Upper Merrion Street, Dublin (begun in 1904), 244 by Aston Webb (1849–1930) and T. M. Deane (1852–1933), also set out to be as impressive as possible. They consciously attempt to conjure up Dublin's Georgian past, particularly in the end pavilions with recessed columns: the elevation facing Upper Merrion Street is an echo of the river front of the Custom 139 House. A comparison of the two buildings shows the greater heaviness of the Edwardian version.

 More restrained Queen Anne and Georgian styles were popular for libraries and public buildings generally. For his Dublin Municipal Technical School building, Bolton Street, begun about 1906, C. J. McCarthy (1858–1947) used a Queen Anne house as a model. The front is of brick, with stone quoins, stone dressings to the windows, and a stone basement. There is a balustrade on the skyline, and the central section of the building is emphasized by a pediment, Venetian window and pillared doorway.

 In the second decade of the century there was a revival of stricter Neo-Classicism, which was especially favoured for banks and public buildings. The winning design in the 1912 competition for the new front of University College, 242 Dublin, by R. M. Butler (1872–1943), is an interesting example. Again there is an echo of the river front of the Custom House, in the use of end bays with 139 recessed Tuscan columns (changed to Ionic in the final design). The very resemblances, however, only serve to underline the differences. The subtleties of moulding and variations of opening which break up the front of the Custom House are deliberately abandoned, so that a much more 'primitive', monolithic effect is achieved. In the pavilions, above the cornice, instead of a balustrade and carved coat of arms there is a severe attic storey, giving a stark skyline. The

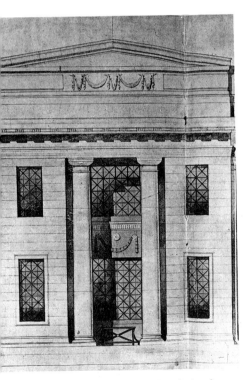

242 Detail of the competition design for University College, Dublin, by R. M. Butler, 1912. (*The Irish Builder*, 1912)

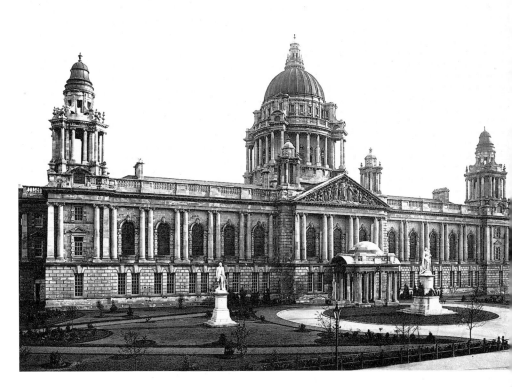

243 The City Hall, Belfast, by Sir Alfred Brumwell Thomas, completed in 1906.

244 Government Buildings, Upper Merrion Street, Dublin, by Sir Aston Webb and Sir Thomas Manly Deane, begun in 1904.

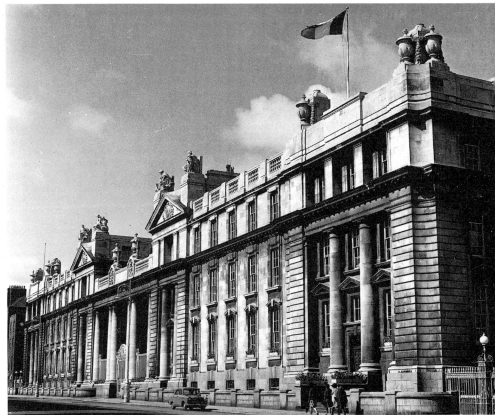

Municipal Buildings at Cork, won in competition in 1923 by Jones and Kelly, are another example of the style.

Church architecture

In church building there was a reaction against the forms of highly ornate Gothic which had become popular in the second half of the nineteenth century. One of the consequences was a fashion for Hiberno-Romanesque, whose massive simplicity suited the new mood. Antiquarians had been making increasingly detailed studies of this period of Irish architecture since the mid-nineteenth century, and there had been several attempts to establish it as a style for church building. Its widespread popularity early in this century was partly due to the fact that it was considered an Irish style, and so served as an outlet for growing national feelings.

One of the most successful of the new Hiberno-Romanesque designs was the church at Spiddal, Co. Galway, by W. A. Scott (1871–1921), dedicated in 1907. 245 It is an unpretentious building depending for its effect on plainness, a heavy monumental quality, and the sculptural juxtaposition of basic shapes. With its simple round-headed windows, its lack of adornment and its bold forms, it is in striking contrast to the delicacy of late Gothic Revival. More explicit in its references to original models is the Honan Hostel Chapel, Cork (c.1916), by James F. McMullen, which has miniature round towers and a west doorway modelled on that of the chapel of St Cronan at Roscrea.

Hiberno-Romanesque was, naturally, best adapted for church building, but it was also occasionally used for secular architecture. An example is the Carnegie Library (now Library and Museum building) at Limerick, designed by George Sheridan and erected about 1906, which has linked round-headed windows and a doorway with heavy geometric mouldings.

Church builders had more difficulty than anyone else in shaking off the dominance of the past, and ecclesiastical architecture remained historical long after more modern forms had been accepted in other fields. Besides Hiberno-Romanesque, some architects went for ideas to North Italian architecture of the early Renaissance – perhaps because the same simple shapes are to be found in lighter, more attractive form. A charming example is the new church of St Thomas in Dublin (c.1932), by F. G. Hicks, which is built of brick with an elegant little arcade surmounted by a wheel window on its west front.

Where a more grandiose effect was required, architects sometimes looked to the Byzantine style: the church of St Francis in Cork (c.1950), by Jones and Kelly, has a nave roofed by a series of domes and walls copiously decorated with mosaic.

Historicism had its last flamboyant fling in the work of Ralph Byrne, whose cathedrals at Mullingar, Co. Westmeath (c.1936), and Cavan (c.1942) show a return to a full-blooded Renaissance style, with a lavish use of Classical detail.

The evolution of modern architecture

Early in the twentieth century a new kind of architecture began to establish itself which was not a revival of any previous style, but was a response to modern methods and materials. It had its roots in the work of the engineers of the nineteenth century, builders of bridges, factories, warehouses and railway sheds. These men were concerned with putting up large, practical structures in the most convenient modern materials – wrought and cast iron and later steel (which was more flexible), and reinforced concrete, developed in France towards the end of

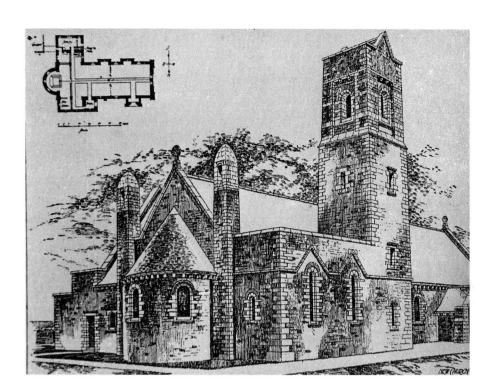

245 Church at Spiddal, Co. Galway, by William A. Scott, dedicated in 1907. (*The Irish Builder*, 1907)

the century. The result was functional buildings whose form was dictated more by the materials used than by the application of an architectural style.

In the nineteenth century the work of these men was accepted as necessary, and even admired, but it was not taken seriously as architecture. It was not until this century that the idea of stripped-down functionalism in architecture gained widespread currency, when it was felt that the form of a building should be the logical consequence of the use to which it was destined and the materials used in its construction. So strongly did the functional architects of the early twentieth century revolt against the concern of the previous generation with decoration and style that they not only banned historical styles, they banned ornament altogether. They felt that the relationship of parts of the building, their proportions and variations of texture, should be sufficiently satisfying in themselves. The most functional approach cannot fail to produce styles distinctive to certain people and certain periods. Discoveries in engineering and the evolution of building methods and materials have also had a great influence on the development of twentieth-century architecture.

It was not until the 1930s that the new ideas began to make themselves felt in Ireland. At this time a number of Russian and German architects (including Walter Gropius) were working in England, and contributing to the establishment there of an international style in architecture. This manifested itself particularly in domestic building – houses that were built of mass concrete and whitewashed, were flat-roofed, and echoed the shapes made familiar by later Cubist painting, where simple curved and plane surfaces are juxtaposed. The style gained popularity in Ireland at about the same time: there is a great deal of it, for example, in the suburbs of Dublin. The 'Sunshine' houses designed by 246 Robinson and Keefe about 1932 are of mass concrete, whitewashed, and composed of simple cubic shapes. It is rather disappointing that though they present a very modern appearance externally their plan might just as easily be that of a Gothic Revival villa.

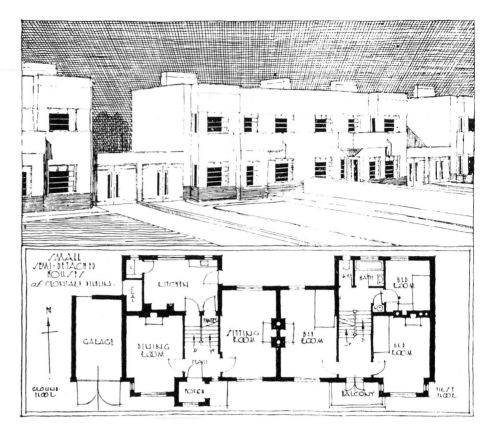

246 'Flat-roof "Sunshine" houses' at
Dollymount, Dublin, by Robinson and
Keefe, *c*. 1932. (*The Irish Builder*, 1932)

247 Ritz Cinema, Athlone, by Michael
Scott, *c*. 1940. (*The Irish Builder*, 1940)

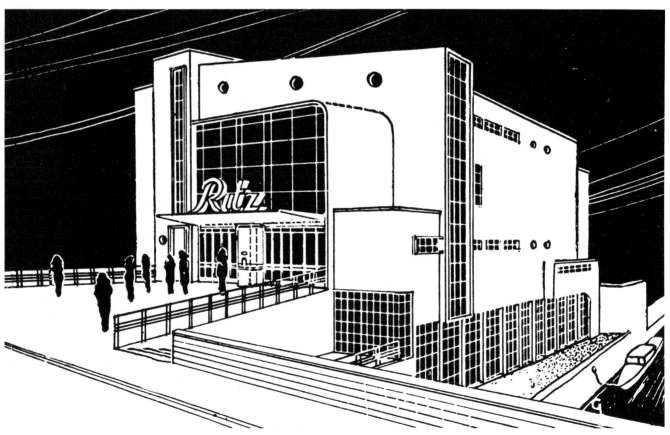

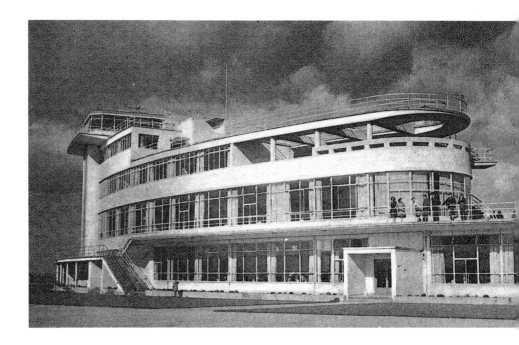

248 Dublin Airport, by Desmond
FitzGerald, completed in 1941,
photographed before later alterations.

247 The design of the Ritz Cinema at Athlone by Michael Scott (b.1905), of about
1940, bears witness to the more widespread acceptance of the style. It, too, is of
mass concrete, and shows the arrangement of windows in long vertical or
horizontal strips which is characteristic of many buildings of the 1930s and early
1940s, as is the use of portholes, and the placing of windows at the angles of a
building.

The large number of hospitals which were built in Ireland in the same period
gave further opportunities for the use of a style whose chaste, functional
appearance was particularly suitable. Examples can be seen at Cashel (by Vincent
Kelly, 1937) and Kilkenny (by J. V. Downes, 1942).

As time went on the style evolved, plans became more daring, and the
proportion of window to wall increased. The building for Dublin Airport at 248
Collinstown (completed in 1941), by Desmond FitzGerald, with a curved central
block flanked by great curved wings, convex towards the airfield so as to service
the greatest possible area, is a particularly adventurous example. The relationship
of flat and curved walls, and of severe window openings with unadorned
surfaces, is exploited too in the Aspro Factory, Inchicore, Dublin (c.1946), by
Alan Hope.

In church architecture the first major break with the past was in the Church of
Christ the King, Cork (c.1931), designed by Barry Byrne of Chicago and J. R.
Boyd Barrett. There is no attempt at a revival of styles, though there is perhaps a
reference to the great Gothic cathedrals in the figure of Christ which presides
over the main entrance. The shape of the building is partly dictated by the need
to hold a large number of people in such a way that the altar is visible to
everyone. The plan is elliptical, with stepped sides, and there are no internal
supports.

It is only in the past twenty years, however, that modern church architecture
has really got under way in Ireland. A good early example of this renaissance is St
Brigid's Church at the Curragh (1958–59), by McNicholl, Ryan and Curran.
The work of the firm of Corr and McCormick has been particularly interesting –
for example the elegant church of St Aengus at Burt, Co. Donegal (1967: partner 251

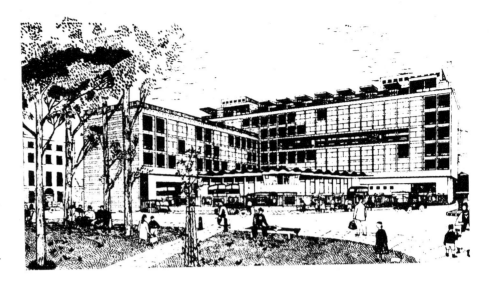

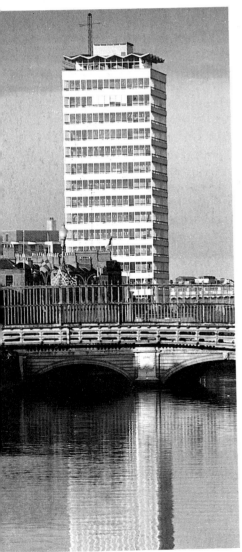

in charge Liam McCormick) or the Church of the Redeemer, Ard Easmuin, Dundalk (opened 1969: partner in charge Frank Corr). At Dundalk the body of the church is elliptical, with the sanctuary on one of the long sides carried up to form an elliptical tower above. The altar is dramatically lit through stained-glass-filled slits in the sanctuary wall. Our Lady of the Wayside at Creeragh, Co. Galway, designed by Leo Mansfield and completed in 1968, was described in a contemporary journal as 'geometric, dramatic and of great simplicity'. Its angular slate roof reaching to the ground makes it look well in a mountainous landscape.

Recent developments

The 1950s and early 1960s saw spectacular developments in architecture. Buildings have become taller – huge skeletons of steel and reinforced concrete, with a much greater use of glass than ever before. With the increase of confidence in new materials and structural methods has come a bolder use of them. In the Busáras (completed in 1953), by Michael Scott, Dublin's first major modern 249 building, the central block not only rises to a great height but seems to be poised on a smaller pedestal. There is a strongly sculptural quality in the shapes of the blocks, and walls of glass are contrasted with unbroken walls of stone. A reaction against the stark functionalism of the 1930s and 1940s is expressed in the decorative use of mosaic, wrought iron and perforated brick.

The influence of Mies van der Rohe has been apparent in the architecture of the 1960s, in tall skyscraper blocks such as Liberty Hall in Dublin (opened in 250 1965), by Desmond R. O'Kelly, or the new County Hall at Cork (opened in 1968), by P. L. McSweeney, though the pure line of the Liberty Hall building is rather marred by the frilly hat on top. The influence of Mies is also to be seen in the work of Ronald Tallon, for example in his factory for Carrolls at Dundalk (1972), where the exterior is entirely composed of a skeleton of structural members interspersed with sheets of glass, and the roof trusses are visible through the windows of the first storey.

By contrast the effect of the New Library at Trinity College, Dublin, won in 252 competition in 1960 by Paul Koralek, is romantic, with its irregular composition and great slabs of mass concrete. Except on the façade, which is faced with granite, the concrete is left raw, with the marks of the wooden shuttering on it.

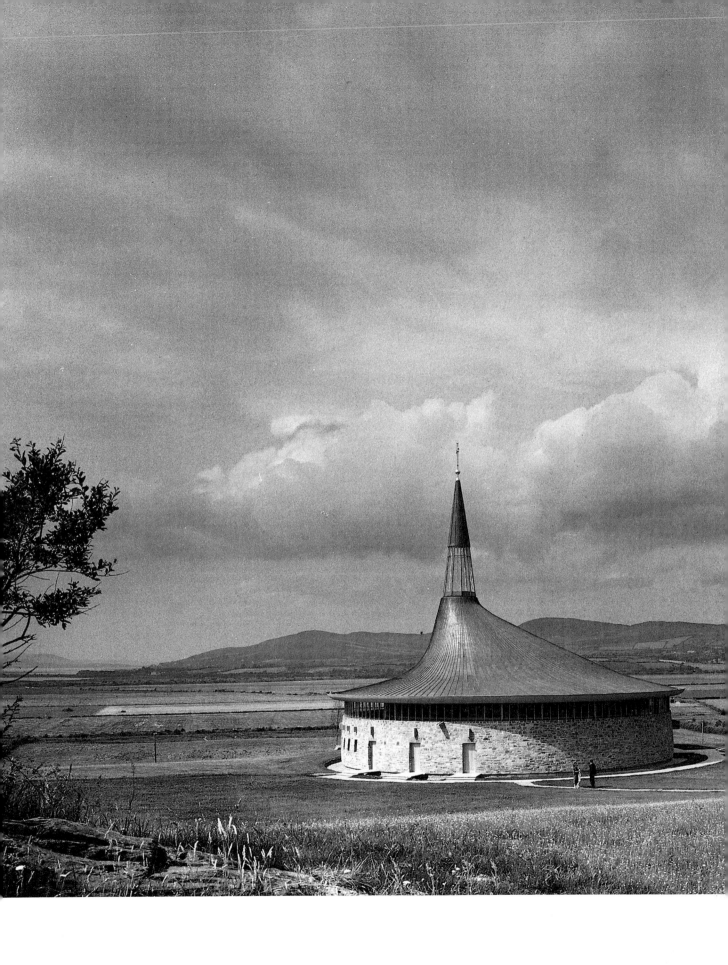

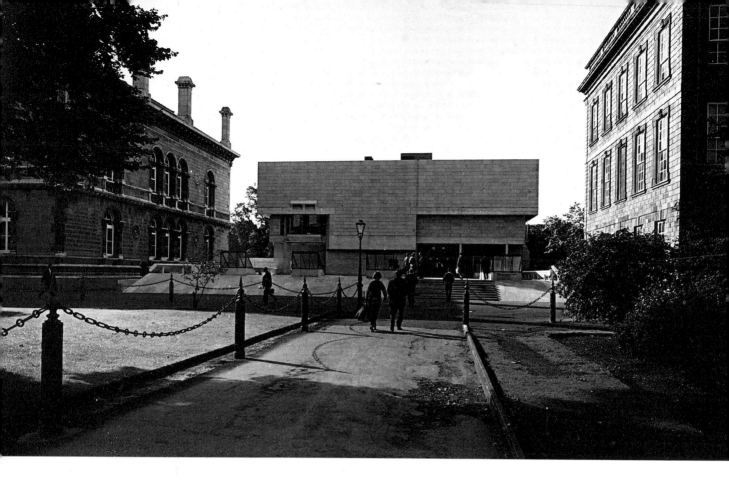

252 The New Library of Trinity College, Dublin, by Ahrends Burton and Koralek, 1961–67. On the left is part of the Museum (now the Engineering School), by Deane and Woodward, begun in 1854; on the right one end of the Old Library, by Thomas Burgh, of 1712–32.

Also romantic is the circular American Embassy building in Dublin, opened in 1964, by John M. Johansen (b.1916), where a richly sculptural effect has been achieved by the use of moulded concrete panels. There has recently been a fashion for cladding the outside of buildings with these pre-cast panels. Well handled, as in the Embassy, the result can be pleasing. Badly handled, as it too often is, it is monotonous and mechanical.

Town and village

Early in the century town planning established itself as a discipline in its own right. In 1914 Lord Aberdeen sponsored a competition for a town plan for Dublin, which was won by Abercrombie, Kelly and Kelly of Liverpool. Their report was published in 1922, under the title *Dublin of the Future*. In the meantime much of the centre of Dublin was destroyed in the bombardment of 1916, and there were grandiose schemes for its reconstruction, which unfortunately came to nothing. A sketch development plan was published by Dublin Corporation in 1941. Limerick had a town planning consultant in 1938, and Cork appointed one in 1939. No immediate or drastic changes resulted, but an interest in town planning has gradually influenced the policies of corporations and county councils.

In terms of the growth of towns and villages, the main contribution of the twentieth century has been in the development of housing schemes. The early ones took the form of blocks of flats in cities, and small groups of cottages in the country. The 'garden suburb' idea (rather more suburb than garden) took hold in the 1930s, resulting in such schemes as those at Crumlin and Cabra in Dublin, and has dominated the planning of housing estates ever since.

The strong French influence on Irish painting already noticed at the end of the nineteenth century continued into the twentieth. Most painters went to Paris to complete their training, and those who didn't studied in London under masters who were themselves French-trained. French influence ranged from the painterly Realism of Manet, which we find in Lavery and Orpen, to the disintegrations of Cubism, brought back from Paris by Mainie Jellett. Although some of Jellett's work is abstract, Irish painting on the whole remained resolutely figurative. Cubism did, however, have a liberating effect, and fed the expressionism of Irish art in the 1940s and 1950s. Avant-garde artists found an outlet for their work in the Irish Exhibition of Living Art, whose annual exhibitions played an important part in promoting modern art. They were also encouraged by the Rosc exhibitions of international modern art in 1967 and 1971, though by the 1960s modern international styles were generally accepted.

Social painters

In the work of both Sir John Lavery (1856–1941) and Sir William Orpen (1878–1931) there is a strong social element. They observed and painted life around them, from the humblest of domestic scenes to State Visits. Both were official war artists, commissioned by the British Government to chronicle the events of the 1914–18 war. And both, from brilliant beginnings, were so much in demand as society painters that their work got bogged down in official portraiture.

In Lavery we see the influence of Manet, and beyond him of Velázquez: all three made the utmost use of the quality of paint, its texture, the effect of one tone set against another without transition, and the energy conveyed by the freedom of brushstrokes. In *My Studio* (National Gallery of Ireland), of 1910–15, **39** this painterly attitude is apparent, as is Lavery's more direct debt to Velázquez's *Las Meninas* in the organization of the composition. Lavery became interested in Irish politics in the second decade of the century, and painted many of the leading political figures of the time and such scenes as the *Requiem Mass for Michael Collins, Pro-Cathedral, Dublin 1922* (Hugh Lane Municipal Gallery).

William Orpen was a superb draughtsman, and although in such a picture as *The Wash House* (National Gallery of Ireland), of 1905, his painterly qualities are **40** obvious, a great deal of the vigour of the picture derives from the strong drawing. Not only the subject but also the attention to line are reminiscent of Degas. An attractive example of Orpen as a society painter is *The Vere Foster Family* (National Gallery of Ireland).

W. J. Leech (1881–1968) represents a later generation of painters influenced by France – in this case Fauve painters such as Matisse and Derain. In the work of Leech we feel that social preoccupations have lost importance: he is interested in colour and in light for their own sake. An example is *Un Matin* (Hugh Lane **253** Municipal Gallery). Brilliant patches of pure colour are placed next to each other, which at a distance fuse into recognizable shapes. Because the patches are large and the colours are bright, the picture conveys an effect of strong sunlight. The impression of space is created not by traditional perspective or shading, but by the way the colours and tones are related to each other and to us, some seeming nearer, some farther away.

Painting and a national identity

A disappointing thing about Irish painting of the late nineteenth and early twentieth centuries is that it has little of the energy of the literary and political

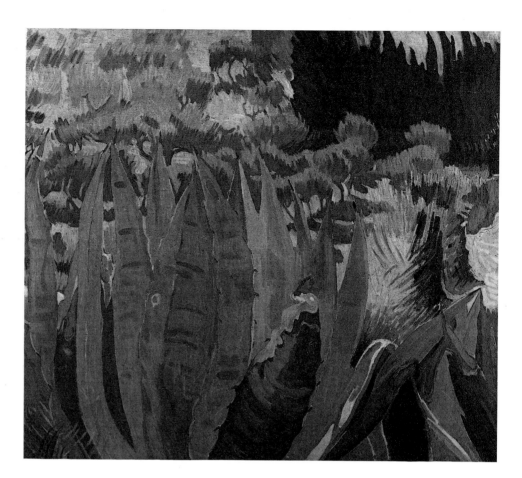

253 W. J. Leech: *Un Matin*.
114 × 142 cm. (45 × 56 in.). Hugh
Lane Municipal Gallery of
Modern Art, Dublin.

254 Seán Keating: *Men of the West*,
c. 1917. 97 × 125 cm. (38 × 49 in.).
Hugh Lane Municipal Gallery of
Modern Art, Dublin.

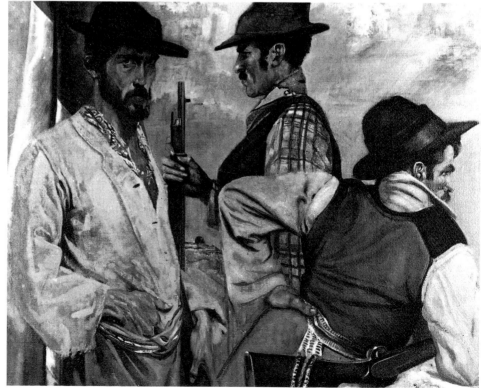

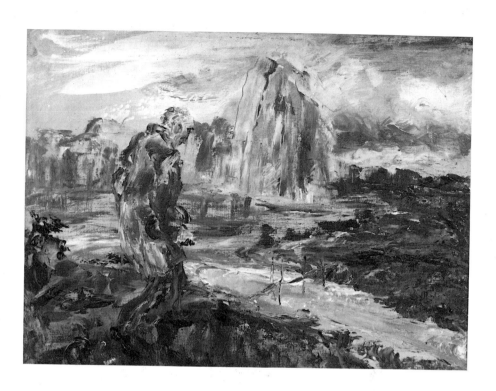

255 J. B. Yeats: *On Through the Silent Lands*, 1951. 51 × 68.5 cm. (20 × 27 in.). Ulster Museum, Belfast.

movements of the time. An exception is perhaps the work of Jack Yeats. George Russell (1867–1935), better known as the poet AE, was a prominent figure in the literary movement, but his rather weak paintings reflect his own interest in mysticism – strange landscapes with mysterious figures and symbols, and a slightly Art Nouveau flavour.

It was Jack B. Yeats (1871–1957) who, as Thomas MacGreevy wrote in 1945, 'During the twenty-odd years preceding 1916. . . . filled a need that had become immediate in Ireland. . . . the need of the people to feel that their own life was being expressed in art'. His work falls into three phases. In the earliest he worked mainly as a black-and-white artist, doing a great many illustrations of sporting life. Around 1905 he began painting in oils and chronicling the times in which he lived – life in his native Sligo, or the political events of the period – in works characterized by clear composition, a fluid and sensuous handling of paint, and broad areas of colour juxtaposed (for instance *Communicating with the Prisoners*, of 1924, in Sligo Museum). His later work is more expressionistic, using thick impasto and flickering brushstrokes to suggest images and moods, as in *On Through the Silent Lands* (Ulster Museum), of 1951, and has a more mystical 255 quality than his earlier painting.

For a number of years up to the beginning of the First World War Orpen taught at the Metropolitan School of Art in Dublin and had a strong influence on a group of young painters who were to rise to prominence in the 1920s, and whose work has strong links with Irish patriotism. They included Patrick Tuohy (1894–1930) and Charles Lamb (1893–1964), but the most important was Seán Keating (1889–1977). He learnt from Orpen the importance of draughtsmanship, and, like him, painted pictures with strong, dramatic composition. He used these techniques to describe Irish life – particularly that of the Aran Islands – and the political struggles of 1916–22. His work, like Orpen's, had a literary side, the subject being important as well as his treatment of it. *Men of the West* (Hugh Lane 254 Municipal Gallery), painted *c*.1917, reflects his political preoccupations, and has the romantic picturesqueness of his Aran pictures. The composition is strong, the

handling vigorous, and there is a haunting quality in the figures with their strange costume, lean, bearded, intent faces, their guns and their tricolour. The picture is symbolic rather than realistic.

Paul Henry (1876–1958) was a painter who captured and made famous a particular vision of the landscape of the west of Ireland. *Lakeside Cottages* (Hugh Lane Municipal Gallery), with its wide cloudy sky, turf stacks, thatched cottages and distant blue mountains is a typical work. The success of these pictures lies in their simplicity – a limited palette, the reduction of the landscape to a few elements, and the broad, simplified treatment of masses. It made them very suitable for reproduction as travel posters, as several were in the 1920s. Henry went on painting this kind of picture for a long time, and because it became a formula for less gifted painters it is hard to see it objectively. His freshness, and the decorative appeal of his work, are better seen in a less common subject, such as *Launching the Currach* (National Gallery of Ireland). Maurice MacGonigal (b.1900) is another painter who lyrically evokes the landscape of the west.

25●

The tradition of social painting was carried on in the work of William Conor (1881–1968). He is unlike other painters of his generation in that he concentrated on the industrial town life of the north, rather than on the romantic aspects of the countryside. His evocations of the gaiety of slum life are particularly haunting.

25●

Cubism and Irish art

Apart from Mainie Jellett (1897–1944), and to a lesser extent Evie Hone (1894–1955), whose most important contribution was in the field of stained glass, there was no widespread Cubist school in Ireland. Cubism did, however, over a period of about twenty years, bring about a revolution in Irish painting. Early in the century Braque and Picasso, in Paris, had begun to experiment with the problem of representing three-dimensional objects on a two-dimensional surface without having recourse to the traditional methods of light, shade and perspective. They solved the problem by breaking the objects to be represented into facets, and showing these at various angles on the canvas. The pictures in which they worked out these problems are jagged and geometric, and objects often look as if they have been constructed out of cubes, hence the term Cubist. Soon the geometric element began to predominate, and objects were reduced to a formal pattern.

Mainie Jellett studied in Paris under Gleizes and Lhote (who had taken up, and developed in a rather mechanical way, the ideas of Braque and Picasso) and their influence can be seen in her work. In *Deposition* (Hugh Lane Municipal Gallery), for example, the geometric composition predominates, and the figures have been schematized to fit into it. The keynote of the picture is the cool, formal relationship of colours and shapes. The next step is total abstraction. In *Abstract* (National Gallery of Ireland) we see a number of flat surfaces set one behind the other in a shallow space, with contrasts of colour and texture.

Mary Swanzy (b.1882) is a painter whose work sometimes shows Cubist influence. In *Landscape* (National Gallery of Ireland) the shapes are simplified, and the picture resolves itself into a grid of straight lines. There is a high horizon, because the landscape has been tipped towards the spectator – a device found in the work of Cézanne, a major influence on Cubist painting.

258

We see the influence of Cubism too in the work of Norah McGuinness (b.1903), another student of Lhote. In *Garden Green* (Hugh Lane Municipal Gallery), painted in 1962, several areas of the picture are broken into facets, giving a rich texture. She uses multiple viewpoints, a device much favoured by the Cubists: a scene is not shown from one fixed point, as in a Renaissance

259

Opposite
256 Paul Henry: *Launching the Currach*. 41 × 60 cm. (16 × 23⅝ in.). National Gallery of Ireland.

257 William Conor: *The Jaunting Car*, c. 1929. 70.5 × 90.5 cm. (27¾ × 35⅝ in.). Ulster Museum, Belfast.

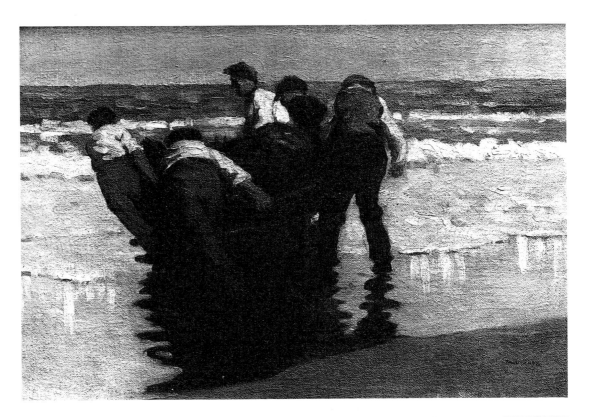

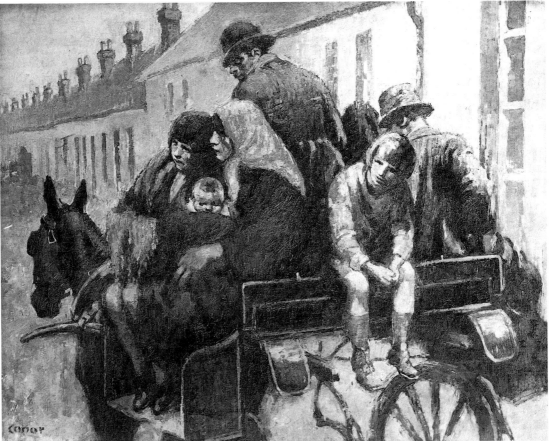

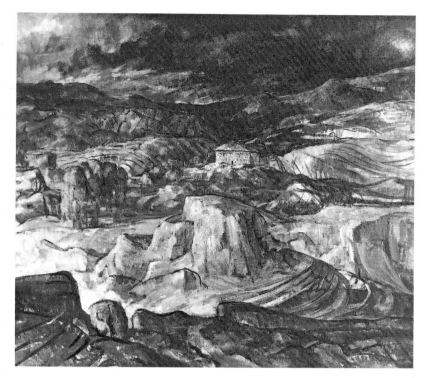

258 Mary Swanzy, *Landscape*. 56 × 64 cm.
(22 × 25¼ in.). National Gallery of Ireland.

259 Norah McGuinness: *Garden
Green*, 1962. 102 × 71 cm.
(40 × 28 in.). Hugh Lane Municipal
Gallery of Modern Art, Dublin.

260 Louis le Brocquy: *Tired Child*,
1954. 79 × 68.5 cm. (31 × 27 in.).
Ulster Museum, Belfast.

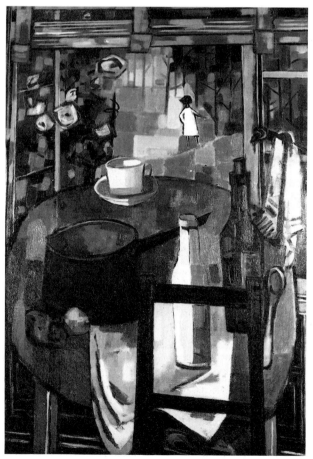

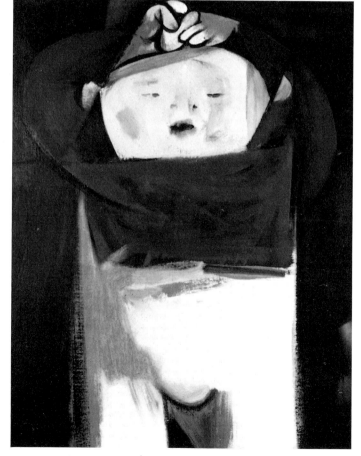

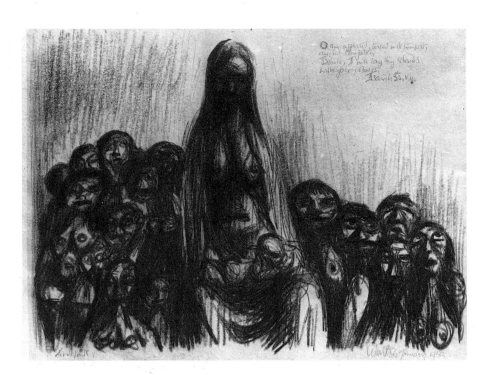

261 Colin Middleton: sketch for *Isaiah 54*, 1950. Crayon on paper, 19 × 24 cm. (7½ × 9½ in.). Private Collection.

picture, but from several different angles at once, and the different impressions fused into one image. Here the table looks as if it were seen from above, whereas the bottles appear in profile. The result is a fuller description of the objects than if a fixed viewpoint had been taken.

When the discoveries of Cubism became known in Ireland, they were a revelation to Irish painters, and a shock to the Irish public, who still liked their pictures to portray recognizable objects. Their most important influence was indirect, and its effect was two-fold. It introduced the Irish public to the idea of non-representational painting, and it gave artists an additional means of expression. This was a further stage in the process begun by the Post-Impressionists. Painters like Gauguin and Van Gogh (followed by the Fauves and German Expressionists) distorted shapes and exaggerated colours, so that their pictures expressed not just what they saw but how they felt about it. The Cubists saw that a greater range could be obtained both in terms of formal composition and in terms of expression by disintegrating the image altogether. It was this expressionist aspect of Cubism, its strong emotional quality, which was taken up by Irish painters.

The Living Art and recent movements in Irish painting

Cubism, and other European movements of the early twentieth century, had a liberating effect on Irish painting in the 1940s and 1950s. A greater liveliness began to make itself felt, as people used their new freedom to make their work as emotionally expressive and personal as possible.

Louis le Brocquy (b.1916) was a founding member of the Living Art. In his painting *Tired Child* (Ulster Museum) the figure is broken up and distorted partly to increase our awareness of shape and movement (look, for example, at the effect achieved by the simplified curve of the arms), but, more than that, it sets out to disturb us with unfamiliar images. 260

Isaiah 54 (Private Collection) by Colin Middleton (b.1910) was shown in Dublin in 1950. It, too, is a picture with strong emotional qualities, but not 261

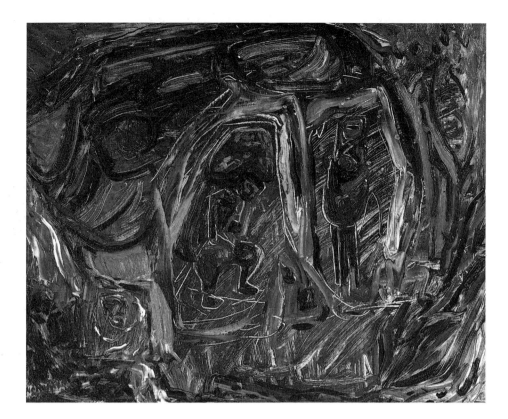

262 Nano Reid: *Tinkers at Slieve Breagh*, 1962. On board, 60 × 75 cm. (23⅝ × 29½ in.). An Chomhairle Ealaíon.

263 Gerard Dillon: *Yellow Bungalow*, 1957. 76 × 56 cm. (30 × 22 in.). Ulster Museum, Belfast.

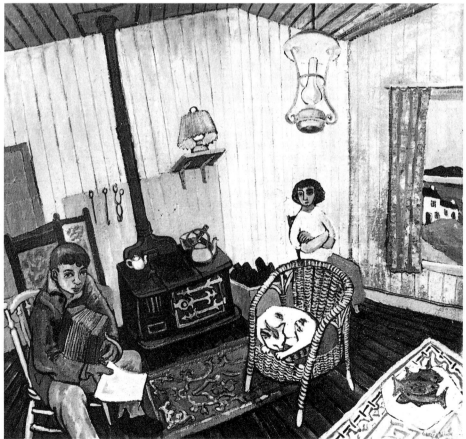

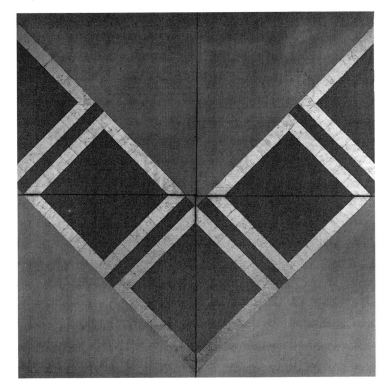

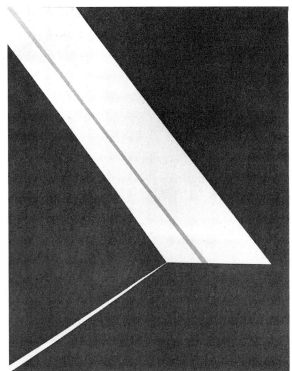

264 Patrick Scott: *Gold Painting 34*, 1965.
Gold leaf and tempera on canvas,
244 × 244 cm. (96 × 96 in.). The Bank of
Ireland.

265 Cecil King: *Painting 1968*, 1968.
150 × 120 cm. (59 × 47¼ in.).
An Chomhairle Ealaíon.

because of the use of Cubist distortions. Here the effect is in the crudeness of the handling, the primitive simplicity of the mask-like faces surrounding the central figure, their grimaces contrasted with her impassive face and monumentality.

There are more lyrical qualities in the work of Nano Reid (b.1905). In *Tinkers at Slieve Breagh* (An Chomhairle Ealaíon), of 1962, we are aware of rich subtle colour and the texture of paint. She has turned away from straightforward representation, but the colours are reminiscent of bogland, and the figures of a woman and child and a man, enclosed within field-like shapes, emerge through the richly sensuous brushstrokes. This lyrical, painterly, and near abstract approach to landscape has been seen more recently in the work of Camille Souter (b.1929), in such paintings as *Bed ends in the Yard*, of *c*.1962 (coll. An Chomhairle Ealaíon), and *Waiting to go to the Canal* (Hugh Lane Municipal Gallery). 262

A number of primitive painters have emerged in this century – either people with no formal art training, who paint with the eyes of children, or painters who deliberately adopt childlike qualities as a means of expression. James Dixon (1887–1970), of Tory Island, Co. Donegal, belonged to the first category. He painted the island and the sea around it with no more regard for perspective or conventional drawing than a child of seven, and as a result his pictures have spontaneity and a childlike charm. Gerard Dillon (1916–71) belonged to the second category. In such a picture as *Yellow Bungalow* (Ulster Museum), of 1957, the childlike qualities of bright colour, odd perspective and familiar objects lovingly depicted are there because that is how the painter can best express himself. 263

Abstract painting, in which there is no reference to recognizable objects, did not begin to establish itself in Ireland until the late 1950s. It is to be seen in the work of Patrick Scott (b.1921): in *Gold Painting 34* (coll. Bank of Ireland, Dublin), of 1965, he relies for effect on the relationship of simple angular shapes on rectangular canvases – four attached together – and on that of gold paint to 264

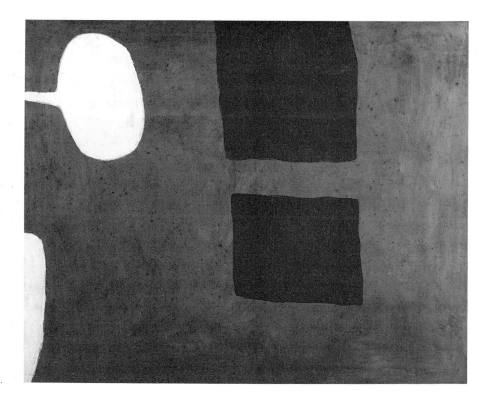

266 William Scott: *Two and Two 1*, 1963.
100 × 125 cm. (39¼ × 49¼ in.). Hugh Lane
Municipal Gallery of Modern Art, Dublin.

267 Michael Farrell: *Orange Squash*,
Pressé Series, 1972. Acrylic on canvas,
275 × 270 cm. (108 × 106 in.). The Bank of
Ireland.

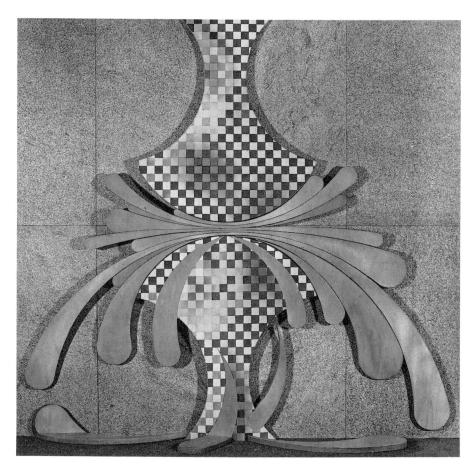

the natural colour of the ground. The results are clear and serene. In *Painting 1968* 265
(coll. An Chomhairle Ealaíon) Cecil King (b.1921) uses straight lines cutting
across the canvas to create an effect of high tension. This is a cool picture, with
colours limited to black, grey and white, and no sensuous exploitation of paint.
The lines are so hard, and the colour so smoothly applied, that our attention is
concentrated on the geometry of the picture. William Scott (b.1913) is a less
detached painter. In *Two and Two 1* (Hugh Lane Municipal Gallery) the colour is 266
warm, and we are made aware of the texture of the paint. Though the picture is
made up of four shapes in groups of two disposed on a rectangular canvas, the
warm natural colour (brick, beige and white) and the suggestion of still life give
the picture an intimate, lyrical quality. Colin Middleton, whose work in the
1950s was savagely expressionist, has developed a manner in which strong
abstract patterns emerge from figure or landscape compositions, as in *Leitrim
Hills 1971* (Ulster Museum). Anne Madden (b.1932) is another painter whose
strong abstracts derive from observation of natural forms.

In the early 1970s the traditional distinction between painting and sculpture
became less apparent: paintings hung on walls are often three-dimensional, and
free-standing sculptures are brightly painted. Deborah Brown (b.1927) gets very
subtle effects of light and colour by using fibreglass shells attached to a canvas,
such as we see in *Fibreglass Form on Black* (Hugh Lane Municipal Gallery).
Michael Farrell (b.1940), in *Orange Squash* (coll. Bank of Ireland, Dublin) of 267
1972, presents us with a picture of which pieces have overflowed onto the floor.
It is a very lively, witty work with two shapes coming sharply together in the
centre causing great globules to shoot out at either side.

SCULPTURE

The early part of the twentieth century is chiefly distinguished for the number of
national monuments erected. These show a dramatic quality (particularly in
contrast to the Victorian worthies of the previous century) and a sensitivity to
materials traceable to late nineteenth-century France, Rodin in particular. In
sculpture, as in painting, Paris was the centre of influence. A large number of
portrait busts were produced, bronze generally replacing the marble of the
nineteenth century.

Towards the middle of the century there was an improvement in the quality
of religious sculpture, distinguished by a return to simple forms and natural
materials. Modern movements were even slower to make themselves felt than in
painting: they did not do so until the 1940s, and it was not until much later that
Irish sculptors turned to abstraction.

The most important sculptor at the beginning of the century, John Hughes
(1865–1941), executed the monument to Queen Victoria (unveiled in 1908) 268
which once stood outside Leinster House, Dublin. For obvious reasons the
monument was removed in our own time, but as an important work by a
talented Irish sculptor it deserves our attention. The monument itself, and the
figure of the Queen, are heavy and rather Baroque: the base has swags of fruit
and putti in carved stone, and the figure is swathed in elaborate folds of dress and
cloak. Most interesting are the subsidiary groups of figures round the base of the
pedestal – *Peace, Fame,* and *Erin presenting a Laurel Wreath to an Irish Soldier.* Their
realism (particularly in the last group) shows a strong affinity with that of the
French sculptor Dalou and the Belgian Meunier.

Augustus St Gaudens (1848–1907), born in Ireland, though he did most of his
work in the United States, was commissioned to do the Parnell Monument in 269
O'Connell Street, Dublin (unveiled in 1911). The bronze figure of Parnell

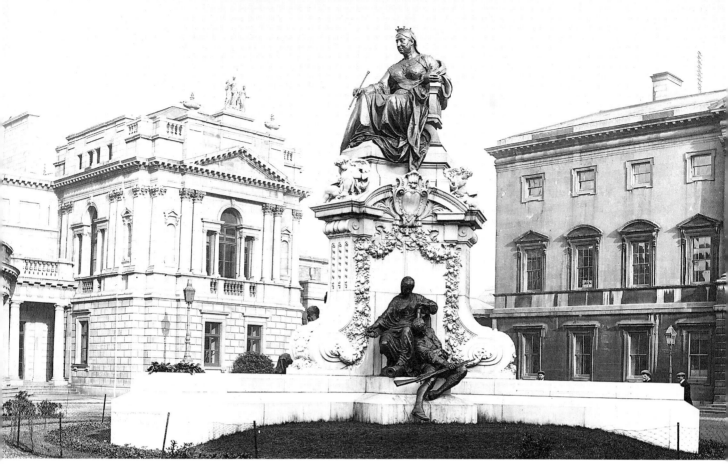

268 John Hughes: Queen Victoria Memorial, Dublin, unveiled in 1908. This photograph, taken soon after the unveiling, shows the statue in its original position, with Leinster House (by Richard Castle, 1745) behind it on the right, and on the left the National Library (by Sir Thomas Deane and Son, opened in 1890).

269 Augustus St Gaudens: detail of the Parnell Monument, Dublin, unveiled in 1911.

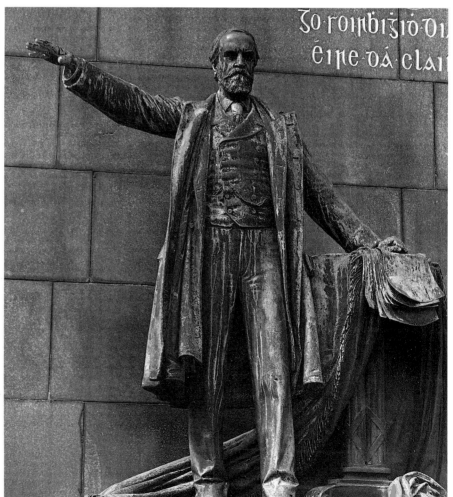

combines realism (the contemporary costume, coat and overcoat flung back, waistcoat creased) with drama (the outflung arm, the heavy fringed drapery falling over the edge of the plinth, the sheaf of paper overhanging the side of the table). The surface of the bronze is broken to catch the light, and this adds to the impression of energy.

Oliver Sheppard (1864–1941) designed several of the best known monuments to Irish patriots. The most famous is perhaps the *Cuchulainn* figure in the General Post Office, Dublin (1911). It has a strong romanticism which we associate more with the nineteenth century, but which in this case is particularly suitable. The dead hero is shown tied to a rock. His head has fallen to one side, so that the summit of the composition is occupied by the raven alighting on the rock. From the bird the eye travels downwards to the strong, shadowed face and the body straining against its bonds. As in the Parnell Monument, the light breaking on the various surfaces of the bronze is a major factor in the effect of the composition. It is to be noted that this figure, though it admirably fulfills its function as a 1916 memorial, was designed five years before the Rising. Sheppard's *1798 Memorial* in Wexford (1905) is also a fine, dramatic piece.

The work of Jerome Connor (1876–1943) is equally emotional, but has a sharper realism, displayed, for example, in the pathetic figures of mourning sailors on his *Lusitania Memorial* at Cobh (completed in 1936).

Albert Power (1883–1945), who was a pupil of Hughes and Sheppard, and distinguished as a sculptor of architectural ornament, did a number of portrait busts of national heroes – for example *Tom Kettle* in St Stephen's Green, Dublin (1919). His most interesting work, however, does not fit into any contemporary category. It is *Leenane: Connemara Trout* (National Gallery of Ireland), executed 270 in green Connemara marble. The way in which the forms of fish and water

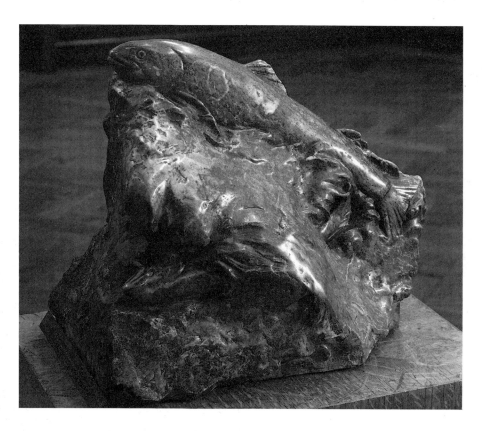

270 Albert Power: *Leenane: Connemara Trout*, 1944. Green Connemara marble, H. 48 cm. (19 in.). National Gallery of Ireland.

emerge from the block of stone derives from Rodin (and ultimately from Michelangelo), but Power has created something original. The subject, and the suitability of the material to it, come as near as anything in the period to distinctive Irishness.

Most recent in the line of national monuments is the dramatic and impressive *Children of Lir* by Oisín Kelly (b.1916), in the Garden of Remembrance in 272 Dublin. The freedom with which the subject is handled, and the simplification of the basic forms, make an interesting contrast to the nineteenth-century tradition.

Considering the amount of church building that went on, there was remarkably little religious art in Ireland in the nineteenth century, and what was produced was mediocre. A great deal of poor stereotyped work was imported from abroad, Italy in particular. At the beginning of the twentieth century attempts were made to remedy this, and a number of enlightened patrons commissioned church decoration from Irish artists. Among the churches that benefited was Loughrea Cathedral, Co. Galway. John Hughes did two pieces of sculpture for the church, one of them a *Madonna and Child* (*c.*1909) in white marble placed above a side altar. The figure of the Madonna is standing, and her arms support the child who sits on her raised knee, a device that gives an elegant swing to the composition. Apart from the evident beauty of the sculpture, it is also interesting for its subject matter: since Catholic Emancipation depictions of the Madonna and Child have been surprisingly uncommon in Irish art.

This early example is rather isolated, however, and it was not until the 1940s that a real change began to take place in religious sculpture. We see it in the work of Seamus Murphy (1907–75). His *Virgin of the Twilight* (1942), in polished 271 Kilkenny limestone, is almost ugly in its monumental simplicity, yet it is far more satisfying to look at than the simpering prettiness of the conventional plaster Madonna.

271 Seamus Murphy: detail of *Virgin of the Twilight*, 1942. Polished Kilkenny limestone, over life size. Fitzgerald Park, Cork.

272 Oisín Kelly: *The Children of Lir* (three children in ancient Irish legend, who were turned into swans), in the Garden of Remembrance, Parnell Square, Dublin, unveiled in 1971.

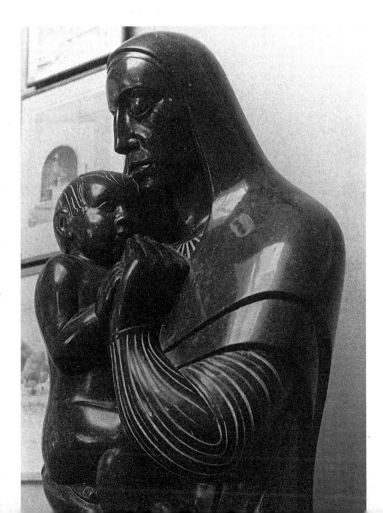

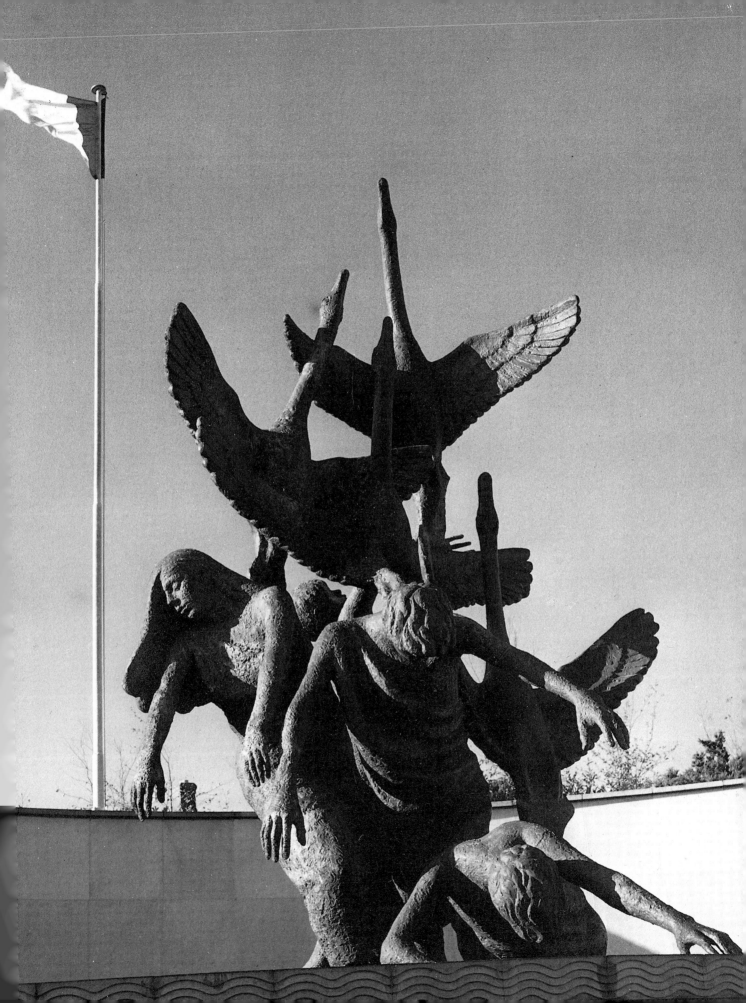

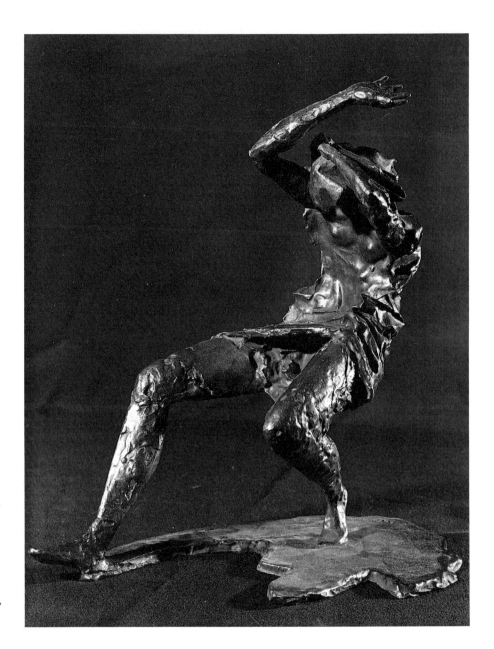

273 F. E. McWilliam: *Women of Belfast, 7,*
1972. Bronze, H. 35 cm. (13¾ in.). Ulster
Museum, Belfast.

Many modern sculptors have returned to the simple monumentality of pre-Gothic religious sculpture. They have drawn inspiration from the un-sophisticated work of Early Christian and Romanesque carvers in Ireland, exploiting the qualities of wood or stone and avoiding the realism of the usual plaster statue. An example is Oisín Kelly's *Last Supper* (*c.*1964) in carved wood in the Church of Corpus Christi, Knockanure, Co. Kerry. The same primitive simplicity, and regard for the quality of materials, is to be found in the religious work of Imogen Stuart.

We have seen that a new dynamism came into Irish painting in the 1940s. Sculpture was much slower to get going. This is very often the case: it is possible to paint without having a great deal of space at one's disposal, but sculpture, which is often on a large scale, needs room, and in its noisier manifestations (such as stonecutting or welding) it needs isolation. It is also generally more expensive than painting, so a sculptor is even more in need of patronage than a painter. He

must have commissions – from the State, from the Church, or, as is more commonly the case nowadays, from commercial concerns. Unfortunately, except for a welcome renewal in church art, there has not been a great deal of patronage for sculptors in Ireland in recent years.

In 1950 Hilary Heron (1923–77) was the most modern Irish sculptor. She was working in carved wood and stone, creating human figures, but simplified, their contours following the movement of the material. Later she began to work in welded metal, producing rich combinations of shape and texture. These pieces are often funny, like her *Crazy Jane* (coll. Jury's Hotel Group) of 1958.

F. E. McWilliam (b.1909) was born and educated in Ireland, but his career has been spent in England. In his *Man and Wife* (Ulster Museum) he uses a technique familiar from Cubist painting: the figures have been distorted, in this case not so much for emotional effect as for the sake of the shapes produced, and the compactness of the composition. This piece is in concrete, but it has the comfortable contours seen in the stone and wood carving of Henry Moore. McWilliam's series of bronzes *Women of Belfast* (1972), also in the Ulster Museum, 273 shows distortion and dislocation for the sake of violent emotional effect.

Abstraction has come fairly recently to Irish sculpture, as it has to painting. It offers excellent opportunities for the sculptor to explore the qualities of materials for their own sake, and to study the relationships of solid and void. Gerda Frömel (1931–75) did not so much exploit as reveal the beauty of the material in which she worked. Looking at her sculpture *Alabaster Interlocking Shapes II* (coll. Bank 274 of Ireland, Dublin), of 1970, we are moved by two impulses – to fit the interlocking pieces together, and to run our hands over the stone, for the sheer sensuous pleasure of it.

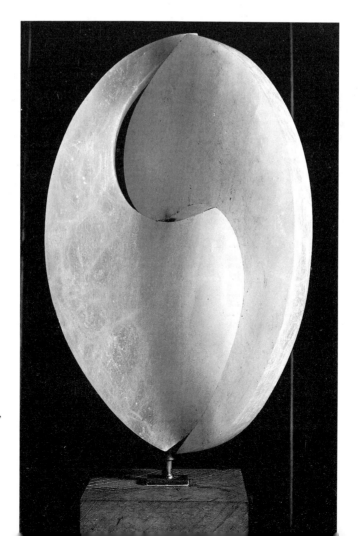

274 Gerda Frömel: *Alabaster Interlocking Shapes II*, 1970. Alabaster on marble stand, H. 64 cm. (25 in.). The Bank of Ireland.

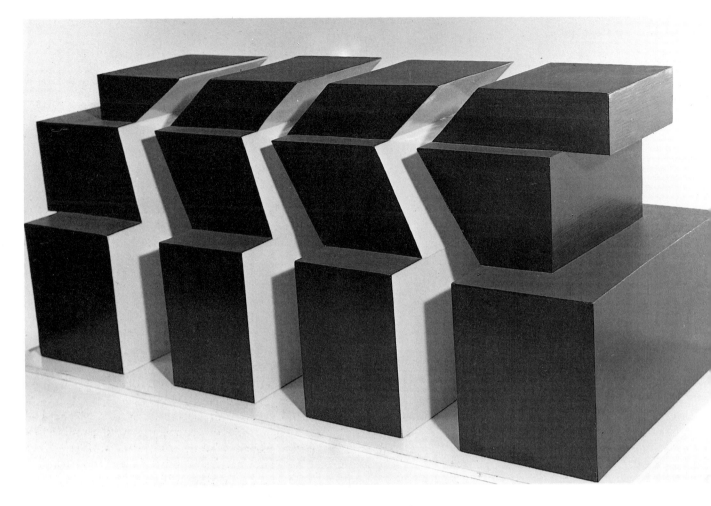

275 Brian King: *Red Shift*, 1969 (maquette for *Shift* in the Hugh Lane Municipal Gallery of Modern Art, Dublin). Wood and plastic, H. 38.1 cm (15 in.). Ulster Museum, Belfast.

The very simplicity of *Grey Box* (Ulster Museum), created in 1967 by Ian Stuart (b.1926), draws attention to itself and the aluminium of which it is made. It is a reminder of the extent to which modern sculpture has been influenced by industrial forms and materials.

In *Red Shift* (also in the Ulster Museum), a work of 1969 by Brian King 275 (b.1942), the eye plays with the blocks, and the spaces between them (brightly coloured to attract attention): the piece is a graphic representation of the word 'shift', as if it were a structure of blocks which had become dislocated by a sharp movement.

APPLIED ARTS

In the early twentieth century there was remarkable vigour in the Arts and Crafts movement. It had begun in England, fostered by people like William Morris, and was an effort to re-establish hand-craftsmanship, and get away from the effects of mass production which had come with the Industrial Revolution. It began in Ireland in the last decade of the nineteenth century, and in the early twentieth century was very much bound up with the new literary and political movements. Though the work produced had many secular applications (hand-weaving, embroidery, jewellery) it was most successfully used in the decoration and fitting out of several churches, where the making of stained glass was the most important craft.

With all the church building which went on in the nineteenth century stained glass had been in great demand. Most of it was mediocre, and much of it was imported from England, Germany and France. At the beginning of this century people began to realize that the quality of stained glass could be greatly improved. Classes were set up in the Metropolitan School of Art around 1903, under the direction of the English artist A. E. Child. Child also worked in the cooperative stained-glass works An Túr Gloine (the Tower of Glass), which was also set up in 1903, and which was a major factor in the revival.

The cathedral of St Brendan at Loughrea, Co. Galway, has a number of fine windows from An Túr Gloine. There are four by Child, and several by Michael Healy (1873–1941), one of the most talented people to join the studio. Catherine O'Brien (d.1963) worked at An Túr Gloine from 1906, and some of her work can be seen in the Church of Ireland parish church at Gorey, Co. Wexford, and in St Naithí's at Dundrum, Co. Dublin. Wilhelmina Geddes (1888–1955) joined around 1915. One of her most important commissions was the 1914–18 War Memorial Window at Ypres in Belgium, but plenty of her work can be seen in Ireland – in St Ann's, Dawson Street, Dublin, for example, or in the Church of Ireland church in Malone Road, Belfast. Her technique is bolder than that of Michael Healy.

Evie Hone, the best known of the second generation of stained-glass makers, also worked at An Túr Gloine, advised by Michael Healy. Having studied with Cubist painters in Paris, she was able to apply the simplified manner they evolved to the design of stained glass. *My Four Green Fields* (1938–39) can be seen at the offices of Córas Iompair Éireann in O'Connell Street, Dublin.

Probably the most outstanding stained-glass artist of the century, Harry Clarke (1889–1931), worked outside the Túr Gloine circle, since the firm of church decorators run by his father was already producing stained glass. His first major commission was for the Honan Chapel, University College, Cork **36** (1915–17). Major schemes by him can be seen at Carrickmacross, Co. Monaghan, Ballinrobe, Co. Mayo, and in the Basilica at Lough Derg, Co. Donegal. Clarke was also a superb book illustrator.

Instead of trying to produce naturalistic pictures foreign to the medium in which they were working, as many of the nineteenth-century artists had done, all these modern stained-glass makers exploited the nature of their material to obtain a richer decorative effect. New techniques in the production of coloured glass, employed in particular by Clarke and by Healy, made possible much greater richness of colour.

Under Church patronage the Arts and Crafts revival early in this century produced fine embroidery and metalwork. At Loughrea Cathedral there is a set of banners executed by Lily Yeats (1866–1949) and her assistants of the Dun Emer Guild, whose designers included Jack B. Yeats and his wife. Evelyn Gleeson of the Dun Emer Guild designed and executed a tapestry of the Four Evangelists for the Honan Chapel, which also possesses a banner of St Fin Barre and an embroidered cope from the same studio.

The Dublin School of Art began classes in enamelling and metalwork around 1915, under Oswald Reeves. Reeves himself designed a tabernacle door for the Honan Chapel (c.1918), and W. A. Scott designed a complete set of altar furniture for the chapel. Another fine example is the tabernacle door in the church of St Michael, Ballinasloe, Co. Galway, by Mia Cranwill. 276

After the impetus of the Arts and Crafts movement had worn itself out interest in design lapsed. It became so poor that there were various government inquiries into the state of design in Ireland. Interest became active again with the setting up of the Kilkenny design workshops in 1963 with the object of improving Irish

design in manufacture. Instead of concentrating on handwork, as the earlier movement had done, the Kilkenny workshops aim at producing good designs which can easily be made in factories. They concentrate their attention particularly on household goods, such as furniture, ceramics and textiles, and they also design jewellery.

In the same period there was a renewed interest in art for churches, and work has been commissioned from Irish artists. Corpus Christi, Knockanure, apart from sculpture by Oisín Kelly, has tapestry Stations of the Cross by Leslie McWeeney. Our Lady of the Rosary, Limerick, has sculpture by Imogen Stuart, and St Dominic's, Athy, Co. Kildare, has Stations of the Cross by George Campbell (b.1917). In enamel and metalwork Brother Benedict Tutty, O.S.B., is a leading artist: Stations, crucifix, tabernacle and sanctuary lamp made by him in the 1960s form a fine ensemble in the church of St Columcille at Tully, Co. Galway.

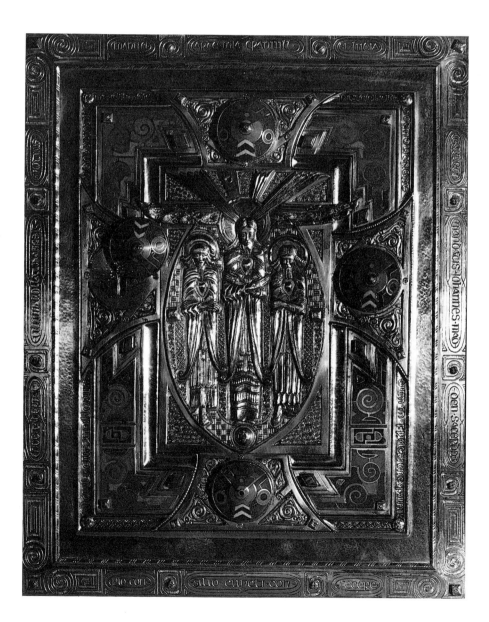

276 Mia Cranwill: tabernacle door in St Michael's, Ballinasloe, Co. Galway, 1926. Silver, gold and coloured enamel. The enamel bosses recall those of the Ardagh Chalice (see pl. **8**), and the figures of Christ and two Apostles loosely resemble the saints on the Breac Maodhóg (pl. **20**).

BIBLIOGRAPHY

This selection includes the more important and more up-to-date works, with the aid of which the reader should find references to further material not listed here. Three abbreviations are used: *CL* (*Country Life*), *IGS* (*Bulletin of the Irish Georgian Society*), and *JRSAI* (*Journal of the Royal Society of Antiquaries of Ireland*).

General

Exhibition: *Aspects of Irish Art* (Columbus and Toledo, Ohio, 1974).
B. Arnold, *A Concise History of Irish Art* (London, 2nd ed. 1977)—B. de Breffny, ed., *The Irish World* (London 1977)—L. M. Cullen, *Life in Ireland* (London 1968)—P. Harbison, *Guide to the National Monuments in the Republic of Ireland* (Dublin, latest ed. 1977)—J. Hewitt, *Art in Ulster 1* (Belfast 1977)—Lord Killanin and M. V. Duignan, *The Shell Guide to Ireland* (London 1967)—E. Malins and the Knight of Glin, *Lost Demesnes, Irish Landscape Gardening 1660–1845* (London 1976).

Architecture

Exhibition: *Irish Architectural Drawings* (Belfast, Armagh, London and Dublin 1965).
B. de Breffny and R. ffolliott, *The Houses of Ireland* (London 1975)—B. de Breffny and G. Mott, *The Churches and Abbeys of Ireland* (London 1976)—C. E. B. Brett, *Buildings of Belfast* (London 1967)—C. E. B. Brett, *Court Houses and Market Houses of the Province of Ulster* (Belfast 1973)—G. Camblin, *The Town in Ulster* (1951)—M. Craig, *Classic Irish Houses of the Middle Size* (London 1976)—M. Craig, *Dublin 1660–1860* (Dublin 1969)—M. Craig and the Knight of Glin, *Ireland Observed* (Cork 1970)—K. Danaher, *Ireland's Vernacular Architecture* (Cork 1975)—H. Dixon, *An Introduction to Ulster Architecture* (Belfast 1975)—D. Guinness and W. Ryan, *Irish Houses and Castles* (London 1971)—P. Shaffrey, *The Irish Town* (Dublin and London 1975)—Ulster Architectural Heritage Society, Belfast, *Architectural Surveys of Towns and Villages in Ulster*.

Painting

National Gallery of Ireland, Dublin, *Catalogue of the Paintings* (1971), and *Illustrated Catalogue* (1963)—S. O'Saothrai, *An Dánlann Naisiúnta* (Dublin 1966)—J. White, *The National Gallery of Ireland* (London 1968)—Crawford Municipal Art Gallery, Cork, *Catalogue* (1953).
Exhibitions: *Great Irishmen* (Belfast 1965)—*Irish Houses and Landscapes* (Belfast and Dublin 1963)—*Irish Portraits 1660–1860* (Dublin, London and Belfast 1969–70)—*Irish Watercolors 1675–1925 from the National Gallery of Ireland* (Dallas Museum of Fine Arts, Texas, 1976).
T. Bodkin, *Four Irish Landscape Painters* (Dublin 1920)—A. Crookshank and the Knight of Glin, *The Painters of Ireland 1660–1920* (London 1978)—W. G. Strickland, *Dictionary of Irish Artists* (Dublin 1913, recent reprint).

Sculpture and applied arts

Exhibition: *Irish Silver 1630–1820* (Rosc, Dublin 1971).
H. Hickey, *Images of Stone* (Belfast 1976)—H. Potterton, *Irish Church Monuments 1570–1880* (Belfast 1974)—P. Warren, *Irish Glass* (Dublin 1970)—G. Willis, *English and Irish Glass* (London 1970)—M. Wynne, *Irish Stained Glass* (Dublin 1977).

Prehistory to 1600

Exhibitions: *Frühe Irische Kunst* (Berlin, Munich and Hamburg 1959)—*Treasures of Early Irish Art, 1500 BC to 1500 AD* (New York, San Francisco, Pittsburgh, Boston and Philadelphia 1978–79).

E. E. Evans, *Prehistoric and Early Christian Ireland. A Guide* (London 1966)—A. T. Lucas, *Treasures of Ireland. Irish Pagan and Early Christian Art* (Dublin 1973)—A. Mahr, *Ancient Irish Handicraft* (Limerick 1939)—S. P. Ó Ríordáin, *Antiquities of the Irish Countryside* (London, latest ed. 1976).

PREHISTORY

General

G. Eogan, 'The Later Bronze Age in Ireland in the light of Recent Research', in *Proc. Prehistoric Soc.*, 30 (1964), pp. 268–351—G. Eogan, 'Report on the Excavations of Some Passage Graves, Unprotected Inhumation Burials and a Settlement Site at Knowth, Co. Meath', in *Proc. Royal Irish Academy*, 74 C (1974), pp. 11–112—M. Herity, *Irish Passage Graves. Neolithic Tomb-Builders in Ireland and Britain 2500 B.C.* (Dublin 1974)—M. Herity and G. Eogan, *Ireland in Prehistory* (London 1977)—J. Raftery, *Prehistoric Ireland* (London 1951)—A. Ross, *Pagan Celtic Britain* (London 1967)—E. Rynne, 'The Introduction of La Tène into Ireland', in *Bericht über den V. Internationalen Kongress für Vor- und Frühgeschichte, Hamburg 1958* (Berlin 1961), pp. 705–09.

Megalithic structures, forts, and stone-carving

A. Burl, *The Stone Circles of the British Isles* (New Haven 1976)—R. De Valera and S. Ó Nualláin, *Survey of the Megalithic Tombs of Ireland*, vols. I, II, III (Dublin 1961, 1964, 1972)—M. Duignan, 'The Turoe Stone: its Place in insular La Tène Art', in *Celtic Art in Ancient Europe. Five Protohistoric Centuries*, ed. P.–M. Duval and C. Hawkes (London, New York and San Francisco 1976), pp. 201–12—E. Hadingham, *Ancient Carvings in Britain: A Mystery* (London 1974)—J. S. Jackson, 'The Clonfinlough Stone: a geological assessment', in *North Munster Studies, Essays in commemoration of Monsignor Michael Moloney*, ed. E. Rynne (Limerick 1967), pp. 11–19—E. Macwhite, 'A New View on Irish Bronze Age Rock-scribings', in *JRSAI*, 76 (1946), pp. 59–80—C. O'Kelly, 'Passage-grave art in the Boyne Valley', in *Proc. Prehistoric Soc.*, 39 (1973), pp. 354–82 (also issued separately)—S. Ó Nualláin, 'The Stone Circle Complex of Cork and Kerry', in *JRSAI*, 105 (1975), pp. 83–131—S. P. Ó Ríordáin and G. Daniel, *Newgrange and the Bend of the Boyne* (London 1964)—J. Patrick, 'Midwinter Sunrise at Newgrange', in *Nature*, 249 (7 June 1974), pp. 517–19—B. Raftery, 'Irish Hill-forts', in *The Iron Age in the Irish Sea Province*, ed. C. Thomas (London 1972), pp. 37–58—J. Raftery, 'The Turoe Stone and the Rath of Feerwore', in *JRSAI*, 74 (1944), pp. 23–52—E. Rynne, 'Celtic Stone Idols in Ireland', in *The Iron Age in the Irish Sea Province*, ed. C. Thomas (London 1972), pp. 79–98—E. Shee, 'Recent Work on Irish Passage Grave Art', in *Bolletino del Centro Camuno di Studi Preistorici*, 8 (1972), pp. 199–224—E. Shee, 'Techniques of Irish Passage Grave Art', in *Megalithic Graves and Ritual*, ed G. Daniel and P. Kjaerum, Jutland Archaeological Society Publications XI (1973), pp. 163–72—T. J. Westropp, 'The Ancient Forts of Ireland: Being a Contribution towards a Knowledge of their types, affinities, and structural features', in *Trans. of the Royal Irish Academy*, 31 (1901), pp. 579–730.

Metalwork

E. C. R. Armstrong, *Catalogue of Irish Gold Ornaments in the Collection of the Royal Irish Academy* (Dublin, 2nd ed. 1933)—R. Cochrane, 'On Broighter, Limavady, County Londonderry, and the Find of Gold Ornaments There in 1896', in *JRSAI*, 32 (1902), pp. 211–24—P. Harbison, *The Axes of the Early Bronze Age in Ireland* (Munich 1969)—E. M. Jope, 'An Iron Age Decorated Sword-Scabbard from the River Bann at Toome', in *Ulster Journal of Archaeology*, 17 (1954), pp. 81–91—E. M. Jope and B. C. S. Wilson, 'The Decorated Cast Bronze Disc from the River Bann near Coleraine', in *Ulster Journal of Archaeology*, 20 (1957), pp. 95–102—M. J.

O'Kelly, 'The Cork Horns, the Petrie Crown and the Bann Disc, The Technique of their Ornamentation', in *Journal of the Cork Hist. and Archaeol. Soc.*, 66 (1961), pp. 1–12—J. Raftery, 'A Hoard of the Early Iron Age, Interim Report', in *JRSAI*, 90 (1960), pp. 2–5—J. J. Taylor, 'Lunulae Reconsidered', in *Proc. Prehistoric Soc.*, 36 (1970), pp. 38–81.

Pottery
R. M. Kavanagh, 'Collared and Cordoned Cinerary Urns in Ireland', in *Proc. Royal Irish Academy*, 76 C (1976), pp. 293–403—R. M. Kavanagh, 'The Encrusted Urn in Ireland', in *Proc. Royal Irish Academy*, 73 C (1973), pp. 507–617.

THE EARLY CHRISTIAN PERIOD

General
Exhibition: *Viking and Medieval Dublin*, National Museum of Ireland (Dublin 1973).
G. Coffey, *Guide to the Celtic Antiquities of the Christian Period preserved in the National Museum, Dublin* (Dublin 1909)—H. S. Crawford, *Handbook of Irish Carved Ornament from Irish Monuments of the Christian Period* (Dublin 1926)—M. and L. De Paor, *Early Christian Ireland* (London 1978)—P. Harbison, 'Passport to the Past – Pre-Reformation Churches and Crosses in Ireland', in *AA Touring Guide to Ireland* (Basingstoke 1976) pp. 289–303—F. Henry, *Early Christian Irish Art* (Dublin 1963)—F. Henry, *Irish Art in the Early Christian Period (to 800 A.D.)* (London 1965)—F. Henry, *Irish Art during the Viking Invasions (800–1020 A.D.)* (London 1967)—F. Henry, *Irish Art in the Romanesque Period (1020–1170 A.D.)* (London 1970)—F. Henry, *La Sculpture Irlandaise pendant les douze premiers siècles de l'Ere chrétienne*, 2 vols. (Paris 1933)—K. Hughes and A. Hamlin, *The Modern Traveller to the Early Irish Church* (London 1977)—L. Laing, *The Archaeology of Late Celtic Britain and Ireland* (London 1975)—A. Mahr and J. Raftery, *Christian Art in Ancient Ireland*, 2 vols. (Dublin 1932 and 1941)—E. H. L. Sexton, *A Descriptive and Bibliographical List of Irish Figure Sculpture of the Early Christian Period* (Portland, Maine, 1946).

Metalwork and manuscripts
Evangeliorum Quattuor Codex Cenannensis (facsimile of the *Book of Kells*), 2 vols. (Berne 1950–51)—*Evangeliorum Quattuor Codex Durmachensis* (facsimile of the *Book of Durrow*), 2 vols. (Olten, Lausanne and Freiburg i. Br. 1960)—T. J. Brown, 'Northumbria and the Book of Kells', in *Anglo-Saxon England*, ed. P. Clemoes (Cambridge 1972), pp. 219–46—H. S. Crawford, 'A Descriptive List of Irish Shrines and Reliquaries', in *JRSAI*, 53 (1923), pp. 74–93 and 151–76—L. S. Gógan, *The Ardagh Chalice* (Dublin 1932)—F. Henry, *The Book of Kells* (London 1974)—F. Henry, 'The Effects of the Viking Invasions on Irish Art', in *Proc. of the International Congress of Celtic Studies, Dublin 1959* (Dublin 1962), pp. 61–72—F. Henry, 'Irish Enamels of the Dark Ages and their Relation to the Cloisonné Techniques', in *Dark Age Britain*, ed D. B. Harden (London 1966), pp. 71–88—T. D. Kendrick and E. Senior, 'St Manchan's Shrine', in *Archaeologia*, 86 (1937), pp. 105–18—H. J. Lawlor, 'The Cathach of St Columba', in *Proc. Royal Irish Academy*, 33 C (1916), pp. 241–443—E. A. Lowe, *Codices Latini Antiquiores, Part II, Great Britain and Ireland* (Oxford, 2nd ed. 1972)—M. MacDermott, 'The Kells Crozier', in *Archaeologia*, 96 (1955), pp. 59–113—M. MacDermott, 'An Openwork Crucifixion Plaque from Clonmacnoise', in *JRSAI*, 84 (1954), pp. 36–40—O. H. Moe, 'Urnes and the British Isles', in *Acta Archaeologica*, 26 (1955), pp. 1–30—C. Nordenfalk, *Celtic and Anglo-Saxon Painting* (London and New York 1977)—M. J. O'Kelly, 'The Belt-Shrine from Moylough, Sligo', in *JRSAI*, 95 (1965), pp. 149–88—R. M. Organ, 'Examination of the Ardagh Chalice – A Case History', in *Application of Science in Examination of Works of Art, Museum of Fine Arts Seminar, 1970*, ed. W. J. Young (Boston, Mass., 1973) pp. 238–71—D. M. Wilson and O. Klindt-Jensen, *Viking Art* (London 1966).

Sculpture
H. S. Crawford, 'Descriptive List of Early Cross Slabs and Pillars', in *JRSAI*, 42 (1912) pp. 217–44, 43 (1913), pp. 151–69, 261–65 and 326–34 (see also *JRSAI*, 46 (1916), pp. 163–67 for supplementary list)—L. De Paor, 'The Limestone Crosses of Clare and Aran', in *Journal of the Galway Archaeol. and Hist. Soc.*, 26 (1955–56), pp. 53–71—A. Hamlin, 'A Chi-Rho-Carved Stone at Drumaqueran, Co. Antrim', in *Ulster Journal of Archaeology*, 35 (1972), pp. 22–28—F. Henry, 'Early Christian Slabs and Pillar Stones in the West of Ireland', in *JRSAI*, 67 (1937), pp. 265–79—F. Henry, *Irish High Crosses* (Dublin 1964)—A. Kingsley Porter, *The Crosses and Culture of Ireland* (New Haven 1931)—H. G. Leask, 'St·Patrick's Cross, Cashel, Co. Tipperary. An Enquiry into its Original Form', in *JRSAI*, 81 (1951), pp. 14–18—P. Lionard, 'Early Irish Grave-Slabs', in *Proc. Royal Irish Academy*, 61 C (1961), pp. 95–169—R. A. S. Macalister, *Monasterboice, Co. Louth* (Dundalk 1946)—M. Moloney, 'Beccan's Hermitage in Aherlow: The Riddle of the Slabs', in *North Munster Antiquarian Journal*, 9 (1962–65), pp. 99–107—H. M. Roe, 'The High Crosses of County Armagh', in *Seanchas Ardmhacha*, 1, no. 2 (1955), pp. 107–14—H. M. Roe, 'The High Crosses of Co. Louth', in *Seanchas Ardmhacha*, 1, no. 1 (1954), pp. 101–14—H. M. Roe, 'The High Crosses of East Tyrone', in *Seanchas Ardmhacha*, 2, no. 1 (1956), pp. 79–89—H. M. Roe, *The High Crosses of Kells* (Meath Archaeol. and Hist. Soc. 1959)—H. M. Roe, *The High Crosses of Western Ossory* (Kilkenny 1958)—R. B. K. Stevenson, 'The Chronology and Relationships of Some Irish and Scottish Crosses', in *JRSAI*, 86 (1956), pp. 84–96—M. Stokes, *The High Crosses of Castledermot and Durrow* (Dublin 1898)—M. Stokes, 'Notes on the High Crosses of Moone, Drumcliff, Termonfechin and Killamery', in *Trans. Royal Irish Academy*, 31 (1901), pp. 541–78—T. J. Westropp, 'A Description of the Ancient Buildings and Crosses at Clonmacnois, King's County', in *JRSAI*, 37 (1907), pp. 277–306.

Architecture
A. C. Champneys, *Irish Ecclesiastical Architecture* (London and Dublin 1910)—H. S. Crawford, 'The Romanesque Doorway at Clonfert', in *JRSAI*, 42 (1912), pp. 1–7—L. De Paor, 'Cormac's Chapel: the beginnings of Irish Romanesque', in *North Munster Studies, Essays in commemoration of Monsignor Michael Moloney*, ed. E. Rynne (Limerick 1967), pp. 133–45—L. De Paor, 'A Survey of Sceilg Mhichíl', in *JRSAI*, 85 (1955), pp. 174–87—P. Harbison, 'How Old is Gallarus Oratory?', in *Medieval Archaeology*, 14 (1970), pp. 34–59—A. Hill, *A Monograph of Cormac's Chapel, Cashel* (Cork 1874)—H. G. Leask, 'Carved Stones Discovered at Kilteel, Co. Kildare', in *JRSAI*, 65 (1935), pp. 1–8—H. G. Leask, *Irish Churches and Monastic Buildings, I – The First Phases and the Romanesque* (Dundalk 1955)—D. Lowry-Corry et al., 'A Newly Discovered Statue at the Church on White Island, County Fermanagh', in *Ulster Journal of Archaeology*, 22 (1959), pp. 59–66—G. Petrie, 'The Ecclesiastical Architecture of Ireland, anterior to the Anglo-Norman Invasion; comprising an essay on the Origin and Uses of the Round Towers of Ireland', in *Trans. Royal Irish Academy*, 20 (1845), later published as a monograph.

NORMAN AND LATER MEDIEVAL GAELIC IRELAND

Architecture
G. Carville, *The Heritage of Holy Cross* (Belfast 1973)—A. Clapham, 'Some Minor Irish Cathedrals', in *Papers by Sir Alfred Clapham with a Memoir and Bibliography* (London 1952) pp. 16–39—B. de Breffny and G. Mott, *Irish Castles* (London 1977)—J. Forde-Johnston, *Castles and Fortifications in Britain and Ireland* (London 1977)—P. Harbison, 'Twelfth and Thirteenth Century Irish Stonemasons in Regensburg (Bavaria) and the End of the "School of the West" in Connacht', in *Studies* (Winter 1975), pp. 333–46—D. Johnston, 'A Contemporary Plan of the Siege of Caher Castle, 1599, and some additional remarks', in *The Irish Sword*, 47 (1975), pp. 109–15—H. G. Leask, *Irish Castles and Castellated Houses* (Dundalk 1941)—H. G. Leask, *Irish Churches and Monastic Buildings, II – Gothic Architecture to A.D. 1400* (Dundalk 1960) and *III – Medieval Gothic, The Last Phases* (Dundalk 1960)—R. A. Stalley, *Architecture and Sculpture in Ireland 1150–1350* (Dublin 1971)—R. A. Stalley, 'A Romanesque Sculptor in Connaught', in *CL* (21 June 1973), pp. 1826–30—R. A. Stalley, *Christ Church, Dublin. The Late Romanesque Building Campaign* (Ballycotton 1973).

Sculpture
F. Henry, 'Irish Cistercian Monasteries and their carved decoration', in *Apollo* (October 1966) pp. 260–67—J. Hunt, 'Bishop Wellesly's Tomb Carvings', in *Journal of the Co. Kildare Archaeol. Soc.*, 15, no. 5 (1975–76), pp. 490–92—J. Hunt (with contributions by P. Harbison), *Irish Medieval Figure Sculpture 1200–1600*, 2 vols. (Dublin and London 1974)—C. MacLeod, 'Medieval Wooden Figure Sculptures in Ireland', in *JRSAI*, 75 (1945), pp. 167–82, 195–203; 76 (1946), pp. 89–100, 155–70—C. MacLeod, 'Some Late Medieval Wood Sculptures in Ireland', in *JRSAI*, 77 (1947), pp. 53–62—E. C. Rae, 'Irish Sepulchral Monuments of the Later Middle Ages', in *JRSAI*,

100 (1970), pp. 1–38; 101 (1971), pp. 1–39—E. C. Rae, 'The Rice Monument in Waterford Cathedral', in *Proc. Royal Irish Academy*, 69 C (1970), pp. 1–14—E. C. Rae, 'The Sculpture of the Cloister of Jerpoint Abbey', in *JRSAI*, 96 (1966), pp. 59–91—E. C. Rae, 'The Tomb of Bishop Walter Wellesley at Great Connell Priory, County Kildare', in *Journal of the Co. Kildare Archaeol. Soc.*, 14, no. 5 (1970), pp. 544–63—H. M. Roe, *Medieval Fonts of Meath* (Meath Archaeol. and Hist. Soc. 1968).

Applied arts
E. C. R. Armstrong, *Irish Seal-Matrices and Seals* (Dublin 1913)—E. C. R. Armstrong and H. J. Lawlor, 'The Domnach Airgid', in *Proc. Royal Irish Academy*, 34 C (1918), pp. 96–126—G. J. Hewson, 'On a Processional Cross of the Fifteenth Century, found near Ballylongford, Co. Kefry', in *JRSAI*, 15 (1881), pp. 511–21; see also *JRSAI*, 67 (1937), pp. 117–18—J. Hunt, 'The Arthur Cross', in *JRSAI*, 85 (1955), pp. 84–87—J. Hunt, 'The Limerick Cathedral Misericords', in *Ireland of the Welcomes*, 20, no. 3 (Sept.–Oct. 1971), pp. 12–16—J. Hunt, *The Limerick Mitre and Crozier* (Dublin n.d.).

The Seventeenth and Eighteenth Centuries

THE SEVENTEENTH CENTURY

M. Craig, *Classic Irish Houses of the Middle Size* (London 1976)—M. Craig, 'New Light on Jigginstown', in *Ulster Journal of Archaeology*, XXXIII (1970), p. 107—M. Craig, 'Portumna Castle, Co. Galway', in *The Country Seat*, ed. H. Colvin and J. Harris (London 1970), p. 36—M. Craig, *Portumna Castle* (Dublin 1976)—A. Crookshank, 'Lord Cork and his monuments', in *CL*, CXLIX (1971), p. 1288—R. ffolliott, 'Houses in Ireland in the seventeenth century', in *Irish Ancestor*, VI (1974), p. 16—M. Girouard, 'Beaulieu, Co. Louth', in *CL*, CXXV (1959), pp. 106, 156—M. Girouard, 'Ireland's Invalides' [on the Royal Hospital, Kilmainham], in *Architectural Review*, CLVII (1975), p. 370—H. Leask, 'House at Oldbawn, being an account of the Caroline House', in *JRSAI* (1913), p. 314—H. G. Leask, 'Early seventeenth-century houses in Ireland', and D. M. Waterman, 'Some Irish seventeenth-century houses and their architectural ancestry', in *Studies in Building history*, ed. E. M. Jope (London 1961), pp. 243, 251—R. Loeber, 'Irish country houses and castles of the late Caroline period: an unremembered past recaptured', in *IGS*, XVI (1973), p. 1—R. Loeber, 'Lord Coningsby and Ireland', letter in *CL*, CLIII (1973), p. 1473—R. Loeber, 'Sir William Robinson', in *IGS*, XVII (1974), p. 3.

THE EIGHTEENTH CENTURY

Architecture (general and on buildings, then alphabetically by architect)
J. Cornforth, 'Russborough, Co. Wicklow', in *CL*, CXXXIV (1963), pp. 1464, 1623, 1686—M. Craig, 'Bellamont Forest, Co. Cavan', in *CL*, CXXXV (1964), pp. 1258, 1330—M. Craig, *Classic Irish Houses of the Middle Size* (London 1976)—M. Craig, 'Some smaller Irish Houses' [for Kilcarty], in *CL*, CVI (1949), p. 131—The Knight of Glin and John Cornforth, 'Castletown, Co. Kildare', in *CL*, CXLV (1969), pp. 722, 798, 882—A. Crookshank, 'Eighteenth-century alterations, improvements and furnishings in St Michan's church, Dublin', in *Studies*, LXIV (1975), p. 386—C. P. Curran, 'The architecture of the Bank of Ireland' (1949) reprinted in *IGS* (1977), p. 1—C. P. Curran, 'Cooley, Gandon and the Four Courts', in *JRSAI*, LXXIX (1949), p. 20—C. P. Curran, *The Rotunda Hospital, its architects and craftsmen* (Dublin 1945)—C. Ellison, 'Remembering Dr Beaufort' [for Ardbraccan], in *IGS*, XVIII (1975), p. 1—B. FitzGerald, 'Carton, Co. Kildare', in *CL*, LXXX (1936), pp. 488, 514—B. FitzGerald, 'Russborough, Co. Wicklow', in *CL*, LXXXI (1937), pp. 94, 120—*The Georgian Society Records of 18th Century Domestic Architecture and Decoration in Dublin* (Dublin 1909–13)—M. Girouard, 'Curraghmore, Co. Waterford', in *CL*, CXXXIII (1963), pp. 256, 308, 368—M. Girouard, 'Westport House, Co. Mayo', in *CL*, CXXXVII (1965), pp. 1010, 1074—The Knight of Glin, 'Architectural books and "palladianism" in Ireland', in *IGS*, V (1962), p. 11—C. Hussey, 'Lucan House, Co. Dublin', in *CL*, CI (1947), p. 278—C. Hussey, 'Powerscourt, Co. Wicklow', in *CL*, C (1946), pp. 1062, 1158, 1206—C. Maxwell, *Country and Town in Ireland under the Georges* (Dundalk 1949)—E. McParland, 'Emo Court, Co. Leix', in *CL*, CLV (1974), pp. 1274, 1346—E. McParland, 'Mount Kennedy, Co. Wicklow', in *CL*, CXXXVIII (1965), pp. 1128, 1256—E. McParland,

'Provost's House, Trinity College', in *CL*, CLX (1976), pp. 1034, 1106—E. McParland, 'The Wide Streets Commissioners: their importance for Dublin architecture in the late 18th-early 19th century', in *IGS*, XV (1972), p. 1—E. McParland, 'Trinity College, Dublin', in *CL*, CLIX (1976), pp. 1166, 1242, 1310—P. Rankin, 'Downhill, Co. Derry', in *CL*, CL (1971), pp. 95, 154—P. Rankin, *Irish Building Ventures of the Earl Bishop of Derry 1730–1803* (Belfast 1972)—R. I. Ross, 'Ireland's oldest public building, Dr Steevens' Hospital', in *CL*, CLX (1976), p. 816—A. Rowan, 'Georgian Castles in Ireland', in *IGS*, VII (1964), p. 3—T. Sadleir and P. Dickinson, *Georgian Mansions in Ireland* (Dublin 1915)—J. Summerson, *Architecture in Britain 1530–1830* (London 1969)—H. Wheeler and M. Craig, *The Dublin City Churches of the Church of Ireland* (Dublin 1948).

The Knight of Glin, 'Francis Bindon', in *IGS* (1967), p. 3—The Knight of Glin, 'Richard Castle', in *IGS*, VII (1964), p. 31—J. Harris, 'Sir William Chambers, friend of Charlemont', in *IGS*, VIII (1956), p. 67—The Knight of Glin, 'Nathaniel Clements and some Irish houses', in *Apollo*, LXXXIV (1966), p. 314—C. Curran, 'Cooley, Gandon and the Four Courts', in *JRSAI*, LXXIX (1949), p. 20—The Knight of Glin, 'The architecture of Davis Duckart', in *CL*, CXLII (1967), pp. 735, 798—M. Craig, 'James Gandon, architect of the Custom House and the Four Courts', in *The Bell*, XVII (April 1951), p. 25—J. Gandon and T. Mulvany, *The Life of James Gandon, Esq.* (Dublin 1846, reprint London 1969 with introduction and appendices by M. Craig)—E. McParland, 'James Gandon and the Royal Exchange Competition, 1768–69', in *JRSAI*, CII (1972), p. 58—E. McParland, *Thomas Ivory, Architect* (Ballycotton 1973)—E. McParland, 'Thomas Ivory', in *IGS*, XVII (1974), p. 15—C. E. B. Brett, 'Roger Mulholland', in *IGS*, XVII (1974), p. 19—C. E. B. Brett, *Roger Mulholland, Architect, of Belfast 1740–1818* (Belfast 1976)—M. Craig, 'Sir Edward Lovett Pearce', in *IGS*, XVII (1974), p. 10—H. Colvin and M. Craig, *Architectural Drawings [at] Elton Hall by Sir John Vanbrugh and Sir Edward Lovett Pearce* (Oxford 1964).

Painting (general, then alphabetically by painter)
D. Alexander, 'The Dublin group: Irish mezzotint engravers in London 1750–75', in *IGS*, XVI (1973), p. 73—J. Cornforth, 'Irish mezzotints after English portraits', in *CL*, CLIV (1973), p. 455—A. Crookshank, 'Early landscape painters in Ireland', in *CL* (1972), p. 470—A. Crookshank, 'Portraits of Irish houses', in *IGS*, V (1962), p. 41.

A. Crookshank, 'William Ashford', in *CL*, CLVII (1975), p. 1352—J. Barry, *The Works of James Barry, Historical Painter*, ed. Fryer, 2 vols. (London 1809)—R. Wark, 'James Barry's self-portrait in Dublin', in *Burlington Magazine*, XCVI (1954), p. 153—H. and S. Berry-Hill, *Chinnery and China Coast Paintings* (1970)—W. Foster, 'George Chinnery', in *Walpole Soc.*, XIX (1930–31), p. 13—H. Potterton, 'A commonplace practitioner in painting and in etching: Charles Exshaw', in *Connoisseur*, CLXXXVII (1974), p. 268—B. de Breffny, 'Robert Fagan, artist', in *Irish Ancestor*, III (1971), p. 71—R. Trevelyn, 'Robert Fagan, an Irish bohemian in Italy', in *Apollo*, XCVI (1972), p. 298—M. Wynne, 'Thomas Frye, 1710–62', in *Burlington Magazine*, CXIV (1972)—W. G. Strickland, 'Hugh Douglas Hamilton', in *Walpole Soc.*, II (1912), p. 99—D. Guinness, 'Robert Healy, Irish sporting artist', in *Ireland of the Welcomes*, XXI (1972)—W. Foster, 'Thomas Hickey', in *Walpole Soc.*, XIX (1930–31), p. 34—W. Foster, 'Robert Home', in *Walpole Soc.*, XIX (1930–31), p. 42—M. Butlin, 'An Eighteenth-century art scandal: Nathaniel Hone's *The Conjuror*', in *Connoisseur*, CLXXIV (May 1970), p. 1—A. Munby, 'Nathaniel Hone's *Conjuror*', in *Connoisseur*, CXX (Dec. 1947), p. 82—H. Pyle, 'Nathaniel Hone, 1718–84', in *The Arts in Ireland*, I (1973)—M. Wynne, 'Hugh Howard, Irish portrait painter', in *Apollo*, XC (1969), p. 314—A. O'Connor, 'James Latham: two portraits', in *Burlington Magazine*, CXVI (1974), p. 154—A. O'Connor, 'James Latham: further documentation', in *Studies*, LXIV (1975), p. 379—G. Goodwin, *James McArdell* (London 1903); V. Manners, *Matthew William Peters, R. A.* (London 1913)—M. Wynne, *Thomas Roberts, 1748–78* (exhibition, National Gallery of Ireland 1978)—M. Wynne, 'Thomas Roberts, 1748–78', in *Studies*, LXVI (1977), p. 299—M. A. Shee, *The Life of Sir Martin Archer Shee* (London 1860)—C. M. Mount, *Gilbert Stuart* (London 1964)—C. M. Mount, 'The Irish career of Gilbert Stuart', in *IGS*, VI (1963), p. 6—M. Webster, *Francis Wheatley* (London 1970)—R. Watson, 'Wheatley in Ireland', in *IGS*, IX (1966), p. 35.

Sculpture

K. Esdaile, 'Christopher Hewetson and his monument to Dr. Baldwin in Trinity College, Dublin', in *JRSAI*, LXXVII (1947), p. 134—T. Hodgkinson, 'Christopher Hewetson, an Irish sculptor in Rome', in *Walpole Soc.*, XXXIV (1951–54), p. 42—H. Potterton, 'William Kidwell, sculptor, and some contemporary mason-sculptors in Ireland', in *IGS*, XV (1972), p. 80—H. Potterton, 'A new pupil of Edward Pierce' [on Kidwell], in *Burlington Magazine*, CXIV (1972), p. 864—H. Leask, 'Dublin Custom House: the Riverine Sculptures' [on Edward Smyth], in *JRSAI*, LXXV (1945), p. 187—J. Gilmartin, 'Peter Turnerelli, sculptor (1774–1839)', in *IGS*, X (1967), p. 1—M. Wynne, 'The portrait medallions of John Van Nost the Younger', in *IGS*, XVIII (1975), p. 37.

Applied arts

Exhibitions: *Irish Delftware* (Castletown House, Co. Kildare, 1971)—*Irish Glass* (City Art Gallery, Limerick, 1971).

D. Bennet, *Irish Georgian Silver* (London 1972)—A. Coleridge and D. FitzGerald, 'Eighteenth century Irish furniture: a provincial manifestation', in *Apollo*, LXXXIV (1966), p. 276—J. Cornforth, 'The Francini in England', in *CL*, CXLVII (1970), p. 634—M. Craig, *Irish Bookbindings 1600–1800* (London 1954)—M. Craig, 'Irish Bookbinding', in *Apollo*, LXXIV (1966), p. 322—C. P. Curran, *Dublin Decorative Plasterwork* (London 1967)—C. P. Curran, 'Riverstown House and the Francini', in *IGS* (1966), p. 3—D. FitzGerald, 'Irish mahogany furniture: a source for American design?', in *Antiques Magazine*, XCIV (1971)—A. K. Leask, 'History of the Irish Linen and Cotton printing industry in the eighteenth century', in *JRSAI*, LXVII (1937), p. 26—A. K. Leask, 'Printed cotton from Robinson's of Ballsbridge', in *JRSAI* (1946), p. 171—E. Sullivan, 'Irish Bookbinding', reprinted in *IGS*, XVII (1974), p. 31—A. Longfield, 'Irish Delft', in *IGS*, XIV (1971), p. 36—K. Ticher, *Irish Silver in the Rococo Period* (Shannon 1972).

The Nineteenth and Twentieth Centuries

THE NINETEENTH CENTURY

General

J. Lee, *The Modernization of Irish Society, 1848–1918* (Dublin 1973)—G. O'Tuathaig, *Ireland before the Famine, 1798–1848* (Dublin 1972)—*Irish Art in the 19th Century* (exhibition, Rosc, Cork 1971).

Architecture

Exhibitions: *Neo-Classicism in Ulster* (Arts Council of Northern Ireland, 1973)—*Ulster Architecture, 1800–1900* (Ulster Museum, Belfast 1972–73).

T. Davis, 'John Nash in Ireland', in *IGS*, VIII (1965), 2—H. Dixon, 'W. H. Lynn', in *IGS*, XVII (1974), p. 25—*The Irish Builder and Engineer* (Dublin 1859ff.; still being produced)—E. McCracken, *Palm House and Botanic Gardens* (Belfast 1971)—E. McParland, 'Ballyfin, Co. Leix', in *CL* (13 and 20 Sept. 1973)—E. McParland, 'Francis Johnston, Architect, 1760–1829', in *IGS*, XII (1969), pp. 3, 4—E. McParland, 'Sir Richard Morrison's Country Houses', in *CL* (24 and 31 May 1973)—T. O'Neill, *Life and Tradition in Rural Ireland* (London 1977)—P. Raftery, 'Patrick Byrne', in *IGS*, VII (1964), p. 48—J. Sheehy, *Kingsbridge Station* (Ballycotton 1973)—J. Sheehy, *J. J. McCarthy and the Gothic Revival in Ireland* (Belfast 1977)—J. Sheehy, 'Railway Architecture', in *Journal of the Irish Railway Record Soc.*, XII, 68 (Oct. 1975)—J. Sheehy, 'Sir John Macneill.', in *IGS*, XVII (1974), p. 22—P. Stanton, *Pugin* (London 1971).

Painting

B. Arnold, 'Solitary Romantic' [on Danby], in *The Arts in Ireland*, II, no. 2 (1974)—E. Adams, *Francis Danby* (New Haven and London 1973)—*Daniel Maclise* (exhibition, Arts Council of Great Britain, London and Dublin 1972)—A. Rorimer, *Drawings by William Mulready* (London 1972)—*Andrew Nicholl 1804–1886* (exhibition, Ulster Museum, Belfast 1973)—J.

Sheehy, *Walter Osborne* (Ballycotton 1974)—J. O'Grady, 'Sarah Purser', in *Capuchin Annual* (1977)—J. White, *John Butler Yeats and the Irish Renaissance* (Dublin 1972).

Sculpture

C. Barrett, *The Crozier Memorial* (Dublin 1976)'Benmore' [John Clarke], *Memorials of John Hogan* (1927)—C. P. Curran, 'Concerning John Hogan', in *Capuchin Annual* (1946–47), p. 172—R. Finch, 'The Life and work of J. E. Carew', in *IGS*, IX (1966), p. 85—J. Kenworthy-Browne, 'Lord Egremont and his sculptors', in *CL*, CLIII (1973), p. 1640—W. C. Monkhouse, *The Works of J. H. Foley* (1875)—B. Read, 'John Henry Foley', in *Connoisseur*, CLXXXVI (1974), p. 262—H. Potterton, 'Dublin's vanishing monuments', in *CL*, CLV (1974), p. 1304—H. Potterton, *The O'Connell Monument* (Ballycotton 1973)—'The Wellington Testimonial', in *Dublin Historical Record*, XIII (1952), p. 49.

Applied arts

M. Boydell, 'Made for Convival Clinking', in *CL* (26 Sept. 1974)—M. Boydell, 'A Versatile National Emblem', in *CL* (23 May 1974)—M. Boydell, 'Waterford Glass', in *The Arts in Ireland*, I, no. 4 (1973)—E. Boyle, *The Irish Flowerers* (Belfast 1971)—E. E. Evans, *Irish Folkways* (London 1957)—A. K. Longfield, *Guide to the Collection of Lace, Ard Mhusaeum na h Eireann* (National Museum of Ireland, Dublin 1970)—A. K. Longfield, *Some Irish Churchyard Sculpture* (Ballycotton 1974)—S. McCrum, *The Belleek Pottery* (Belfast 1972)—S. Murphy, *Stone Mad* (London 1966)—T. O'Neill, *Life and Tradition in Rural Ireland* (London 1977).

THE TWENTIETH CENTURY

General

M. Catto, *Art in Ulster 2* (Belfast 1977)—R. Elliott, *Art and Ireland* (Dublin, probably 1906)—*Irish Art* (Parkside Press 1944)—*Irish Art 1900–1950* (exhibition, Rosc, Cork 1975–76)—M. Longley, *Causeway, The Arts in Ulster* (Belfast 1971).

Architecture

D. Evans, *An Introduction to Modern Ulster Architecture* (Belfast 1977)—Sir J. R. O'Connell, *The Honan Hostel Chapel* (Cork 1916).

Painting

Exhibition: *The Irish Imagination 1959–1971* (Rosc, Dublin 1971).

J. White, 'A E's Merrion Square Murals and other Paintings', in *The Arts in Ireland*, I, no. 3 (1973)—A. Crookshank, 'Deborah Brown', in *The Arts in Ireland*, I, no. 4 (1973)—*Gerard Dillon* (exhibition, Belfast and Dublin 1972–73)—P. Henry, *An Irish Portrait* (London 1952)—P. Henry, *Further Reminiscences* (Belfast 1974)—*Paul Henry 1876–1958* (exhibition, Dublin 1973)—*Mainie Jellett 1897–1944* (exhibition, Dublin 1974)—E. Waldron, 'Cecil King', in *The Arts in Ireland*, I, no. 2 (1972–73)—J. Lavery, *The Life of a Painter* (London 1940)—*Louis le Brocquy, A Retrospective Selection of Oil Paintings, 1939–1966* (Dublin and Belfast 1966–67)—A. Denson, *An Irish Artist, W. J. Leech RHA* (Kendal 1968)—W. Orpen, *An Onlooker in France 1917–1919* (London 1921)—*Nano Reid* (exhibition, Dublin and Belfast 1974–75)—D. Walker, 'Pat Scott', in *The Arts in Ireland* I, no. 1 (1972)—*William Scott* (exhibition, Tate Gallery, London 1972)—*J. B. Yeats and his Family* (exhibition, Rosc, Sligo 1971)—*Jack B. Yeats, 1871–1957, A Centenary Exhibition* (Dublin, Belfast and New York 1971–72)—J. McGreevy, *Jack B. Yeats* (Dublin 1945)—H. Pyle, *Jack B. Yeats* (London 1970).

Sculpture and the applied arts

M. Allen, 'Jerome Connor', in *Capuchin Annual* (1963, 1964, 1965)—A. Denson, *John Hughes* (Kendal 1969)—T. Hickey, 'The Kilkenny Design Workshops', in *The Arts in Ireland*, I, no. 3 (1973)—G. McCann, 'F. E. McWilliam', in *Threshold*, no. 21 (Summer 1967)—H. Potterton, *Andrew O'Connor* (Ballycotton 1974)—J. White and M. Wynne, *Irish Stained Glass* (Dublin 1963).

INDEX